THE POLITICS
OF RECLUSION

The past mysteriously invites us to know
the closely woven meaning of its moments.

—Wilhelm Dilthy

Cultural analysis is intrinsically incomplete.
And, worse than that, the more deeply it
goes the less complete it is. It is a strange
science whose most telling assertions are its
most tremulously based, in which to get
somewhere with the matter at hand is to
intensify the suspicion, both your own and
that of others, that you are not getting it
quite right.

—Clifford Geertz

THE POLITICS OF RECLUSION

Painting and Power in Momoyama Japan

KENDALL H. BROWN

University of Hawai'i Press, Honolulu

© 1997 University of Hawai'i Press
All rights reserved
Printed in the United States of America

02 01 00 99 98 97 5 4 3 2 1

Library of Congress Cataloging-in-Publication Data
Brown, Kendall H.
 The politics of reclusion : painting and power in
Momoyama Japan / Kendall H. Brown.
 p. cm.
 Includes bibliographical references and index.
 ISBN 0–8248–1779–6 (cloth. : alk. paper). — ISBN 0–8248–1913–6
(pbk. : alk. paper)
 1. Painting, Japanese—Kamakura-Momoyama periods, 1185–1600.
2. Hermits in art. 3. Symbolism in art—Japan. I. Title.
ND1053.4.B76 1997
759'.952'09'02—dc21 96–39173
 CIP

University of Hawai'i Press books are printed on acid-free
paper and meet the guidelines for permanence and durability
of the Council on Library Resources

Book design by Kenneth Miyamoto

Contents

Illustrations follow page 117.

Acknowledgments

Think where man's glory begins and ends,
And say my glory was I had such friends.
—WILLIAM BUTLER YEATS

I WOULD LIKE to personalize Yeats' couplet, ruining the rhyme and meter but preserving the spirit of gratitude. In place of his word "friends," I must substitute "teachers." Whatever small glory may exist in this book, it is both the indirect and direct product of a group of remarkable scholars whom I have the honor of calling my teachers. Because their impact is seen throughout this study, it is appropriate to begin by acknowledging my debt to the many teachers who have contributed to this book.

To commence with those individuals who have shaped me intellectually, first I am indebted to Professors James Cahill of the University of California, Berkeley and Vincent Scully of Yale University—two mentors whose scholarship I vainly struggle to emulate. It was during the happy hours in their classes that I gradually realized not only the joy of intellectual endeavors but, more specifically, that the significance of art is found beyond the formal borders of art objects. Large measures of gratitude are also due Professors Mary E. Berry and Helen McCullough of Berkeley, as well as Professors Conrad Totman and Stanley Weinstein of Yale. Memories of their dedication have helped me stay the course.

The research on which this book is based was supported by research grants from the Japanese Ministry of Education (Monbushō) and the Japan Foundation, which allowed me to study at Osaka University and Kyoto University, respectively. During several years in Japan, I had the privilege of learning from two scholars whom I am pleased to call *sensei*. Professor Takeda Tsuneo, emeritus, of Osaka University, has been a source of endless knowledge and wisdom, always delivered with the greatest kindness and encouragement. Similarly, Professor Sasaki Jōhei of Kyoto University provided equal measures of intellectual stimulation and patient advice. I would also like to thank specially Professors Kawai Masatomo of Keiō University and Kobayashi Tadashi of Gakushūin University for a decade of friendly counsel.

Much of what is lucid, solid, and stimulating in this book can be attributed to the work of those people who read and reread my manuscripts. Professors Richard Barnhart, Edward Kamens, and Mimi Yiengpruksawan of Yale University made countless comments on everything from syntax to the concepts at the heart of the work. Professor Stephen Addiss of the University of Richmond suggested important alterations. In addition, Professor Melinda Takeuchi of Stanford University did a yeoman's job in shaking up my thinking, pointing out myriad weaknesses, and—like a Zen master—giving a solid *katsu* blow to a weak first draft. The insight of these scholars has been humbling but invaluable. The book would likely not exist without their work and wisdom.

For the translation of my ideas to the printed page, I am greatly indebted to my wife, Kuniko. She constantly amazed me with her forbearance and her skill as she immersed herself simultaneously in everything from the intricacies of the romanization of Chinese to the mysteries of modern computer commands. I must also add my voice to the growing chorus of writers who have expressed deep thanks to Patricia Crosby of the University of Hawaiʻi Press for her consummate professionalism.

I have saved for last my deepest gratitude—gratitude for someone who, sadly, will not be able to read these words. In her integrity, determination, enthusiasm, and knowledge, the late Carolyn Wheelwright was, and is, a deep source of inspiration. This book is dedicated to Carolyn Wheelwright, a true "lofty scholar."

1.
Introduction
Seen and Unseen Worlds

IT IS OUR GOAL in this study to restore the continuity between the appearance of late-sixteenth-century and early-seventeenth-century Japanese paintings of Chinese scholar-recluses, exemplified by the Seven Sages of the Bamboo Grove and the Four Graybeards of Mt. Shang, and the events that together constitute the cultural experience of Momoyama period Japan. As much as we are able, the object here is to reconstitute the subtle nexus between the seen world of the painting surface, consisting of iconography and style, and the unseen world of culture, consisting of politics, religion, sexuality, and other of the myriad elements of human life. Although it will be necessary to discuss literature, politics, tea ceremony, painting, and philosophy in separate sections, we should keep in mind that the interpretation of meaning is not an issue of understanding the paintings against a cultural background, but rather of seeing all elements—subject, style, artist, patron, place, and ideology—set in the same stream of experience. To this end, our analysis of paintings quite consciously is limited to one chapter, and it is embedded roughly in the middle of the study so that the larger culture of eremitism leads to the paintings, and in turn, the paintings lead back to the culture of Momoyama period Japan.

Chinese Hermits in Japanese Painting

If we consider eremitism to mean withdrawal from society, whether a real or fictive flight from the mundane realm of human affairs, then eremitism is one of the fundamental concepts in nearly all societies. In Japan, as in China, eremitism or reclusion had a long and important role in the development of religion, political philosophy, literature, and art. At the broadest level, one could consider aspects of Buddhist imagery and landscape painting to express aspects of eremitism in that they often sug-

1

gest or depict the rejection of the human realm. In these subjects, however, reclusion is usually subsumed by larger themes and hence is of peripheral importance in this study.

The direct pictorial expression of eremitism is found in a genre that we may call "hermit painting"—painting that takes as its primary subject the recluse actually engaged in the act of reclusion. Hermit paintings span virtually the entire history of Japanese painting, ranging from the anonymous Heian period *Senzui byōbu* (Landscape Screen) (fig. 1) to the 1771 *Jūben jūgi* (Ten Conveniences and Ten Pleasures) (fig. 2) album, ten leaves of which were brushed by Ike Taiga (1723–1776) and the other ten by Yosa Buson (1716–1783). The *Senzui byōbu* likely shows the Tang dynasty poet Bo Juyi (772–846) living in reclusion,[1] while the *Jūben jūgi* album illustrates verses extolling the hermit's life by Qing writer Li Liweng (1616–1680).[2]

Although painted in different times, and representing the first and last great examples of the genre, these works share the essential features of hermit painting in Japan. First, the iconography indicates that the hermits depicted in the paintings are Chinese; indeed, the vast majority of Japanese hermit paintings depict continental rather than home-grown exemplars. Second, the imaginary eremitism in these pictures is not in the least unpleasant: there is neither a hint of the suffering nor the slightest suggestion of the deprivation that marks the actual experience of most hermits. To the contrary, the figures seem to enjoy the congenial conditions provided by the natural realm. In both pictures, the hermit-poets take up their brushes to write verses that, we assume, praise life locked in the embrace of nature. Third, the eremitic life is associated with the production (and consumption) of high culture. Fourth, in both works the specific locus of the scholar-recluse is the hermit's hut. The elegant rusticity of the structure stands for the simple yet tasteful style of living which takes place within it. Finally, although the English word "hermit" and perhaps even the Japanese equivalents *tonseisha* and *intonsha* imply the state of being alone,[3] the *Senzui byōbu* is typical of much hermit-theme painting in Japan in that it shows the poet-hermit accompanied by servants and being visited by a friend. In this case, the *Jūben jūgi* album is somewhat rare in that only one leaf (Taiga's *Convenience of Fishing*) shows multiple hermits.

The depiction of Chinese hermits underwent evolution in subject and style during the six-hundred years between the Heian period when some anonymous artist fictionalized Bo Juyi's life in reclusion and the Edo period when Nanga painters such as Buson and Taiga brushed seemingly countless pictures of generic scholar-gentlemen reposing in nature. The Heian tradition of polychrome screen paintings showing Chinese gentlemen living or traveling in nature continued through the

Muromachi period,[4] but these panoramic scenes were far outnumbered by ink monochrome hanging scrolls featuring Zen Buddhist exemplars such as Budai (in Japanese, Hotei), Hanshan (Kanzan), and Shide (Jittoku), and Xianzi (Kensu). These and other Zen eccentrics may be considered hermits in that they rejected not only the normative social order but that they even abandoned the order of the monastic community. By the late sixteenth century, pictures of Zen eccentrics increasingly gave way to images of secular Chinese figure subjects in nearly all pictorial formats.

In the "Method of Composition for Painting *Shōhekiga*" section in *Honchō gashi* (History of Japanese Painting) of 1678, Kano Einō (1631–1691) reflects the values of the conservative Kyoto branch of the Kano school when he writes that "landscapes should be painted in the *jōdan*, figures in the *chūdan*, and flowers-and-birds in the *gedan*."[5] Extant *fusuma* and wall paintings *(shōhekiga)* at late-sixteenth-century and seventeenth-century temples, castles, and villas reveal that the figures painted in the *chūdan* and other rooms usually were not the Zen patriarchs and eccentrics favored in Muromachi period scrolls but rather were Confucian exemplars, Daoist immortals, and famous literary men.[6] *Fusuma* (sliding wall panels) and screens of the period include paintings of purely didactic Confucian subjects, such as the "Twenty-four Paragons of Filial Piety" *(nijūshikō)* and "Mirror of [Good and Bad] Emperors" *(teikan)* and Daoist figures, typically groups of immortals *(gunsen)* such as the "Eight Immortals" *(hassen)*.

Most frequent are pictures of what the Chinese call "lofty scholars" or *gaoshi (kōshi)*. These *gaoshi* are distinguishable as literary men or scholars by their flowing robes, drooping caps, sparse hair, and long beards—the standard uniform of the Chinese scholar-official. Their designation as "lofty" or "high minded" derives from the fact that they usually are represented in nature, having escaped to this liberating realm from the shackles of government service. By espousing eremitism, the preeminent symbol of the rejection of worldly bureaucratic status, these men show their true merit, and, ironically, their fitness to govern. The Chinese subjects of hermit paintings need not be real hermits (men who spent their entire lives in nature), but may well be the part-time or even armchair recluses classified as the "hermit in the city."

One type of hermit-theme painting depicts generic lofty scholars. These nonspecific recluses typically appear as the *qin* pluckers, *go* players, calligraphers, and painters in pictorial themes such as the "Four Accomplishments" *(kinkishoga)*. A second type of hermit picture presents historical or semihistorical figures culled from Chinese antiquity. These historical figures can be divided into two types: those part- or full-time hermits who serve as Confucian exemplars; and those known pri-

marily as poets or scholars, whose reclusion often carries anti-Confucian
implications. Among the notable figures of the first group are: the ripa-
rian Taigong Wang (Taikōbō), an early Zhou dynasty paragon of humble
virtue and learned accomplishment who chose to fish along the banks of
the Wei River rather than serve at court (although in some versions he
acquiesces to emperor Wenwang's blandishments and briefly assists
him); Xu You (Kyoyū), who fled to the Ying River to wash his ears after
emperor Yao improperly suggested that Xu take over the throne; and
Xu's compatriot Chaofu (Sōho), whose almost risible propriety led him
to restrain his ox from drinking the river water defiled after being used
to cleanse Yao's unseemly words from Xu You's ears.

In the category of pictures of historical hermits are many men best
known in China as poets but equally eminent in Japan as recluses. Most
famous are Tao Yuanming (Tōenmei) (365–427), Li Bo (Rihaku) (701–
762), the aforementioned Bo Juyi, Lin Hejing (Rinnasei) (967–1028),
Zhou Maoshu (Shūmoshuku) (1017–1073), Su Dongpo (Sotōha) (1036–
1101), and Huang Shangu (Kōsankoku) (1045–1105). Tao Yuanming and
Lin Hejing achieved celebrity in China for their verse in praise of reclu-
sion and thus are natural subjects for hermit painting in China and in
Japan. In their native land, Bo Juyi, Li Bo, Zhou Maoshu, Huang Shangu,
and Su Dongpo were little associated with world rejection, yet in Japan
they were transformed into models of an idealized type of literary reclu-
sion. As temporary exiles, Bo Juyi, Huang Shangu, and Su Dongpo expe-
rienced life removed from human society, but this separation was not of
their own choosing and was certainly far less congenial than it appears
in Japanese paintings. For the Japanese, the real link between these men
and reclusion comes not from the actual experience of life in nature;
rather the association of these figures with the idealized role of the her-
mit likely derives from their reputed devotion to some aspect of nature.
For instance, in Japanese painting Li Bo is almost always shown gazing
at a waterfall. The connection between Chinese literati and the hermit's
attachment to nature is most evident for Tao Yuanming, Huang Shangu,
Lin Hejing, and Zhou Maoshu—a quartet known collectively as the Four
Admirers *(shiai)* because of their admiration for the chrysanthemum,
orchid, plum, and lotus flower, respectively. The grouping of the Four
Admirers is credited to the Yuan poet Yu Ji (Gushū) (1272–1348),[7] but
the theme was painted frequently by the Japanese beginning in the
Momoyama period.

Of all the lofty Chinese gentlemen painted in the guise of hermits by
Japanese artists of the sixteenth and seventeenth centuries, perhaps no
figures were rendered as frequently as the Seven Sages of the Bamboo
Grove *(Chikurin no shichiken)* and the Four Graybeards of Mt. Shang
(Shōzan shikō). These two themes were painted in pictorial formats from

folding fans to *fusuma* panels, and commissioned by patrons from every social group with the resources to patronize artists. Judging from *fusuma* in situ at Zen temples and imperial villas, as well as those described as being at castles,[8] paintings of the Seven Sages and the Four Graybeards were in demand by Buddhist priests, aristocrats, and military men. While these two themes were sometimes painted on folding fans and hanging scrolls, they generally were brushed on the large-scale *fusuma* and screen formats. Although most extant screens cannot be traced back to an original patron, it seems likely that screens of the Seven Sages and the Four Graybeards had the same broad patronage as *fusuma* versions. For example, we do not know the patron of the Tokyo National Museum *Four Graybeards* and *Seven Sages* screens (fig. 3), bearing the signature and seals of Kano Motonobu (1476–1559) and dated to 1552, whereas the *Miyako rinsen meishō zue* (Illustration of the Famous Gardens in Kyoto) of 1799 records that in 1552 Motonobu painted *fusuma* of the same themes for the retired *daimyō* Ōtomo Sōrin (1530–1587) in the Kyakuden no ma (reception chamber) at the Zuihōin of Daitokuji.

Complexity and Contradiction: The Culture of Aesthetic Reclusion in the Momoyama Period

What accounts for the widespread acceptance of paintings of Chinese hermits such as the Seven Sages and the Four Graybeards in the late sixteenth and early seventeenth centuries? No study has thoroughly explored this question, but both Japanese and western scholars have proffered answers in the course of examining other aspects of Momoyama painting. Some Japanese scholars have favored formal explanations for the development of late-sixteenth-century figure painting. Because the Seven Sages and the Four Graybeards were usually painted on *fusuma* and screens (formats that had little or no temporal specificity), it has been argued that the growth of these and other Chinese figure subjects stems from largely practical concerns. Because *fusuma* and screens are not occasional paintings but rather "architectural" formats visible at all times, this intrinsic functionality often is interpreted as a sign of inherent decorativeness, which, in turn, is thought to mediate against any strong or specific meaning. In the same vein, the large physical expanses created by screens and *fusuma* are assumed to lead artists and their patrons to choose pictorial subjects that best occupy space. For figure paintings, it is argued that subjects with multiple figures—such as the Seven Sages and the Four Graybeards—were brushed with greater frequency precisely because these multifigure themes could easily fill multipanel paintings.[9]

The explanation makes simple sense and does partly explain the increase of multifigure themes, the combination of seemingly unrelated figure subjects, and the many boy servants who populate most *fusuma* and screen figure paintings. However, if we accept too readily formal explanations for the development of subject and style, it is then tempting to see all characteristics of the pictures as interior to the demands of style rather than governed by exterior circumstances such as the desires of patrons and artists. For instance, when we begin with the thesis that Chinese figure subjects are decorative simply because they appear on *fusuma* and screens, it is easy to look for and find spurious support for the thesis.

In a brief essay on screens of Chinese figures in the *Kangakei jinbutsuga* (Chinese-Figure Painting) volume of the *Nihon byōbue shūsei* (Collection of Japanese Screen Paintings) series, Toda Teisuke postulates that since the subject matter of these screens was foreign to the Japanese cultural experience, the paintings likely were based on earlier Chinese paintings (which do not survive) rather than on the creative impulses of Japanese artists. Because of this perceived distance between the visual image and the thematic core, together with the tendency to copy the external features of earlier pictures, Toda contends that the Japanese paintings easily became "patternized." This patternization is seen as consonant with the supposedly decorative nature of screen (and *fusuma*) paintings, especially when rendered in color on gold. This circular reasoning leads to the conclusion that "the tendency to use the subjects of Chinese-figure pictures solely as pattern reveals the essential character of color-and-gold painting."[10]

The loss of meaning resulting from patternization is taken up in a companion essay by Kanazawa Hiroshi that surveys the development of medieval screens of Chinese figures. Kanazawa contends that in early-fifteenth-century "poem picture scrolls" *(shigajiku)* featuring "subjective" themes, such as Zen exemplars, single hermit subjects or idealized hermitages, reflect the eremitic thought valued in the Gozan culture because Zen monks were meant to imagine themselves as the Zen figures or lofty scholars in the pictures. Conversely, Kanazawa maintains that multifigure subjects such as the Seven Sages and the Four Accomplishments painted on screens and *fusuma* are "objective," and thus neither intended nor perceived to represent the values of the viewers. This ostensible withering of meaning is based on the ideas that these figure themes were painted on inherently decorative formats, and that these subjects—often not of Zen significance and frequently mixing only loosely related groups of figures—had little if any compelling significance for their audience.[11]

The largely formal explanations of scholars such as Toda and Kana-

zawa are balanced by the work of other art historians who have begun to look for significant meaning in these paintings. For instance, in an important recent essay, Ōnishi Hiroshi writes that Momoyama paintings of Chinese figures "give evidence of a combined yet competing effort by cultivated warriors, priest-intellectuals, and master painters to conceive a new constellation of ideals and symbols at a transitional moment."[12] By interpreting these paintings of Chinese hermits and lofty scholars in light of their cultural rather than physical dimensions, art historians have begun to suggest political and escapist interpretations.

Given the location of some of these paintings in buildings associated with the military class, as well as the Confucian nature of many of the subjects, a few art historians have pointed out didactic political implications. Carolyn Wheelwright, for instance, presents an interpretation of the development of Chinese-figure subjects such as the Seven Sages, Four Graybeards, and Xu You and Chaofu within the sixteenth-century political context:

> These ancient Chinese stories were becoming more and more popular among the military class of Japan. As the generals of war-torn provinces strove to extend their control over a unified Japan, they increasingly attempted to equate their actions with those of virtuous figures in China's past. Thus, they commissioned pictorializations of politically approved stories as visual support from ancient Chinese tradition.[13]

Wheelwright argues that these Chinese figures served to legitimate military rule in two ways. First, they show the "obedience and service" of scholars to the state. The pictures encourage the ruled to act as wisely and obediently as these great paragons from Chinese antiquity. Second, the images show the wisdom and righteousness of the ruler who understands and encourages such filial behavior by the very act of commissioning such pictures. By surrounding himself with images of virtuous models from China's past, the ruler suggests that he is as sagacious and benevolent as the men who grace his walls.

Wheelwright's argument stresses the aura of prestige associated with Chinese-figure subjects and suggests the need to understand the legitimization of power as a fundamental feature of Momoyama painting for the military classes. Because Wheelwright's comments are part of a general introduction to Chinese-figure subjects in Momoyama painting, she does not expand on this important beginning. While Wheelwright's analysis goes a long way toward explaining the presence of the Seven Sages, the Four Graybeards, and other Chinese hermit themes in paintings made for military patrons, how can we account for the significant presence of the same subjects in paintings at Buddhist temples and aristocratic residences?

Aristocratic and priestly patrons certainly desired to connect them-
selves with a prestigious past, as well as to display their own erudition
and virtue. Moreover, because aristocrats made some claims to political
power in the Momoyama period, it is possible that their commissioning
of the same themes (often in the same style and by the same artists) as
the *samurai* was a means of competing with the military hegemons. Zen
priests, who ostensibly renounced worldly power, present a very different
case. "Confucian messages of obedience and service to the state," to use
Wheelwright's phrase, are less likely to have been requested by priests
who, externally at least, wished to convey an aura of detachment from
worldly affairs.[14] Many of these same Chinese-figure themes continued
to be painted in the Edo period, not only by Kano artists working for
shogunal patrons but more often by decidedly nonofficial artists working
for merchant-class patrons.

Writing about the plethora of pictures depicting lofty Chinese
scholars in the oeuvre of the early Nanga master Sakaki Hyakusen
(1698–1753), James Cahill targets the problem of analyzing these works
and suggests an interpretation very different from that of political legiti-
mization:

Depictions of the idealized occupations of "lofty scholars," in both Chi-
nese and Japanese painting, are so ubiquitous and usually so conven-
tionalized that we are inclined to pass lightly over the associations they
carried in their time. Even in China, they had more often represented an
ideal than an actuality; they were typically painted for men who tended
in fact to be harried officials at the capital or in provincial posts, or men
variously engaged in earning a livelihood in the "dusty world," or mer-
chants who aspired to gentry-scholar status, either for themselves or for
their sons. In Japan, the discrepancy between the ideal and reality was
even wider.

[Hyakusen's] . . . only means of entry into that [scholarly] world was
by painting the kinds of pictures associated with Ming-Ch'ing *wen-jen*,
and in this he could excel. In his pictures he expressed constantly the
ideal of high-minded aestheticism, close communion with nature, and
untrammeled ease. Su Tung-p'o, an archetypal literatus-painter, drifts
past the Red Cliff in picture after picture; scholars wander through land-
scapes or gather in gardens or mountain pavilions, or gaze at waterfalls
to cleanse their minds. In one of his paintings . . . a group of scholar-
gentlemen stand on the stone bridge at T'ien-t'ai, gaze at a waterfall, and
compose poetry (which one of them is inscribing) all at once. Such a
compounding of symbolism, along with the constant search for a suit-
able style in which to embody it, bespeaks an almost desperate effort to
set forth persuasively—and thus, in a sense, to possess for himself—the
wen-jen (literatus) and *kao-shih* ("lofty scholar") ideal.[15]

Cahill's account of Hyakusen's paintings of lofty-scholars could well be a description of many Momoyama paintings of the Seven Sages or the Four Graybeards. The painted Chinese hermits of the Momoyama period typically engage in high-minded aesthetic pursuits, commune with nature, and relax in gardens and mountain pavilions. Gazing thoughtfully at waterfalls is de rigeur. Momoyama hermit-theme paintings are marvels of compounded symbolism, often an iconographic soup that, although perhaps indicative of patternization and the withering of meaning, is more likely—as in Hyakusen's case—the sign of a concentrated effort to create visually the ideal world of the Chinese scholar-hermit.

Despite many differences between the early eighteenth century when Hyakusen painted and the late sixteenth century, there is an underlying commonality between the desires of Hyakusen and his merchant-class patrons and Momoyama period aristocrats and Zen priests. Both groups were often at odds with the military government, and thus in both periods the fictive world of the lofty Chinese scholars must have provided an appealing avenue of escape from unpleasant realities. How then can we resolve these two differing interpretations—one that argues for a didactic political meaning and the other that, when applied to Momoyama painting, suggests an escapist intent? In short, can the same subjects serve opposing goals? Are hermit themes such as the Seven Sages and the Four Graybeards symbols of political power or are they symbols of escape from, and rejection of, that power?

The answer proposed here, and argued in the body of this study, is that these pictorial themes served both purposes. As with the philosophy of "the tea ceremony" (chanoyu), which embodies so much of Momoyama culture and in many ways functions as a catalyst for the paintings, pictorializations of hermit themes such as the Seven Sages and the Four Graybeards should be understood as both "a symbol of power and a salve of power."[16] The ambivalent coalescence of historical reality and ideal fiction in these paintings, again paralleling the philosophical and practical foundations of tea, allowed both a temporary, imaginary escape from subordination to social order while simultaneously facilitating the acceptance of that order. The paintings thus subvert the normative social structure even as they underline it; conversely, hermit pictures crystallize ideals of aesthetic reclusion while signaling the impracticality of actually realizing such an existence.

The origins of this multivalent meaning lie in the involute rhetoric of eremitism, the complex Momoyama political environment, and the dense iconography of the paintings. In China and Japan, the various hermit or lofty scholar subjects were by no means monolithic in their meaning. The values of eremitism, particularly as based on Confucianism, were broad and flexible enough to accommodate a range of potential interpre-

tations. One type of Confucian eremitism is political, involving renuncia-
tion of public office as a protest against bad government. A second com-
ponent of Confucian eremitism is not political but personal. Rejection of
the responsibility and recompense of office is not simply an act of politi-
cal protest, but a road taken in favor of scholarship and self-cultivation.
In this second aspect, Confucian eremitism expresses a spirit kindred
with that of Daoist and even Buddhist reclusion.[17] The two faces of Con-
fucian reclusion—political protest and aesthetic escapism—were not
antagonistic but compatible. Men who renounced public office for polit-
ical reasons may have spent their time in reclusion engaged in activities
no different from those of hermits interested solely in self-cultivation.
Conversely, hermits given to no higher aims than drinking wine and writ-
ing poetry could be seen by others as representing a protest against the
political order in that, by focusing on themselves, they were opting out of
the normative social order. In this way, themes as different as the Seven
Sages and the Four Graybeards represent both sides of the same coin. In
China, the Four Graybeards of Mt. Shang had overtly political implica-
tions, showing the duty of good Confucians to withdraw in protest of bad
government and, conversely, to serve when good administration was
restored. The Seven Sages of the Bamboo Grove, in contrast, were sym-
bols of the neo-Daoist assertion of individual freedom and the flouting of
propriety.[18]

 The original Chinese implications of these subjects were often trans-
formed as they were adapted in Japan. By virtue of their associations
with Chinese antiquity, the Seven Sages, the Four Graybeards, and other
figure subjects usually took on connotations of superior learning and
cultural sophistication in Japan. Some of the new accretions in meaning,
such as making the Seven Sages and the Four Graybeards symbols of
longevity and wisdom, are hardly surprising. Other changes in significa-
tion, such as possible implications of homoeroticism, are more unex-
pected.

 The web of meanings in these themes is compounded by, and more
fully apprehended within, the multiple dimensions of their cultural con-
text. If texts require multiple contextualization to be well read, Momo-
yama paintings can only be understood adequately within the milieu of
Momoyama society. If we see these paintings as activities rather than
objects, then their meaning is not fixed but free. When we take into
account the role of the patrons who used the paintings to do ideological
bidding, then it is understandable that the same themes—indeed, the
same paintings—could serve different discourses.

 Rather than providing a simple background that throws into high
relief a single implication of the paintings, the conflicting interests of the
Momoyama patronage groups serve to refract the already composite

meanings latent within most Chinese-hermit themes. In essence, the three primary patron groups shared the same set of cultural symbols, but because of differences in status were likely to find variant meanings and functions in these symbols. Thus, while aristocrats, priests, and warriors all venerated the mantle of wisdom and cultural achievement associated with Chinese figures exemplified by the Seven Sages and the Four Graybeards, the reading of these subjects as symbols of political criticism or legitimation likely depended on who was doing the reading. In short, there was enough cultural common ground for these symbols to have meaning among competing social groups, but there was also sufficient conflict between those groups to engender different readings of the symbols.

It is the paintings themselves that provide the most critical factor in creating a multivalency of meaning. Regardless of the original Chinese associations of each theme, most Japanese pictorializations of the Seven Sages and the Four Graybeards create an idealized world where groups of lofty scholars live in communion with nature and where they engage in refined activities. Thus, the figures, whatever their motivation in traditional accounts, in Momoyama and early Edo period paintings appear to have rejected society to find personal and creative liberation through a life devoted to nature, artistic pursuits, and intimate human relations.[19] This type of reclusion—neither religious in origin nor overtly political in practice—has been termed "aesthetic reclusion" (suki no tonsei).[20]

By emphasizing aesthetic reclusion, the paintings become politically ambivalent. Because aesthetic reclusion presents eremitism as an end in itself, this broadening of meaning is sufficient to neutralize even subjects that carry political implications. Given the expansion of significance, which at the surface level reads as the flattening out of meaning, it is not surprising that some scholars have been inclined to see only decorative patternization and the loss of significance. Yet the overlay of aesthetic reclusion does not mitigate political meaning. The elements of aesthetic reclusion in pictures of the Seven Sages and the Four Graybeards give these images a common overlay of meaning that resonates with all patron groups. At the same time, the original or primary significance of the themes—whether political legitimation or political protest—may continue to function in a subaltern position.

Aesthetic reclusion, as expressed in countless Momoyama period hermit paintings and in the ideology of tea, exhibits five primary characteristics: communitas, scholarly pastimes, appreciation of nature, ritual poverty manifest as elegant rusticity, and reference to the Chinese past. Although these characteristics are not always found in every picture of the Seven Sages and the Four Graybeards, the balance of these features is present in the majority of pictures.

While aesthetic reclusion is marked by withdrawal from worldly society, it does not entail the rejection of human companionship. To the contrary, the state of communitas—the gathering of like-minded individuals on equal footing—is one hallmark of aesthetic reclusion. Momoyama hermit paintings typically show groups of lofty scholars usually engaged in "pure conversation" or artistic pursuits. This emphasis on sharing human experience provides a criticism of the hierarchical structure of normative society in which humans are cut off from each other by divisions of class or rank. A by-product of this private male world of communitas is the suggestion of homoerotic relations between hermits and their boy servants.

In the pictorial realm of aesthetic reclusion, hermits frequently engage in learned pursuits: they play the board game *weiqi (ki),* pluck the zither or *qin (kin),* and brush or study painting and calligraphy scrolls. They also partake in a proto-tea ceremony, an activity suggested by the connoisseurship of vessels, evident in the fine ceramics and bronzes on tables, and the sharing of drink, implied by the servant boys who heat or serve wine. The devotion to scholarly pursuits and communal drinking are clear emblems of the cultivated gentleman and, not incidentally, indications of a life of leisure. Again the unrelieved devotion to leisure activities and self-cultivation stands in stark contrast to real life, where few men had the opportunity to engage so completely in such activities. When not occupied in deep conversation or learned pastimes, hermit-scholars typically are entranced by the beauty of the natural environment surrounding them. The appreciation of nature usually consists of gazing at dramatic waterfalls and towering mountains or lounging beneath stately pines and sturdy bamboo. Nature, wearing its most congenial face, provides an alternate order to the human realm from which these men have fled. The fusion of man with nature represents a liberation from the impermanence of human society as the hermit becomes part of the comforting cycle of nature.

The mountains and forests embracing the hermits in Momoyama paintings do not represent nature as it often is, harsh and foreboding, but rather create an edenic setting in which the figures are sheltered and nurtured. The conjoining of the cultured world of lofty scholars and the enlightening realm of nature is symbolized by the pavilions and other structures in which these hermits presumably live. In the manner of the *sōan*-style (grass hut) tea pavilions so much in favor during the Momoyama period, these shelters are simple but elegant, made of rustic materials and open to the elements but finely crafted by human hands. The elegant rusticity of these pavilions embodies the leisured refinement of the hermits who inhabit them.

The final characteristic of hermit paintings and of aesthetic reclu-

sion in the Momoyama period is an overwhelming desire to recall the Chinese past. From the architectural style of pavilions and garden railings to the waterfalls and mountains surrounding the figures, the context of the pictures is Chinese. Just as the land within the pictures is a Japanese dreamscape of China, the hermit-scholars culled from the pageant of Han civilization are arrayed to create a dream history of Chinese antiquity. To a large degree, the real subject of the paintings is Chinese culture—Chinese culture arranged and manicured to create best the air of cultural legitimacy desired by those who owned and viewed them.

The pictorial combinations of communitas, scholarly pastimes, appreciation of nature, elegant rusticity, and recourse to Chinese history serve to recreate the rich mix that characterizes aesthetic reclusion in Momoyama culture. These paintings, as with the culture of tea, suggest a social order that, albeit fictive, is in direct opposition to the normative order of Momoyama society where power—gained through military might, wealth, or social rank—determined status. Paintings, like tea objects, were commodities affording status to their owners based on little more than the amount of their price and the skill or fame of their creator. Yet their status as commodities does not dissipate the thematic content of hermit paintings, which provided an imaginary escape from the prescribed social structure.

Paintings of Chinese hermits such as the Seven Sages and the Four Graybeards create an imaginary sphere into which the viewer may easily project himself.[21] In an age of pandemic warfare and political strife, for viewers of all patronage groups these paintings must have served as an avenue of civilized withdrawal. This pictorial alter-reality offered a realm of peaceful human coexistence with benevolent nature when the real environment was marked by warfare, status equality among men when society was marked by status distinctions as well as intense intraclass competition, and a life devoted to music, literature, and art when most lives were spent in much different and far less benevolent pursuits. The universality of aesthetic reclusion is all the more apparent when we realize that the *fusuma* paintings made for one context were often transferred to other locations.[22] The ideals of tranquillity, equality, and devotion to the arts—together with the paintings, which provide pictorializations of them—found equal favor among aristocrats, priests, and *samurai*.

Even as the aesthetic reclusion described in paintings of the Seven Sages and the Four Graybeards suggests an alternative social order, the political interpretation of this order is subject to wide variation. When created for aristocrats or Zen priests displaced or marginalized by military rulers, the message of escape from the world likely implied a rejection and implicit criticism of that political authority. This "aesthetics of

discontent," which could not be expressed in direct form, was channeled into the indirect and safe medium of hermit painting.[23] However, when the same themes were deployed by the politically powerful *samurai* class, they could serve as an idealized picture of military rule. No matter how much their rule in fact was based on martial strength, the message of these paintings suggested just the opposite. By showing a desire for the alternate order of aesthetic reclusion, those in power demonstrated the cultural legitimacy of their rule. The more one desired (or pretended) to reject the political realm, the better he could justify his rule over it.

Text: The Explication of Meaning

Depending on the context in which they were read, the fact that the same pictures could express an ideology of power and a counterideology to that power speaks to the integral role of these images in Momoyama society. Despite the obvious popularity and importance of pictures of the Seven Sages and the Four Graybeards, there is no unassailable evidence to support their interpretation as symbols of aesthetic reclusion. We have no letters from patrons to artists detailing what they wanted and why; we possess no diary entries that record viewers' feeling about the paintings or analyze their meanings.[24] Before outlining a strategy for gathering and presenting circumstantial evidence in support of our thesis, how can we account for the claims of decorativeness and patternization attributed to screens and *fusuma* of Chinese figures?

It has been argued that because of their large scale and functional nature, *fusuma* and screen painting lend themselves to patternization and decorativeness with a concomitant weakening or loss of meaning. We offer an entirely different interpretation of the potential of large-scale painting to carry meaning.[25] If wall painting *(shōhekiga)* is supposed to be decorative because it is architectural, we first point to the symbolic function of architecture as evidence that even functional elements may carry important meaning. For instance, in the large audience chambers *(ōhiroma* or *taimensho)* of early-seventeenth-century temples and palaces,[26] the raised portion of the room *(jōdan no ma)* features elements of *shoin*-style architecture, including a large alcove *(tokonoma)*, built-in desk *(tsukeshoin)*, staggered shelves *(chigaidana)*, and decorative doors *(chōdaigamae)*. In addition to suggesting status through sheer visual profusion, these *shoin* elements associate the powerful occupants of the *jōdan no ma* (whether temple abbot, high-ranking aristocrat, *daimyō*, or *shōgun*) with the learning and cultural refinement symbolized by the *shoin*.

By their large size and cycloramic configuration, rooms of *fusuma* (and, to a lesser extent, sets of screens) create a dynamic visual environ-

ment that literally surrounds the occupant. At a metaphoric level, the painted doors and walls of a room are no longer doors and walls but a fictive reality into which the viewer is invited to enter like a reader entering the world of a novel. *Fusuma* painted with flowers and birds, for instance, become idealized forests, holding the general associations of nature such as freshness and vitality but also conveying the specific symbolic meanings (longevity, wealth, or good government) attached culturally to those flowers and birds. In the same way, wall paintings of scholar-hermits such as the Seven Sages and the Four Graybeards construct a metaphoric world of aesthetic reclusion in which the patron and other viewers place themselves physically and mentally. Far from being merely decorative, *shōhekiga* construct physical as well as ideological space.

If we can accept *fusuma* and screen paintings as ambient formats capable of carrying significant meaning, how can we determine what those meanings might have been in the Momoyama period? Given the lack of textual documents that spell out literally the meaning of these paintings, we must rely on circumstantial evidence, analyzing the art within the circumstances of its creation and reading. We will treat art as a social agent, attempting to experience images based on their location, function, and presence within the broader culture. Since the goal is to find the range of significant implications of paintings of the Seven Sages and the Four Graybeards during the seventy-five years from around 1550 to 1625,[27] we shall read these paintings both in light of the macro context of the historical adaptation of hermit themes in ancient and medieval Japanese literature and within the micro context of Momoyama society and politics.

If the larger task is to articulate the Japanese discourse on reclusion using the Seven Sages and the Four Graybeards as examples, it makes sense to focus first on the history of these Chinese subjects in Japan. The second chapter begins with the standard Chinese accounts of the Seven Sages and the Four Graybeards. We then examine how these two quintessential hermit themes were appropriated in Japanese literature from the late Nara period through the Muromachi period. Our investigation surveys poetry in Chinese *(kanshi)* and Japanese *(waka)*, popular stories *(setsuwa)*, tales *(monogatari)* for both courtly and aristocratic audiences, so-called recluse literature, Chinese verse by Zen priests, and finally, linked verse *(renga)*. We analyze how the Seven Sages and the Four Graybeards generally were adapted to serve new functions in Japan and, specifically, how they sometimes became symbols of political legitimation and political protest in literature.

After tracing the trajectory of eremitism in literature, chapter three locates this discourse within the Momoyama sociopolitical context. The

chapter commences with a discussion of the idea of "public good" *(kōgi)* by which military rulers sought to legitimate their rule through the conspicuous display of virtue. The best way to show virtue was to patronize the arts, specifically those arts such as tea which (in the manner of hermit painting) imply a rejection of worldly values. We look briefly at the *kōgi* strategies deployed by Oda Nobunaga (1534–1582), then turn to Toyotomi Hideyoshi's (1536–1598) use of tea as a means of legitimate escapist recreation and as a tool of political legitimation.

The second part of the chapter investigates the theory and practice of tea as a paradigm of eremitism that coalesces the ideals of aesthetic reclusion into a ritual practice that both shapes and reflects the values central to hermit paintings of the period. Tea was practiced by the same groups of men who were patrons of hermit-theme paintings and, by the second quarter of the seventeenth century, tea rooms *(chashitsu)* even became the location of paintings of the Seven Sages and the Four Graybeards. Echoing the characteristics of aesthetic reclusion, the setting and practice of tea is analyzed in terms of liminality, fusion with nature, communitas, elegant rusticity (subsumed in the term *wabi*), pursuit of scholarly pastimes, and evocation of the Chinese past.

In the fourth chapter, we turn to paintings of the Seven Sages and the Four Graybeards. Rather than structure the chapter by chronology or artist, we discuss the paintings based on the five characteristics of aesthetic reclusion outlined earlier. The focus of the study is a core group of screens and *fusuma* representing the work of the dominant Momoyama painting schools: the Kano, Kaihō, and Unkoku. Because the first part of the chapter concentrates on iconography and style in relation to the generic ideology of aesthetic reclusion, the second part of the chapter looks at two sets of paintings within the specific contexts of their patronage and presumed function. Pictures of the Seven Sages and the Four Graybeards at Nobunaga's Azuchi Castle and the Four Graybeards Returning to Court at Nishihonganji are discussed in regard to the meanings suggested by their specific location within these two buildings, their relation to adjacent pictorial themes, and the thematic requirements of their patrons as best they can be construed.

The brief fifth chapter expands the discourse on aesthetic reclusion to analyze the phenomenon of actual aesthete-recluses and the role of eremitism in neo-Confucian philosophy of the early seventeenth century. The chapter concludes with the examination of some fundamental principles of aesthetic reclusion that lie at the heart of eremitism in ancient China and serve to connect hermit-theme paintings with the ideologies of tea and neo-Confucianism as espoused in Japan in the first decades of the seventeenth century.

Context: The Role of Social Art History

A major issue in uncovering and reconstructing meaning in Momo-yama hermit paintings is the necessity of using, at length, nonpictorial materials. On one hand, this method runs the risk of distressing art historians wary of going beyond the boundaries of formal studies of style. On the other hand, the lengthy discussion of the social milieu may well attract the criticism of scholars who question the very notion of recovering context.

In the absence of incontrovertible evidence about the meaning of pictures, we tend to be as critical of claims (especially new ones) about cultural significance as we are uncritical about the interpretation of style. Where style often is seen to be self-evident, content is not. This is understandable: the physical reality of the surface, manifest as style, can be apprehended at a glance. We easily reach conclusions about style, such as calling a painting "decorative," because the evidence, the "decorativeness," can be "verified" with our eyes. In contrast, function, intent, and meaning—the diverse experiential aspects of painting that depend on cultural context—are invisible to the eyes. Unless the implications of the painting are absolutely transparent or some contemporary documents provide an evidential "smoking gun," the art historian who seeks to interpret meaning risks the charge, and the real danger, of reading into the art work.

Semiotic theory, largely in its linguistic mode, has been critical of the conventional notion of context. This skepticism, although still holding that meanings are determined within the material and historical world, holds that rather than providing an objective field as a given set of facts and circumstances that validate or determine the meaning of art works, context itself is a product of interpretation. In the words of Norman Bryson and Mieke Bal, "What we take to be positive knowledge is the product of interpretive choices. The art historian is always present in the construct she or he produces."[28] Semiotic theory further cautions that context is not finite and cannot be known in its totality; rather, context is infinitely expandable, extending to include the place of the art historian within contemporary art-historical discourses.

Perhaps the most practical aspect of the semiotic criticism of context is the caveat that, in light of the preceding points, we should be wary of treating context as a simple or neutral foundation that gives rise to art and upon which we can base an objective understanding of that art. This argument is based on the reasoning that art works, much less a broad group of paintings such as our Seven Sages and Four Graybeards, are not autotelic or complete in themselves. Because pictures are signs, their

meaning is not singular or closed, but multiple and open. Even within a single historical period, such as the relatively brief Momoyama era, a painting may be read by different viewers in different ways. In sum, the revised notion of context proposed by semiotic theory seeks to supplement "the idea of convergence, of causal chains moving toward the work of art" with the idea of "lines of signification opening out from the work of art, in the permanent diffraction of reception."[29]

To recover some of these "lines of signification," we must attempt to reconstruct the social and intellectual context of Momoyama and early Edo period Japan. This reconstruction is achieved in part by pursuing "bits of seemingly esoteric information and lines of seemingly arcane discussions [that] were not esoteric or arcane"[30] in the culture that produced the art that we seek to understand. To achieve this goal, we look at a broad range of literary texts, political theories, religious beliefs, ritual acts, and even sexual mores as part of the invisible world that informs the visible realm of the painting surface. The breadth and depth of this contextual study takes us very far from most art historical inquiry into Momoyama painting, but it does not distance us from the pictures. To the contrary, we can more fully "see" these pictures once we understand the Japanese tradition of eremitism, the historical adaptation of Chinese models within this tradition, and the specific political, social, and aesthetic configurations of the Momoyama and early Edo periods.

2.
A Tradition of Transformation
The Seven Sages and the Four Graybeards in Japanese Literature

DISCOURSE ON EREMITISM began long before the Momoyama period and was developed in forms other than painting. It is in literature, both poetry and prose, that Japanese attitudes toward reclusion evolved first and can be apprehended most readily. This chapter surveys the treatment of the Seven Sages of the Bamboo Grove and the Four Graybeards of Mt. Shang in Japanese literature from the eighth through sixteenth centuries. As we find references to these subjects in poetry, both in Chinese *(kanshi)* and Japanese *(waka* and *renga),* and prose fiction *(setsuwa* and *monogatari)* as well as medieval recluse literature (so-called *inton bungaku*), we will examine how the implications of the Seven Sages and the Four Graybeards were adapted to fit the various discourses in which they were deployed.

Specifically, we will see that in China, and even more so in Japan, the associations of the Seven Sages and the Four Graybeards were varied in the extreme. While in China these two themes carried strong associations of political reclusion, pro and con, as well as implications of aesthetic reclusion, in pre-Momoyama Japanese literature, the political aspects of the themes are usually absent. Based on the evidence found in literature, Japanese understood Chinese hermits such as the Seven Sages and the Four Graybeards in terms of the characteristics associated with aesthetic reclusion. Japanese writers refer to the Seven Sages or the Four Graybeards as paradigms of communitas, purity of spirit, love of nature, devotion to scholarly pursuits such as writing poetry or making music, and drinking wine. Despite the numerous and varied descriptions of the Seven Sages and the Four Graybeards that we have found, (with a single exception) no one Japanese writer relates the full story of either hermit group. Instead, Japanese writers typically deploy the Chinese recluses as paradigmatic examples of some characteristic or ideal central to their text.

It is possible that in some or even all of these cases, the Japanese author relates only one characteristic of the Seven Sages or the Four Graybeards because that is all he or she knows about them. However, given the broad knowledge of the Seven Sages and the Four Graybeards within the whole of Japanese literature prior to the Edo period, it seems far more probable that most authors who invoked these Chinese recluses were familiar with the fuller stories and broader implications of the Seven Sages and the Four Graybeards. If this is indeed the case, Japanese writers engaged in a process of highly selective adaptation of the two subjects, choosing those aspects which suited their purpose and ignoring those which did not. Before proceeding with the investigation of the Seven Sages and the Four Graybeards in Japanese literature, it is necessary to determine the original configurations of their stories in China in order to judge better the Japanese transformations.

Biographies

The English name "Four Graybeards of Mt. Shang" is a translation of the Chinese *Shangshan sihao (Shōzan shikō)*, literally meaning the "four whites of Mt. Shang." The character *hao* or "white" refers to white hair and is a euphemism for old men, who are distinguished by white hair and beards. The English term "graybeard" conveys the same idea with a slight change in coloration. According to *Gaoshi zhuan* (Lives of Eminent Gentlemen),[1] the Four Graybeards were a quartet of elderly scholar-officials who fled from the despotic government of the late Qin dynasty (221–206 B.C.) to the safety of Mt. Shang (in present-day Shanxi province). There, the four men—Dongyuangong (Tōenkō), Qili Ji (Kiriki), Jiaoli xiansheng (Rokuri sensei), and Xia Huanggong (Kakōkō)—lived in seclusion and engaged in scholarly pursuits for several years.

Soon after the founding of the Han dynasty, the emperor Gaozu decided to choose a successor. Under the influence of a favorite concubine, he passed over his first son, the crown prince Huidi, and chose the son of the concubine. Distressed by this obvious transgression of Confucian ethics, the empress Lu sent the loyal minister Zhang Liang to Mt. Shang to persuade the Four Graybeards to return to court as Huidi's guests. After mulling over the matter, the four elders (long sought by Gaozu) decided to return to court as a gesture of respect for Huidi and as a rebuke to the emperor. Their appearance at court, complete with a dressing-down of the monarch for his disrespect of learned men and failure to understand reciprocal obligations, as well as praise for his virtuous son, caused Gaozu to reinstate Huidi as the next emperor.[2]

The Four Graybeards are a textbook case of the Confucian ideal of politically inspired reclusion: the scholar-officials withdraw as a protest

against bad government and return to official service in the aid of a benevolent administration. As a symbol of Confucian protest reclusion, the Four Graybeards present a picture of the hermit as a righteous political agent. It is in this context that they appear—wearing black whiskers but official court robes—among other paragons of Confucian piety on the lacquer-painted Lelang basket from the late first or early second century.[3]

The story of the Four Graybeards contains two parts—the life on Mt. Shang and the return to court—and thus manifests a second level of interpretation; specifically, that of aesthetic reclusion. Because the Four Graybeards spent time living in the mountains, it is natural to assume that this period of solitude was passed in scholarly pursuits. This interpretation was favored by a number of Chinese painters. Well-known pictures by Ma Yuan (ca. 1190–1264) in the Cincinnati Art Museum and Wu Wei (1459–1508) in the Palace Museum, Beijing, show the Four Graybeards living peacefully in seclusion. While recorded, but not extant, pictures by Ma Yuan and Zhao Mengfu (1254–1322) feature the moment when Zhang Liang asks the Four Graybeards to return to court. The Cincinnati and Beijing works depict the time before Zhang's visit when the Graybeards are absorbed in a game of *weiqi*. Paintings of the Four Graybeards meeting Zhang Liang or returning to court likely were painted for scholars entering service, while images of the Four Graybeards in reclusion would have been appropriate for those leaving the bureaucracy.[4] In Japan, the distinction between the two parts of the story is clearly signaled by style: the Four Graybeards in Reclusion theme is almost always painted in ink monochrome—a medium associated with life in nature; while the subject of the Four Graybeards returning to court invariably is rendered in polychrome and gold—materials connected with court culture.

If the Four Graybeards represent Confucian political reclusion with a secondary implication of aesthetic reclusion, the Seven Sages present the inverse and do so in a far more diffuse fashion. The Seven Sages of the Bamboo Grove, or *zhulin qixian (chikurin shichiken)*, are the most famous band of Chinese recluses. Major figures, both collectively and individually, in Chinese literature and philosophy, the Seven Sages present a welter of different and even conflicting themes in recluse ideology. Some of these themes are the product of historical verities, others the result of historical fictions.

The seven men—Ruan Ji (Genseki) (210–263), Ji Kang (Keikō) (223–266), Shan Tao (Santō) (205–283), Xiang Xiu (Shōshū) (226–300), Liu Ling (Ryūrei) (ca. 225–280), Wang Rong (Ōjū) (234–305), and Ruan Xian (Genkan) (230–281)—were revered for their individuality, becoming veritable icons in a "cult of personality" that venerated the eccentricity of

these and other Wei-Jin period (220–419) literary men and hermits. The grouping of the Seven Sages of the Bamboo Grove, however, is likely the creation of marginalized Eastern Jin (317–419) literati and aristocrats who sought models for their own gatherings.[5] Thus, in its very conception, the eremitism of the Seven Sages is not merely a fiction, but one created to foster the idea of eremitic communitas.

With the construct and commendation of the Seven Sages by literati of the late fourth and early fifth centuries, the old idea that virtue is attained through service to the public good *(gong)* was transformed into a new focus on the perfection of the self through the cultivation of a "wholly individualistic attitude" personified by the Seven Sages.[6] As immortalized in numerous anecdotes recorded in *Shishuo xinyu* (New Specimens of Contemporary Talk), Liu Yiqing's (402–444) compendium of Wei-Jin eccentrics, the Seven Sages represented neo-Daoist and anti-Confucian attitudes manifest in the periodic escape from mundane affairs to find pleasure in conversation, poetry, music, and wine.[7] The goal of this behavior was freedom from social conventions through spontaneous and unrestrained behavior that sought to uncover the state of "thusness-in-itself" or "naturalness" *(ziran).*[8]

The apotheosis of the Seven Sages as symbols of a new conception of the ideal man was based in part on the writings of several of the Seven Sages. In *Yangshenglun* (Treatise on the Cultivation of Life), Ji Kang displays little interest in immortality or service to society, the goals of orthodox Daoism and Confucianism, respectively; instead, Ji's treatise emphasizes cultivation of the individual as manifest in the spirit of reclusion. In Ji's words, "Pure and empty, calm and peaceful [the sage] reduces his personal needs and wishes." Casting off fame and position, which diminish his virtue, the sage severs mundane attachments and refrains from luxury. "Only then does he let himself be soaked through by magic mushrooms, wetted thoroughly by sweet springs, dried by the morning sun, lulled by the fine strings [of the lute]."[9]

The legend of the Seven Sages, and the actual biography of Ji Kang, displayed a new kind of recluse—one who combined periodic (or even just imagined) reclusion with official service.[10] The liberation of the self, although facilitated by life in nature, could also be achieved by the sage living in society. Thus, not only mountain ascetics but even urban officials could attain this goal if only they redirected their energies and consciousness toward perfection of the self. As attested by many of the anecdotes in *Shishuo xinyu*, the cultivation of the self often took the form of cultivated eccentricity manifest in loose dress, long hair, dissolute ways, unconventional sexual activity, and frequent inebriation in the name of liberation from social norms. Self-cultivation also assumed the more conventional configuration of dedication to nature, literature, music, and high-minded conversation with kindred spirits.

The type of reclusion attributed to the Seven Sages is partially captured in a letter by Ji Kang to Shan Tao preserved in *Wenxuan, juan* 4:

> Today I only wish to stay on in this out of the way land and bring up my children and grandchildren, on occasion relaxing and reminiscing with old friends—a cup of unstrained wine, a song to the lute [*qin*]: this is the sum of my desires and ambitions.[11]

Ji's reminiscences with old friends likely would have included "pure conversation" *(qingtan)*. The engagement of like-minded men in *qingtan* had its roots in Confucian oral discourse of the Eastern Han (25–220) and was a hallmark of the Wei-Jin eccentricity chronicled in *Shishuo xinyu*. As with so many characteristics of self-cultivation, *qingtan* came to be associated with the Seven Sages. The kind of verbal repartee in the service of deep truths required of its adepts both philosophical profundity and verbal refinement. As such, it was a useful tool in furthering self-cultivation and in creating a spirit of communitas among groups of real and would-be recluses.

Ji Kang's letter also mentions playing the *qin*, an instrument close to his heart and closely associated with self-cultivation. Ji Kang's essay on the lute makes it clear that playing the *qin* was considered a necessary skill for those with sufficient depth and detachment to appreciate its subtle sound. According to Ji, *qin* music was a frequent accompaniment to the elegant gatherings of refined men as they set out on private forays along clear streams and over verdant hills.[12]

The "unstrained wine" mentioned in Ji Kang's letter was imbibed freely by all of the Seven Sages, but none drank so frequently or so deeply as Liu Ling. Stories of Liu Ling's legendary dipsomania appear in numerous anthologies and were well known to Japanese poets and painters.[13] Wolfgang Bauer holds that the importance of wine is one hallmark of neo-Daoist thought associated with the Seven Sages:

> In marked contrast to the sages of older Taoism, the "Sages of the Bamboo Grove," and still more their epigones, could no longer be thought of without a bottle of wine in their hand, a pose that might be called an iconographic characteristic (metaphorically speaking). The official collapsing with glazed eyes behind his desk, who uses his offices primarily for drinking bouts, and makes his acceptance of a position in the provinces depend on the quality of the wine cellar, became a kind of ideal figure to be applauded and admired.[14]

Frequent and extreme inebriation was an obvious way of flouting social conventions, but the "positive" effect of wine to shut out the distractions of the exterior world and unlock the creative spirit also count for its appeal to the members of the Seven Sages and their imitators.

Less common than drunkenness, but equally part of the behavior

attributed to the Seven Sages, was homosexuality. Several tales relate the intimate relations of Ji Kang, Ruan Ji, and Shan Tao. *Shishuo xinyu* (*juan* 19:11) describes the friendship of the three as "stronger than metal and fragrant as orchids" and relates the incident in which Shan Tao's wife spies on the intimate nocturnal activities of the three friends.[15] Ruan Ji expressed his love of other men in passionate poetry. Among the several poems on homosexuality in his "Jade Terrace" collection is the verse on the love of the imperial catamite Anling, the favorite of the King of Chu, and Longyang, the companion of King Anxi of Wei.[16] The ostensible bisexuality or homosexuality of these three members of the Seven Sages can be interpreted as another way of breaking social taboos. Seen in a more positive light, the physical intimacy between Ji Kang and Ruan Ji is the ultimate expression of the bonding between like-minded men. In the words of R. H. van Gulik, "Their close friendship has become the classical example of similar male attachments among poets and artists of later ages."[17]

The Seven Sages, in their communitas (including its homosexual overtones), appreciation of nature, devotion to music and poetry, and combination of eccentric behavior (such as drunkenness) with personal refinement, are clear exemplars of aesthetic reclusion. As developed in the Wei-Jin and Eastern Jin periods, the neo-Daoist focus on self-cultivation and rejection of social norms can be considered the locus classicus of aesthetic reclusion. If the Four Graybeards symbolize political reclusion with secondary implications of aesthetic reclusion, the Seven Sages present the reverse case. Their thoughts and actions were aimed at the cultivation of the self, but this radical self-involvement implied objurgation of Confucian values of service to the state (even when they served as bureaucrats). The dual implications of political and aesthetic reclusion account for the popularity of the Seven Sages among later Chinese and Japanese painters.[18] The rich nexus of themes connected to the Seven Sages also made them models of reclusion for the sinophiles among the first Japanese poets.

The Adoption of the Eremitic Ideal in Early Japanese Poetry

The Japanese adoption of Chinese recluse ideology, including specific exemplars such as the Seven Sages, began in Japanese *kanshi* of the eighth century. The cultural codes and interpretative assumptions that culminated in Momoyama painting have their genesis in these poems written in Chinese. Early Japanese poems on reclusion generally exhibit several shared features. In formal structure, diction, and imagery, these poems are deeply indebted to Chinese models. The reclusion described

and championed in these poems is not overtly political in motivation. It usually involves neither protest of, nor escape from, bad government, but rather valorizes life in nature and cultural accomplishment. The interest in nature as a spur to creative liberation has Daoistic overtones. Moreover, there is a distinctly literati character in that scholarly pursuits —such as writing verse and playing music—are highlighted in the poems.[19]

Some poems also contain references to famous Chinese scholar-recluses who are invoked as exemplars of eremitism. These paradigmatic hermits—such as Tao Yuanming or the Seven Sages—are marked by eccentric or at least distinctive behavior, and, despite their status as hermits, exhibit a fondness for human interaction. Borrowing their themes and models from China, Japanese poets composing in Chinese sought to recreate the Chinese cultural experience on Japanese soil. This fact is important because it demonstrates that, from its outset, reclusion in Japan was conceived in terms of Chinese culture.

Chinese ideas of reclusion were conveyed to Japan in Tang poetic encyclopedias such as *Chuxueji* by Xu Jian (557–641) and *Yiwen leiju*, as well as massive anthologies such a*s Yutai xinyong* and the widely influential *Wenxuan* (Selections of Refined Literature) edited by Xiao Tong (501–531).[20] Not only does *Wenxuan* contain one chapter (22) of poems on "Summoning the Recluse" *(zhaoyin)*, but it includes many of the best-known poems and short prose pieces by members of the Seven Sages. Ruan Ji is represented in *Wenxuan* (poems 93–109) by his seventeen "Poems Singing the Heart," which cover topics including the ephemerality of love, wealth, honor, fame, the folly of political involvement, loneliness, dissolute behavior, the passage of time, and regrets for youth.[21] Ji Kang's bitter letter to Shan Tao attacking social conventions, his "Treatise on Nourishing Life," and several of his poems are found in the chapters on Letters, Essays, and Miscellaneous Verse, respectively.[22] In addition, poems mentioning Xiang Xiu, Liu Ling, and Ruan Xian number among the verses anthologized.

For Japanese of the ninth century and later, the best source of biographical information on famous Chinese was *Mengqiu* (Enquiries of Youth). An eighth-century Chinese primer including more than six hundred historical and legendary figures, it was compiled by the minor official Li Han (fl. 746) and known in Japan at least by 878, when it was used for the instruction of the fourth son of Emperor Seiwa (r. 858–876).[23] The Seven Sages are mentioned several times in *Mengqiu*: they appear singly or as a group in sections 1, 25, 55, 56, 81, 117, 175, 344, 373, and 570.[24] Almost all of these accounts tell of the refined but decidedly eccentric behavior of the Seven Sages.

The earliest Japanese mention of the Seven Sages of the Bamboo

Grove is an oblique reference in a poem by Chizō (fl. 650–700) in *Kai-fūsō*.[25] The second *kanshi* anthology, *Keikokushū* (Collection for Ordering the State) compiled by Yoshimine Yasuyo (785–830), contains a more significant reference. Among the several poems that sing the praise of the recluse's life, a verse by Ii Nagashiro (dates unknown) links the Seven Sages to a pastoral scene:

> A house where the long embankments are old.
> Fine fields west of it and east;
> To enter I stroll among willows,
> Cross a moat to reach the guest's hall.
> Ice has bound the moat, its ripples stilled:
> Frost has fallen, leaves are gone.
> But still there's plenty of wine and lute-playing,
> All in the manner of the Bamboo Grove.[26]

The last line makes it clear that the Seven Sages are associated with life in reclusion, particularly when that life is distinguished by wine drinking and *qin* playing.

An equally brief but resonant reference to the Seven Sages is found in *Man'yōshū* (Collection of Ten Thousand Leaves), the oldest extant collection of Japanese verse, compiled in the late Nara or early Heian period. One verse from a sequence of thirteen poems (3:338–350) in praise of wine by Ōtomo Tabito (665–773) mentions the dipsomaniacal desires of the Seven Sages:

> Inishie no What the [Seven] Wise Men
> nana no sakashiki of ancient times
> hitodomo mo wanted, it seems,
> horiseshi mono wa was wine.
> sake ni shi arurashi[27]

The theme and many of the phrases from Tabito's poem-series are drawn from Chinese poetry. Specific allusions include Tao Yuanming's "Poems on Drinking Wine," Wang Xizhi's (321–375) "Orchid Pavilion Preface" (known in Japan from *Yiwen leiju*), and Liu Ling's "In Praise of the Virtues of Wine" from *Wenxuan* (*juan* 4) and other sources.

Tabito's fascination with Chinese literature and the lives of recluses such as Liu Ling and others of the Seven Sages seems to have made an impact on his own style of living. As governor of Dazaifu, Tabito formed a small circle of friends from among other officials and spent much of his time in the provincial capital writing poetry and studying Chinese literature. Tabito's more famous son Yakamochi (718–785) surpassed his father in poetry and in fashioning himself as a Chinese-style recluse-poet. Yakamochi served as provincial governor in several remote towns,

where he devoted the greater part of his time to elegant pursuits. Yaka-
mochi often invited his boon companion Ōtomo Ikenushi (dates un-
known) to accompany him on his official postings, and together the two
men lived as virtual aesthete-recluses, "conscious . . . of themselves as lit-
erary men, dashing off elaborate notes in a foreign language [Chinese] to
extol the pleasure of nature, wine, and music, and comparing themselves
to the poets of the past."[28] Their passionate poetry and florid correspon-
dence suggest a homosexual aspect to this pastoral literary life.

These early poems on eremitism demonstrate knowledge of the
Seven Sages and, more critically, the deployment of them as exemplars
of the reclusive life spent in pursuit of music making and liberating
inebriation. That officials such as Tabito and Yakamochi should take on
the guise of aesthete-recluses reveals how deeply the Japanese avant-
garde had absorbed the Seven Sages' combination of government service
with devotion to pastimes implying a specific rejection of that vocation.
As Japanese culture evolved during the Heian and Kamakura periods,
the Seven Sages and the Four Graybeards remained models for literary
creation and behavior, but these Chinese models were increasingly inte-
grated into a cultural experience independent from that of China.

Two Modes of Borrowing: The Cases of *Waka* and *Setsuwa*

Before turning to the analysis of the Seven Sages and the Four Gray-
beards in narrative tales *(monogatari)*, it is useful to delineate two basic
modes of deploying Chinese eremitic themes. The tradition of direct ref-
erence to Chinese exemplars first seen in late Nara period *kanshi* contin-
ued in poetry and prose of later periods; of course, Japanese paintings of
Chinese figures (such as the Tōji *Senzui byōbu,* fig. 1) also provide evi-
dence of the enduring fascination with sages and exemplars from Chi-
nese history. The popular *setsuwa* genre demonstrates how Chinese
subjects continued to serve as direct models for the characterization of
Japanese figures, but also reveals the movement towards subtle appro-
priation and transformation of continental models. A second literary tra-
dition eschews extensive biographical history of, and direct comparison
to, Chinese models. Instead, Chinese ideas of reclusion are synthesized
with Japanese experience. The development of recluse themes in Heian
waka poetry provides an early example of the Japanese internalization of
Chinese culture.

The reclusion demonstrated in the poems included in early *kanshi*
anthologies and *Man'yōshū* was not to remain the exotic hobby of a few
sinophile poets among the Heian intelligentsia. Rather, the ideology of
aesthetic reclusion was absorbed into *waka*—the poetic *lingua franca* of
the Heian period. The evolution of reclusion themes in *waka* poetry is

discussed by Mezaki Tokue in his article "Aesthete-Recluses During the Transition from Ancient to Medieval Japan."[29] As the title implies, Mezaki finds the reclusion exhibited in most *waka* to be dominated by "aestheticism" *(suki).* Although many hermits took Buddhist vows, Mezaki contends that for most of these recluses or *tonseisha,* world rejection was a creative rather than a religious or political act. For Mezaki, "the act of becoming a *tonseisha* provided a basis for cultural creativity and the sustaining of spiritual liberty."[30] The reclusion of the person who cultivates a deep attachment to solitude, poverty, purity, a closeness to nature, and devotion to accomplishments such as playing *go* or writing poetry, is termed "aesthetic reclusion" *(suki no tonsei).*

Mezaki traces three stages in the development of aesthetic reclusion as a thematic topic in *waka:* he begins with the latent desire for it in the early-tenth-century *Kokinshū* (Collection of Ancient and Modern Poems) age, progresses through the refined withdrawal of low ranking mid-Heian aristocrats, and culminates with the mature fusion of *suki,* Buddhism, and eremitism in poetry of the late twelfth and early thirteenth centuries. The restricted vocabulary and imagery of *waka* disallow any reference to Chinese hermits such as the Seven Sages or the Four Graybeards. Instead, it is the *waka* poet himself who wears the mantle of hermit-poet: his sensitive reaction to nature, elegant poverty, and devotion to literary pursuits all signal his status as "aesthete-recluse." The transformation of Chinese ideas of aesthetic reclusion in Japanese *waka* is manifest in the poets' emphasis on the hermit's hut as the symbol of reclusion. Usually termed a "grass hut" *(kusa no iori)* or a "mountain dwelling" *(yamazato),* in its rural location, natural materials, and simple elegance of design, the hut comes to stand for the eremitic experience. The poet-hermit's humble residence is associated with aesthetic reclusion in China; famous examples include, Tao Yuanming's house beside five willows, and Bo Juyi's hut below Mt. Lu (probably depicted in the Tōji *Senzui byōbu,* fig. 1). However, in the *waka* of Japanese recluses, such as Kisen (fl. 810–824), Ryōzen (d. 1058), and Saigyō (1118–1190), the hermitage often comprises both the location and the subject of the poem.

In contrast to *waka, setsuwa* collections typically contain myriad references to a wide variety of Chinese figures, both historical and legendary. Many of the Chinese figures mentioned in these popular tales are Buddhist ascetics and Daoist *sennin* rather than hermits and literary men. Yet, for our purposes, the descriptions of Chinese ascetics and immortals are useful in that they demonstrate how continental figures continued to function as templates for the literary creation of Japanese sages. In the *setsuwa* tradition, Japanese sages *(hijiri)* such as En no Gyōja of Mt. Ōmine and Yōshō of Mt. Hiei are described as possessing

characteristics similar to those of Daoist immortals: they abstain from ingesting grains, preferring to eat pine needles or bark to purify their bodies; they wear old garments full of holes or dress in vines and leaves; they live in caves or rustic huts deep in the mountains; they are given to solitude, often walking alone in the wilderness for long periods, but may also be accompanied by young boy servants; both fly, become invisible, walk on fire and "ascend to heaven"; and, finally, they are considered immortal.[31] The attempt to portray Japanese sages in the guise of Daoist immortals demonstrates how Japanese continued to model themselves (or, at least, their semimythical culture heroes) after the Chinese immortals described in imported texts.

Even as Japanese continued to cast themselves in the guise of Chinese exemplars, they also reinterpreted and thereby transformed Chinese themes so as to conform to the particular configurations of their own culture. For example, one section of *Uji shūi monogatari* (Tales from the Uji Collection), compiled between 1212 and 1221, relates the exemplary deaths of Boyi (Hakui) and Shuqi (Shukusei), two princes of Guzhu, who declined to serve the new emperor Wu of Zhou (r. 1122–1115 B.C.) out of loyalty to the emperor Zhou of Yin (r. 1154–1122 B.C.). Leaving the capital, where they had refused to eat the grain of Zhou, the men retired to Mt. Shouyang to subsist briefly on ferns before dying of starvation. Before expiring, the two Zhou loyalists wrote a poem championing protest reclusion as the only virtuous action possible in a degenerate age. The story appears in *Lunyu* (Analects) (*juan* 16:12), where Confucius praises the two men for their loyalty.[32] The Japanese probably knew the story from *Shiji* (Historical Records) of Sima Qian (145–190 B.C.), where Boyi and Shuqi are eulogized in detail.[33] Where as Chinese writers had praised them for their virtuous protest, the anonymous Japanese author of *Uji shūi monogatari*—in the course of recounting an anecdote from the *Zhuangzi* concerning a dialogue where Confucius is bested by a bandit—chastises the men for wasting their lives.[34]

The priest Mujū (1226–1312) provides an example of a Japanese writer who freely reinterprets the meaning of well-known Chinese stories in order to fit his own discourse. In his 1283 *Shasekishū* (Collection of Sand and Pebbles) (10:4), Mujū tells the story of Xu You, the exemplary Confucian who washes his ears in a river to cleanse himself of impure words, and Chaofu, his even more exemplary compatriot, who refuses to let his ox drink the polluted river water. While in China, their extreme behavior became a parable of devotion to Confucian principle as well as a model for the purity of reclusive spirit,[35] Mujū presents the story in the context of tales about Japanese ascetics who gave up their property in pursuit of Buddhist ideals.[36] In contrast to the dominant political implications of the theme in China, Mujū concludes that the world rejection

of Xu You and Chaofu was the result of pure idealism and thus akin to Buddhist renunciation of the material realm.[37]

In short, a Chinese Confucian theme of political reclusion is pressed into the service of Japanese Buddhism. It likely mattered little for Mujū that Xu You and Chaofu lived long before the advent of Buddhism in China; more likely, Mujū wanted to demonstrate the core of shared experience underlying superficial differences in tradition. For Mujū, these points of intrinsic commonality point to the superiority or, at least, the efficacy of Buddhism in that it subsumes or parallels the other great East Asian philosophies.

The Adaptation of Bo Juyi and the Four Graybeards in Heian Prose

In *monogatari* literature of the tenth through thirteenth centuries, we can observe the Japanization of eremitism in which its ideals and models, while still based on Chinese eremitism, are assimilated into a distinctly Japanese context. This literature reveals a recontextualization or rearticulation of the cultural dialectic in which the old subjects remain but their meanings are significantly changed. With this material, we confront squarely what David Pollack has termed the "fracture of meaning," the "dialectical relationship between the antithesis of alien [Chinese] form and native [Japanese] content."[38] In the case of reclusion, Chinese figures still serve as models, but what they are models of depends more on the requirements of the Japanese context than on the original qualities of the Chinese figures.

The dialectical play between continental and native culture is an integral aspect of Heian court literature. The complex interplay between Chinese prototypes and Japanese forms, clearly the point of such Chinese-Japanese poetry compilations as *Kudai waka* and *Wakan rōeishū*,[39] is also manifest in the treatment of Chinese hermit subjects in *monogatari*. Because Chinese history and literature were such integral parts of the Japanese cultural landscape by the Heian period, it is difficult to gauge their impact. Chinese legends were often incorporated into Japanese culture with an incomplete understanding of their original dimensions and a distorted sense of their earlier significance. In this partially detached or even wholly disembodied state, Chinese figure subjects could easily be given new meanings based on their function within the Japanese context.

Before turning to an analysis of the recluse themes of Bo Juyi and the Four Graybeards in Heian *monogatari*, we can gauge the degree to which Chinese recluses were absorbed into and transformed by Heian culture by examining a common phrase used to denote a long passage of

time. In one section of the twelfth-century *Torikaebaya monogatari* (The Changelings), the narrator describes the extended rapture of courtiers hearkening to a priest's sermon by writing, "For those who listened to his voice . . . truly once again 'the handle of the ax would rot and one would even forget one's birthplace'."[40] The phrase draws on the story of Wang Zhi (Ōshitsu) (ca. 255–209 B.C.), a Qin dynasty woodcutter who, when gathering firewood deep in the mountains of Kuzhou, stumbled across a cave occupied by strange old men playing *weiqi*. After eating a date stone proffered by one of the white-haired elders, Wang fell into a trance. Upon awakening, he touched his ax, only to find that the handle had rotted during his long sleep. Returning to his village, Wang could recognize neither the new houses nor their inhabitants.

The story—included among other stories in *Shuyiji*—was known in Japan by the late Heian period, when the reference to Wang's rotted ax handle became part of literary language.[41] While this kind of allusion to Chinese legend surely was intended to create a sense of cosmopolitan erudition, it also suggests how thoroughly Chinese themes had penetrated and been transformed in Heian culture. As employed in *Torikaebaya monogatari*, the mystical story of Wang Zhi's strange experience in the deep mountains is reduced to a metaphor for deep absorption. The wider implications of the incident, and perhaps even the connection of the rotted ax handle to Wang Zhi, may well have been lost on the author and readers.

Murasaki Shikibu's (d. 1014?) early-eleventh-century *Genji monogatari* (Tale of Genji) provides several examples of how meaning may change when Chinese subjects are adapted in the Japanese cultural context. It has been frequently noted that the Tang poet Bo Juyi—the Heian culture hero par excellence and "the model of life itself"[42]—served both in his life and in his literary creation as the model for aspects of Murasaki's "Shining Genji." For example, in the opening *Kiritsubo* (Paulownia Court) chapter, the emperor's love for Kiritsubo is likened to the emperor Xuanzong's love for Yang guifei as immortalized in Bo Juyi's *Changhenge* (Song of Everlasting Sorrow).[43]

For Murasaki and her contemporaries, Bo Juyi was more than the creator of verse, he was a symbol of the Chinese poet-recluse.[44] In the *Suma* chapter, for instance, Genji's residence-in-exile at Suma beach and his activities there resonate with the experiences of Bo Juyi. Murasaki adds references to the Japanese exiles Ariwara Yukihira (ca. 818–ca. 893) and Sugawara Michizane (845–903), but it is Bo Juyi who stands as the model for the transformation of Genji's exile into a period of aesthetic reclusion. The physical appearance of Genji's rustic "Chinese" *(karameita)* house—with plaited bamboo fence, stone stairs, pine pillars, and grass-thatched roof—is very similar to Bo Juyi's house below Mt. Lu.

When Genji longs for distant friends in the capital, he quotes Bo's poem "On the Evening of the Full Moon of the Eighth Month." Upon the arrival of Genji's retainer Tō no Chūjō, they drink a toast to Bo and quote his poem on reunion with his friend Yuan Zhen (779–831).[45]

Murasaki is not content to have Genji merely live in a dwelling similar to Bo Juyi's hermitage and recite his poems; she casts Genji in the garb of the ideal Chinese poet-recluse, spending his days in the refined pursuits associated with reputed aesthete-recluses such as Bo. In one remarkable passage, Genji spends a day inventing games, playing the *qin*, practicing calligraphy and painting, tending the garden, chanting sutras, writing poetry, viewing the moon, and, finally, chanting the verse of Bo Juyi.[46] This conflation of aesthetic reclusion and the paradigmatic example of Bo Juyi is foreshadowed early in the *Suma* chapter when Genji, preparing for life in exile, gathers those "simplest objects of rustic life"— a seven-stringed *qin*, scrolls of Daoist, Confucian, and Buddhist writings, and the "Collected Works of Bo Juyi."[47]

Bo Juyi was never a recluse, but only a temporary exile. His poetic corpus, preserved most fully in *Boshi changqing ji*, contains only one poem (52:17a) that expresses Bo's views on reclusion, and even that lone verse has little to do with aesthetic reclusion.[48] In his apotheosis as the ideal man, it mattered less what Bo actually was than what he was thought to be. In Heian Japan, Bo Juyi was not so much a real person circumscribed by the facts of his biography, but a man of myth—a fictive figure to whom writers and painters could attribute any qualities that were generally consistent with popular belief gleaned from reading his works and the legends accreted to them. Thus, Bo's exile was reinterpreted by Murasaki in the more positive light of aesthetic reclusion when a Chinese model was needed.[49] In short, Bo Juyi serves as the perfect model for Genji only after Bo is fictionalized.

Murasaki's technique of transformation and appropriation of Chinese models to create a shadow text for her own narrative is employed more subtly in an allusion to the Four Graybeards of Mt. Shang in the *Miotsukushi* (Channel Buoys), the chapter of *Genji monogatari* that details Genji's life immediately after return from exile. Although mentioned in passing, and significantly altered at that, the story of the Four Graybeards provides a historical "precedent" for the events in Murasaki's narrative. When the emperor decides to abdicate, the crown prince—actually Genji's illegitimate son—becomes the Reizei emperor, and the emperor's son by Lady Shōkyōden is made crown prince. Genji, despite his peculiar position and secret relationship to the new emperor, is made a minister, and his father-in-law is invited out of retirement to become regent. The old man protests the appointment because of old age:

It was pointed out, however, that in foreign countries statesmen
who in time of civil disorder have withdrawn to deep mountain retreats
have thought it no shame, despite their white beards, to be of service
once peace has been restored. Indeed they have been revered as
the true saints and sages [*hijiri*].[50]

Most commentators have pointed out that the white-bearded foreign
statesmen of this passage are the Four Graybeards, yet the implications
of the allusion are rarely discussed. Murasaki's narrative echoes and dis-
torts the story of the Four Graybeards in two ways. First, because the
tale of the Four Graybeards involves passing over the natural crown
prince for the son of a mistress, the crowning of the bastard Reizei in
Genji monogatari offers a loose parallel. While there are differences
between the two narratives, Murasaki never draws a direct parallel.

In contrast, the direct comparison of Genji's father-in-law to the Four
Graybeards demonstrates how Murasaki either misunderstands or, more
likely, purposely alters the basic contours of the Chinese story. Murasaki
states that the retirement of the Genji's father-in-law "had been occa-
sioned in part by the fact that affairs of state were not going as he
wished, now all was in order."[51] To parallel her narrative, Murasaki
writes that the white-bearded foreign men returned to government ser-
vice after order was restored. In fact, the Four Graybeards' return to
court preceded and, indeed, brought about a restoration rather than fol-
lowed it. Although Murasaki's alteration of the Four Graybeards ratio-
nale for returning to service seems slight, as with her earlier recasting of
Bo Juyi as an aesthete-recluse, it signals a fundamental shift in the Japa-
nese relation to Chinese culture. Specifically, Murasaki interprets the
Four Graybeards not as men whose authority stems from their knowl-
edge and adherence to Confucian principle, but men whose salient
feature is their government service despite advanced age. In short, in
Genji monogatari the Four Graybeards are important not because they
are good Confucians, but merely because they are geriatric Chinese.
When the original story is changed, however slightly, the cultural
dynamic is fundamentally altered. The primacy and integrity of Chinese
culture are compromised; Japanese writers such as Murasaki create the
Chinese history they want as much as they follow that which existed on
the continent.

The general shift in cultural dynamics, and the particular alteration
of the Four Graybeards witnessed in *Genji monogatari*, had its genesis
some two hundred years before Murasaki's age. The Four Graybeards
were known in Japan by the eighth century, when they are mentioned in
the *Sangō shiiki* (Indications of the Goals of the Three Teachings) by the

great Buddhist theologian Kūkai (774–835). In the *Kamei Kotsujiron* (Account of Kamei Kotsuji) chapter, Kūkai champions Buddhism by recounting the life of a mendicant priest who exemplifies Buddhist rejection of the material world. Besides enumerating the mendicant's virtues, Kūkai praises this true follower of the Buddhist law by comparing him favorably to Chinese Daoist and Confucian exemplars. For instance, Kamei's asceticism is such that even his appearance of "agedness" is greater than that of the Four Graybeards.[52]

A similar reduction of the Four Graybeards to symbols of old age is made in poem 369 of the eleventh-century *Wakan rōeishū*.[53] For Japanese writers and poets of Murasaki's age and before, the long, hoary beards of these men made them natural symbols for elderliness. The advanced age of the Four Graybeards is associated with wisdom in the early Heian *Utsuho monogatari* (Tale of the Hollow Tree).[54] Because none of these sources mentions the role of the Four Graybeards in protesting the bad governments of the Qin emperors and Gaozu of the Han, or their part in restoring Huidi to his legitimate position as heir, it is possible that the full ramifications of the story were largely unknown. However, the story of the Four Graybeards' return to court is included in *Shiji*, a text well known among mid-Heian aristocrats such as Murasaki Shikibu, who has Genji recite a line from it in the *Sakaki* (Sacred Tree) chapter of *Genji monogatari*.[55] Further, Murasaki's allusion to the Four Graybeards in the *Miotsukushi* chapter suggests a relatively sophisticated knowledge of the Four Graybeards.

There is no question that the story of the Four Graybeards was thoroughly known by the time the anonymous *Kara monogatari* (Tales of China) was written in the late Heian or early Kamakura periods. *Kara monogatari* mixes the *setsuwa* format with *waka* and thus resembles an *uta monogatari*. The hybridization in format is matched by the content, which combines biographical information gleaned from Chinese sources with an often idiosyncratic Japanese interpretation of those biographies. The Four Graybeards' return to court comprises the seventeenth of the twenty-seven tales. Japanese scholars have located *Shiji* and *Gaoshi zhuan* as major sources for the *Kara monogatari* account, but *Mengqiu* and *Yongshi shi* may also have suggested several of the accretions in this lengthy and creative Japanese retelling.[56]

The first half of the Four Graybeards' story in *Kara monogatari* conforms to the basic outline of the standard Chinese versions, adding only small details and comments on the motivation of the characters to fill out the skeletal narrative of the Chinese versions. One example of this minor authorial intervention comes at the outset, when the narrator speculates that Gaozu may have chosen to promote his younger son Yin over Crown Prince Hui because Empress Lu, Hui's mother, was overly

ambitious in promoting her son. An instance of embellishment is the addition of the official Chen Ping (d. 178 B.C.), an advisor to Gaozu, who accompanies Zhang Liang to Mt. Shang in the *Kara monogatari* version. Despite these accretions, the didactic Confucian essence of the story is preserved. The Four Graybeards return to serve the crown prince and, after lecturing Gaozu, affect a change in his choice of a successor.

In the introduction to his translation, Ward Geddes writes that *Kara monogatari* "represents an appreciably complex attempt to adapt the Chinese stories to the tastes and preferences of a cultivated Japanese reader."[57] This creative adaptation usually takes rather standard forms. At the end of the second tale, recounting Bo Juyi's meeting with the Lute Girl, the author concludes: "Apparently feeling that people throughout the land were sullied by the baseness of the mundane world, Bo Juyi lived alone and never set foot in the capital again."[58] This statement of Bo's reclusion, a clear contradiction of historical fact, is the logical extension of the recluse ideology previously seen in the treatment of Bo in the *Suma* chapter of *Genji monogatari*.[59] Given this emphasis on reclusion, which is one part of *Kara monogatari*'s larger theme of the transcendent nature of the human soul, we should not be surprised that the author adds a similar coda to the tale of the Four Graybeards.

The second half of the Four Graybeards story, rarely mentioned in other Japanese textual or pictorial sources, is also based on accounts in *Shiji* and *Hanshu*. Before concluding with several paragraphs on Confucian reclusion, the narrator details a bitter and bloody court drama in which Empress Lu attacks her rival Lady Qi and Qi's son Yin. After Lady Qi is murdered and dismembered by Empress Lu, her ghost kills the empress. As if to contrast the petty rivalry of these female courtiers with the selfless behavior of Confucian worthies, the narrator turns abruptly to the Four Graybeards. Seeing their mission accomplished, the four sages triumphantly return to their "mountain retreat," the praise of a grateful nation ringing in their ears. The narrator adds her or his own voice to the chorus of approbation for the Graybeards' decision to serve when needed and withdraw after order has been restored.

The tale of the Four Graybeards concludes with a comparative discussion of other famous Confucian recluses. The author briefly recounts the story of Taigong Wang's service to Wen of Zhou, Xu You's ear-washing episode, and Chaofu's tetchy reaction. In the last case, the legend of Chaofu prohibiting his ox from drinking is confused with a story from *Mengqiu* in which Chaofu smashes a sounding gourd used to scoop water. In contrast to the "appealing" benevolence of the Four Graybeards, the narrator claims to be unmoved by these other "ludicrous" stories. A *waka*, indirectly criticizing Chaofu's hypersensitivity, brings the tale of the Four Graybeards to a close.

The extended account of the Four Graybeards in *Kara monogatari* demonstrates that by the early thirteenth century the Japanese elite thoroughly understood this subject. Not only did the Japanese know the story line, they comprehended the Confucian theme of reclusion as protest and the concomitant duty of sages to return to service when needed. The *Kara monogatari* narrative also emphasizes affairs at the Han court. While the court intrigue described here involves the murderous relations between females, in later pictorial adaptations the focus is on the romantic connections between males. The concluding discussion of the Four Graybeards in relation to other Confucian recluses reveals that some Japanese were making connections and judgments about Chinese subjects and, more important, that the Four Graybeards were viewed by at least one author as superior exemplars. These points are potentially important in helping explain the pairing of recluse themes in Momoyama painting and the popularity of the Four Graybeards relative to pictures of Taigong Wang, Xu You, and Chaofu. Finally, the *Kara monogatari* narrative exhibits the Japanese reworking of Chinese history. This is not the subtle interweaving of Japanese and Chinese themes characteristic of Murasaki Shikibu, but direct editorial intervention in the recounting of a Chinese subject.

The Symbolic Reduction of the Seven Sages and the Four Graybeards in Medieval Warrior Tales

In "war tales" *(gunki monogatari)* of the Kamakura and Muromachi periods, we witness not only a dramatic rise in the number of references to Chinese historical subjects but the increasingly critical interpretation of these themes by Japanese writers. Most war tales are filled with references—whole narratives or brief allusions—to military exploits and political intrigues gleaned from Chinese tradition. Most of the references involve military and overtly political incidents that, like the Japanese war tales they adorn, tell of the rise and fall of great armies and states. The frequent digression to Chinese exemplars serves to structure and amplify the Japanese events by placing them in the broader and grander context of Chinese culture. Among the myriad examples of loyalty and filial piety, or its absence, there is sporadic mention of Chinese hermits.

Because the stories of Chinese recluses are pressed into service as instructive parallels to Japanese events, this comparative function often leads to new interpretations of the Chinese stories. The mid-fourteenth-century *Taiheiki* (Chronicle of Great Peace), for example, includes one passage in which Chinese ideals of protest are cited and then subverted. *Taiheiki* (5:2) tells the story of the great counselor Nobufusa, an official under the former emperor, who is asked to serve the new emperor and

triumphant Ashikaga *shōgun*. Nobufusa answers, quoting the *Xiaojing* (Classic of Filial Piety), that his poor record of service makes him unfit to serve any emperor. Nobufusa concludes his protestations by claiming it would be better to starve like Boyi at Shouyang than serve two masters. The Ashikaga vassal Sukeakira responds by criticizing as useless and un-Confucian the behavior of Confucian recluses such as Boyi and Shuqi, Xu You and Chaofu. While Chinese had criticized the same men, this censure had always been directed from the life-affirming standpoint of philosophical Daoism as well as Wei-Jin period neo-Daoism.[60]

In the early-fifteenth-century *Soga monogatari* (Tale of the Soga), Xu You and Chaofu appear again in a somewhat unusual context. When a courtesan wishes to avoid sleeping with an unwelcome suitor, she tells the story of Xu You and Chaofu to illustrate the point that the "virtuous man doesn't consort with two men."[61] The Chinese story is misunderstood or purposely reinterpreted: neither Xu You nor Chaofu fled to avoid serving a new lord. In this altered form, the story is able to serve a more general function—that of a model for virtuous resistance.

The reduction of Xu You and Chaofu to generic symbols of Confucian reclusion, and their consequent function in all manner of contexts, is paralleled in references to the Seven Sages and the Four Graybeards. In the thirteenth-century *Heike monogatari* (Tale of the Heike) (3:19), an oblique reference to the Four Graybeards connects their reclusion with the "pure reclusion" of Buddhist hermits. When several learned courtiers take Buddhist vows and retire to Ōhara and Mt. Kōya, the narrator provides a precedent for this behavior by alluding to "those in antiquity who hid in the Shang Mountain clouds and purified their minds under the Ying River moon."[62] Of course, neither the reclusion of the Four Graybeards nor that of Xu You and Chaofu, the ostensible models cited here, was motivated by Buddhist ideals. The point of connection is the purity of the Confucian reclusion of these Chinese hermits and the purity of the Buddhist reclusion of the Japanese courtiers. The result of this passage, so similar to that cited earlier in Mujū's *Shasekishū*, is the reduction of the Four Graybeards to symbols of reclusive purity undifferentiated from that of Xu You and Chaofu.

A similar reduction of the Four Graybeards, this time importantly paired with the Seven Sages, is found toward the end of *Heike monogatari* (10:8). When a Taira family captain visits a former warrior who has taken Buddhist vows and retired to Mt. Kōya, he is struck by the wonderfully emaciated, aged, and altogether holy appearance of his young friend. The narrator concludes, "It seemed that the Seven Sages of the Bamboo Grove in Jin or the Four Graybeards of Mt. Shang in Han [*sic*] could not have been more impressive to behold."[63] Again the Four Graybeards serve as models for Buddhist priests, but here they do so only in

their superficial appearance. We have already seen how the Four Gray-beards had functioned as models of old age in Kūkai's *Sangō shiiki*, *Wakan rōeishū*, and *Genji monogatari*, but the addition of the Seven Sages is startling.

This initial pairing of the two groups of hermits, so common in later painting, seems rather remarkable at first blush. In the literary tradition before *Heike monogatari*, the Seven Sages and the Four Graybeards were never paired, much less mentioned, in the same work. Moreover, a nota-bly aged or inspiring appearance had never previously been one of the characteristics attributed to the Seven Sages. Yet, when we consider the dual traditions of boiling down Chinese recluse themes to provide a generic model for some Japanese experience and then the doubling of these exemplars to strengthen the analogy, it seems inevitable that the Seven Sages and the Four Graybeards eventually should be mentioned in tandem.

While the link between the impressive appearances of the Seven Sages and the Four Graybeards in *Heike monogatari* is precedent setting, an equally generic but more expected connection is found in *Soga monogatari*. In chapter 12, the narrator uses the two bands of recluses as exemplars for the sagacity of the mother of the Soga brothers. The Soga matriarch is praised for being "as wise as the Seven Sages of the Bamboo Grove and the Four Graybeards who hid on Mt. Shang."[64] The quality of wisdom, like that of an impressive appearance, is universal: it implies nothing about the specific narrative or ideology previously associated with the Seven Sages and the Four Graybeards. The wisdom attributed to these groups of men reveals nothing about their reasons for reclusion: there is neither the implication of Confucian withdrawal or service nor the suggestion of neo-Daoist self-cultivation.

When we ignore the very different histories that distinguish the Four Graybeards from the Seven Sages in favor of common denominators such as their impressive appearance or uncommon insight, we can begin to find a number of other similarities that may have led to their pairing in medieval Japanese war tales. First, the Seven Sages and the Four Gray-beards are similar in that each presents a multifigure assembly of men. Second, based solely on their group names, the two sets of recluses are closely associated with nature: the Seven Sages inextricably linked to their leafy bamboo grove, and the Four Graybeards forever associated with airy Mt. Shang. Third, both groups are sufficiently grounded in Chinese antiquity to give them elevated status. Yet, unlike Xu You and Chaofu, neither group is so obscured by the mists of legend that their existence is called into doubt.

The shorthand reduction of the Seven Sages and the Four Gray-beards to symbols of old age and wisdom is important in that it shows

the radical Japanese adaptation of these themes and, in this transformed state, the eventual pairing of themes that in their original telling were nearly antithetical in significance. It is useful to note that this coupling takes place in literature intended primarily for the warrior class—the same class that was one of the chief patrons for the pictorializations of the Seven Sages and the Four Graybeards in the Momoyama and early Edo periods. The reduction of these recluse themes to peripheral status as generic symbols in war tales is by no means indicative of the status of reclusion in medieval Japanese literature. The reclusion experience and ideology in Heian period *waka* blossomed into the "recluse literature" so prominent in the Kamakura and early Muromachi periods.

Medieval Recluse Literature

By the end of the Heian period, reclusion had become a major theme in both poetry and prose. The modern terms *inja no bungaku* (recluse literature) and *inton no bungaku* (reclusion literature) are used to denote this genre that takes the hermit's experience as its thematic center. William LaFleur deftly summarizes the rise of "recluse literature":

By the late twelfth century... the writing brush had passed from the hand of the court lady to that of the monk *(inja)*, that is, to a person either in retirement from the world or at least adopting such a pose. Thus it happened that the hermit's hut ... became not only the real or postured locus for literary composition but also one of literature's central topoi.[65]

To a large degree, we can measure the rise of reclusion and its literary expression by the amount of criticism of false hermits found in medieval writing. In chapter 10 of *Hosshinshū* (Collection on the Awakening of Faith) of 1216, the recluse Kamo no Chōmei (1155–1216) denounces those who hide themselves in nature with the intent of gaining worldly fame.[66] Among the numerous references to reclusion in *Ichigon hōdan* (Fragrant Conversation in One Word), a thirteenth-century compilation of sayings by Pure Land Buddhist monks, many serve to censure worldly monks. Entries 40, 44, and 47, for example, condemn recluses *(tonsei no hito)* who are driven by self-attachment and concern for reputation.[67] Similarly, in *Shasekishū*, priest Mujū spends many lines decrying the ills of modern Buddhism, including certain recreant recluses:

[They] hear the name of "recluse [*tonseisha*], but do not know its reality. Year after year we can see an increasing number of people who escape the world" [*tonsei*] simply to get ahead in life and in spite of the fact that they have no religious aspiration at all. While in the world they are

nobodies without either fame or profit, but on entering the gate of the
recluse they now have both! So nowadays perhaps we ought to change
the character *ton* of *tonsei* and write it with a homonym so as to read
tonsei (to covet the world).[68]

Mujū's discussion of reclusion in terms of conflict between religious
aspirations and secular interests reflects a basic struggle in much recluse
literature as well as in the critical analysis of modern scholars. Recluse
literature has long been an area of keen interest for Japanese literary
specialists,[69] and, in the last decade or so, has similarly engendered
debate among western scholars.[70] Rather than rehashing the various argu-
ments analyzing the motivations in works such as Chōmei's *Hōjōki* (An
Account of My Hut) and Yoshida Kenkō's *Tsurezuregusa* (Essays in Idle-
ness), this section focuses on the deployment of recluse themes, includ-
ing the Seven Sages in recluse literature. The discussion concludes with
a brief analysis of the relation of reclusion literature to political power.
 Chiteiki (Account of the Pondside Pavilion),[71] the Heian period
precursor to later recluse literature, establishes many of the themes and
engages in the strategic deployment of Chinese models common to later
recluse literature. Written in Chinese in 982, *Chiteiki* fuses its author
Yoshishige Yasutane's (934–1002) two consuming interests—Chinese
learning and Pure Land Buddhism—with a description of his life of
make-believe reclusion on the outskirts of Kyoto. Yasutane's themes of
scholarship, religious devotion, appreciation of nature, and respect for
ancient exemplars are all symbolized by his dwelling and the commun-
ion with the past that occurs there. The pavilion keeps out the pollution
of the mundane world and, in its simplicity, facilitates a virtuous way of
living. The account begins with a lengthy description (nearly half the
text) of the destruction visited on all manner of residences commonly
built in the capital; for Yasutane, these structures do not possess virtue
and thus can bring neither fortune nor longevity to their inhabitants. In
contrast to the evanescent world where what is praised yesterday is
destroyed today, the private realm inside Yasutane's gate remains con-
stant because it is built on an attachment to the beauty of nature, devo-
tion to the Pure Land, and a feeling of connection to the Chinese past.
 A graduate of the National University, Yasutane served as a secretary
(naiki) in the Document Bureau of the Ministry of Central Affairs *(naka-
tsukasa-shō)*. While still a student he formed the Kangakue, a society to
praise Amida, recite the *Lotus Sutra*, and write Chinese poems on the
Pure Land. Like his model Bo Juyi, Yasutane believed that secular
accomplishments in literature might serve a religious function. However,
his skepticism of lay life eventually led Yasutane to take the tonsure and
move to Mt. Hiei in 986.

Before taking vows, Yasutane built a series of small buildings around the sizable pond that lent its name to the title of his essay. Along with a separate house for his wife and children, Yasutane constructed a western hall to enshrine an image of Amida, a two-story building to store his books, and an eastern pavilion for his private use. He planted bamboo for summer to the north of the pavilion and willows for the spring to the east; Yasutane also placed a window in the west wall so he could read by moonlight in the autumn.[72] Not planned merely to be harmonious with nature, Yasutane's pavilion is modeled after famous houses of the past; Yasutane mentions the lodging of Xiao He (d. 193 B.C.), a government official who lived at some remove from the capital, and the bright and spacious residence of Zhong Changtong, a figure of the second century.

Yasutane's recourse to the dwellings of Xiao He and Zhong Chang-tong signals the retrospective nature of the entire work. When in his pavilion, Yasutane professes no interest in the contemporary world. Every evening after eating, he enters the eastern pavilion, where he turns to his books and there meets a worthy ruler, a worthy teacher, and worthy friends—namely, Emperor Wen of Han, Bo Juyi of the Tang, and the Seven Sages of Wei. Wen is praised for his frugality and peaceful rule, Bo for his poetry and devotion to Buddhism, and the Seven Sages for their aspiration to reclusion even while serving at court.[73] In the case of the Seven Sages, Yasutane likely has in mind Ruan Ji, who served the Sima clan and Ji Kang, who was employed by the Wei court. Through these encounters, Yasutane claims to possess "the three enjoyments," an allusion to a line from *Lunyu* (16:5).[74]

Yasutane's reference to the Seven Sages as models of aspiration to reclusion while serving at court is important in several respects. First, because in his own life Yasutane surely felt the conflict between bureaucratic service and the desire for the scholarly life of the aesthete-recluse, in the Seven Sages he found a comforting example of the compatibility of these opposing desires. Assuming that he actually knew of the government service of Ji Kang and Ruan Ji and was not simply presupposing service or inventing it to better fit his own circumstances, the scholarly Yasutane may well have known that involvement in politics eventually led to Ji Kang's execution. If so, Yasutane suppresses this dire fact, thus preserving the Seven Sages as examples of successful government service combined with reclusive spirit. Second, the passage spells out Yasutane's hunger for and success in communion with these friends from the Chinese past. For educated and sensitive sinophiles such as Yasutane, the Seven Sages (along with the ubiquitous Bo Juyi) were not mere symbols for qualities of wisdom or agedness but were living presences who gave meaning and depth to their lives.

Kamo no Chōmei's *Hōjōki* of 1212 is often interpreted as a refine-

ment and expansion of Yasutane's *Chiteiki.*[75] Unlike Yasutane, Chōmei avoids references or comparisons to Chinese figures. Only the perennial Bo Juyi rates even a subtle allusion, that coming when Chōmei mentions playing the *Pipa jing* or "Lute Song" (one of Bo's best-known works) on his own lute *(biwa).* In the manner of much *waka* on reclusion, Chōmei internalized the experience of the aesthete-recluse and apparently saw little need to point out the Chinese progenitors of such behavior.[76] Yet, in many ways, Chōmei styles himself after the great Chinese recluses so well known to Japanese literati. The opening sentences of the work tell how Chōmei's rejection of society was conditioned by the natural disasters and political turmoil of his day. Reminiscent of the paradigmatic Daoist immortals in *setsuwa,* Chōmei wears clothes woven of wisteria fiber and eats berries and nuts. In the manner of Ji Kang, Chōmei is devoted to his *qin:* he goes so far as to play the instrument in harmony with the sound of the wind in the pines—the sine qua non of refined Chinese eremitism. In the manner of the Seven Sages and others, Chōmei champions the companionship offered by intimate communion with nature. Chōmei's close friendship with the sixteen-year-old son of the nearby caretaker may echo the male love associated with three of the Seven Sages.

Although they are never mentioned, throughout *Hōjōki* one feels the presence of the Seven Sages or, at least, many of their values. Chōmei's enthusiastic embrace of eremitism—so strong that he concludes by noting the irony of his attachment to nonattachment—represents perhaps the purest Japanese expression of the values of self-cultivation associated with the hermit's life outside the strictures of human society.

In contrast to *Chiteiki* and *Hōjōki,* the breadth of its subject matter and the entirely worldly life of its author make *Tsurezuregusa* an unlikely example of recluse literature. However, Kenkō's discussion and development of many of the themes central to the earlier texts explain its inclusion among the prime examples of *inton no bungaku.* Yoshida Kenkō (ca. 1283–ca. 1352), descended from a family of Shintō priests and one of the noted court poets of the early fourteenth century, became a Buddhist priest in 1324 and wrote *Tsurezuregusa* about six years later. Although Kenkō never retired from life in Kyoto, the pose of the detached literatus idly jotting down thoughts recalls the creative privilege of the recluse. Moreover, Kenkō's mood of nostalgia, brought on by a keen sense of life's transience, combined with an active affirmation of life, particularly the positive interest in how to create a life worth living, recalls the mixture of pessimistic withdrawal and sanguine eremitism characteristic of Yasutane and Chōmei. Despite Kenkō's delight in contradiction, denouncing things of this world in one passage only to champion them in the next, in *Tsurezuregusa* he consistently advocates eremitism as a means of freeing

oneself from mundane distractions and thereby increasing one's aes-
thetic sensitivity.

Kenkō's praise for reclusion spent in the pursuit of scholarly pas-
times reads as an evolution of the values championed by Yasutane and
Chōmei. First, although the hermit's dwelling does not occupy a central
position (or appear in the title) as in *Chiteiki* or *Hōjōki*, nonetheless,
Kenkō includes several passages that imply its importance. In section 10,
Kenkō states that "A man's character, as a rule, may be known from the
place where he lives."[77] The following section discusses a lonely looking
hut, its impressive appearance marred only by a fruit-laden tangerine
tree. Second, Kenkō defines the admirable man as one who excels at Con-
fucian scholarship, Chinese and Japanese poetry, music, etiquette, and
penmanship, as well as possessing a fondness for wine.[78] In a section high-
ly reminiscent of *Chiteiki*, he describes the pleasures of the scholar's life
in retirement: "The pleasantest of all diversions is to sit alone under the
lamp, a book spread before you, and to make friends with people of a
distant past you have never known."[79] Kenkō then specifies four Chinese
works—*Wenxuan*, the collected works of Bo Juyi, and the writings of
Laozi and Zhuangzi—as those books he prefers.

As Kenkō makes clear, a key function of reading such literature is the
opportunity to communicate with famous men ("friends") from Chinese
antiquity. In his own writing, Kenkō uses references to Chinese models
as a way of connecting present and past. To stress the rigorous purity of
the true recluse, Kenkō recounts the story from *Mengqiu* (no. 145) in
which Xu You, who had long been living without any possessions, re-
ceives a "sounding gourd" *(narihisago)* to help him scoop water. Dis-
tracted by its noisy rattle when he hangs it on a tree, Xu discards the
gourd and reverts to scooping water with his hands.[80] If the true recluse
possesses purity of spirit marked by freedom from worldly entangle-
ments, he still maintains several positive attachments. Love for the beauty
of nature is one such attachment—a point Kenkō makes by quoting Ji
Kang's line, "The heart rejoices to visit mountains and lakes and see the
birds and fish."[81] Kenkō then adds, "Nothing gives so much pleasure as
to wander to some spot far from the world, where water and vegetation
are unsullied."[82] The Seven Sages, in the person of Ji Kang, are pressed
into a new role as paradigms for the appreciation of nature.

Another attachment characteristic of the aesthete-recluse is the desire
for communitas, manifest in communion both with like-minded men of
one's own era and with those of the past. Again a Chinese exemplar, spe-
cifically Ruan Ji of the Seven Sages, is deployed as a model for the
recluse who enjoys the pleasures of socializing while avoiding its pitfalls.
After despairing the waste of time caused by endless chatting and rejoic-
ing in the pleasure of conversation with kindred spirits, Kenkō cites

Ruan Ji's "brown eyes of welcome" displayed to men he liked.[83] Given the reputation of the Seven Sages as archetypes for the art of "pure conversation," Ruan Ji is a natural symbol of conviviality.

In light of the valorization of Ruan Ji and, by extension, the Seven Sages, as paragons of admirable qualities such as judicious sociability, love of nature, and wisdom, it is worth noting that Ruan Ji was not universally seen as an appropriate role model in Japan. One generation older than Kenkō, the Pure Land reformer Nichiren (1222–1282) employs Ruan Ji as an example of how evil events in the past can cause disasters in the present. In *Risshō ankokuron* (Establishment of the Legitimate Teaching for the Protection of the Country) of 1260, Nichiren writes that although Ruan Ji was talented, the imitation of his wild manner and appearance by young aristocrats led to the downfall of the Jin dynasty.[84] Nichiren's conclusion is historically suspect, but his disapproval of Ruan Ji suggests that, by at least the Kamakura period, Japanese writers were aware of the historical dimensions of the Seven Sages as models for Jin period aristocrats. Moreover, although Nichiren acknowledges Ruan Ji's talent and heterodoxy, he is quite willing to censure these qualities because of their deleterious consequences. The Japanese adaptation of the Seven Sages was flexible enough to accommodate their function even in an admonitory fashion.

Both individually and collectively, *Chiteiki, Hōjōki,* and *Tsurezuregusa* provide evidence of the complex relations between reclusion ideology and political power. In sum, this recluse literature implies a critique of the normative social order by positing the corrective world of the recluse. Although the authors of these works were members of the aristocracy, all three men were marginalized from the center of power by their birth, political events, or even by their religious feelings. Moreover, as Michele Marra argues in *The Aesthetics of Discontent,* the authors of *Hōjōki* and *Tsurezuregusa* (and we may add *Chiteiki*), through the championing of reclusion and rejection of society, suggest an "alternate space" and a "counterideology to power." Yet, if these key texts of recluse literature offered an implicit critique of the dominant culture and its political leadership, why were these texts not only not censured by the political authorities, why were they held in such high esteem by the very culture whose values they criticized?

There is not sufficient space here for a rigorous political reading of recluse literature, but two points—which have implications for Chinese hermit painting in the Momoyama period—merit brief discussion. First, and rather generically, the criticism implicit in recluse literature was tolerated and even praised because it provided an outlet for feelings that many felt strongly but few could voice safely. The quietly critical voice of the iconoclast hermit provided a necessary safety valve in a society where

silent acquiescence was the rule. The criticism implicit in recluse litera-
ture thus served as a type of social conscience.

Second, and much more specifically, the social criticism inherent in
recluse literature was acceptable because it was implicit rather than ex-
plicit and, essentially, constructive rather destructive. To varying degrees,
Yasutane, Chōmei, and Kenkō construct the world of the hermit not as a
replacement for the normative social order, but as a compatible and in-
structive alternate order. This is achieved by emphasizing the hermit's
world as representing a type of liminal experience where, divorced from
mundane concerns, recluses engage in appreciation of good friends
(even if these compatriots lived in China a thousand years earlier), devo-
tion to the beauty of nature, and the creation of music or literature, all
while living in the simple elegance of a pavilion or grass-thatched hut.
Because of the emphasis on aestheticism, this type of reclusion posed no
real threat to the normative social order.

The final evidence of the political ambivalence of the eremitism in
recluse literature is provided by the writers' statements on the compati-
bility of reclusion with life in the capital. In *Chiteiki*, Yasutane creates a
private world of the recluse that exists parallel to the world of the gov-
ernment official. Content as a humble but sincere official, Yasutane states
that he neither wants to curry favor at court nor suffer the hardships of
life in the mountains. In short, he advocates the "middle reclusion"
championed in Bo Juyi's sole poem on eremitism.[85] In contrast, in *Hōjōki*
Chōmei chooses to leave the world and live wholly as an aesthete-recluse.
The opening sections of *Hōjōki* contain a compelling critique of society,
implying that the present disorder is attributable to poor political leader-
ship. Despite his renunciation of secular society and location of the
world of the recluse in nature, Chōmei never preaches that others should
follow his path. By stating "I do not prescribe my way of life to men
enjoying happiness and wealth,"[86] Chōmei allows most readers of *Hōjōki*
to experience vicariously the life of the hermit without implying that
they should follow him. Finally, Kenkō's *Tsurezuregusa* reestablishes the
realm of the recluse within the realm of political order. Reclusion, an
ideal for Yasutane and a reality for Chōmei, becomes a pose for Kenkō.
This is not to say that Kenkō did not believe in the benefits or the beauty
of aesthetic reclusion, but rather that he saw it as efficacious, part of the
required cultural wardrobe of the ideal courtier. By returning reclusion
to the court, Kenkō suggests an "enlightened center."[87] By acting like a
recluse or even pretending to be one on occasion, the political leader can
absorb those qualities that help create a more enlightened rule. Far from
suggesting a rejection of the normative order, Chōmei posits the values
of reclusion as a salvation of that order.

The political dimensions of aesthetic reclusion suggested by Yasu-

tane, Kenkō, and Chōmei have obvious ramifications for the Momoyama
period pictures of Chinese hermits painted for military men, aristocrats,
and powerful priests. Before moving to these paintings and to the func-
tion of the aesthetics of reclusion in Momoyama culture, a brief analysis
of two genres of medieval poetry will demonstrate important develop-
ments in the function and formalization of recluse ideology as well as
the creative deployment of the Seven Sages and the Four Graybeards as
models of eremitism.

The Formalization of Reclusion Ideals and Models in Gozan Poetry and Renga

In the two new forms of medieval poetry, "linked verse" (renga) and
the Chinese verse written by Zen priests, we can first observe the ritual-
ization of reclusion that eventually led to the ersatz eremitism of the tea
ceremony and, moreover, we can detect a new emphasis on the Seven
Sages and the Four Graybeards that will ultimately manifest itself in
painting. Although renga and Chinese poetry by Zen priests (hereafter
called Gozan poetry, the poetry of the major Zen temples or Gozan) draw
upon very different literary traditions, they share a thematic interest in
eremitism. The celebration of the ideals of aesthetic reclusion is readily
apparent in the Gozan poetry to which we turn first. The remainder of
this section analyzes the more subtle expression of the eremitic experi-
ence in renga composition and theory.

In the Muromachi Gozan community, the fascination with Chinese
culture and, specifically, the ideal of aesthetic reclusion was largely man-
ifest in the painting and poetry that has refined reclusion as its dominant
subject. The increased attraction of reclusion is apparent in the many
"poem and painting scrolls" (shigajiku) that take the scholar-recluse's
ideal studio (shosai) as their poetic and pictorial theme.[88] While the
reasons for the imaginary escape offered by literature and painting are
rooted in the Japanese political and social experience, the means of that
escape are found in a reexploration of Chinese forms and subjects.[89]

Gozan poems and pictures on reclusion reveal the manifold desires
for retreat to the elegant hermitage, refuge in the cleansing beauty of
nature, retirement into the realm of scholarly achievement, and return to
the world of Chinese culture. In its intent, the reclusion of Gozan priests
can be summarized as partly the sincere desire for world rejection and
partly a pose intended to convey status. As such, this reclusion expresses
the contradiction of detachment and attachment that characterizes the
recluse literature discussed above and is a key feature of the Momoyama
period eremitism ritualized in the tea ceremony and visualized in paint-
ings. On one hand, Gozan priests sought escape from political turmoil

and social responsibility by retreating to the ideal world of the aesthete-recluse as represented by the conflated images of the hermit locked in the purifying embrace of nature and the sinophile scholar adrift in the elegant and elite fantasy world represented by Chinese culture. On the other hand, these priests wished to preserve such positive elements of their existence as the familiar sights and sounds of Japan, as well as the friendships and comfortable status gained as priests. This inherently contradictory reclusion could only exist in the imagination and, thus, could only be resolved in fictive creations such as poetry and painting.

Although these poem and painting scrolls of ideal studios are Chinese in their verbal and visual language, Chinese subjects generally are present only in poetic allusion to continental archetypes. Often, the poems compare the Japanese hermitages to such paradigmatic Chinese retreats as Wang Wei's (699–759) Wangchuan Villa and Su Dongpo's Snow Hall. While these painted and poetic descriptions of idealized hermitages indicate the importance of the recluse fantasy in Gozan culture, another manifestation of this phenomenon is the plethora of poems, and even a few extant paintings, that take lofty Chinese scholars and recluses as their subject.

The evidence of extant Muromachi paintings suggests that, among poet-recluses, the favorite pictorial subjects for Gozan priests were Tao Yuanming, Li Bo, Du Fu, Su Dongpo, and Lin Hejing.[90] The poetry of the priest Ikkyū (1394–1481) suggests a similar set of Chinese exemplars.[91] While the exact implications of these paintings and poems vary from support of Confucian ideals to homoeroticism, most invoke the world of aesthetic reclusion, where Chinese poet-recluses drink wine, stare at the wonder of nature, write poetry, play music, converse with friends, or simply live in stylish hermitages. Likely it is the very breadth and intensity of the Japanese desire to recreate on their own soil the world of the aesthete-recluse that explains their tendency to present not only bona fide poet-hermits such as Tao Yuanming and Lin Hejing in the garb of the aesthete-recluse, but to transform Li Bo, Du Fu, Su Dongpo, and Zhou Maoshu into similarly worthy models of cultured withdrawal.[92]

For would-be Japanese recluses, continental exemplars—whether real or manufactured—provided valuable precedents for the conflation of eremitism and literati pastimes. As the subjects of poems and paintings, Chinese hermit-scholars were idealized archetypes onto whom Gozan priests could project themselves. Just as literati-priests imagined themselves to be the residents of the studio-hermitages described verbally and visually in pictures of ideal studios (shosaizu), so too these priests likely imagined themselves as incarnations of Tao Yuanming, Li Bo, or Lin Hejing, passing their days pleasantly picking chrysanthemums, viewing waterfalls, or dreamily writing poems from an elegant retreat. In the

same way that ideal studios are represented in rather generic form
despite their specific titles, these paradigmatic Chinese hermit-poets are
usually interchangeable in personal appearance; they are recognizable
by a characteristic activity (such as viewing a waterfall) or symbol (such
as the flower they admire), but are anonymous in their uniformly saga-
cious countenances. It is precisely this impersonality that allows them to
function so efficiently as emblems of aesthetic reclusion.

The best gauge of the popularity and conception of lofty Chinese
scholars in Gozan culture is found in the massive *kanshi* anthology mag-
niloquently titled *Kanrin gohōshū* (Collection of Literature of the Five
Phoenixes).[93] A 1623 compilation of Gozan poetry of the fourteenth, fif-
teenth, and sixteenth centuries, edited by Ishin Sūden (1569–1633), *Kan-
rin gohōshū* divides Chinese-figure subjects into five chapters. Chapter
57 includes several hundred poems on Buddhist deities, Zen patriarchs,
and famous laymen. Chapters 58 to 61, titled "Section on Chinese Fig-
ures" *(Shina jinmeibu),* provides a chronological Who's Who of Chinese
history, including roughly one thousand poems on figures spanning Chi-
nese mytho-history from the legendary culture-hero Shennong to the
Song philosopher Wang Anshi (1021–1086). Based on headnotes, it seems
that many of the poems were originally inscribed on paintings, particu-
larly fans.

The poems—almost all consisting of four seven-character lines—are
listed by subject, classified first by the name of the figure subject and
then subdivided by different activities or themes associated with the sub-
ject. Assuming that Ishin Sūden was even-handed in his choice of poems
(and he appears to have aimed for comprehensiveness), the number of
poems for each subject reveals its relative popularity among Gozan
priests. The content of the poems suggests how these Japanese authors
perceived and deployed these subjects.

The Seven Sages and the Four Graybeards appear in chapter 59,
which covers figures of the Han through Tang dynasties. The chapter
begins with poems on Han Gaozu, the Hongmen Banquet, and Zhang
Liang. After one poem on "Xia Huanggong Presenting a Letter," there are
ten poems on the "Four Graybeards of Mt. Shang," followed by three
poems on the "Four Graybeards Playing *Go*" and three on the "Four
Graybeards Returning to Court." Later in the same chapter, we find
seven poems on the Seven Sages of the Bamboo Grove and two poems
apiece for Liu Ling and Shan Tao. The Four Graybeards total seventeen
poems, and the Seven Sages tally eleven poems. By comparison, *Kanrin
gohōshū* includes sixty-five poems on Tao Yuanming (plus twelve on the
Three Laughers), fifty-one on Li Bo, nearly fifty on Du Fu, seventy-five
on Su Dongpo or his poems, twenty-one on Lin Hejing, and seventeen on
Huang Shangu. Among subjects with strong implications of Confucian

withdrawal, Xu You and Chaofu rate only two poems, while there are nineteen on Yan Ziling, a late-Han recluse who gave up his quiet life devoted to fishing in order to serve his childhood friend, the emperor Guangwu, then retired again.

The number of poems on the Seven Sages and the Four Graybeards indicates that among Gozan poets these subjects did not find the same favor as individual poet-recluses such as Tao Yuanming, Li Bo, and Su Dongpo. However, these numbers also show that the Seven Sages and the Four Graybeards enjoyed a limited popularity. The poems on the Seven Sages and the Four Graybeards are similar in many regards, and the majority are rather repetitive in style as well as in content. Stock epithets and phrases recur with numbing repetition, as the poets draw more on approved images than on their imaginations. Yet, it is precisely this generic quality that makes the poems useful in assessing how these figure subjects were viewed in Gozan culture.

The poems on the Seven Sages emphasize the white beards and wizened appearance of the men—descriptions that recall their mention (together with the Four Graybeards) in the *Heike monogatari* and their appearance in painting. Many of the poems also mention their drinking, reading, music making, and *go* playing. While this type of reclusion devoted to scholarly pastimes is seen as one example of the purity attributed to their way of living, several poems also describe the life of the Seven Sages as marked by *fengliu (fūryū)*. The term means something like "elegance" or "refinement" in Japanese, but in Chinese it is used to distinguish a person with a talent for letters and an unconventional life or someone who leads a dissolute life. It is entirely possible that all three meanings are intended in the description of the Seven Sages.

As for the Four Graybeards, the poems in *Kanrin gohōshū* reveal that Gozan priests were familiar with the two major facets of their story, with an equal number of poems on their playing *go* and on their return to court. The poems on the Four Graybeards' Return to Court frequently compare the crown prince to a young bird, and the Four Graybeards to nurturing adult birds. Thematically, the poems emphasize the moral integrity of the Four Graybeards, stressing the righteousness of their return to the Han court. Most of the ten verses on the Four Graybeards similarly express admiration for the sages' role in restoring righteous government.

Poems on the Four Graybeards Playing *Go* emphasize the lofty detachment of the men, seeing them as models of world rejection. In most of these poems, the political role of the Four Graybeards is not mentioned explicitly, but this aspect of their story seems implicit even in verses on their lives in retirement. Although not included in *Kanrin gohōshū*, a four-stanza Chinese poem written in 1467 by the Rinzai priest

Ōsen Keisan (1429–1493) describes a now lost or unidentified *fusuma* or screen painting of the "Four Accomplishments" *(kinkishoga)*, and includes a reference to the Four Graybeards. The work begins with a stanza describing the sound of the *qin* harmonizing with the wind in the pines. The somewhat cryptic third and fourth stanzas refer to the calligraphy *(sho)* and painting *(ga)* components of the theme.

The second stanza concerns playing *go,* and it is in this context that the Four Graybeards appear. Keisan writes:

> Unmoved by the rise or fall of worldly affairs,
> Mountain sages, silhouetted against the sunset, intently
> playing their game.
> The young prince has called the sages from Mt. Shang,
> Beware lest the clatter of the[ir] *go* game be heard
> beyond the hermit's world.[94]

Although the painting seen by Keisan seems to show the Four Gray-beards in retirement playing *go,* the third line of the poem links their retirement on Mt. Shang to their subsequent return to serve the crown prince Huidi at court. The poem directly links the playing of *go,* and by extension all the gentlemanly accomplishments, with the political detach-ment of recluses, who are unmoved by worldly affairs. Yet, by connecting the sages' retirement to Huidi, we may well interpret the Graybeards' time in retirement—and all devotion to scholarly pastimes—as one basis for political legitimation.

The two contradictory implications inherent in the Four Graybeards story are clearly manifest in these medieval Japanese poems. That Momo-yama paintings should similarly dilate on these themes, with similar political implications even in scenes of reclusion, shows continuation of themes expressed in Gozan verse.

Different from Gozan poetry in form and subject but not in underly-ing content is *renga.* As with *waka,* with which it coexisted as the favored verse forms among medieval aristocrats, rules of *renga* composition for-bade reference or even allusion to Chinese figures.[95] However, because theoretical essays by several *renga* poets make reference to famous Chi-nese figures, we may be sure that most *renga* poets were well versed in Chinese traditions, including the aesthete-recluse.[96] Most important, in both content and context, *renga* demonstrates a formalization of the ere-mitic experience, as the activities, mood, and environment associated with aesthete-recluses are deployed as a conventional topic, aesthetic sensibility, and physical location of this verse form. The act of making *renga* was not simply the recording of the aesthetic-reclusion experience, the setting down in verse of the hermit's interaction with nature, his intercourse with friends, or communion with exemplars from the past.

The process of creating *renga* suggested the temporary physical embodi-
ment of such a life. It is in this capacity as a recreation of, and substitute
for, actual aesthetic reclusion that *renga* sets the stage for the develop-
ment of *wabi*-style tea.[97] As such, *renga* links the traditions of recluse
poetry and prose detailed in this chapter with the culture of tea that is
the focus of the following chapter.

In the act of its creation, *renga* parallels the communitas characteris-
tic of aesthetic reclusion. With the exception of rare solo compositions
(*dokugin*), *renga* is a group production dependent on the social and
creative interaction of several poets. *Renga* demands a group conscious-
ness based on the equal participation of all members in pursuit of a com-
munal literary creation. Because this group creation is verbal, it is not
farfetched to think of a *renga* sequence as a documented form of the
"pure conversation" associated with the Seven Sages of the Bamboo
Grove. Because *renga* was typically produced by small groups of seques-
tered men, its practice led to the creation of specially furnished rooms
where practitioners would meet in an atmosphere evocative of a recluse's
retreat.

The importance of a proper atmosphere for the composition of *renga*
is evidenced by the *renga* poets' reference to the art as a *za*; literally, a
seat or place to sit, but also indicating a gathering or colloquy. In its
physical connotation, *za* usually indicated the newly developed *tatami*
room, an intimate and comfortable space in comparison to the tradi-
tional Japanese interior. *Za* was often used in the compound *ichiza*,
meaning one place, one time, one group—in short, a single experience.
For the creation of effective *renga*, the host of the gathering had to
choose not only a location conducive to writing poetry but also an appro-
priate time of day and a harmonious mix of participants. According to
the 1349 *Renri hishō* (Secrets of *Renga* Composition) by the early *renga*
master Nijō Yoshimoto, the proper *ichiza* must include a location with
an "appropriate view" of nature, a season or time of day when nature is
in flux, and poets with similarly quietistic temperaments.[98]

Informal *renga* gatherings were held either outdoors or at the resi-
dences or temporary accommodations of leading poets such as Shinkei,
Sōgi, Shōhaku (1443–1527), and Sōchō (1448–1532). We have no records
that indicate the appearance of these poets' residences, but from their
writings we know that *renga* poets conceived of their homes as "huts,"
typically referring to them as *io* or *iori*, *yadori*, and *sōan*.[99] These terms
were probably meant figuratively rather than literally. Yet, even if the
poet's hut is largely a trope, this metaphoric language demonstrates how
the guise of the aesthete-recluse had become the desired persona of the
renga poet. When the hut, long a symbol of privation and poverty, also
functions as the emblem of "refined taste and comfortable status,"[100] we

witness the apotheosis of the recluse-poet as a dominant symbol of cultural sophistication and accomplishment.

In keeping with the ideology of aesthetic reclusion manifest in the linguistic transformation of the poets' residences into hermits' huts, many *renga* sequences take the experience of the recluse as their thematic core. For instance, in the famous *Yuyama sangin hyakuin* (100 Verses by Three Poets at Yuyama), Sōgi, Sōchō, and Shōhaku met on an evening in the tenth month at the mountainous setting of Arima Spa to compose a poetic sequence that traces the evolving emotions of a hermit living in a mountain dwelling.[101] Throughout the sequence, the poets refer to the location of the poem as a *yamazato, yado, shiba no io* (brushwood hut), and *kusa no io* (grass hut). Similarly, the speaker of the sequence is called a *yosutebito* or recluse, *yamagatsu* or mountain person, and one who has "sleeves of moss" *(koke no tamoto),* a metonym for recluses or monks who wear dark robes. The verses describe the hermit's appreciation of the beauty of nature, his loneliness as well as intimate nocturnal conversations with a companion, and his attachment to the dwelling itself.

Renga represents two important stages in the development of aesthetic reclusion in medieval Japan. First, through the process of its composition, *renga* formalized the style of living associated with the aesthete-recluse, changing what had been first a literary ideal, and then the real experience of a few, into a socio-literary ritual practiced by many. Second, *renga* elevated and crystallized the values expressed in hermit literature into a theoretically defensible and practically applicable aesthetic construct that could then be disseminated back into the broader cultural milieu. Through *renga,* the ideal hermit was no longer a solitary or obscure figure but now an important social actor whose dwelling had become a status symbol and whose experience was now the subject of literature. The ideals of aesthetic reclusion manifested in *renga* practice and content are consistent with similar ideals expressed in *waka* and Gozan poetry, as well as in recluse literature. But more than just the literary evocation of the aesthete-recluse's life, the creation of *renga* poetry involved the actual embodiment of such an existence and, thereby, prefigured the tea ceremony. The evolution of ritual eremitism and its political ramifications in the ideology and practice of tea is the subject of the next chapter.

3.
Symbolic Virtue and
Political Legitimation
Tea and Politics in the Momoyama Period

IN THE PRECEDING SURVEY of the Seven Sages and the Four Graybeards in pre-Edo period literature, we have observed how some writers deployed the Seven Sages of the Bamboo Grove and the Four Graybeards of Mt. Shang in the service of discourse on aesthetic reclusion and politics, while others utilized them as exemplars of virtues as dissimilar as the purity of Buddhist detachment and parental wisdom. We also explored how aesthetic reclusion evolved from a relatively marginal theme in early Heian poetry to a central one in Muromachi *renga*, where the experience of the aesthete-recluse became not only a common literary topic but even the generic identity of the poet. The foregoing discussion of aesthetic reclusion, and its sometime models the Seven Sages and the Four Graybeards, largely avoided political implications; however, one salient feature of so-called recluse literature can be expanded to suggest a reading of images of aesthetic reclusion in the Momoyama period. Ancient Chinese scholar-hermits condensed so many different meanings, ranging from love of nature to rejection of the political status quo, that in medieval Japanese literature and art they were richly ambivalent. For those who controlled the government, literary or artistic discourse on the aesthete-recluse could represent a perfect alternative social order, the endorsement of which demonstrated the righteousness of their rule. For those on the periphery of political power, the same verbal or visual image might posit the ideal world of the aesthete-recluse as an implicit criticism of the normative political order.

This chapter explores some aspects of the nexus of politics and culture in the Momoyama period in order to establish the key factors that determined the creation and reception of paintings of the Seven Sages and the Four Graybeards. We focus first on the political theory of *kōgi*, or "public good," by which rulers sought to legitimize their political power through claims to virtuous behavior and cultural accomplishment. Sec-

ond, we examine the general theory of *chanoyu*, the tea ceremony, viewing it as a type of ritualized aesthetic reclusion. As a theoretical construct, tea posits a rejection of normative values and thus can serve as a critique of political power. Yet, when read within the context of *kōgi*, the practice of tea by military men may also suggest the legitimacy of their power. Before commencing with the analyses of *kōgi* and tea in Momoyama society, we return briefly to the Muromachi period in order to locate a historical precedent for the deployment of the eremitic ideal as a tool of political legitimation in the Momoyama period.

The Institutionalization of the Aesthete-Recluse in the Kitayama Epoch

In the age of the third Ashikaga *shōgun* Yoshimitsu (1358–1408), there developed one of the cultural watersheds in Japanese history. This so-called Kitayama epoch epitomized many of the values of the Muromachi period as well as engendered practices and institutions that were to mature in later eras. Most critically, Yoshimitsu turned the military government *(bakufu)* into a leading patron of the arts, a move designed to elevate warriors into a cultural elite equal or superior to aristocrats. One way of acquiring the knowledge necessary for cultural sophistication was the engagement of professional aesthetic advisors.

Literature of the late fifteenth century uses the term *tonseisha* or "recluse" for men who served as professional counselors on the arts.[1] One famous passage from *Taiheiki* describes how the Ashikaga warrior Sasaki Dōyo, forced by enemy troops to flee the capital, prepared the banquet room *(kaisho)* of his residence with precious ceramics and hanging scrolls, filled the guardhouse with choice food and drink, stocked the sleeping chamber with aloe-scented silk sleeping garments, and then "directed two *tonseisha* to remain behind, giving them precise instructions that 'if someone should come to this dwelling, greet him with a cup of wine.' "[2] When the invading commander was forced to retreat in the face of an Ashikaga counterattack, he repaid Dōyo's courtesy by leaving even more lavish gifts.

Tonseisha served as hosts at private parties, as well as at *renga* gatherings and tea competitions *(tōcha)*. By the Higashiyama epoch of Ashikaga Yoshimasa (1436–1490), *tonseisha*—notably the famous "Three Amis"[3]—were also employed as art connoisseurs, choosing, arranging, and cataloging Chinese and Japanese paintings, calligraphy, and ceramics in the shogunal collections. In the Muromachi context, the *tonseisha* was not only a man who had abandoned his social status but one who possessed superior training in the arts, as well as the ability to get along well with others. The use of the word *tonseisha* or "hermit" to des-

ignate men so intimately attached to other men, and to precious art objects, reveals much of the medieval conception of aesthetic reclusion and its co-option by the political center.

At the practical level, if nonmilitary men were to serve in close proximity with and, in some respects, as superiors to, high-ranking *samurai*, it was necessary for these men to claim a status outside the conventional social structure. By adopting the guise or merely the title of "hermit," the aesthetic advisor could instruct his superiors without threatening sacrosanct status relationships. Moreover, because the well-established characteristics of the aesthete-recluse—sociability, continental learning, and aesthetic sensitivity—were the same qualities desired in an aesthetic advisor, it made sense that the aesthetic advisor should take the title of hermit. Finally, and most important, the guise and title of hermit conveyed a level of cultural accomplishment superior to the hermit's employer in that *tonseisha* had the de facto meaning of *suki no tonseisha* or "aesthete-recluse."[4] When Sasaki Dōyo left behind a pair of *tonseisha* to entertain the military chief who invaded the capital, it was an explicit statement of Dōyo's cultural refinement and an implicit statement of his political legitimacy. In a similar fashion, when *shōgun* such as Yoshimitsu and Yoshimasa engaged the services of *tonseisha* or *dōbōshū* to serve at parties or to organize their art collections, the concomitant messages of cultural and political superiority would have been crystalline.

The patronage of *tonseisha* was an important aspect of the "cultural right to rule"[5] in which military men demonstrated that they were no longer pretenders to court culture, but masters of a culture that was arguably their own. Not merely a culture distinct from that of the aristocracy, the culture presided over by *tonseisha* was based on the rejection of many of the conventional values associated with political dominance. In short, patronage of the *tonseisha* proved politically efficacious in that the recluse-advisor stood for the rejection of power—a key plank in Confucian theory of the legitimation of power. The patronage of *tonseisha* by Yoshimitsu, Yoshimasa, and other Muromachi period military rulers thus foreshadows the role of tea in the subsequent Momoyama age.

"Public Good" and the Cultural Right to Rule in Momoyama

In the Momoyama period, political control was acquired through military power. But gaining power and keeping it were very different things. While military strength was essential to grasping the reigns of power, as John Whitney Hall has written, "Acquisition of legal authority and political legitimacy by the military hegemons was also a requirement, if only after the fact."[6] Max Weber's dictum, that every system of

authority attempts to establish and cultivate the belief in its legitimacy by the greatest number of means possible, is one key to understanding Momoyama culture.[7] For military hegemons, legitimacy could be sought by straightforward means of political tactics—such as occupying a legally constituted office—or by more subtle ethical and cultural strategies. In the later cases, the claims to authority were legitimized to the extent that the ruler could transfer his supposed personal characteristics into the public domain.

The salutary effect of mixing learning or cultural accomplishment *(bun)* with military skill *(bu)* is a basic feature of *samurai* culture.[8] Confucian ideas of ethical rule and self-cultivation are echoed frequently in the "house rules" of military clans. For instance, Chōsokabe Motochika (1539–1599), in items six to nine of his code, urges followers to practice humanity, righteousness, and propriety, as well as to develop their minds through the study of books and pursuit of the arts.[9] While Motochika's exhortations to his subordinates may have been meant sincerely, when a military leader claims to possess such characteristics, these qualities become part of the political rhetoric of *kōgi*. The ruler's invocation of benevolence and education are crucial to his claim to act on behalf of the "public good."[10]

In part, the submission to *kōgi* by *daimyō* or other warriors was a semantic reference to official position, as the term in the Heian and Kamakura periods designated ceremonies at the imperial and shogunal courts. More important, however, the primary force of *kōgi* was to allow the ruler to pose as a servant of the public good. Even in the Muromachi period, for a *daimyō* to establish himself as *kōgi*, he had to show that he was superior to his vassals. One way of showing superiority was through "ability" *(kiryō)*, defined in this context as the mix of peerless ethics with skill in military and political leadership. If a *daimyō* should fail to establish his superior ability, in theory his retainers were empowered to dissolve the lord-vassal relationship.[11] While individual *kōgi* units ruled their specific domains, they in turn were subsumed by the national *kōgi* embodied in the hegemon or *shōgun*. Implicit in *kōgi* is the idea that the group gives up its rights to the ruler but in return expects to receive virtuous rule from above. In its essence, the Confucian concept of *kōgi* presupposes the idea of a *kokka* (literally, "national family") or nation subservient to a benevolent ruler who governs in its interest and name.

Although an important aspect of Japanese political theory from the Muromachi period onward, *kōgi* gained increasing importance in the Momoyama era, when warrior hegemons attempted to consolidate power at the national level. Oda Nobunaga, for instance, took control of Japan by force of arms but made claims to legitimacy through *kōgi* by asserting that his regime was established in order to preserve the *kokka*.

Nobunaga's rationale for expelling the Ashikaga *shōgun* Yoshiaki was that the *shōgun* lacked "ability" and that only he, Nobunaga, could serve the public good. Through his lack of ability, Yoshiaki failed *kōgi* and thus was "disloyal" *(fuchū)* to the *kokka,* while Nobunaga's competence as a ruler proved his loyalty to the realm and thus earned the public's approval to rule. To use Nobunaga's own terminology, he served not the *kokka* but the realm or *tenka* (all "under heaven").

In the manner set forth in Confucian texts, Nobunaga conceived of *tenka* as not only the sphere of his political control but also as a universal principle embodied in the ruler.[12] Nobunaga frequently employed Chinese words and names to ground symbolically his rule in Chinese precedent.[13] Moreover, and more to the point, Nobunaga also deployed paintings—such as the compendium of Chinese legendary and historical figures that covered the walls inside Nobunaga's Azuchi Castle—to manifest his claim to possess the principles of legitimate rule.[14]

Hideyoshi's rise to supreme power in 1582 was accompanied by a new sophistication in the cultural expression of political legitimacy. For Hideyoshi, as for Nobunaga, the appeal to symbolic authority was rooted in the Confucian ideal of virtuous rule as manifest in *kōgi.* By demonstrating his goodness and righteousness, the hegemon had an effective means of locating his personal power within the larger traditions of political ethics and institutions. In a letter to the viceroy of India in 1592, Hideyoshi espoused his ostensible theory of political leadership in a country marked by civil strife:

> I gravely lamented this [disorder] from the time of my manhood and so gave thought and deep attention to the arts of self-cultivation and the problems of governing the country. Now I nurture the military men and show mercy to the cultivators with humanity, wisdom, and attention to defense. I have made justice correct. I have established security.[15]

Hideyoshi's own claims to self-cultivation manifest in his humanity and wisdom are greatly expanded in the writings of his subordinates. In *Tenshōki* (Record of the Tenshō Era), Hideyoshi's biographer begins by listing his subject's ten virtues: fidelity to superiors, justice to followers, bravery, compassion, righteousness, honesty, wisdom, authority, astuteness in inquiry, and charity in perception.[16] Hideyoshi's virtues—the ostensible basis for his political authority—are the characteristics of the ideal Confucian ruler. The comparison to virtuous Chinese sage-rulers was made implicitly by Hideyoshi's biographer and explicitly by Hideyoshi himself. In his famous 1588 edict proclaiming a national confiscation of swords, Hideyoshi justified his action by citing the precedent of the sage-emperor "Yao of China who pacified the realm and [then] used precious swords and sharp blades as farming tools."[17]

Hideyoshi's claims to virtue present a revealing view of symbolic legitimation in action. The recourse to symbol and metaphor creates a fiction that serves to disguise the real mechanics of political power. While in fact the ruler maintains order by means of power, in the fictive account he is the benevolent custodian of public peace, governing because of virtues such as humanity and wisdom. In the construct of *kōgi*, it is imperative that the ruler demonstrate his virtue even if only symbolically. It is in regard to the symbolic expression of virtue that both tea and paintings of Chinese figures play a critical role.

Virtue may be manifest through mastery or, at least, appreciation of the arts. In the tradition of *daimyō* and *shōgun* before them, Nobunaga and Hideyoshi's practice and patronage of the arts stemmed from genuine fascination mixed with the recognition that association with high culture implied a social preeminence useful as a sign of complete hegemony. Nobunaga's practice of *renga*, epitomized by a well-publicized exchange of verses with the poet Satomura Jōha (1527–1602), has led Donald Keene to conclude, "Surely the political and social functions of *renga* had never been more conspicuously displayed."[18] Hideyoshi's often strategic support of *renga* and *nō* drama equaled Nobunaga's acumen in using patronage and practice of literary arts as a sign of the cultural right to rule.[19]

Deployed as manifestations of cultural accomplishment, *renga* poetry and *nō* drama showed the learning of those who practiced or patronized them, but these arts could little demonstrate the precise nature of the patron's ostensible virtue. A much more direct and comprehensive expression of virtue is achieved through recourse to metaphors in which the ruler is likened to salutary exemplars of the past. Hideyoshi's comparison of himself to the sage emperor Yao in the sword edict is a good instance of this strategy. Yet, as suggested in the introduction to this study, paintings of Chinese-hermit themes such as the Seven Sages and the Four Graybeards offer both a far more complex and a more direct manner for conveying the patron's professed dedication to time-tested Confucian virtues such as devotion to scholarly pastimes, love of nature, desire for communion with other like-minded worthies, and detachment from worldly concerns. In the manner of hermit-theme paintings, tea provided a rich recreation of aesthetic reclusion. Precisely because tea was so dense in implications, the experience was widely sought and politically potent.

The Patronage of Tea

The breadth and depth of tea patronage is surely testament to its wide-ranging appeal and manifold role in Momoyama society. Tea was

practiced by all members of Momoyama society with the wealth suffi-
cient to build and stock a teahouse *(chashitsu)*, and time enough to en-
gage in tea gatherings *(chakai)*. More to the point, tea was virtually a
required avocation for any man who sought access to the highest levels
of Momoyama society or wished to style himself a person of impor-
tance.[20] Just as men of the medieval age desired the fictive mantle of the
tonseisha or hermit, Momoyama men sought the sobriquet of *chajin* or
tea adept. In the last decades of the sixteenth century and first decades of
the seventeenth, tea became a national sacrament. As such, it was avidly
pursued by Zen priests, wealthy merchants, aristocrats, and warriors
alike. The contributions to tea by merchants, particularly the connec-
tions of the Sakai merchants Tsuda Sōkyū (d. 1591) and Sen Rikyū to
Daitokuji, are well documented.[21] Similarly, tea was long supported by
aristocrats, from the Sumiya teahouse built on Mushanokōji in central
Kyoto by the courtier and *renga* poet Sanjōnishi Sanetaka (1455–1537)[22]
to the various teahouses built by Prince Toshihito (1579–1629) at Katsura
villa.[23]

For priests and aristocrats, tea was only one of several avenues of
cultural expression, but for military men, tea was the preeminent sign of
cultural accomplishment. In the words of Mary E. Berry, "The tea cere-
mony absorbed the military community and became its most common,
and competitive, form of entertainment."[24] As the mark of a cultured
gentleman-warrior, the acquisition and dispensation of tea vessels, as
well as the strategic hosting of tea gatherings, has been much analyzed
in Momoyama military culture. Nobunaga, for instance, confiscated tea
wares from defeated enemies or conquered cities, then gave much of this
booty to his generals as rewards.[25] Hideyoshi was noted for holding tea
gatherings after battlefield victories or to cement new alliances.[26] His
Grand Tea Gathering at Kitano in 1587 represents the hegemon's attempt
to consolidate his rule over the people of Kyoto by display of his accom-
plishments in tea. In the apt phrase of Louise Cort, "Hideyoshi con-
quered Kyoto with tea just as surely as Nobunaga did with fire and the
sword."[27] At the most mundane level, military leaders often employed tea
gatherings to bring together opposing camps and to create ceremonies
over which they, or their prestigious tea masters, could preside.[28] In
1585, upon receipt of the title of regent *(kanpaku)*, Hideyoshi, accompa-
nied by Rikyū, demonstrated his new status by serving tea to the em-
peror Ōgimachi (r. 1557–1586) at the Imperial Palace.[29]

While specialists in Momoyama history and scholars of tea have
dilated on the overtly political dimensions of the military patronage of
tea, the genuine understanding and appreciation of tea by military men
has often received short shrift. When we downplay the extent to which
samurai considered tea as a real or at least symbolic release from social

pressure, we are likely to overlook how the aesthetics of reclusion implicit in tea could serve as a subtle expression of the cultural right to rule. At the deepest level, tea became a potent symbol of social superiority only after its patrons could make a convincing claim to understand the rejection of normative social values which, as we shall demonstrate, are essential to tea ideology in the Momoyama period. Among all of the hegemon's potential assertions of political legitimacy based on cultural accomplishment, the most compelling claim to virtue is that which posits the rejection of the very power it seeks to hold. In short, the old Confucian ideal of political legitimacy based on virtue—that the man who can be trusted with power is the man who disdains power—could be neatly demonstrated through the practice of *wabi*-style tea, precisely because it is based on symbolic world rejection.

In the Momoyama period, tea was not merely enjoyed, it was employed as a tool of political legitimation. Yet, tea was a real avocation: an opportunity for temporary release from the myriad pressures felt by men working to maintain power or those struggling to gain it. At the same time, tea offered a means of advancing one's political interests. While men of all classes found useful tea's combination of aesthetic escapism and political pragmatism, for the military rulers who bore the real pressures of leadership, tea was indispensable. Among the many teamen *(chajin) samurai*, Hideyoshi provides a good model of the military tea adept who seems to have wrung from tea every drop of personal satisfaction and political advantage. In his important essay "Chanoyu and Momoyama: Conflict and Transformation in Rikyū's Art," Theodore Ludwig details how, for instance, during the late summer at the end of an enervating Kyūshū campaign, Hideyoshi hosted a number of intimate tea gatherings as compelling diversions from warfare. Held in small, *sōan*-style *chashitsu*, complete with simple flower arrangements and humble utensils, and including only two or three of Hideyoshi's closest tea advisors, these *chakai* had little direct political value; yet, this "aesthetic mode of life" must surely have refreshed the weary Hideyoshi.[30]

At his Osaka and Fushimi castles, Hideyoshi built a number of tearooms in different sizes and styles. The famous three-mat golden tearoom at Osaka Castle, which had been dismantled and taken to the Imperial Palace for Hideyoshi's tea with the emperor, served as a virtual display case of Hideyoshi's collection of "famous wares" *(meibutsu)*. Most tea gatherings were held in spaces such as the small Yamazato tearoom in the "mountain village enceinte" (Yamazatomaru).[31] At Fushimi Castle, built in 1594, the Yamazatomaru was greatly expanded—now including gardens, an artificial lake, arbors, moon-viewing platforms, *nō* stages, and two teahouses—so as to recreate the idealized countryside inside the castle walls.[32] The theme of "private cultivation in retirement"[33]

expressed at the Yamazato complex at Fushimi suggests the degree to which tea offered a real opportunity for escape into a physical and psychological space where the patron could forget the blood and bile of military and political battles as he enjoyed the pleasures offered by devotion to nature, scholarly pursuits, like-minded *chajin*, and the elegant beauty of the teahouse.

In the Momoyama period, men of position used tea both as a method of political manipulation and as a means of civilized escape in a brutalized age. Yet this simple dichotomy obscures the deeper and more subtle sociopolitical significance of tea; namely, that tea transformed the values of aesthetic reclusion into ritual practice, and this codified and commodified ersatz eremitism could be displayed—literally and figuratively—as a sign of ultimate cultural accomplishment that, in turn, helped legitimize those who held or sought power. By engaging in a ritual that inverts the normative social experience, the participants in tea gatherings could claim to possess that brand of Confucian political theory that posited the rejection of power as one key aspect of the right to rule. Just as the Greek historian Thucydides held that "Of all manifestations of power, restraint impresses men most," Momoyama political culture indicates that of all the ways of showing public virtue, the guise of the aesthete-recluse was the most impressive.

The Physical and Symbolic Structure of Tea

To understand the way in which political tensions could be expressed and ultimately resolved in tea, it is necessary to analyze the practice of tea in Momoyama in respect to its physical forms and their conceptual underpinnings. Tea was not a monolith but a living organism, which evolved into different and often hostile schools, each with its own practice, theory, and set of "sacred" texts. In form as well as function, the opulent *basara* tea of the mid-Muromachi was nearly as different from restricted *wabi* tea of Momoyama as *wabi* tea was different from the accommodating *daimyō* tea espoused by Kobori Enshū (1579–1647) in the mid-seventeenth century.[34] The evolution of tea corresponded to the requirements of its patrons, and it is no coincidence that *wabi* tea reached its zenith in the Momoyama period.

In *wabi* tea of the Momoyama period there is no single set of values or practices. The tea advocated by Rikyū in the 1570s and 1580s, and continued in the next decades by his conservative disciples, is different from that espoused between 1590 and 1615 by his apostate pupil Furuta Oribe (1543–1615).[35] Even Rikyū's own practice of tea for Hideyoshi varied dramatically. For instance, his tea gatherings for Hideyoshi ranged from the showy affair of 1585 in the glittering golden tearoom to the sub-

dued intimacies held beginning 1582 in the crepuscular Taian at the Myōkian.[36] Yet, despite variations in the forms and functions of tea gatherings, the dominant form of Momoyama period *chanoyu* was the *wabi* style, and its characteristic manifestation was the small, rustic *sōan* teahouse.[37]

Although each *sōan* teahouse had a unique design and each tea gathering had a distinct character resulting from its combination of guests, the vessels and art objects used, and the season, weather, or time, nonetheless we can distinguish an overarching style and ethos of *wabi* tea. The physical and symbolic structure of *wabi* tea discussed here is an ideal. No matter the ulterior political and economic motives that may have stimulated teamen to host or attend tea gatherings, when they crossed the threshold of the *sōan*, they entered into a make-believe world; when they lifted a bowl of tea to their lips, they partook in a shared fiction.

This ideal of *wabi* tea—the beliefs of the protagonists in this fictional world—is reconstructed from extant Momoyama and early Edo teahouses as well as from primary texts on tea. The following descriptions of *sōan chashitsu* reflect the design of standing Momoyama teahouses such as the Taian at Myōkian and the Karakasatei and Shiguretei at Kōdaiji. In addition to this physical evidence, several texts on tea allow us to enter the minds of tea adepts and trace their thoughts. The important texts of *wabi* tea include *Yamanoue Sōjiki*, the 1589 diary of Rikyū's contemporary Yamanoue Sōji (1544–1590),[38] and *Nanpōroku* (Record of Nanpō), the teachings of Rikyū as supposedly set down in 1593 by his disciple Nanpō Sōkei (dates unknown).[39]

Besides the writings of Rikyū's Japanese followers, Portuguese Jesuits living in the Kyoto area wrote lengthy and, perhaps, more objective accounts of tea. João Rodrigues, a fluent Japanese speaker with broad experience among the powerful Japanese of the Momoyama period, was well acquainted with several of Rikyū's followers. Rodrigues' long accounts of tea—found in his *Arte de Cha* and in the opening of chapter 35 in his *História*—demonstrate how thoroughly Rikyū's ideals of *wabi* tea had permeated Momoyama culture.[40]

Rodrigues' opening paragraph to chapter 35 in *História* presents a good summary of the aesthetic and conceptual core of *wabi* tea, which he, in Momoyama fashion, calls *suki:*

> Now everything used in the gathering—house, path, meal, utensils— must be adapted and matched to what *suki* professes, that is, the solitude and rustic poverty of a hermit. There should not be anything glossy or rich-looking; everything should be natural, comely, lonely, nostalgic, agreeable. Nature has endowed things with an elegance and grace which

move the beholder to a feeling of loneliness and nostalgia, and a discernment of these qualities constitutes one of the main features of *suki*.[41]

Rodrigues goes on to describe the planting of trees in the garden to achieve a feeling of natural artlessness. Then he lists the principle features of *suki* (or *wabi*-style tea) as cleanliness, rustic poverty, solitude, and awareness of subtlety. These qualities produce the qualities of modesty and integrity that, in turn, result in an affair where "the great nobles can mix with the lesser gentry without lessening their dignity thereby, for *suki* is a kind of rustic relaxation in the countryside."[42]

Rodrigues' account is valuable not only for the trenchant description of *wabi* but also for the analysis of how the artificially created effect of nature, with the implications of purity and world rejection, functions as a coy type of social rejection in which status distinctions are obscured even as they are preserved. As Rodrigues' description makes clear, the paradox of aesthetic reclusion—in which renunciation of society is achieved through attachment to values such as love of nature, scholarly pastimes, friends, and rustic beauty—is embedded in the very fiber of *wabi* tea. Tea embodies the antithetical values of world rejection and world affirmation characteristic of Momoyama culture.

Theodore Ludwig applies anthropologist Victor Turner's theories of ritual antistructure to *wabi* tea to show how it reduced conflict and promoted consensus in Momoyama society by positing a symbolic rejection of that society, which, in fact, allowed for its continuation. As a communal ritual that creates an antistructure where members of different social classes and ranks are temporarily made equal (or nearly so) in the pursuit of a shared experience, the tea gathering subverts the social order but, by doing so within the circumscribed context of ritual, serves as an outlet for social tensions.[43]

For Turner, the creation of a ritual antistructure—in essence, a temporary alternative social order—is based on liminality, communitas, symbolic poverty, display and veneration of sacred objects, and the secret rehearsal of a sacred history.[44] The *wabi*-style tea gathering presents an excellent model of ritual antistructure: the symbolic journey through the *roji* garden and entry into the *sōan* tearoom create a state of liminality in which the participants are cut off from the outside world; the tea gathering itself creates communitas, as the guests and host intimately engage in conversation and the drinking of tea; the small-scale, grass-thatched *sōan* is emblematic of poverty; the tea wares and scrolls used and exhibited serve as virtually sacred objects; and the discussion of venerable themes associated with the tea vessels and the calligraphy or painting scrolls hung in the *tokonoma* constitute the rehearsing of a venerable history.

It is precisely this symbolic density of the *wabi* tea experience that creates a multiplicity of potential meanings. For military leaders, the mask of the aesthetic hermit was a powerful expression of cultural accomplishment and thus an effective way of demonstrating *kōgi*. Yet, for those out of power, patronage of tea demonstrated a cultural right to rule equal to that of the military hegemons. Moreover, the relative leveling of social distinctions implicit in the ritual antistructure of *wabi* tea called into question the prevailing social order.[45] Because the symbolic antistructure of tea is also the informing concept behind many Momoyama hermit-theme paintings, it is useful to analyze in depth how Turner's concepts of ritual antistructure—liminality, ritual poverty, communitas, use of scared objects, and secret rehearsal of the past—inform the construct of aesthetic reclusion.

The ritual experience, for Turner, is defined first and foremost by the idea of liminality. Liminality refers to symbolic or actual behavior signifying separation of an individual or group from the normative social structure. In the liminal experience, the participant casts off his or her ordinary identity and takes on the "liberating mask" of a ritual actor. As such, the "liminar" is "divested of the outward attributes of structural position, set aside from the main areas of social life in a seclusion lodge or camp, and reduced to an equality with his fellow initiands regardless of their political status."[46] Although Turner is writing about West African religious ceremonies, he could be describing the ideals of tea in Momoyama Japan.

In ritual liminality, movement toward a new fictional status is conceived as a make-believe journey. If liminality is a state of passage, then travel is the perfect model for, or replication of, the liminal state. Turner finds liminality in rituals that take place in seclusion and, more obviously, in pilgrimages that remove the participant from everyday constraints even as they allow him or her to reenact (physically and symbolically) a sacred journey.[47] The tea gathering, with its preamble through the *roji*, begins with a ritual pilgrimage through nature as a prelude to seclusion in the *chashitsu*, where the ritual is performed.

The role of the *roji* in tea is similar to the natural setting of the Seven Sages and the Four Graybeards in Momoyama painting. By suggesting the liminality essential to ritual antistructure, the *roji* in tea and landscape setting in painting constitute a crucial element of aesthetic reclusion. Because no *roji* survive intact from the Momoyama period, we will have to base our analysis of the ideal on the *roji* as reconstructed from early-seventeenth-century *roji* and texts such as *Nanpōroku*. According to the *Oboegaki* (Memoranda) chapter of *Nanpōroku*, Rikyū first attributed positive values to this transitional space, and from his time the characters for "dewy ground" and "dewy path" were used.[48] The implication of

dew is the freshness and purity associated with water. *Nanpōroku* stresses that the *roji* should be watered just before the arrival of guests, during the break in the tea gathering, and again before the guests depart in order that it always be kept in a pristine state.[49]

The idea that the *roji* was a pure ground where the tea adept could be reborn aesthetically, if not socially and spiritually, is further evidenced by the likely entrance to many *roji*. Basing his opinion on diary accounts describing tea gatherings, Kumakura Isao has argued that many *roji* were entered through a type of small gate that resembled the "crawl door" *(nijiriguchi)* entrance characteristic of *sōan*. Passing through this tiny door produced the sensation of entering "a utopia conceived as another world in the mountains . . . , a place which, although in the city, gave the appearance of remote mountains and deep valleys."[50]

Inside the *roji*, a number of design features were employed to create the effect of a path leading to a hermit's hut deep in the mountains. Because *roji* were small, usually squeezed into an urban plot or within the precincts of a temple or castle enceinte, the *roji* designer had to deploy a variety of symbols to suggest a mountain wilderness. For instance, in order to traverse the few meters of most Momoyama *roji*, guests were often invited to slip into special *geta*[51] and even hold a "*roji* staff" *(roji tsue)*, an elegant version of the walking stick used when hiking in the mountains.[52] The stepping-stones *(tobiishi)*, deployed first in the Momoyama period, are likely meant to evoke a rocky mountain path, just as the "sleeve-brushing pine" *(sodezuri matsu)*—planted so close to the path that one brushes past it—suggests that the tea adept has penetrated deep into the mountains.

The most symbolically significant feature of the *roji* is the *tsukubai*, a low handwashing basin *(chōzubachi)* surrounded by several stones. In *Nanpōroku*, Rikyū is quoted as saying that the first act in the *roji* is to rinse one's hands to "wash off the stains of worldly dust."[53] The *tsukubai*, its name derived from the verb *tsukubau*, "to squat," is placed low so one has to bend down as if rinsing in a mountain stream.[54] With its obvious conflation of purification with the experience of nature, the *tsukubai* epitomizes the *roji*.

The forest of symbols found in the *roji* helps suggest the state of liminality essential to the ritual eremitism of tea. According to *Nanpōroku*, the great purpose of the *roji* is to wash away "worldly defilement" *(seji no kegare)* so that host and guest may meet mind to mind *(jikishin)*.[55] In short, the liminal path through nature is a prerequisite to communitas. Turner identifies two ways in which the emphasis on nature is critical to liminality: first, if social structure is the product of human culture, the emphasis on nature suggests a negation or erasure of social order; second, once freed from the shackles of social structure, nature serves to

"regenerate" the new status of the participant by suggesting alternative structures of life.[56] As a metaphoric journey through the mountains to a hermit's hut, the experience of the *roji* cleanses the tea adept of his worldly identification and prepares him for rebirth as an aesthete-recluse inside the *sōan* teahouse.

By creating artificial barriers and then passing through them, by adding symbols of natural purity and then acknowledging them, tea practitioners fashioned a highly artificial but effective evocation of the liminal experience of journeying through a mountain wilderness. If the gate at the entry to the *roji* symbolizes leaving the mundane world, garden shrubbery the mountain flora, and the *tsukubai* a limpid stream, then—in the make-believe world of tea—the *sōan* is the hermit's hut hidden deep in the wilderness.[57] As the movement through the *roji* is a ritual pilgrimage, the entry into the tea hut represents the culmination of the physical and metaphorical journey. Both the location of the tea gathering and its preeminent physical manifestation, the *sōan chashitsu* is the preeminent symbol of liminality as well as of the ritual poverty and communitas that lie at the heart of *wabi* tea.

In that liminality is a state of detachment from ordinary society, the entrance to most *sōan* teahouses makes clear the idea of rebirth into a new realm. Rikyū is generally credited with developing the *nijiriguchi* entrance that necessitates access to the *sōan* by crawling on one's hands and knees through the small opening. This highly contrived ingress to the *sōan*, reminiscent of the birth process, expresses the symbolic importance of the teahouse. Moreover, the small size of *nijiriguchi* meant that military men could not enter the *sōan* wearing their clearest emblem of status—their swords. Thus, a sword rack (*katanakake*) was placed to the side of the *nijiriguchi*. Although participants in tea gatherings certainly were well aware of the status of other participants, the divestiture of swords and symbolic rebirth engendered by the *nijiriguchi* point to the ideals of liminality and communitas characteristic of *wabi* tea. Key to both concepts is ritual poverty.

The liminal state enhances communitas in part by the importance accorded poverty. According to Turner, "Liminal poverty, whether it is a process or a state, is both an expression and instrumentality of communitas."[58] With neither the status qualifications nor possessions of men of power, impoverished men such as peasants, beggars, and hermits can easily be assigned the symbolic role of representing fundamental human values. Thus, to maximize the sense of communitas between participants in the ritual process, signs of rank or other status distinctions must be minimized or eliminated. Mimicking the condition of the poor is a simple way of denying the normative social structure and of creating the optimal conditions for communitas.[59]

Whereas in Turner's West African societies the most conventional symbols of poverty were the clothes of beggars or outcasts,[60] in the ersatz eremitism of *wabi* tea, the rustic *sōan* teahouse was the preeminent symbol of poverty and, by extension, of communitas. No matter the actual costs of *sōan* teahouses (which were very high indeed), the symbolic renunciation of wealth and concomitant denial of social status in this architecture provide the *wabi* tea gathering with a spirit of poverty that, in theory, allows tea men to meet as equals. By comparison, in the larger, more elaborate and multipart *shoin* tearooms favored by Kobori Enshū, the eremitic fantasy is a more distant memory, and the ideal of communitas is substantially compromised.

The definitive architectural manifestation of *wabi* ideals is the Taian teahouse, likely designed by Rikyū at Hideyoshi's request. After approaching along a simple path that serves to heighten the feeling of withdrawal from the mundane world, guests enter the Taian through a *nijiriguchi*. Once inside, guests find themselves engulfed in an other-worldly darkness and an almost impossibly small room. In total size, the Taian is four-and-one-half *tatami* mats, the standard dimensions for a *sōan*. Yet, because two mats are used for two one-mat preparation spaces and a half-mat is employed for the *tokonoma*, the space for the *chakai* is only two mats (less than two meters square). One of these mats includes a built-in charcoal brazier, further reducing the area available for sitting.

Inside the Taian, daylight becomes twilight. The only natural illumination comes from three small windows covered with paper on a bamboo lattice. Rather than seeking to offset the lack of available light, the treatment of the interior emphasizes the chill and desiccated mood. The walls, plastered roughly so that bits of straw emerge, include areas where the plaster is broken off to reveal the lattice infrastructure. The lowest portion of the walls is covered with paper *(washi)*, which sets off the rough surface above. In the same rustic vein, the supporting pillars are made of rough-cut, unfinished wood. The ceiling is constructed of a bamboo lattice with an infill of woven reeds, smoke-dried to increase the feeling of age. Only in a ritual where poverty is considered a virtue could such a tiny, dark, and aggressively humble interior be considered the pinnacle of aesthetic experience.

The defining feature of the Taian, and all other *sōan*, is the grass-thatched roof, from which this type of teahouse takes its name. The grass-thatched *sōan* is a recreation of the hermits' huts long championed in Japanese prose and poetry.[61] Just as the mountain location and humble materials of the hermit's hut indicated his detachment from mundane concerns, the artificial wilderness of the *roji* and the contrived (and costly) poverty of the *sōan* were designed to show the tea adept's ostensible rejection of society. In chapter 33 of his *História*, João Rodrigues

notes that in distinction to "ordinary social dealings," tea "is a secluded exercise in imitation of solitary hermits who have retired from social concerns."[62]

If the *sōan* is a type of fictionalized and aestheticized hermit's retreat, then the activity that takes place within it may be considered an equally imaginative brand of aesthetic reclusion. Of course, the practice of tea was always directly colored by political and financial considerations, and these worldly concerns were nowhere more apparent than in the collecting of tea utensils, ceramics, calligraphy, and painting to be used or displayed in the tearoom. Although very much commodities to be bought, sold, or taken by force if circumstances allowed, these artistic creations may also be considered as "sacred objects," the presence of which serves to bring together the participants of the ritual.

At the level of anthropological ritual, or "deep play" in Geertzian terms, the objects collected so avidly by tea adepts served as the regalia of an aesthete-recluse. This is not the place to survey Raku ware and the various other types of ceramics and utensils championed by Rikyū and his followers,[63] but suffice it to say that in general the same ideals of simplicity, naturalness, and seeming poverty that characterized the *sōan* applied to tea wares. Tea ceramics—at least as interpreted by professional masters such as Rikyū—concentrated the essential values of the *wabi* aesthetic into discrete objects. Treasured as "famous objects" *(meibutsu)* in catalogs and diaries, and venerated on the *tokonoma, chigaidana* (staggered shelves), or *daisu* (utensil stand) in teahouses, the paraphernalia of tea became one of its core attractions.

The ritual experience, for Turner, is distinguished not only by shared belief in sacred objects but also by the rehearsal of a sacred history. The gathering in the *sōan* is clearly the reenactment of the meeting of hermits, which had been venerated in Japan since the time of Ōtomo Yakamochi and the copying of the *Senzui byōbu* (fig. 1), and in China from the times of the Seven Sages and the Four Graybeards. Yet, as with ritual actors in many cultures, for tea adepts in late-sixteenth- and early-seventeenth-century Japan, it was not enough to recreate the activities of ancient models in routine or ritualized forms.

The experience of the originators of the eremitic tradition became more compelling when it was "represented in stereotyped or liturgical form."[64] Thus, calligraphy samples by, or paintings of, paradigms of aesthetic reclusion as diverse as Saigyō and Tao Yuanming became a standard feature of tea gatherings. As we shall see in the next chapter, paintings of the Seven Sages of the Bamboo Grove and the Four Graybeards of Mt. Shang may well have served as visual parallels for the ritual aesthetic reclusion of tea. Moreover, the creative acts of collecting artworks, studying them, and arranging them in the teahouse were akin

to the emphasis on scholarly pastimes associated with the aesthete-recluses of the past.

The *wabi* tea gathering was, above all else, an intimate and shared experience. While *chakai* before and after the late sixteenth century often involved groups of five or more men, *wabi* tea gatherings usually consisted of two, three, or four men, including the host—the *sōan* was designed to accommodate no more. As the preceding paragraphs have indicated, the tea gathering featured discussion of the various artistic treasures together with, in João Rodrigues' words, "peaceful contemplation of the things of nature."[65] While diaries reveal that tea gatherings were sometimes composed of political rivals or uneasy allies, if we are to believe texts such as *Nanpōroku* and *Yamanoue Sōjiki*, the conversation was intended to be as genteel as Rodrigues' indicates.

Besides conversation about some feature of the *roji* or a new scroll, the other primary activity of the tea gathering was the communal partaking of specially prepared libations. In addition to the thick tea, a light meal, even some wine, and a thin tea were often provided. Tea gatherings thus involved the intimate sharing of drink and food. In sharp contrast to tea in both earlier and later periods, the *wabi* style of Rikyū was based on the host carefully making a bowl of tea and then humbly proffering it to his guests. In the rustic intimacy of the *sōan* teahouse, the collective fantasy of the *wabi* tea ritual created the potential for communitas between the participants.

Conclusion

One key to understanding both the appeal of tea and of pictures of groups of Chinese recluses is the ideal of communitas. As evoked in tea and in paintings of the Momoyama period, communitas functions on two levels. First, it means the social communion of men as equals (if only at a symbolic or ceremonial level). Second, it refers to the cultural communion of Japanese elites with Chinese antiquity. Both aspects of communitas are central to Momoyama culture.

Turner distinguishes two basic types of social communitas: existential or spontaneous communitas and normative or ritual communitas. By existential or spontaneous communitas, Turner means the pioneering activities of prophets or gurus whose fellowship has no clear-cut utilitarian aims.[66] In time, the behavior of these figures is formalized into the normative communitas of some enduring structure such as a ritual. In this construct, the communitas of the Seven Sages or the Four Graybeards may be considered spontaneous,[67] while tea as formalized by Rikyū and others is an example of normative communitas. Because ritual communitas attempts to preserve, at the symbolic or ideal level,

the nonutilitarian nature of the spontaneous communitas experience, participants in rituals of communitas frequently look upon past models as paradigmatic.[68]

This is not to suggest that Rikyū had in mind the Seven Sages or the Four Graybeards as he fashioned *wabi* tea. Indeed, *Nanpōroku* contains no reference to these or any other Chinese figures. However, we do well to remember that according to early texts of *wabi* tea, Rikyū and others frequently likened the experience of the tea adept to that of the hermit. More important, in the Momoyama period, the warriors, priests, and aristocrats who were disciples of tea were also often the enthusiastic patrons of paintings of Chinese hermit subjects. And, while Rikyū's taste discouraged painting on the walls of the *sōan*, by the mid-seventeenth century, when Enshū encouraged wall painting in *shoin*-style tearooms, the Seven Sages and the Four Graybeards were among the themes frequently painted. For instance, the Seven Sages are pictured on *fusuma* in the Ninoma at the Nakashoin at Katsura villa (fig. 4), and at the Mittan tearoom at the Ryōkōin, Daitokuji (fig. 5), the Seven Sages and the Four Graybeards are painted on *kobusuma*.

The ritual process, in Turner's analysis, usually includes a "mythical or pseudo-historical account" of its utopian origins. Moreover, "Communitas is almost always thought or portrayed by actors as a timeless condition, an eternal now."[69] For part-time and would-be Japanese hermits of the Momoyama period, the locus classicus of ideal communitas was Chinese antiquity, and their pseudo-historical models were recluses such as the Seven Sages and the Four Graybeards. By recreating in tea gatherings and in pictures the imagined manner of living of these exemplars, powerful Japanese of the Momoyama and early Edo periods were able to effect a meaningful connection with the Chinese past. Just as Yasutane and Kenkō wrote about conversing with "friends" from Chinese history, tea adepts could temporarily become the modern equivalents of such aesthete-hermits.

When the experiences of communitas and liminality are converted into an institutionalized structure such as tea, the original or spontaneous experience becomes a model of behavior to be represented in "stereotyped and selected liturgical form."[70] The invocation of this exemplary past through symbols functions not so much to convey actual techniques but rather to express mnemonics or bodies of information about cultural values. As such, powerful mimetic symbols such as rituals, and paintings, not only reflect the ideals of a society but help create them.

Given the political turmoil of the Momoyama period and the popularity of tea among its elites, the communitas and liminality implicit in tea had a wide range of implications. Under normal circumstances, the antistructure created through ritual communitas may call into question

the political status quo or basic values of the society. In times of signifi-
cant social upheaval, however, the fictive ritual order may appear to be
the central and ordering structure.[71] In the Momoyama period, tea served
both purposes simultaneously. The ersatz eremitism of tea, along with
the models of reclusion provided by Chinese hermits, present an ideal-
ized alternative social structure in reaction to the political upheaval of
the century of civil war *(sengoku)* that climaxed in the Momoyama par-
oxysms of bloodletting and political subterfuge. In short, the make-believe
world of the hermit, whether invoked through the tea gathering or in
painting, provided a sustained, organized, and politically valent escape.
The precise political valence of each tea gathering or hermit painting
was dependent on the exact context, yet, with a few exceptions, it is
impossible to reconstruct the context of tea gatherings and paintings.
Moreover, it seems safe to say that the same *chakai* or same painting may
have been judged very differently depending on the individual. Thus, we
can offer only the general range of interpretations.

Whereas actual Momoyama society was ordered hierarchically, in
the ritual communitas of *wabi* tea the microcosmic society is a relatively
homogenous whole. Thus, while members of the ordinary social struc-
ture wear role masks appropriate to their station, in ritual communitas
all members wear the same mask and assume the same persona. The fic-
tive society of communitas is often presented as an egalitarian paradise
—a society of "free and equal comrades." Liberated from distinctions of
social rank, participants in communitas are free to become total persons.
Like the aesthete-recluses of history and art, they may engage in unfet-
tered connection with nature, the arts, and other like-minded men. How-
ever, even if these activities did not take place and if status distinctions
did remain at some level, tea gatherings still provided the fiction of such
an experience.

When the ideal of aesthetic reclusion was ritualized in tea, eremitism
became a paradigmatic antistructure. Although a metaphor for what is
outside of, or subversive to, ordinary social structure, aesthetic reclusion
coalesces the determined form of a ritual order. In this normative form,
eremitic ritual calls increasingly upon clearly recognized cultural models
to give it shape and meaning. These models could remain unvocalized,
like the deep structure of the tea ceremony itself, or they may be ex-
pressed in symbols. Because these symbols refer to specific cultural
models and assumptions, they are implicit rather than explicit. For their
implications to be understood, the symbols of tea, and the iconography
of hermit-theme pictures, must be read within the context of this ritual
antistructure. In the preceding pages, we have demonstrated how the
roji, sōan, and tea gathering are metaphors for the liminality and com-
munitas central to aesthetic reclusion. Another kind of symbol, as sug-

gested above, is provided by the pictures of recluses such as the Seven Sages and the Four Graybeards—pictures that frequently adorned the interiors of structures belonging to those who partook in the collective fantasy of tea.

As we shall see, Momoyama and early Edo period paintings of Chinese hermit themes may often have served as visible models for aesthetic reclusion. Pictures of the Seven Sages and the Four Graybeards, for instance, function as a visual liturgy to be read by all those who wish to participate in the ideal of aesthetic reclusion. While the tea gathering is a metaphoric recreation of the recluse experience, pictures of Chinese figures show the ideological context of such a ritual. Finally, when the once spontaneous or existential act of reclusion becomes the stuff of ritual and pictorial symbol, it no longer acts as a direct threat to social structure, but can be manipulated as a safeguard of the normative order. As the ritualization of aesthetic reclusion, tea—aided and abetted by hermit-theme paintings—serves the seemingly paradoxical function of subverting and preserving the political status quo. At the ritual or metaphoric level, eremitism is the escape from subordination, but the end result of such rituals and visual metaphors is the acceptance of that subordination.

4.
The Visual Structure of Aesthetic Reclusion
The Seven Sages and the Four Graybeards in Momoyama Painting

IN THE PRECEDING CHAPTER we observed how the characteristics of aesthetic reclusion formalized in *wabi* tea—communitas, liminality, appreciation of nature, symbolic poverty, and the rehearsal of a venerable history—may be used by those in power to suggest their cultural right to rule. We also suggested that many of the qualities that define *wabi* tea equally apply to paintings of Chinese scholar-recluses. Indeed, the fluorescence of *wabi* tea among the same patrons who commissioned pictures of the Seven Sages, the Four Graybeards, and other Chinese recluses suggests that painting and tea worked in tandem to express the ideals of aesthetic reclusion. In this chapter we demonstrate the specific ways in which aesthetic reclusion is manifest in these paintings.

Of the many ways to organize the analysis of a group of thematically linked paintings, this study employs one that is somewhat atypical. The rationale for adopting this organization, and the reasons for rejecting others, merit some explanation. Most traditional would be a chronological study in which we attempt to trace the development of the Seven Sages and the Four Graybeards themes. Because these themes increased dramatically in frequency in the third and fourth quarters of the sixteenth century, if we could recover and firmly date all paintings of our subjects, we would be able to comment meaningfully on their evolution. Perhaps we could determine subtle but important differences in these themes as painted during the times, for instance, of Nobunaga and Hideyoshi. However, given the tremendous destruction of many, if not most, large-scale paintings created in the Momoyama period, we do not have a large enough sample of works to conduct such a study. Furthermore, of the handful of surviving screen and *fusuma* paintings, most are undated. Even if we attempted such a chronology, our subsequent conclusions would be based on very shaky foundations.

Another approach would be to analyze our themes as interpreted by

artist and school. Because the Seven Sages and the Four Graybeards were painted by artists of almost all major Momoyama ateliers, it would be useful to determine if these schools had different interpretative stances. As we shall see, it is clear that some artists treat these themes with differences in form and, in a few cases, perhaps even in conception. However, since this book is concerned with broad meanings, we will note these variations but not organize our analysis around artists or schools.

Because our goal is to find the significance of the paintings in the context of Momoyama politics and culture, it would make sense to analyze the paintings by patron groups. If we could compare pictures of the Seven Sages and the Four Graybeards as made for military, priestly, and aristocratic patrons, perhaps we could find important alterations in theme or style that signal the particular values of one group relative to another. Again, the paucity of extant examples, especially among works created for military patrons, makes this approach difficult. Even more troubling is the fact that the original patrons of most screen paintings are unknown. Moreover, as noted in the introduction, it was not uncommon for *fusuma* panels to be transferred from their original location to the temples where they are found today. Although the *fusuma* at some temples were surely painted for that site, there are many examples of *fusuma* reported (accurately or apocryphally) to be from halls of the imperial palace or military fortifications.[1] The mobility of even these "architectural paintings" seems to indicate a high degree of shared values among the patrons of painting. This conclusion is bolstered by the fact that most major schools of artists—the Kano, Hasegawa, Unkoku, and Kaihō—fulfilled commissions for *samurai*, priests, and aristocrats alike. This evidence suggests that on the whole these paintings of the Seven Sages and the Four Graybeards express meanings that transcend the specific interpretations of individual artists or the particular status of the patrons.

The most direct way of understanding the thematic significance of pictures of the Seven Sages and the Four Graybeards is to analyze them in terms of the characteristics of aesthetic reclusion. After beginning with a brief analysis of the other politically valent Chinese-figure subjects, the discussion is divided into sections on communitas, scholarly pastimes, appreciation of nature, elegant rusticity, and the transformation of Chinese tradition manifest in the combination of figure subjects. While most of these thematic divisions are straightforward, the section on communitas will also explore the themes of homoeroticism and longevity connected to the pictorial combination of old men and young boys in sixteenth-century Japanese culture. Appended to the sections analyzing the visual expression of aesthetic reclusion is a discussion of style, which analyzes the implications of adopting various traditional modes of

painting, as well as the significance of painting in ink monochrome or color and gold.

This method seeks to elucidate the essential character of these paintings by placing them within the larger framework of aesthetic reclusion as understood and deployed in Momoyama culture. However, because this analysis examines the paintings largely divorced from the specific contexts of patronage and placement within a building, we conclude the chapter with a site-specific analysis of two important sets of paintings. With Kano Eitoku's long since destroyed *Seven Sages* and *Four Graybeards* screens at Azuchi Castle and with Watanabe Ryōkei's (d. 1645) wall and door paintings of *Four Graybeards Returning to Court* and *Xiwangmu Presenting the Peaches of Immortality to Han Wudi* in the Tai-mensho at Nishihonganji, we can begin to reconnect the thematic treatment of these subjects with their place and patronage.

Painting Power

The first Japanese manipulation of Chinese exemplars as symbols of the cultural right to rule predates the Momoyama period by at least six hundred years. The power and prestige of figures from Chinese history likely were first deployed in Japan when thirty-two pictures of Chinese sages *(kenjō no sōji)* were placed in the Shishinden (Hall for State Ceremonies) of the Imperial Palace early in the Heian period. According to *Konendai ryakki* (Short Imperial Chronicle), these imaginary "portraits" of Chinese sages from the Shang to Tang dynasties were positioned between the eighteen pillars that separated the inner building from the north aisle and, beginning in the reign of Yōzei (r. 876–884), were put up on ceremonial occasions as a background for the emperor.[2] The tradition of painting these sages continued until virtually the end of the Tokugawa period, when the last set of *kenjō no sōji* was brushed by Kano Eisen'in II (1730–1790) and Sumiyoshi Hiroyuki (1755–1811) in 1790.[3]

The physical and symbolic effect of the *kenjō no sōji* paintings was to place the Japanese emperor literally within a historical progression of Chinese sages. While the practice was adopted from Tang court ritual, where it seems natural enough, the unmodified deployment of Chinese symbols in Japan is contrived. In semiotic terms, the disparity between the signifier and the signified is distressingly large. As much as they may have wanted to think (or display) themselves as heirs to the Chinese pantheon of philosopher-kings, Yōzei and his descendants were no more the equivalent of Chinese sages than the Tokugawa *shōgun* were comparable to Confucius and his disciples—whose "portraits" they placed in a ceremonial chamber of *bakufu* headquarters.[4]

This type of comparison to Chinese models is direct, but it lacks sub-

tlety and complexity: we see that the Japanese rulers are comparable to the great continental exemplars, but we do not see why. We understand the ruler's claim to possess continental-style political benevolence, but the specific configurations of that virtue remain obscure. What is necessary to create a more convincing picture of virtue is to show its characteristics or, at least, its manifestations. One such approach is to display in painting the well-ordered society that results from proper rule. Pictorial themes such *nō-yōsangyō* (Agriculture and Sericulture) or even *rakuchū rakugaizu* (Scenes in and around the Capital) could suggest the results of good rule.[5] Somewhat more direct is the *teikan* (Mirror of [Good and Bad] Emperors) theme, a Ming dynasty subject introduced to Japan in 1598, which displays anecdotes associated with malevolent and, primarily, benevolent emperors.[6] *Teikan* paintings show specific examples of virtuous behavior, but we still observe manifestations rather than essences.

In these various pictures we witness virtuous acts, yet we have little sense of the configuration of the personality behind the behavior. The pictures thereby remain psychologically distant and obviously didactic. In that personal virtue is an important basis of the political concept of the right to rule based on public good *(kōgi)*, the convincing demonstration of that virtue is a critical component of art that seeks to legitimize political authority. It is as expressions of ostensible values—specifically, the symbolic rejection of power—that pictures of aesthetic reclusion express one essential feature of Momoyama culture. Pictures of Chinese recluses engaged in the characteristic acts of aesthetic reclusion differ from "portraits" of Confucian sages in that the hermit pictures physically demonstrate the nature of virtue. The expression of virtue in these pictures is not so much dependent on the viewer knowing the biographical facts of the subject but rather on the viewer being able to understand the thematic structure and content of the paintings. But the emphasis on aesthetic reclusion in pictures of the Seven Sages and the Four Graybeards was not an automatic manifestation of these subjects. The following survey of late Muromachi period paintings of these same subjects demonstrates the degree to which most Momoyama period pictures constitute a carefully constructed genre.

Pre-Momoyama Paintings of the Seven Sages and the Four Graybeards

Although relatively minor pictorial subjects before the Momoyama period, the Seven Sages of the Bamboo Grove and the Four Graybeards were painted at least several times in the century between 1450 and 1550. These pre-Momoyama works differ significantly from most images

of the Seven Sages and the Four Graybeards produced in the late six-
teenth and early seventeenth centuries in that the theme of aesthetic
reclusion, if present at all, is only a minor motif. The earliest image of
the Four Graybeards focuses on the imperial pageantry associated with
their return to court, while several late Muromachi paintings cast the
Seven Sages in the guise of Zen eccentrics.

We have already mentioned that both subjects were represented in
China from early times, with paintings—recorded or extant—dating
from the Song through the Qing dynasties. Although Toda Teisuke has
speculated that Japanese artists copied their pictures from Chinese pro-
totypes,[7] no Chinese paintings of the Seven Sages or the Four Gray-
beards are known in Japan before the Edo period. As indicated in the
discussion at the beginning of chapter 2, the Chinese treated the Seven
Sages and the Four Graybeards as entirely separate themes, never com-
bining them in word or picture. While our analysis of the two themes in
Japanese literature revealed that the two figure groups were paired in
the medieval war tales *Heike monogatari* and *Soga monogatari*,[8] the first
Japanese paintings of the subjects treat them independently.

The earliest extant Japanese painting of the Four Graybeards is a
little-known pair of six-panel screens now in the Hōryūji Treasure House
at the Tokyo National Museum. According to the museum label, these
polychrome paintings on silk likely date from the fifteenth century. The
screens are also called *Shariden byōbu*, because they supposedly came
from the Relic Hall (Shariden) at Hōryūji.[9] The left screen illustrates
Wenwang Summoning Taigong Wang and the right depicts the *Four Gray-
beards Returning to Court* (fig. 6). The story of the Four Graybeards
Returning to Court *(shikō raichō)* was known in Japan at least from the
time of *Kara monogatari* (ca. 1200). In the version offered there, the Jap-
anese author adds a comparative reference to Taigong Wang, telling how
after being summoned to court, he had no thought of returning home.[10]
Indeed, the two themes share the basic story of recluses returning to
court and thus may easily be construed as Confucian parables of politi-
cal withdrawal and subsequent return to service.

With no knowledge of the artist, and no real certainty about patron
or context, it is difficult to speculate on the specific function of these
screens. However, we can make a few tentative if obvious conclusions
about their meaning. First, the panels demonstrate that artists and
patrons had enough knowledge and interest in these themes to paint
them in a large and expensive format. In short, they were thought to be
important. Second, as the pairing of the stories in *Kara monogatari* indi-
cates, the common Confucian theme of service to a righteous govern-
ment probably explains their primary significance here. In both paint-
ings, the pomp and elegance of court is emphasized over the solitude and

simplicity of life in reclusion. The scenes are composed largely of stately processions in which carriages, horsemen, and an entourage of attendants accompany the returning scholars.[11] In the *Four Graybeards* screen, the action begins with the Graybeards emerging from an elegant pavilion on snowy Mt. Shang at the (viewer's) far left; in the second panel, they play *go* in a stylish pavilion overlooking the water; the third panel shows a boat arriving at the shore; in the fourth panel, they proceed by horseback through an exotic landscape; the fifth panel constitutes the climax, in which the Graybeards are presented at court; the empty main hall of the palace is seen in the sixth panel. At first glance, the large number of courtiers and attendants makes it difficult to pick out the Four Graybeards who approach the palace, accompanied by a man who may be Zhang Liang. One would have to know the story well to realize that the quartet of white-haired men represents the Four Graybeards.

The emphasis is on courtly elegance; the scant attention to life in reclusion seen in these colorful panels presages polychrome-and-gold paintings of the Momoyama and early Edo periods that show the Four Graybeards at court and pair them with other pictures of court activities. This chapter's concluding discussion—on the wall paintings of the *Four Graybeards Returning to Court* and *Xiwangmu Presenting the Peaches of Immortality to Han Wudi* (figs. 27 and 30) at the Taimensho of Nishihonganji—suggests how the combined use of lavish material and presentation of historically unrelated themes create an idealized image that may function as a generic expression of aesthetic reclusion, but which, depending on the context, may also carry specific political connotations. Related Kano screens include the *Four Graybeards Returning to Court* paired with *Minghuang and Court Ladies*,[12] or with the *Wind and Water Cave* (fig. 14).[13] Kano Sanraku's (1559–1635) famous screens at Myōshinji couple *Wenwang Meeting Taigong Wang* with the *Four Graybeards Living in Retirement* (fig. 13).[14] Both scenes take place in nature rather than at court; but, in the case of the Graybeards, if Sanraku had included Zhang Liang inviting them to return to service, the subject would better parallel the screen of Taigong Wang being entreated to serve by the Zhou emperor Wenwang.

The Seven Sages were painted several times prior to the Momoyama period but always in a style very different from that seen in the Hōryūji Treasure Hall *Four Graybeards* panels. One of the earliest examples is a now lost hanging scroll formerly in the Tanaka collection.[15] Bearing a seal of Gakuō (fl. 1504–1520), the ink monochrome scroll shows seven men in scholar's robes and caps emerging from a bamboo-filled defile below a cliff. One man carries a staff, another swings a fan, and yet another shoulders a *qin*. The emphasis is on the group identity of the men, with five of them packed tightly together and the remaining two

placed slightly above and behind. They do not converse and are not obvi-
ously engaged in gazing at natural phenomenon; only the presence of the
qin hints at their refined hobbies. This spirit of aesthetic reclusion, how-
ever slight, foreshadows the norm in Momoyama period paintings of the
Seven Sages but contrasts sharply with other early-sixteenth-century pic-
tures of the Seven Sages.

The first extant screen of the Seven Sages is a single six-panel *byōbu*
(fig. 7) in the Tokyo National Museum with the seal of the Kamakura
painter Keison (fl. late 15th–early 16th c.).[16] The artist shows the Seven
Sages in a bamboo grove at night, with a full moon indicating the noc-
turnal setting. Besides the bamboo, pine trees cling to rocks, placed like
bookends at either side of the composition. The inclusion of the pines
may signal Keison's use of flora as symbols of Confucian virtues: bam-
boo being an orthodox emblem of strength combined with flexibility,
and pines an equally venerable symbol of integrity and steadfastness.
The Sages, spread across the interior four panels, are grouped into con-
versing pairs. As in Gakuō's hanging scroll, several Sages carry walking
sticks and one white-bearded Sage holds a fan.

The screen has a bizarre quality not uncommon in the painting of
Keison and other early-sixteenth-century followers of Kenkō Shōkei (fl.
1487–after 1506). The exaggeration of the Southern Song Xia Gui style—
apparent in the hard-edged rocks, repetition of similar forms, and sharp
tonal contrasts—results in a feeling of psychological or spiritual inten-
sity. The landscape further expresses the special character of the Seven
Sages in that two pairs of thin bamboo stalks curve so as to encompass
the figures. While these curving stalks parallel the curving backs of sev-
eral of the men, the sharply vertical bamboo behind them serves to
frame the heads of three of the Sages.

In addition to the unorthodox nocturnal setting, the spectral peaks
looming in the distance, and the strange correspondence of the bamboo
to the human figures, the mood of eccentricity is clearly indicated by the
appearance of the Sages. Although dressed in the standard robes and
caps of lofty scholars, the men are decidedly bizarre in expression, with
heavily wrinkled faces, grimacing mouths, and upturned eyes, all of
which suggest Daoist immortals or Buddhist arhats more than scholarly
gentlemen. One figure holds a fungus, while another wears a gourd—
both conventional symbols of immortals. The figure wearing the gourd
reads a book, and although this motif conveys a scholarly pastime in
later paintings, within the context of this picture the book suggests some
magic Daoist text. Another man holds a bell or rattle—iconography asso-
ciated with Zen rather than with Daoism or Confucianism.

The emphasis on the eccentricity of the Seven Sages—manifest in
their appearance as well as in their Daoist and Zen attributes—is consis-

tent with the body of Keison's figure painting, composed largely of Dao-
ist immortals and Zen exemplars.[17] The *Seven Sages* screen thus places
its subject within the context of personal eccentricity and unconven-
tional behavior. Keison's screen, although containing the compositional
and thematic stress on communitas which forms the basis of Momo-
yama Seven Sages pictures, seems to reflect the values of Zen more than
those of aesthetic reclusion as understood in the Momoyama period.

The function of the Seven Sages as models of eccentricity, in the
manner of conventional Zen exemplars such as Budai (Hotei), is best
witnessed in the paintings of Sesson Shūkei (1504–1589?). Sesson's earli-
est painting of the Seven Sages is the hanging scroll the *Seven Sages
Dancing* (fig. 8) in the Burke collection, New York.[18] Watched by a small
group of court women and servant boys within a bamboo grove enclosed
by a split-bamboo fence, four of the Seven Sages play instruments while
two dance wildly and one looks on. The origin of their merriment is
surely wine—a pot of which is held aloft by one of the dancing Sages. If
painted one hundred years later, we would be tempted to interpret this
painting as a satirical jibe: the Seven Sages, symbols of virtue and pro-
priety in Momoyama painting, reduced to drunken voluptuaries who
indulge, literally, in wine, women, and song. However, given the Zen con-
text of much of Sesson's work and the early Japanese tradition of regard-
ing the Seven Sages as models of inebriation,[19] this image of drunken
song and dance should not be regarded as less than serious.

Sesson painted pairs of screens of the Seven Sages at least twice. The
Seven Sages on Horseback shows them riding donkeys along a mountain
river at night as several young boy servants rush along carrying wine and
other provisions.[20] Better known is the *Seven Sages of the Bamboo Grove*
in the Hatakeyama kinenkan, Tokyo (fig. 9).[21] Again, the Seven Sages are
represented as icons of eccentricity. Spread out across the composition
and enlarged to monumental scale, the seven men converse in groups,
gesture wildly, laugh madly, and generally appear to be in a state of
drunken euphoria. As in the Burke scroll, one man holds a wine pot and
another hoists an empty cup. In the left screen, two boy servants carry-
ing wine pots echo their counterparts in the *Seven Sages on Horseback*
screens. Reprising motifs from Keison's screen, one Sage shakes a bell
(as he throws his head back to laugh), and another holds a stalk of fun-
gus. This compounding of Zen Buddhist and Daoist imagery with inebri-
ation presents the Seven Sages as models of the eccentricity associated
with self-cultivation. Although the spirit of camaraderie and freedom
from worldly affairs suggest characteristics of aesthetic reclusion, the
primary emphasis here is on the Seven Sages as exemplars of radically
individualistic behavior in the manner of Zen eccentrics.

The Tokyo National Museum screens of the *Four Graybeards of Mt.*

Shang and the *Seven Sages of the Bamboo Grove* from the studio of Kano Motonobu (fig. 3) provide an instructive comparison to the paintings by Sesson and his followers.[22] This important pair of screens will be analyzed shortly in terms of the characteristics of aesthetic reclusion, but we will first employ it to point out some fundamental differences between Motonobu's scholarly interpretation of the Seven Sages and Sesson's Zen-inspired view of the same men. Where the Seven Sages painted by Sesson have slightly grotesque physiognomies, featuring bulging foreheads, deep-set eyes with upturned irises, and large noses, those by Motonobu and his studio have rather unexaggerated facial features. Where Sesson's Sages often bare their teeth in dramatic expressions and wave their arms in exaggerated gestures, the Sages of Motonobu manage no more than weak smiles and keep their arms against their bodies. Finally, where Sesson's figures dominate their rather mysterious environments, Motonobu's men harmonize with their setting, emerging from behind a clump of bamboo and gazing tranquilly at ducks floating lazily on a river. The resulting effects are of aggressive strangeness in Sesson's paintings and of passive benignancy in Motonobu's work. While their personalities dominate Sesson's screens, it is their activities that matter most for Motonobu. For Sesson, the Seven Sages serve as exemplars of unconventional behavior as a means of enlightenment, for Motonobu the same figures—paired with the Four Graybeards—create an ideal order based on the principles of the aesthetic reclusion. Although likely painted around the same time, these two pictures effectively elucidate the different functions of Chinese recluses in the Muromachi and Momoyama cultures.

Momoyama Paintings: Some Characteristic Images

The Tokyo National Museum screens of the *Seven Sages of the Bamboo Grove* and the *Four Graybeards of Mt. Shang* were painted in 1552, before Oda Nobunaga's ouster of Ashikaga Yoshiaki and the formal beginning of the Momoyama period. However, these screens differ significantly from other images of their same period and thus foreshadow the orthodox treatment of the subjects in the Momoyama and early Edo periods. Moreover, although published as the work of Motonobu until recent decades, they now are generally thought to be the work of Motonobu's large and capable studio.[23] Even the lost *fusuma* of the Seven Sages and the Four Graybeards at the Zuihōin of Daitokuji, attributed to Motonobu in Akizato Ritō's *Miyako rinsen meishō zue* of 1799, are likely the work of Motonobu's atelier working under the superannuated master.[24] The Tokyo National Museum screens are thereby representative of many of the works analyzed in the following pages as normative or

orthodox paintings of the Seven Sages and the Four Graybeards in the Momoyama period. We employ a core of screens and *fusuma* that exhibit standard iconography and conception of their subject. In some cases, the paintings may well be studio works. In other cases, the paintings analyzed here are probably genuine but uninspired works from the hand of the signed artist. As a rule, the most creatively adventurous paintings are the least rich in terms of thematic expression.

Hasegawa Tōhaku (1539–1610), arguably the greatest painter of the Momoyama period, produced several pictures of the Four Graybeards, but none are discussed in the following sections. Tōhaku's eight *fusuma* from 1602 of the *Four Graybeards on Horseback* at the Tenjuan of Nanzenji,[25] are wonderful examples of the artist's brushwork and daring approaches to composition and space, but they tell us little about the Four Graybeards. In fact, the paintings are so lacking in thematic information about the figures that the identification of the men as the Four Graybeards is rather tenuous. Another example, Tōhaku's eight *fusuma* of the *Four Graybeards of Mt. Shang* (fig. 10) at the Shinjuan of Daitokuji,[26] demonstrates Tōhaku's brilliant abilities to suggest deep space and to fill surface space with a bare minimum of forms. They also are superb examples of Tōhaku's formal paralleling of shapes and brush styles. Precisely because Tōhaku is preoccupied with the exploration of formal concerns, using the Four Graybeards largely as an excuse for his play of forms, the paintings—although superb—have minimal thematic consequence.

Another example of formal interests dominating thematic ones is Kaihō Yūshō's (1533–1615) *Seven Sages of the Bamboo Grove* painted on a set of sixteen *fusuma* at the Hōjō of Kenninji.[27] Yūshō turns the Seven Sages into a graphic dance of brushstrokes and tonal contrasts, even going so far as to echo the positive shape of a sleeve in the negative (cutout) shape of a cliff to suggest that his forms are parts of one interlocking puzzle. As with Tōhaku's paintings, all that these *fusuma* tell us about their ostensible theme is that the Seven Sages and the Four Graybeards had become such standard themes in the Momoyama painters' repertoire, that the most daring artists felt free to use them primarily as the basis for formal exploration.

The images that support the bulk of our analysis are paintings from the Kano and the Unkoku ateliers—those schools that fulfilled the largest number of commissions and often did so in the most orthodox manner. For paintings of the Seven Sages, we focus on Unkoku Tōgan's (1547–1618) *fusuma* at the Kyakuden of the Ōbaiin at Daitokuji (fig. 11), and his screens at the Eisei bunko, Tokyo (fig. 12).[28] Paintings of the Four Graybeards feature the aforementioned works by Sanraku at Myōshinji, in which a screen of the *Four Graybeards on Mt. Shang* is paired

with one of *Wenwang Summoning Taigong Wang* (fig. 13), and those attributed to Kano Mitsunobu, in which a screen of the *Four Graybeards Returning to Court* is paired with one of the *Wind and Water Cave* (fig. 14). For pictures pairing the Seven Sages and Four Graybeards, the Motonobu screens are supplemented by the previously mentioned *kobu-suma* by Shōkadō Shōjō in the Mittan of the Ryūkōin at Daitokuji (fig. 5) and by a pair of 1623 screens by Kano Yasunobu (1613–1685) at Shō-juraigōji, Shiga (fig. 15).[29] In addition to this core group, other related paintings are discussed as appropriate.

Finally, because at the broadest level this study seeks to understand not just the implications of paintings of the Seven Sages and the Four Graybeards but the entire range of Chinese scholar-recluse themes in Momoyama art, for each characteristic of aesthetic reclusion we also analyze examples of related pictorial subjects. Thus, paintings of the Four Admirers *(shiai)*, Four Accomplishments *(kinkishoga)*, groups of Daoist immortals *(gunsen)*, and miscellaneous Chinese scholars are brought to bear. Whenever possible, paintings in American collections are used to demonstrate some domestic resources in this field. Our thematic analysis of the qualities of aesthetic reclusion begins with communitas, then turns to scholarly pursuits, appreciation of nature, elegant rusticity, and the claims on Chinese history implicit in the mix of figure themes.

Communitas

The essential feature of aesthetic reclusion is communitas. The spirit of communion and shared values between men who meet as equals is a salient feature of the East Asian eremitic experience and a necessary component of the political claim to *kōgi*. If aesthetic reclusion is, to a large degree, the rejection of social hierarchy and the acquiring of deeper humanity through intimate human contact, the communion of individuals is the most basic way of demonstrating those experiences. Communitas is present in many figure themes. For example, as Zen exemplars the Four Sleepers *(shisui)* express their universal conscious-ness through the extreme communitas of slumbering together. Yet, it is in pictures about aesthetic reclusion that communitas is most consis-tently and clearly expressed.

The emphasis on communitas in pictures of Chinese scholar-recluses is evidenced in the many group themes portrayed. First, while individ-uals such as Tao Yuanming and Su Dongpo were the scholar-recluses favored in the Chinese verse written by Gozan monks,[30] in Momoyama painting these subjects are largely replaced by multifigure themes such as the Seven Sages and the Four Graybeards. Second, the development

of previously unpainted themes—such as the Eight Immortals of the Winecup *(inchū hassen)*, Four Admirers, and the Nine Old Men *(kyūrō)* —as well as the increased popularity of the *kinkishoga* theme attest to the new interest in representing groups of men. While the growth of multifigure pictures stems in part from the expanded space provided by the large-scale screen and *fusuma* formats, these subjects dominate even small-scale fan paintings.[31]

The evocation of communitas in multifigure themes emerges from the fact that the Chinese scholar-recluses are usually depicted in some type of interpersonal communication. The most obvious and frequently shown form of communitas is conversation. The Motonobu screens of the *Four Graybeards* and the *Seven Sages* (fig. 3) are typical of the tendency to arrange figures in large groups or pairs, rarely placing a figure alone. The three Sages at the left form a single visual unit that is repeated in most later paintings of the Seven Sages and the Four Graybeards. For instance, in the screens at Shōjuraigōji, Shiga (fig. 15), by Kano Yasunobu, this same triad appears with very slight modification.[32] The group arrangement furthers the notion that the men are in philosophical accord with one another. In Motonobu's triad of Sages, the two exterior figures look in toward each other, and the figure at the left has his mouth open as if speaking. In Tōgan's Ōbaiin *Seven Sages fusuma* (fig. 11), the two Sages in sedge hats engage in a similar tête-à-tête.[33] Their intimate glances and open mouths bespeak a confidential friendship reinforced by their shared style of clothing and physically connected forms. The similar pair of Sages, standing in the bamboo grove in the left screen of Tōgan's Eisei bunko *Seven Sages* (fig. 12), demonstrates the conventional nature of this paired-figure motif.

Even in Sanraku's *Four Graybeards on Mt. Shang* screen (fig. 13), three of the men face inward, creating an implication of sympathetic conversation. It is only in scenes of the Four Graybeards Returning to Court, such as Mitsunobu's Metropolitan screen (fig. 14), that group conversation between the four men is avoided. However, even here one Graybeard turns to look at another as if seeking reassurance. In this theme—where aesthetic reclusion and its concomitant quality of communitas are not the point—the intimate relations between the figures are downplayed or dispensed with altogether.

In addition to participation in the dialogic relation of conversation, communitas is conveyed through the sharing of common interests. These motifs are discussed in greater length in following sections, but it must be noted that engaging in scholarly pursuits or even partaking in the wonder of nature are obvious methods of demonstrating sympathetic relations between like-minded men. The ubiquitous reading of scrolls brings the figures into close physical contact and defines a shared expe-

rience.[34] Three of the Four Graybeards read in tandem in Motonobu's screen (fig. 3), as do the pairs of Sages at the right of Tōgan's Ōbaiin *fusuma* (fig. 11) and his Eisei bunko screens (fig. 12). When, in Yasunobu's *Seven Sages* screen (fig. 15), one Sage peers over at the book held open by his obliging comrade, the gesture seems almost mandatory. Because we can never read the text of these mysterious scrolls or books, the Sages and the Graybeards are made all the more intimate for the secrets they share.[35]

Shōkadō Shōjō's *kobusuma* of the *Four Graybeards Playing Go* and *Seven Sages Reading a Scroll* (fig. 5), painted in the early 1630s at the Mittan tearoom of the Ryōkōin at Daitokuji, offer another example of the communitas brought about by scholarly pastimes. All Seven Sages huddle around a calligraphy scroll unrolled between them, while the Four Graybeards gather at a *go* board.[36] In Tōgan's Eisei bunko *Seven Sages* screens (fig. 12), the two Sages at the far left are also brought together by this game, which necessitates the matching of wits. Extant paintings of the Seven Sages and the Four Graybeards from the Momoyama and early Edo periods do not include scenes of playing and listening to music, but as we discuss in the following section, sharing music is one method of expressing communitas present in other paintings of Chinese scholar-recluses.

The communitas of the Seven Sages, the Four Graybeards, and their fellow scholar-recluses is accentuated by their isolation from the mundane world. As is examined further in the section on appreciation of nature, the freedom from worldly entanglement (with its implication of liminal status) underscores the interpersonal harmony of these hermits. Moreover, the enjoyment of nature provides a shared activity that specifically reinforces their humanity even as it points again to their sympathetic interests. It is surely no coincidence that virtually all depictions of scholarly activities and communitas take place in an idyllic natural setting, whether manifest as a bamboo grove, a wooded riverside, or a secluded mountain valley.

The spirit of communitas is also fostered through the appearance of the figures in paintings of the Seven Sages and the Four Graybeards. These men, along with other scholar-recluses, are invariably presented as generic types: in addition to being male, they are always middle-aged or, more often, elderly.[37] As such, standard scholar-recluses are portrayed as being the same sex and the same general age as the patrons of the paintings. Although Japanese artists probably knew the names and personalities of the Seven Sages and the Four Graybeards,[38] they never attempt to paint these figures so that individual members can be recognized. For instance, Ruan Ji, Ji Kang, and Liu Ling were famous for their behavior, but in no extant Momoyama painting of the Seven Sages is there any

attempt to distinguish these men from their less illustrious comrades. For instance, although Ji Kang was known for his devotion to playing the *qin,* that instrument is generally included in pictures of the Seven Sages only when the theme is conflated with that of the *kinkishoga*—in which the *qin* is a mandatory prop.

In Momoyama and early Edo painting, Chinese scholar-recluses are reduced to an idealized type. In part, this repetition of generic features can be attributed to the fact that virtually all major Momoyama painters trained in the Kano school, which codified a standard Chinese scholar prototype. This patternization of features, however, serves an important purpose in furthering the values of communitas. The homogenized appearance of the Seven Sages and the Four Graybeards implies that the men share not only the same noble countenance but the same lofty values. The standardized physiognomy of these and other Chinese scholar-recluses allows viewers to more easily imagine themselves as the participants in these fictive scenes of communitas. Recluses such as the Seven Sages and the Four Graybeards are identifiable by external attributes: by their natural setting, their clothes, their communion with other men, and their engagement in scholarly pastimes. These external attributes could all be copied and—as the previous chapter demonstrated—were imitated in the aesthetic reclusion recreated in tea. In some instances, guests at tea gatherings even changed into special clothes and grasped staffs, physically donning the garb associated with painted scholar-recluses, to traverse the *roji* before entering the *chashitsu.* The *nijiriguchi* in *sōan*-style teahouses functioned symbolically to reduce all participants to the same social status.

As in the sixteenth- and seventeenth-century culture of tea, the pictorial realm of Chinese scholar-recluses was a world of men. Besides groups of hermits, boy servants are a ubiquitous feature in most paintings of the Seven Sages, the Four Graybeards, and related subjects. While these typically prepubescent boys usually trail behind their masters (figs. 3 and 15), carry scrolls or writing sets (figs. 11 and 15), heat wine or tea (fig. 15), or nap while seated (fig. 12), in some cases they are shown in semi-intimate poses with their employers. A common figure is the boy servant who supports his elderly master by holding his hand and letting the old scholar rest on the boy's shoulder (fig. 13).

A few Momoyama and early Edo paintings of Chinese figures take this intimacy a step further and suggest a homoerotic overtone to the intimate relations between elderly recluses and their lithesome boy attendants. This homoeroticism is best seen in Yūshō's single surviving screen of the *Eight Immortals of the Winecup* (fig. 16).[39] Painted in 1602 (Keichō 7) for Kamei Korenori (1557–1612), the lord of Shikano in Inaba, the screen shows four inebriated scholars, presumably half of the eight

figures mentioned Du Fu's (712–770) famous poem on the most promi-
nent drinkers of his age. The generic scholar at the far left puts his arm
around the shoulders of a comely boy attendant and draws his face close
so as to whisper into the lad's ear. While this degree of physical intimacy
is rarely matched in other paintings of the period, this blatant example
of the sexual appeal of beautiful boy servants hints at possible homo-
erotic implications for the youthful and attractive attendants in other
paintings.

According to medieval tales of love between monks and temple aco-
lytes *(chigo)*, young boys were prized for their round, smooth faces, long
hair, white skin, and gentle dispositions. A good description of this canon
of boyish charm is observed in *Aki no yo no nagamonogatari* (A Long Tale
for an Autumn Night)[40] and the sixteenth-century hand scroll illustrating
it.[41] Even when no overtly intimate act is depicted, the love between men
and youths (known as *wakashudō*, the "way of youths") is a subtle but
key aspect of the communitas in paintings whenever elder men and
young attendants are in close proximity. In a culture where priests, aris-
tocrats, and *samurai* often engaged in sexual relations with adolescent
boys,[42] a homoerotic reading of the pictures does not seem out of place.

The implication of homoeroticism in paintings of the Seven Sages
and the Four Graybeards is reinforced by the pairing of these subjects
with distinctly homosexual themes. For instance, the Metropolitan
screens attributed to Mitsunobu pair the *Four Sages Returning to Court*
with the *Wind and Water Cave* (fig. 14). In Kano Ikkei's *Kōsoshū*, a man-
ual of Chinese painting subjects, the Wind and Water Cave is classified
under "Male Love" *(nanshoku)*.[43] The subject portrays the older scholar
Su Dongpo traveling to the Wind and Water Cave (Fengshuidong) to visit
his young paramour Li Bi, better known by his official title, Li Jietui.[44]
The story of the Four Graybeards returning to court to serve the young
crown prince loosely parallels Su Dongpo's journey to join his youthful
companion. This theme of older men going to meet young men is likely
the rationale for Mitsunobu's pairing of the otherwise distinct subjects.
As such, it has been suggested that the homosexual interest of older
men—and presumably the screen's patron—in beautiful young men
makes up one important layer of meaning in the paintings.[45]

The homoerotic interpretation of these screens is bolstered by con-
temporary fan paintings with the same themes. Of the sixteenth-century
Kano fan paintings depicting the Wind and Water Cave, many may have
been given by older priests to acolytes, because the poems on these fans
are dedicated to the acolytes who are addressed with the suffix *bishōnen*
(beautiful youth) appended to their names.[46] Similarly, some poems on
fan paintings of the Four Graybeards Returning to Court contain roman-
tic language likening the crown prince to a young bird who is tended and

nurtured by the Graybeards.[47] In sum, in a culture marked by frequent bisexual and homosexual relations among men, communitas between men very likely carried some implication of homoeroticism. Even in pictures where the artist did not paint clearly homoerotic themes or portray special intimacy between men and boys, the mere combination of these figures may well have been read by contemporary viewers in light of cultural norms of sexuality.

A second component of the pictorial combination of elderly men and children is the implication of the sacred. In his article "Folk Culture and the Liminality of Children,"[48] Iijima Yoshiharu suggests that in Japan, children and the aged were traditionally viewed as semisacred. He writes, "The Japanese notion of 'god' encompasses both old white-haired gentlemen and children. Child gods were often lesser gods under the control of a master god or the servants or followers of older gods."[49] Following C. G. Jung's assertion that child and sage are archetypal symbols of the Self, the combination of these figures follows from the fact that both stand outside social norms. Too young or too old to work, and both close to death, the child and elderly sage are thought to be in contact with the nonhuman world. As such, children and sages have access to a "deeper strata of culture" and a deeper perception of life, which, consequently, makes their activities instructive to adults who seek to restore order to society.

In this light, paintings of elderly Chinese recluses such as the Seven Sages and the Four Graybeards may well tap into archetypal images of the sacred even as they touch upon the homoerotic undercurrents in the upper strata of Momoyama society. The spirit of communitas manifest in the combination of old recluses and young servants is so conventional that we tend to discount the possibility of it holding any deep or significant meaning. However, it seems more likely that the conjoining of white-haired sages and fair-skinned youths was common precisely because it carried such a rich variety of associations.

Scholarly Pursuits

We have already touched on the importance of scholarly pastimes as a manifestation of communitas. Reading calligraphy scrolls or playing *go* are not signs merely of shared avocations but also manifestations of the creative freedom at the heart of aesthetic reclusion. Moreover, because these activities are associated with Chinese learning and represent the apogee of Confucian education, scholarly pastimes are potent and multivalent symbols that find their way into almost every Momoyama picture of Chinese scholar-recluses. As a direct expression of learning *(bun)* and an obvious symbol of the social superiority of the

ruling class, scholarly pastimes are inextricably linked to the legitimation strategy of ruling in the public good *(kōgi)* on the basis of personal virtue.

The primary pictorial example of scholarly pursuits is the *kinkishoga* theme, often translated as the Four (Gentlemanly) Accomplishments: plucking the *qin (kin)*, playing *weiqi (ki)*, and looking at or brushing calligraphy *(sho)*, and painting *(ga)*. These four activities, first codified in China, were viewed in late-medieval Japan as quintessential signs of Confucian learning and continental culture. Sōami's *Kundaikan sōchōki*, circa 1471, mentions a painting on the theme in the shogunal collection, and according to the *Zokusui shishū*, Kōzei Ryūha (1374–1446) inscribed a poem on the *kinkishoga* theme upon a fan painting.

The earliest extant *kinkishoga* paintings include screens attributed to Josetsu (fl. late 14th c.–early 15th c.) (and sometimes to Minchō, 1352–1431) now split between a private collection and the Ryōkōin, Daitokuji. Of the same period is a set of *fusuma* painted in 1492 by Oguri Sōkei (active late 15th c.) at the Yōtokuin of Daitokuji.[50] A recently discovered set of *kinkishoga* screens by the early-sixteenth-century painter Shabaku may have been based on a set of four hanging scrolls by the Yuan artist Ren Renfa (1255–1328), a rare Chinese painting on the theme and one long known in Japan.[51] As evidenced by the many works produced in Motonobu's studio, the *kinkishoga* theme gained popularity in the early sixteenth century. Best known are a set of *fusuma* from the Reiun'in at Myōshinji and a pair of screens now at the Tokyo National Museum that contrast the *kinkishoga* theme with that of Li Bo Gazing at a Waterfall.[52]

The recently acquired pair of *kinkishoga* screens (fig. 17), in the Metropolitan Museum of Art, provides a good example of the Motonobu-style rendering of this theme.[53] The right screen, echoing some motifs from the left screen from the Josetsu-Minchō pair, begins with a scholar accompanied by a *qin*-toting attendant crossing a bridge over a bubbling rill. Beneath a large tree and next to a table laden with books, vases, and another *qin (kin)*, three scholars sit gazing intently at a *go* board *(ki)*. A young servant sleeps happily at their side. The left screen commences with a scholar, resembling the literatus Su Dongpo in his sedge hat and black cowl,[54] trailed by two servants carrying bundles of books. Beyond a slender waterfall is a grass-thatched pavilion from which a lone scholar —his activity suggesting that he is Li Bo—gazes at the cataract. Within this elegant cottage, three juvenile servants unroll a painting *(ga)*. If we assume that the books held by the servants contain examples of calligraphy *(sho)*, then these screens, as they proceed from right to left, sequentially show *kin, ki, sho,* and *ga*. The figures associated with these activities are generally nonspecific scholar-recluses. Yet, because the iconography of the first figure in the left screen resembles the Song poet,

painter, and sometime exile Su Dongpo, and the man gazing at the waterfall reprises a pose associated in Japan with the Tang poet Li Bo, these screens fuse the *kinkishoga* theme with historical figures considered scholar-recluses.

A similar mix of the *kinkishoga* and historical figures is found in Kano Eitoku's (1543–1590) famous 1566 *Four Accomplishments fusuma* (fig. 18) in the Hondō of the Jukōin at Daitokuji. The rightmost panel depicts a scholar playing the *qin* (with a boy attendant sleeping by his side) while two scholars sit listening in rapt concentration.[55] The emphasis on the close communitas between the *qin* player and his audience recalls the story of the Zhou dynasty musician Boya, who played for his friend Zhong Ziqi, who could divine Boya's deepest thoughts from his music. When Zhong died, Boya broke his *qin*, never to play again. In the next panel, a scholar in a boat leans over to view lotuses. This vignette, unrelated to the *kinkishoga* theme, recalls the Northern Song scholar Zhou Maoshu (aka Dunyi) (1017–1073) who was noted in Japan for his admiration of lotus.[56] Zhou is one of the Four Admirers *(shiai)* who appear frequently in later Japanese painting. The third panel of Eitoku's *fusuma* shows two scholars playing *go* in a grass-thatched pavilion. In front of them, the scholar who relaxes against the pavilion railing suggests the famous third-century calligrapher Wang Xizhi in that he gazes out at several waterfowl. In Chinese and Japanese painting, Wang is associated with looking at waterfowl, the graceful forms of which he sought to imitate in his calligraphy. Eitoku, following the lead of Motonobu and others, gives his *kinkishoga* picture a sense of historical specificity and cultural depth by mixing in depictions of, or references to, actual men.

The tradition of mixing the *kinkishoga* theme, or aspects of it, with pictures of specific scholar-recluses extends to depictions of the Seven Sages and the Four Graybeards. We have already mentioned Shōkadō Shōjō's Ryōkōin *kobusuma* of the *Four Graybeards Playing Go* and *Seven Sages Reading a Scroll* (fig. 5). Although only half of the Four Accomplishments are shown here, the picture so obviously refers to the theme that Takeda Tsuneo titles it *Kinkishoga*.[57] Because several of the Seven Sages wrote poetry, and one of them, Ji Kang, was famous for playing the *qin*,[58] it stands to reason that these activities—half of the *kinkishoga*—should be included in their depictions. In Tōgan's Eisei bunko screens of the *Seven Sages* (fig. 12), we see two Sages reading a scroll at the far left and, at the far right, a *qin* resting on a table in a grass-thatched pavilion. The *qin* is unplayed because the two Sages in the pavilion have begun a game of *weiqi*. Tōgan includes only three of the *Four Accomplishments*, but these are sufficient to evoke the *kinkishoga* theme and its associations of devotion to learning, creativity, and communitas.

In many Momoyama paintings of the *kinkishoga* theme, the various iconographic clues—*qin, go* board, and examples of calligraphy and painting—are partially hidden.[59] There are several implications of hiding or obscuring *kinkishoga* iconography. First, when the iconography of this theme is downplayed, the subject can more easily be fused with other subjects. In the thematically dense paintings of Chinese scholar-recluses, a certain understatement of each theme helps sew together different themes. Second, the subterranean nature of these subjects invites the viewer into a more intimate relation with the world of Chinese antiquity. The hiding of *kinkishoga* iconography may function as part of a "game" in which the viewer is challenged to explore the pictures in order to find "clues" to the subject. Motonobu, for instance, calls upon our powers of observation in the Metropolitan screens when we have to hunt to find the books stacked on the table or carried by the attendants. Our knowledge of cultural convention is tested for us to associate these books with the writing *(sho)* element of the four scholarly pursuits. When we finally figure out that the painting represents the *kinkishoga* theme, or that the man in the sedge hat is Su Dongpo, or (in the case of Tōgan's Eisei bunko screens) that the seven scholar-recluses are indeed the Seven Sages, we feel not only pride at our cultural sophistication but also a greater sense of communion with these figures because we share their culture.

The second component of the scholarly pursuits in these paintings relates not to practicing elegant accomplishments but to collecting. Since most Momoyama versions of the *kinkishoga* theme involve looking at painting and calligraphy rather than producing it,[60] there is already an element of collecting and connoisseurship in these paintings. As mentioned above, pictures of the Seven Sages, the Four Graybeards, and other scholar-recluses often feature servants standing next to tables laden with antiquities. Typically, these tables are present in scenes where the setting is emphasized and the figures are placed in or near a pavilion. Where setting is minimized (figs. 11 and 15), the tables usually are dispensed with.

Often, these tables bear books, paper, and an ink stone (fig. 13), implying the scholarly nature of the figures and hinting at the *kinkishoga* theme. Other frequently painted objects include incense burners, ceramic vases, jars and wine pots, bronze vessels, and oddly shaped rocks in trays. Because these objects were collected in China, they add to the authenticity and continental flavor of the pictures.[61] Moreover, in that many of the same objects were considered collectibles in Momoyama Japan, the inclusion of these objects posits a connection between the two cultures. Just as the host of a tea gathering would set out his most cherished objects, the Sages and the Graybeards (figs. 12 and 14) display their prized possessions. The emphasis on these precious objects and scrolls suggests that the Chinese scholar-recluses in these paintings pos-

sess values similar to those held by Momoyama period practitioners of tea and patrons of painting.

Appreciation of Nature

Perhaps the most obvious aspect of Momoyama pictures of the Seven Sages and the Four Graybeards is their setting in nature. The subject of the Four Graybeards Returning to Court takes place before a palace, but the court buildings in these paintings (fig. 14) are invariably far simpler in structure and closer in proximity to nature than the real imperial palaces of either China or Japan. Among pictures of the Seven Sages and the Four Graybeards on Mt. Shang, even when the setting is minimal—as in Tōgan's Ōbaiin *fusuma* (fig. 11) or Tōhaku's Shinjuan *fusuma* (fig. 10)—the artists provide rocks and plants sufficient to indicate a natural location. In both themes, nature is part of the subject: a bamboo grove or some indication of a mountainside are mandatory features in every picture. Yet, nature serves as more than an iconographic indicator. We have already mentioned that communitas between the scholar-recluses is enhanced through their setting in nature. Isolated from the distractions of normative human society, the Sages and Graybeards are free to engage in their own interests—whether scholarly arts or communion with like-minded men.

Nature serves first as a means of conveying liminality to scholar-recluse themes. When placed in a landscape setting, pictures of the Seven Sages, the Four Graybeards, and other scholar-recluses (figs. 12, 13, 14, 17, and 18) often include bridges over which figures cross. While it may be argued that the bridge is a standard motif without significant meaning, the bridge-crossing motif provides a convenient metaphor for the hermit's crossing from the mundane world into the purifying realm of nature. The bridge thus functions in the same manner as the entry gate in the *roji*.[62] Nature, the antithesis to the urban environment, is conceived as a realm free from defilement in which humans purify themselves. Not surprisingly, water, the quintessential symbol of purification, is featured in the *roji* in the form of the *tsukubai*, and is often present in Momoyama paintings (figs. 3, 11, 12, 16, and 17) as a stream or other waterway along which scholar-recluses stroll or over which they pass.

Where the *roji* is contrived to symbolize a journey through the mountains, pictures of scholar-recluses provide graphic views of this wilderness and the figures who pass through it. In both the ersatz wilderness of the *roji* and the painted mountains of hermit-theme pictures, nature is neither wild nor harsh, but tame and well manicured. The small clumps of bamboo in pictures of the Seven Sages (figs. 3, 5, 11, 12, and 15) never resemble the dense bamboo groves actually found in East

Asia. Similarly, the pine trees typically placed around the Four Gray-beards (figs. 3, 5, 10, and 15) contort for dramatic effect and to highlight the Graybeards. These pines, along with the sharp-edged rocks, derive from the Ma-Xia style of the Southern Song Painting Academy as filtered through Zhe school painting. These pictorial motifs also suggest the types of trees and rocks found in Momoyama gardens. Judging from the appearance of the Momoyama and early Edo period gardens at the San-bōin of Daigoji and the Ninomaru of Nijō Castle, dramatic pines and many large rocks were features of late-sixteenth- and early-seventeenth-century landscape architecture.

In both the paintings and gardens, nature is molded to conform to the demands of its human occupants. Nature serves to nurture the scholar-recluses rather than to overwhelm or overshadow them. One indication of the edenic treatment of nature is the insertion of garden fences into landscape scenes.[63] In the fourth panel of Eitoku's Jukōin *Four Accomplishments* panels (fig. 18), one such railing extends from the area of the table to some rock-cut steps. In the second and third panels of Tōgan's Eisei bunko screens (fig. 12), a similar garden rail is tucked into the bottommost rocks. These stylish fences turn the natural wilder-ness into an elegant garden setting.

When nature is denied its essential naturalness, it more easily becomes the carrier of symbols and cultural references. The waterfalls, trees, flowers, and birds in these pictures are not so much those objects as they exist in the realm of nature but rather those objects as they exist in the world of Chinese culture, and, specifically, as they serve as icono-graphic markers of figure subjects. Thus, in Motonobu's screens of the *Four Graybeards* and the *Seven Sages* (fig. 3), when two Sages looks at waterfowl, we read this seemingly simple act as a reference to the subject of Wang Xizhi gazing at waterfowl—also referenced in Eitoku's Jukōin painting. When a Graybeard in Motonobu's Tokyo National Museum screen or two Sages in Tōgan's Eisei bunko screens (fig. 12) look up at a cataract, the educated viewer recalls the theme of Li Bo Viewing the Waterfall on Mt. Lu.[64] Or, when a Sage in Tōgan's Ōbaiin *fusuma* writes a poem on the face of a rock, the allusion is likely to the Zen eccentric Hanshan (Kanzan).[65]

In a similar fashion, the flora in pictures of the Seven Sages and the Four Graybeards carry multiple symbolic associations. By virtue of their name, the Seven Sages of the Bamboo Grove are inextricably tied to bamboo, and thus bamboo is always included in paintings of them. The Four Graybeards have no such botanical association, although as early as the Song dynasty artists evoked their habitation on Mt. Shang by plac-ing them under pine trees.[66] In Japan, beginning with Motonobu (fig. 3) and continuing into the seventeenth century (fig. 15), pines functioned

as the standard emblem of the Four Graybeards. By pairing these figure subjects with plants carrying Confucian associations of strength and integrity,[67] Japanese artists begin to gloss over the very real differences between the historically neo-Daoist Seven Sages and the Confucian political implications of the Four Graybeards. When Tōgan places several large pines in his Seven Sages screens (fig. 12), he imputes Confucian values to this originally anti-Confucian theme. Liberated from a single meaning by their setting (and their activities), the Seven Sages are free to accrue a wide range of potential meanings.

When the significant differences in the original stories of the Seven Sages and the Four Graybeards are minimized, the themes are better able to serve as emblems of the far broader and more malleable values of aesthetic reclusion. For example, the inclusion of pine, bamboo, and plum (along with several other plants) in Eitoku's Jukōin *Four Accomplishments* (fig. 18) adds another thread of significance to the already dense weave of associations in his painting. These plants, emblems of the ideal Confucian character in China, were usually termed *shōchikubai* in Japan and, among their multiple meanings, were considered to be symbols of longevity. Thus, the mountains and forests in paintings of scholar-recluses serve not only as markers of the liminality induced by life in nature, but they also function as a forest of symbols that grounds the themes in a welter of associations ranging from simple auspiciousness to connotations of political integrity.

Elegant Rusticity

In those paintings that place scholar-recluse subjects in a landscape setting, some type of shelter or dwelling is usually provided.[68] Mountain temples and hermitages have long been an integral feature of landscape painting in China and Japan. As discussed in the review of Gozan poetry in chapter 2, the Muromachi genre of "ideal studio pictures"*(shosaizu)* takes the scholar-priest's imaginary mountain retreat as its main subject.[69] Where the hermitages in *shosaizu* are often depicted as empty or inhabited by a solitary figure, the pavilions in Momoyama screens and *fusuma* are usually the site of scholarly pastimes, as well as human interaction.

In many compositions, the pavilion is the visual and thematic focus of the painting. For instance, in the left screen of Motonobu's Metropolitan *kinkishoga* pair (fig. 17), the visual progression—following the movement of the Su Dongpo figure—is toward the pavilion at the viewer's far left. In Eitoku's four *fusuma* panels on the east wall of the Jukōin (fig. 18), the primary compositional focus is on the waterside pavilion. In the four panels on the north wall, a bridge leads to a pavilion placed

at the far left—the entire *fusuma* cycle thus culminating at an elegant hermitage.

The device of ending a room-size composition with a dwelling is clearly demonstrated in Tōgan's eight *fusuma* panels depicting Tao Yuanming's Homecoming *(Guiqulai)* in the Shoin of the Fumon'in at Tōfukuji.[70] Here, the viewer (again beginning at his right) encounters first the landing of Tao Yuanming's boat and concludes in the last panel with Tao's return to his residence. Tōgan frequently deployed elegant pavilions as compositional bookends. In the screens of Tao Yuanming, and Lin Hejing (fig. 19) in the Asian Art Museum of San Francisco, Tōgan gives each scholar-recluse a tiny hermitage and then pushes these structures to the outside of the picture. The identical compositional device is exploited by Tōgan in his Eisei bunko *Seven Sages* screens (fig. 12). The hermitage at the far right acts as a magnet, holding close the two Sages beneath a pine and pulling in the single Sage accompanied by two boy servants; at the left, the two Sages about to cross a stone bridge make their way toward the elegant pavilion, where their comrades play *go*. In these paintings, the hermitage functions in the manner of the *sōan* in the tea ceremony: it is approached after a preamble through nature and, as the center of communitas and scholarly pursuits, serves as the focus of the eremitic experience described in the picture.

In Tōgan's screens, as in Eitoku's *Kinkishoga fusuma*, the doubling of rustic pavilions makes these structures as much the pictorial focus as are the figures. More than a setting for the activities of aesthetic reclusion, the hermitage embodies the fashionable rusticity at the heart of *wabi*-style tea. Just as the small grass-thatched *sōan chashitsu*—epitomized by the Taian at Myōkian[71]—is the ultimate physical expression of the *wabi* aesthetic, the pavilions in hermit-theme paintings pictorialize that ideal. Although by no means pictures of actual *sōan*, these painted pavilions capture the essential spirit and function of the *sōan*. The painted pavilions typically are quite small, comprised of a single room or two. Thus, as in the four-mat *sōan*, the inhabitants are forced into intimate communion. While numerous Momoyama landscape paintings show temples or villages composed of groups of multistory structures with tiled roofs and elaborate bracketing,[72] when scholar-recluses such as the Seven Sages are featured, the architecture tends to be far smaller and more rustic, implying a direct connection between these elevated figures and the *sōan* style of architecture. Judging from extant structures such as the Shiguretei and Karakasatei (fig. 20) at Kōdaiji,[73] Momoyama period *sōan* had either hipped or hipped-and-gabled roofs. The two pavilions in Tōgan's Eisei bunko screens (fig. 12) display these two basic types of *sōan* architecture.

The most distinctive feature of these pavilions is the preponderance

of grass-thatched roofs (figs. 12, 17, 18, and 19). Among Chinese Song Academy and Zhe school paintings of lofty scholars in nature, most show structures with roofs constructed of tile or wood (the latter often covered in snow).[74] With a few exceptions, grass-thatched roofs are reserved for the humble dwellings of farmers and fishermen. In sum, Chinese examples rarely show exalted scholars in the type of small, open, grass-covered pavilions so commonly associated with scholar-recluses in Momoyama painting. Not surprisingly, the Japanese preference for *sōan* teahouses seems to have had a major impact on the type of architecture described in hermit-theme painting. The occasional wooden shingle pavilion in Momoyama pictures of Chinese recluses (fig. 19) is not out of place when we recall that some *sōan*-style *chashitsu*—the Taian, for instance—had shingle roofs. As with actual Momoyama *sōan,* these painted structures seem rustic but were considered the epitome of sophistication and elegance.

Although physically similar in dimensions, roof structure, and materials, most painted pavilions bear little or no resemblance to the few extant Momoyama *sōan* in details such as walls, doors, and interior design. Yet, we can detect a fundamental point of commonality in the spirit of rustic elegance that underlies painted and built structures. We have already seen how the expression of poverty, created by diminutive size and humble materials, links actual *sōan* and painted pavilions. Equally essential to the spirit of the *sōan* is the sense of connection to nature. In actual *sōan,* such as the Taian and the Karakasatei (fig. 20), the sense of naturalness is created largely through the use of unfinished materials such as unplanned branches used for the posts and cross-beams of the *tokonoma* or straw visible in the rough plaster of the walls. In painting, where these details are difficult to convey, the idea of human integration with nature is expressed through the radically (and impractical) open design of the pavilions, which allows the inhabitants uninterrupted visual access to the splendors of nature displayed around them. In this regard, the pavilions in Momoyama paintings—especially those waterside structures best exemplified in Eitoku's Jukōin *Four Accomplishments* (fig. 18) and the similar structure with a hipped-and-gabled roof in Yūshō's Kenninji *Four Accomplishments fusuma* (fig. 21)—foreshadow the light, airy seventeenth-century waterside tea pavilions such as the Shōkintei (Pine Lute Pavilion) (fig. 22) and the Gepparō (Lookout Over the Moon on the Waves) at the Katsura Detached Palace. It is entirely possible that the garden and pavilions at Katsura—the whole place an aristocratic fantasy of aesthetic reclusion—are based loosely on the images found in hermit-theme paintings.

A large part of the elegance of the Momoyama *sōan* comes from the subtle juxtaposition of different materials. While some artists do convey

a sense of the materials and subtle design features in their hermit-theme pictures, details such as tile floors (figs. 12, 14, and 19) or elaborate brackets and railings (figs. 17, 18, and 21) are distinctly Chinese. Although exhibiting the essential spirit, scale, roof configuration, and material of Momoyama *sōan*, there is no mistaking the fact that these painted pavilions are Chinese. No anomalous *tatami* or *tokonoma* creep into the pictures. In keeping with the figure subjects, the architectural setting is Chinese. Yet, by downplaying the large scale, tile roofs, bright colors, and ornate designs often featured in Japanese pictures of Chinese architecture,[75] Momoyama artists suggest a Chinese parallel or prototype for the Japanese *sōan*. The prestige of Chinese culture is preserved, but it is made congenial to Japanese taste.

The Combination of Chinese Figures

For all their similarities to Momoyama *sōan*, the pavilions in hermit-theme paintings are distinctly Chinese. More broadly, the landscape setting is meant to evoke China and, most significantly, the scholar-recluses who dwell there are Chinese. Despite the parallels to aesthetic reclusion as codified in *wabi* tea, these paintings depict China, Chinese history, and Chinese culture. But the China in these paintings is neither China as it was nor even as it was known in Japan. Rather, this is China as Japanese artists and patrons wanted it to be. Chinese history and culture are distorted to further the aims of Japanese patrons: to show off their knowledge, to increase their status, and to provide models as well as parallels for their own values. In short, Chinese culture is shaped into any form that helps further the aims of the Japanese doing the shaping. There is nothing unique about this aspect of Momoyama culture and painting; the Japanese had been manipulating continental culture virtually from the time they first had contact with it. We have already seen, for instance, how Murasaki Shikibu in *Genji monogatari* purposely "misreads" the stories of Bo Juyi and the Four Graybeards to utilize them as prototypes for her own characters.[76] The "*wakan* dialectic," in which the Japanese take the external forms of Chinese culture but invest them with new meanings, functions equally well in painting.

Figure painting, like literature and ritual, offers a way for cultures to rehearse a venerable past. In Momoyama Japan, this cultural watershed could sometimes be Japan of the Heian period, but more often it was Chinese mytho-history. Since for the Japanese the real value of the Chinese past consists of the ways in which it can be transformed, the rehearsal of Chinese culture in Momoyama figure painting is largely a matter of transfiguration. We have already looked unsystematically at several of these transfigurations, ranging from the pictorial pairing of

the Seven Sages and the Four Graybeards to the mix of historical figures and the generic scholars who participate in *kinkishoga* pictures. Whenever the Japanese mix and match Chinese subjects that do not go together in the Chinese tradition, we witness the Japanese transformation of China. In this section, we analyze three distinct but congenial ways in which Momoyama painters and patrons consciously revise Chinese history by rearranging historical figure subjects. We tentatively term these three strategies "paralleling," "joining," and "transforming."

"Paralleling" refers to the depiction of one figure subject in such a way that another subject is recalled. For example, we have observed how Eitoku, in his Jukōin *Four Accomplishments* panels (fig. 18), places several of his generic scholar-recluses in poses of *qin*-playing and waterfowl-viewing so that they are reminiscent of the historical *qin* player Boya and bird-watching calligrapher Wang Xizhi. Closely related is the effect of one historical subject doing something associated with another historical figure, as in Motonobu's depiction of two of the Seven Sages looking at waterfowl in the manner of Wang Xizhi in his Tokyo National Museum screens (fig. 3). Or, in the case of Tōgan's *Seven Sages* screens (fig. 12), two of the Sages pause from their *go* game to stare at a waterfall—an activity in Japan associated with the poet Li Bo.

In that paralleling suggests only a comparison and does not explicitly state that one figure is another, it does no damage to historical reality. Rather, it attaches a broader range of historical associations to any single subject. In the above cases, the implication is that Chinese scholar-recluses of different periods share an interest in aesthetic reclusion. Through paralleling, Momoyama artists make relatively subtle adjustments in the Chinese cultural norm to suggest newly fashioned meanings for old subjects.

By "joining," we mean the mixing or conjoining of historically unrelated but thematically similar subjects. As with paralleling, this type of transformation may be carried out by members of the very culture being transformed. For instance, the theme of the Four Admirers—the grouping of the third-century poet Tao Yuanming (aka Tao Qian) with the eleventh-century figures Lin Hejing (aka Lin Bu), Zhou Maozhu (aka Zhou Dunyi), and Huang Shangu—was likely the work of the Yuan dynasty poet Yu Ji. Yu joins these four historically unrelated figures in a poem, linking them at the thematic level on the basis of each man's passion for a particular flower. Japanese painters go a step further and paint the four men together—as if they existed at the same historic moment. When these four recluses are placed in a single landscape, as in Tōhaku's *fusuma* paintings of the *Four Admirers* (fig. 23),[77] the primacy of historical verity (in fact, all four men never existed in one place) is usurped by interpretative transformation (in the fictive realm of painting, the four

occupy the same setting). In short, fiction replaces fact as Japanese art-
ists create a dreamscape of the Chinese past. Because the historical
transformation does damage only to chronology but not to the standard
understanding of the subjects, as with paralleling the result actually is a
fairly innocuous broadening or deepening of conventional meanings.

Joining is evident in many Momoyama hermit-theme paintings.
Tōgan's *Tao Yuanming* and *Lin Hejing* screens (fig. 19) provide a rather
typical example of this technique for boosting thematic content.[78] Here,
the mood is of scholarly reverie in which the gentlemen-hermits enjoy
the harmonious life of the aesthete-recluse. Both Tao Yuanming and Lin
Hejing are seen to live in elegant *sōan*-style hermitages, where they are
surrounded by books, writing brushes, pots of wine, and other parapher-
nalia associated with lofty scholars. Not only is each man placed next to
his beloved plant (chrysanthemums for Tao and a plum for Lin), but
each figure gazes out into nature (Tao looking at a mountain and Lin at
one of his pet cranes). The pictorial pairing of Tao Yuanming and Lin
Hejing makes thematic sense because both men spent years as actual
aesthete-recluses—Tao in his country residence beneath five willow trees
and Lin on Gushan (Lone Hill) Island in the West Lake. By joining them
in a single pair of screens, Tōgan suggests the logical parallel in their
experiences. To Japanese of the late sixteenth and early seventeenth cen-
turies, it mattered little that Lin lived six hundred years after Tao, for the
two men were judged as functionally equivalent. Finally, in regard to
these screens, this pair may well be half of a set of screens depicting the
Four Admirers, with the ostensible other pair showing Huang Shangu
and Zhou Maoshu. Moreover, such a set of screens may well have been
structured around the four seasons—a favorite motif and ordering prin-
ciple in Japanese art. The picture of Lin Hejing takes place in winter
(indicated by the snow-covered mountain and the plum), while the
image of Tao Yuanming is set in autumn (more subtly suggested by the
one brown-leafed tree and the blossoming chrysanthemums). The hypo-
thetical matching pair of screens would feature Zhou Maoshu, whose
favorite flower was the summer-blooming lotus, and Huang Shangu with
his beloved orchid, a spring-blooming plant. The implicit seasonality of
the Four Admirers make this subject not only more appealing to Japa-
nese viewers, but, because Japanese so associated their own culture with
sensitivity to the seasons, a seasonal motif serves to suggest another
point of connection with venerable Chinese models.

Last, and most critical, is "transforming" or transformation. This is
the process of pairing or mixing subjects that are historically and (in
their original pictorial forms) thematically unrelated. Transforming is
the most culturally transgressive type of transfiguration in that the origi-
nal and normative meanings of themes are significantly altered. It is

through the transforming of Chinese figure subjects that the values of
Momoyama culture are most clearly revealed. The first type of trans-
forming involves transferring the theme of one subject to another. A
good example is found in the *Four Graybeards Returning to Court* and the
Wind and Water Cave screens (fig. 14) attributed to Kano Mitsunobu. The
clearly homoerotic subject of the *Wind and Water Cave* screen seems to
inform also the *Four Graybeards* painting, creating the thematic link
between the paintings even as it radically alters the standard interpreta-
tion of the Four Graybeards story.

In a second type of transforming, different subjects are mixed or
paired to suggest a new theme, which may differ slightly, or significantly,
from the original meaning attached to either of the conflated subjects.
For example, we have analyzed how the pairing of the Seven Sages and
the Four Graybeards, together with the paralleling of activities associ-
ated with other scholar-recluses or the *kinkishoga* theme, functions to
turn these subjects from ones that express the values of neo-Daoist self-
exploration and Confucian ideals of withdrawal and service, respectively,
to complex, hybrid themes that combine those original meanings with
the larger "metatheme" of aesthetic reclusion.

The alteration of meaning and cultural transformation seen in paint-
ings of the Seven Sages and the Four Graybeards has minor precedent in
the Japanese literary tradition, where the two subjects are paired to
stand as emblems of pure wisdom and august appearance. Purely picto-
rial transfiguration is evident in the combination of Chinese figure sub-
jects to produce entirely original painting themes. Typically, this thematic
hybridization is witnessed in pictures that pair or mix Daoist and Confu-
cian subjects.[79] A dense expression of transforming is found in Kano
Takanobu's (1571–1618) four *fusuma* panels of the *Four Accomplish-
ments* (fig. 24) in the Seattle Art Museum.[80] Spread over the left three
panels, and occupying a landscape setting enclosed by an ornate balus-
trade, are five scholars engaged in the four scholarly pastimes. The *kink-
ishoga* theme begins in the second panel, where a scholar in the water-
side pavilion plays the *qin* while a companion listens. This man leans
against the pavilion rail, an open book of calligraphy resting on his lap.
Two scholars play *go* in the third panel. And, in the fourth, a scholar
gazes at a landscape painting held by a teenage servant. The paired
arrangement of all but one of the scholars indicates the spirit of commu-
nitas. The octet of fair-skinned and ruby-lipped boy attendants implies a
homoerotic element, even as their combination with the elderly sages
also suggests a sacred character. The crowded setting, with large pines
and several species of flowering plants, as well as dramatic greenish
rocks, is far from wild but still evokes the fusion of these elegant scholars
with nature. The table, attended by a moon-faced lad, is laden with a lac-

quer box, bronzes, a celadon cup, and a large dish filled with food or per-
haps flowers. These scholars are evidently collectors of antiquities.

In the spirit of transformation typical of Momoyama hermit-theme
painting, Takanobu adds two rather curious figures. In the third panel,
where two scholars bend over the *go* board, another man looks on from
behind the left *go* player. Although dressed in the same scholar's cap and
rich gown as his companions, this man holds an ax against his right
knee, and two bundles of firewood rest behind him. This figure is Wang
Zhi, the legendary woodcutter who, after stumbling upon some old men
playing *go* deep in the mountains, fell into a trance. Upon awakening, the
rotted condition of his ax handle indicated that more than one hundred
years had elapsed. The story of Wang Zhi and his ax had been known in
Japan since the Heian period and had even been featured in medieval
drama.[81] Wang Zhi's presence here, although thematically unrelated to
the *kinkishoga,* makes some narrative sense because of his connection to
watching men play *go.*

An even more anomalous figure in the paintings is the Daoist
immortal Zhang Guolao (Chōkarō), a Tang dynasty magician associated
with the emperor Xuanzong (Gensō). Zhang Guolao was known for his
magic horse, kept in a gourd, with which he reportedly entertained
Xuanzong's court. Here, Zhang Guolao uses his miniature horse to enter-
tain two children—a connection between a man and children echoing
that of the scholar in the pavilion who holds open a book for two chil-
dren, and the scholar in the leftmost panel who is flanked by two boys.

At first blush, the transformation of the erudite *kinkishoga* subject
resulting from the addition of Wang Zhi and Zhang Guolao would seem
to weaken the theme of aesthetic reclusion—devotion to scholarly pur-
suits, communitas, and appreciation of nature—usually associated with
the subject.[82] The painting certainly contains novel combinations that
lead us to question its meaning. However, it is too facile to suggest that
the transforming combination of themes unrelated in China results in
the primacy of decorative appeal. By including Zhang Guolao in a schol-
arly setting, Takanobu seems to imply that even Daoist immortals belong
to the world of aesthetic reclusion characteristic of so many of their
countrymen. Moreover, the insertion of Zhang Guolao and Wang Zhi—
figures emblematic of immortality and extreme longevity, respectively—
suggests that the scholar-recluses engaging in scholarly pastimes are also
imbued with an aura of magic and eternal life. Finally, the synthesis of
Confucian, Daoist, and folk themes in this painting demonstrates the
breadth of the Chinese cultural experience. Elevating yet entertaining,
eminently ethical but also embracing magic, the twin pillars of Confu-
cianism and Daoism—the core of Chinese civilization—are linked through
the alternate order of aesthete-recluses living together in nature.

Commencing in the late fifteenth century, the three front rooms of the *hōjō* (abbot's quarters) of Zen temples usually featured *fusuma* paintings. While Muromachi and early Momoyama period *hōjō* typically included landscape, bird-and-flower, and figure subjects, beginning around 1600, specifically Daoist and Confucian figure subjects were commonly painted in two of the three rooms.[83] While many examples of this tendency can be observed in *hōjō* from the mid-seventeenth century, very few *hōjō* remain from the late Momoyama. Ōnishi Hiroshi has argued that the four *fusuma* panels recently acquired by The Metropolitan Museum of Art were painted in 1606 for the wall separating the Shitchū (middle room) and the Danna no ma (master's room), the central and east rooms at the front of the Hōjō at Ryōanji, Kyoto.[84] The panels forming the west wall of the Shitchū depict a *Flying Immortal* observed by other immortals (fig. 25) and compose four of the sixteen *fusuma* of Daoist immortals, which originally filled the room. On the back of these panels, forming the east wall of the Danna no ma, are pictures of *Scholars Reading a Scroll* (fig. 26), which make up four of twelve *kinki-shoga* panels originally in that room.

Ōnishi points out that when we consider the pictorial scheme of the entire Hōjō, adjacent rooms showing Daoist immortal and scholar-recluse themes combine to present "dioramas" that place the patron and other viewers within the "paradise of a scared past."[85] Thus, the pairing or mixing of Daoist and Confucian subjects, seen in Takanobu's Seattle *Four Accomplishments* panels and other *fusuma* sets,[86] were a rather standard feature in the *hōjō* complex. Although each room could be read in terms of its specific theme, when the viewer mentally integrated these different subjects, the result was a broad image of Chinese mythohistory —an encyclopedic and utopian view of Chinese culture demonstrating the sophisticated knowledge and control over the Chinese past by the Japanese elite.

The Implications of Style

Relative to questions of meaning, issues of style in Momoyama screen and *fusuma* paintings are well studied. Momoyama painting usually is divided into two basic styles based on material: ink monochrome, and polychrome on gold.[87] In a world where pictures were generally painted in ink or in polychrome on gold, the choice of materials was vitally important.[88] In screen and *fusuma* painting, ink monochrome was often employed for pictures of the Seven Sages and the Four Graybeards on Mt. Shang, while the subject of the Four Graybeards Returning to Court was invariably rendered in color on gold. In the many Kano school

fan paintings of the period, these stylistic-thematic divisions are absolute. Among extant Momoyama and early Edo period *fusuma* and screens, in only a few works—such as Sanraku's *Four Graybeards on Mt. Shang* (fig. 13)—is a reclusion theme rendered in polychrome on gold.[89]

Clearly, ink monochrome, along with ink and light color, were materials considered appropriate for pictures of figures in reclusion. Ink painting is associated not only with Chinese landscape, the setting for these figures, but it is also the style associated with those Chinese figures noted for their unconventional behavior. While emperors and famous philosophers, notably Confucius and his disciples, were typically rendered with fine ink outlines and color in-fill,[90] figures known for individualistic or eccentric personalities were usually brushed in a looser, more expressive monochrome style. This tradition, associated in Japan with the Southern Song artist Liang Kai (fl. early 13th c.) and adapted by Sesshū Tōyō (1420–1506), flourished in the Momoyama period in the ink monochrome paintings of Tōhaku (fig. 10), Tōgan, and Yūshō. Tōgan's Ōbaiin *Seven Sages fusuma* (fig. 11) present a tour de force revival of the expressive Liang Kai style: the two Sages under a pine on the east wall are rendered with incisive nail-head-stroke and wire-taught-line convention that imparts a sense of steely determination and rigorous virtue to them; in contrast, the three sages on the west wall—particularly the man casually brushing a poem on a rock—are depicted with gentle, fluid lines that suggest rather more congenial personalities. In large-scale ink monochrome work paintings, Kano painters such as Motonobu (fig. 3), Eitoku, and Yasunobu (fig. 15) employ a stylized, conservative version of the Liang Kai mode in which the sharp-edged drapery folds and "nervous" jagged outlines are turned into a stylistic shorthand for Chinese figures, whether Zen priests or scholar-recluses.[91] In pictures of (small) figures in landscapes, Motonobu (fig. 17) and Eitoku (fig. 18) utilize the descriptive fine-line-and-color style. Tōgan generally adapts this mode of brushwork in his ink and light color figure-in-landscape paintings (figs. 12 and 19), as well as in his large figure works.

When using either the expressive Liang Kai style or the descriptive fine-line-and-color style, Japanese artists are working in well-established Chinese modes. By adapting old styles, Japanese artists formally evoke the Chinese past. For instance, the "spontaneous" brushwork in Tōgan's Ōbaiin *Seven Sages* not only expresses the character of the various sages but, by nature of its own associations with pictures of other Chinese figures and great continental artists of the past, serves to evoke more deeply the world of Chinese learning. That Momoyama artists such as Tōgan could paint in styles associated with great masters like Liang Kai and, even more important, wave the brush in a manner perhaps not too dis-

similar from that of the lofty Chinese scholars who are their subjects, creates an intimate connection between the style and the content of hermit-theme painting.

In the case of the controlled, inexpressive fine-line-and-color mode, the associations of this style also connect it to Chinese antiquity. First, strong, clear, and detailed brushwork invests pictures of historical subjects with a kind of formal authority. James Cahill has written that "well-made" paintings of political themes "objectified that message, gave it the status of an embodied truth, a kind of prestige of permanence."[92] Second, and to quote further from Cahill, "Paintings could invest some practice with the authority of classical precedent, by depicting it in an image that recalled an antique parallel."[93] Once the parallel is created—the style used in the Japanese present echoing an established one from the Chinese past—the events depicted attain a universality that deepens the viewer's connection to them.

Painting in color on gold carried its own set of associations in Momoyama Japan. The material wealth and opulent taste indicated by gold and bright mineral pigments evoke court culture. The equation of gold and bright color with court subjects applies not only to pictures of native court culture but also to scenes of the Chinese Han and Tang courts. Thus, when Momoyama artists paint the Four Graybeards returning to the court of Han Gaozu, the "appropriate" polychrome-and-gold style is employed. Besides the screen attributed to Mitsunobu (fig. 14), several anonymous polychrome-and-gold screens show the Four Graybeards Returning to Court paired with themes of amusements at court.[94] Watanabe Ryōkei's wall paintings in the Taimensho of Nishihonganji (figs. 27, 28, and 29), analyzed formally and contextually in the following section, provide a dramatic example of polychrome and gold for court subjects, including the Four Graybeards Returning to Court.

While polychrome and gold make sense for courtly scenes, how can we understand the same materials when used for pictures of scholar-recluses or Daoist immortals in nature? In Takanobu's *Four Accomplishments fusuma* (fig. 24), Sanraku's *Wenwang Summoning Taigong Wang* and *Four Graybeards on Mt. Shang* screens (fig. 13), and the Kotonobu-attributed *fusuma* of *Flying Immortals* and *Scholars Reading A Scroll* (figs. 25 and 26), why do the artists employ gold foil for clouds and areas of ground? In part, no doubt, this stylistic choice is "decorative." The expense and reflective quality of the material suggests the wealth of the patron even as it brightens shadowy interiors. But we do well to consider decorativeness as one aspect of a painting, not as a final judgment on a painting's significance or lack of it. Decorativeness does not preclude other meanings.

Ōnishi Hiroshi, following the standard interpretation of Momoyama

painting, suggests that the dynamic, opulent effect of painting on gold could be a shift from the "retiring, meditative mood of the medieval monastic world to one based on positive, dominating human action and optimistic worldly desire."[95] While Ōnishi and others identify one characteristic of Momoyama culture, the fact remains that monochrome depictions of Chinese scholar-recluses and immortals continued to form a major part of the orthodox pictorial repertory of the Kano, Unkoku, and Kaihō schools well into the seventeenth century. More than indicating a shift to some broad Momoyama *weltanschauung*, the use of gold for recluse subjects more likely indicates the artist's attempt to place these figures in a paradisical or other-worldly setting.

Four *fusuma* panels attributed to Kano Sansetsu (1590–1651) show the *Eight Daoist Immortals* (fig. 30) and offer a first-rate example of the kind of golden dreamspace so frequently encountered in Momoyama painting.[96] Gold flattens the pictorial surface, dissolving or denying any illusion of three-dimensional space, and abstracts the figures from their surrounding. Largely freed from the spatial context of a convincing landscape or interior setting, and metaphorically detached from any specific context within Chinese history, this group of elegant immortals serves more dramatically as an emblem of Chinese culture.

In Sansetsu's *Eight Daoist Immortals fusuma*, as in the other Chinese figure subjects rendered in this style, the abstracting power of gold acts as a physical agent of thematic transformation. Although radically different in appearance, in effect this gold is similar to the "white," unpainted expanses of *fusuma* in Tōgan's Ōbaiin *Seven Sages* (fig. 11), Tōhaku's Shinjuan *Four Graybeards* (fig. 10), and Yūshō's Kenninji's *Seven Sages*. With the result that these Daoist immortals are less part of Chinese religious tradition and more symbols of the prestige and power of Chinese learning and longevity, the flat expanse of gold echoes the "theme-enhancing" strategies of paralleling, combining, and transforming. In essence, the flat but dense gold ground provides a visual metaphor for the flattening of historical specificity but enriching of meaning also created by thematic emphasis on aesthetic reclusion.[97]

Two Sites: Azuchi Castle and the Nishihonganji Taimensho

To this point, we have talked in general terms about the significance of Momoyama paintings of Chinese scholar-recluses epitomized by the Seven Sages and the Four Graybeards. We have determined standard motifs and meanings within a cross-section of representative works, and we have analyzed the broad significance of these paintings within the general configurations of Momoyama culture. As stated at the beginning of this chapter, this methodology is largely dictated by the lack of prove-

nance for virtually all screen paintings and for the many *fusuma* long
removed from their original locations. Even when the paintings remain
in their original context, usually within the *hōjō* of a Zen subtemple, it is
difficult to determine exactly how the patrons or occupants of that space
understood (and were meant to understand) the paintings around them.[98]

To broaden our analysis of paintings of the Seven Sages and the Four
Graybeards in the Momoyama and early Edo periods, in this section we
will analyze paintings of our themes at two sites—the warlord Oda Nobu-
naga's Azuchi Castle and the Taimensho (audience hall) at the temple
Nishihonganji. In these cases, we not only know where these subjects
were placed and how they were arranged vis-à-vis other subjects, but,
because we can also make reasonable assumptions about the function of
these rooms, the specific implications of the themes become somewhat
more apparent. However, given the massive scale and the site-specific
function of the painting cycles at both Azuchi Castle and the Nishihon-
ganji Taimensho, Chinese figure paintings there are probably not para-
digmatic of all Momoyama pictures of the Seven Sages and the Four
Graybeards. A plush audience hall and the private room atop a castle
present spaces substantially different from those in a Zen *hōjō*, aris-
tocratic villa, or tearoom. Nonetheless, these two sets of Chinese figure
paintings offer considerable insight into possible readings of our subjects.

Despite the preponderance of polychrome-on-gold paintings by
Kano school artists at both locations, Azuchi Castle and the Taimensho
at Nishihonganji stand at opposite poles of Momoyama painting. First,
and most obviously, the paintings at Azuchi are not extant, as they
burned, along with the castle, in the summer of 1582; the paintings at
Nishihonganji are in an excellent state of preservation. Ironically, al-
though they no longer exist, the Azuchi paintings are relatively well
documented in Momoyama sources and often discussed by modern
scholars; the Nishihonganji wall paintings, in stark contrast, have no
documentation, are little studied, and, until recently, their provenance
was the subject of considerable speculation. Second, the two sites
bracket the Momoyama epoch: the Azuchi Castle project of 1576–1581
began the great age of Momoyama period large-scale commissions by
the Kano school; the Taimensho at Nishihonganji, painted circa 1630–
1632, is one of the last great commissions by the Kyoto branch of the
Kano school. Third, the paintings at Azuchi were made for a military
patron during a time of warfare and national disunity; the paintings at
Nishihonganji were intended for priestly patrons during a period of rela-
tive peace. Finally, the cycle of Chinese figures painted at Azuchi Castle
culminates with pictures of the Seven Sages and the Four Graybeards
(presumably on Mt. Shang); the Nishihonganji Taimensho features the
Four Graybeards Returning to Court.

Azuchi Castle is one of the most important structures of the Momo-yama period, a role signaled by the traditional name for the period—Azuchi-Momoyama. When Oda Nobunaga began construction in 1576, and commissioned Eitoku and his atelier to paint the *fusuma* and walls on five of the six floors, he initiated not only an age of castle building but also one of massive painting cycles. Hideyoshi's Osaka Castle (1585), Jurakudai (1587), and Fushimi Castle (1594) all featured Kano school paintings. Because there are neither written records of these designs nor extant paintings (the buildings and their contents were either burned or dismantled), the descriptions of Azuchi provide the only evidence of late-sixteenth-century castle painting. We can assume, however, that most castles imitated Azuchi by including Chinese historical subjects.[99]

Incinerated two weeks after Nobunaga was murdered by Akechi Mit-suhide (1526–1582) on the second day of the sixth month in 1582, Eitoku's paintings at Azuchi were in place for less than one year after they were completed. Yet, the spectacular nature of the castle design and the paintings has led both Momoyama and modern writers to discuss them at length. Modern scholarly interest in Azuchi Castle was rekindled when Naitō Akira published a massive study and hypothetical recon-struction of it in 1976.[100] Naitō bases much of his analysis on the descrip-tion of the castle interior in Ōta Gyūichi's *Shinchō kōki* (Record of Nobunaga), in the recently discovered *Tenshu sashizu* (Specification Plans of the Castle), and on the general impressions of the Jesuits invited there by Nobunaga.[101] In "A Visualization of Eitoku's Lost Paintings at Azuchi Castle," Carolyn Wheelwright suggests the appearance of these works by surveying extant Kano paintings of the same themes. While Wheelwright devotes most of her attention to extant images of figure and bird-and-flower themes found on the lower floors, the more recent-ly published *Maboroshi no Azuchijō tenshu fukugen* presents pictorial "recreations" of the figure subjects on the two top floors.[102]

As noted often by Jesuit and Japanese visitors alike, Nobunaga intended Azuchi Castle as a physical manifestation of his military and political control of the nation, and also as a symbol of his self-pro-claimed divinity. Nobunaga's self-apotheosis as *shintai*—the living "body of the god"—was expressed in the castle design and painting program.[103] A stupa dedicated to Prabhutaratna (the Buddha who originates from the ground and occupies the center of the cosmos) extended from the basement to the second floor, and may have been matched symbolically by a first-floor room dedicated, with a pile of stone arranged on a plate, to the "popular *Shintō* deity *Bonsan*."[104] The Buddhist element intro-duced by the stupa is continued in the paintings for the "chapel" on the fifth floor.

Of the seventeen rooms with wall paintings, eleven were composed

of bird, flower, and animal subjects, one was devoted to Buddhist sub-
jects, and five featured Chinese-figure themes. Because Gyūichi's descrip-
tions are very general and later recreations are equally speculative, any
pronouncement on these pictures is tentative. However, a review of the
placement of pictorial subjects suggests how Chinese historical subjects
may have been deployed to express Nobunaga's vision of total cultural
and political supremacy.

The Taimensho on the first floor, where Nobunaga would conduct
official audiences, was divided into four-, six-, and eight-mat rooms. In
the southeast section was an eight-mat room with ink monochrome pic-
tures of Confucian scholars. Wheelwright speculates that these pictures
may have been similar to Eitoku's Jukōin *Kinkishoga fusuma* (fig. 18),[105]
but, given the generic nature of Gyūichi's description, the pictures may
have depicted figures larger than those at the Jukōin. Of the seven
painted rooms on the second floor, a twelve-mat sitting room featured an
image of Xiwangmu (Seiōbo), the Daoist "Queen Mother of the West."
Wheelwright hypothesizes that Xiwangmu was paired with Dongwang-
gong (Tōōkō), the "King Father of the East"—a theme illustrated in a
pair of screens by Yūshō at Jōshinji, Shiga.[106] It is also very possible that
the room showed Xiwangmu presenting the peaches of immortality to
Han Wudi—a theme painted by Motonobu's atelier at the Daisen'in at
Daitokuji and by Ryōkei at Nishihonganji.[107]

On the north and south flanks of the second floor were the eight-mat
Room of Sages (Kenjin no ma) and Room of Immortals (Sennin no ma),
both painted in color on gold. In the Room of Sages, Gyūichi describes a
figure producing a horse from a gourd. This is surely the immortal
Zhang Guolao, a figure who would seem distinctly out of place in a
picture of *kenjin*—a term that implies Confucian worthies—if it were not
for the Myōhōin *fusuma* and Takanobu's Seattle *Four Accomplishments
fusuma* (fig. 24), in which Zhang and his horse also make appearances
among scholar-recluses. In the Room of Immortals, Gyūichi mentions
Lu Dongbin (Rodōhin), a former scholar-official included among the
Eight Immortals. In some paintings, he is seen wearing a voluminous
robe as he rides over waves holding a sword, but in Kano school *fusuma*
at Nanzenji and Kōdaiji, he receives a secret scroll from Zhongli Quan
(Shōriken).

Among the seven rooms of the third floor, an eight-mat room on the
east side includes pictures of Xu You washing his ears and Chaofu lead-
ing his ox homeward. Gyūichi mentions that their native village is also
pictured—an iconographic detail not found in the pair of hanging scrolls
attributed to Eitoku in the Tokyo National Museum or in any other
extant paintings. The necessity of filling the large expanse of a wall panel
may well have led in part to the introduction of this genre detail.[108]

While the placement of Chinese figure paintings on the first several floors of Azuchi Castle is rather desultory, Nobunaga's symbolic program begins in earnest on the fifth floor. It almost seems as if the occasional Chinese subjects among the preponderance of rooms painted with bird-and-flower themes serve as light appetizers before the rich iconographic stew served in the single rooms on the fifth and sixth floors—the top-most levels of the castle and its symbolic climax. More specifically, the progression of themes on these lower floors from generic scholars (first floor), to Daoist immortals (second floor), then to Confucian paradigms of virtuous reclusion (third floor) may signal the supremacy of this last theme when painted again on the topmost level.

On the octagonal fifth floor was a Buddhist chapel complete with depictions of Shakyamuni Establishing the Law, Shakyamuni Preaching the Law, and the Ten Great Disciples; images of hungry ghosts and demons were depicted in the gallery. Although Gyūichi lists paintings of celestials on the ceiling and dragons on the pillars of the next floor, the *Tenshu sashizu* describes these images in the Buddhist chapel, a more appropriate setting. In the Buddhist culture of Momoyama period Japan, we might assume that the Buddhist images in the chapel would form the climax of the castle. But Nobunaga, often an enemy of Buddhist sects, surmounted this chapel with a room in which Eitoku was commissioned to paint the greatest patriarchs of Chinese civilization.

Gyūichi writes that both the exterior and interior of this crowning room were gilded. We can thus assume that the paintings inside were in color on gold. The interior presented a diorama of Chinese mythohistory with a parade of culture heroes painted in the eight one-bay spaces on the walls between the doorways (diagram 1). Gyūichi describes the room as portraying the Three Emperors, the Five Sovereigns, the Ten Disciples of Confucius, the Four Graybeards of Mt. Shang, and the Seven Sages of the Bamboo Grove. The *Tenshu sashizu* specifies the subjects: north wall east side—Duke of Zhou; east wall north side—Ten Disciples of Confucius; east wall south side—Confucius; south wall east side—Shennong and Fuxi; south wall west side—Huangdi (Yellow Emperor); west wall south side—Laozi; west wall north side—Wen Wang in His Carriage; north wall west side—Taigong Wang.

The northern half of the room and one part of the east wall are reserved for Confucian subjects, while the southern walls are given over to Daoist themes. All of these painting subjects are listed in the *Seiken* (Sages and Saints) chapter of Kano Ikkei's *Kōsoshū*.[109] Chronologically, the parade of patriarchs begins on the south wall with the three men to whom Chinese legend credits the founding of civilization. Next comes Laozi, the founder of Daoism and Chinese philosophy. Beginning on the north portion of the west wall, Confucian themes commence with the

Diagram 1. Arrangement of Kano Eitoku's paintings on the sixth floor of Azuchi Castle, based on *tenshu sashizu*.

virtuous first emperor of the Zhou, his prized advisor the reclusive Tai-gong Wang, and then the paragon of good leadership, the Duke of Zhou. According to *Tenshu sashizu*, the east wall shows the Ten Disciples and then Confucius. Because this arrangement is chronologically awkward, the order may have been reversed.

Gyūichi's account in *Shinchō kōki* describes paintings of the Seven Sages of the Bamboo Grove and the Four Graybeards of Mt. Shang, subjects not mentioned in *Tenshu sashizu*. Naitō speculates that they may have been painted on wooden panels above the doors on the east and west walls.[110] Because they are not listed on the ground plan but were observed by Gyūichi, it is possible that the Seven Sages and the Four Graybeards were painted on screens in the manner of Motonobu's Tokyo National Museum screens. If indeed painted on screens, the Seven Sages and the Four Graybeards may not have been originally intended for this space, but moved up prior to Gyūichi's visit. If we can accept, however, that the images of the Seven Sages and Four Graybeards—in whatever format—were meant for the sixth and top floor of Azuchi Castle, how can we account for their placement in such illustrious company?

The most prosaic explanation would hold that the Seven Sages and the Four Graybeards are included simply because of their status as famous worthies from Chinese antiquity—worthies well known in the Kano repertoire. This type of reductive explanation, in which all Chinese subjects are reduced to being old, Chinese, and therefore venerable, would deny any specific connotations to these subjects or to their arrangement in the room. Another explanation, assuming considerable sophistication by the painter Eitoku and the patron Nobunaga, holds that the paintings on the top floor of Azuchi Castle constituted a subtly worked out program that elucidates the principles of Nobunaga's claim to ultimate authority. Beginning with the Three Emperors mentioned first by Gyūichi, the diorama begins with the three mythic sage emperors credited with founding Chinese civilization. Laozi, associated with establishing Daoism and the foundation of Chinese philosophy, is next in this visual history. The subsequent five wall panels depict famous Confucians, both models cited by Confucius, as well as the philosopher and his disciples. After the founders of civilization and metaphysics, we witness the creators of ethical and "legitimate" government.

Whether painted on free-standing screens or in the smaller spaces above the doors, the Seven Sages and the Four Graybeards are somewhat separated from the larger spaces reserved for the patriarchs of Chinese culture. Moreover, they are placed in tandem as paired themes. We have noted earlier that these subjects, so disparate in meaning in China, were linked in Japanese painting on the basis of the shared trait of group reclusion in nature. Thus, if we can assume that the subjects here represent ideals of world rejection implicit in eremitism (as they seem to in Motonobu's screens and most other Momoyama examples), then the Seven Sages and the Four Graybeards may well function as the thematic conclusion to the entire mythohistoric picture cycle.[111]

This room, the crowning glory of Nobunaga's claim to status as a living divinity, is a statement about his knowledge of the Chinese past, his equality with its patriarchs, and, finally, his understanding of its essential philosophy of statecraft: that the legitimate and divine monarch, one who ruled in the name of Heaven, was fit to rule because of his virtue. In chapter 3, we have already seen that for Nobunaga the idea of ruling in the name of "public good" *(kōgi)* was best expressed through the practice of arts such as tea, which, at the symbolic level, posited a rejection of the very political authority that the ruler sought to possess. As we have also shown, pictorial themes such as the Seven Sages and the Four Graybeards functioned as a pictorialization of the aesthetic reclusion that was the ultimate expression of personal virtue. In this light, it is reclusion—as symbolized by the Seven Sages and the Four Graybeards, and foreshadowed in the pictures of Wen Wang and Taigong Wang—that

brings the diorama at the top of Azuchi Castle into the most direct and intimate relation with the practice of political legitimation so essential to Momoyama statecraft. We do not know if Eitoku placed all of his figures atop Azuchi Castle in a connected setting, or, in the manner of the paintings of Confucian sages in the imperial palace, presented them without background. In either case, the close presence of various culture heroes, tied together by the decontextualizing effect of gold leaf, created an abstracted and politically potent rehearsal of Chinese history into which Nobunaga placed himself.[112]

At Azuchi Castle, the mix of historical Confucian themes with legendary figures such as Shennong or Huangdi is an example of the transformation strategy repeated in many Momoyama paintings. The Taimensho at Nishihonganji (figs. 27, 28, and 29) presents a related mix of Daoist and Confucian themes. But, rather than creating a broad historical panorama, the wall paintings here display three separate but resonant themes unified through a similar setting. The interpretation of these paintings is largely dependent on their function. However, any discussion of the Taimensho and its paintings must begin with the clouded history of the building.

Temple legend has long held that the oldest and most famous structures at Nishihonganji—including the National Treasure Karamon (with its carvings of Xu You and Chaofu), Hiunkaku, nō stage, and massive Shoin, including the Taimensho—came from Toyotomi Hideyoshi's Fushimi Castle. The genesis of this legend stems from the historical relation between the temple and Hideyoshi. To make peace with the powerful Honganji priests, in charge of the powerful Jōdo Shinshū (True Pureland) order, and to unseat them from their impregnable temple-fortress at Ishiyama Honganji in Osaka, Hideyoshi in 1591 donated land between Rokujō and Shichijō avenues in the center of Kyoto for a huge new temple. In 1602, when the Tokugawa came to power with the defeat of the Toyotomi forces at Sekigahara, Tokugawa Ieyasu encouraged a schism within the Honganji hierarchy, with the result that the new pro-Tokugawa Ōtani branch built a rival temple several blocks to the east. Since the new temple was called Higashihonganji, the main temple came to be known as Nishihonganji. Most buildings at Nishihonganji were destroyed in a great fire of 1617, and rebuilding started several years later. The connections of the temple to the Toyotomi clan, together with the fact that Fushimi Castle was dismantled in 1615 after the defeat of the Toyotomi at the battle of Osaka Castle, led to the legend that the grandiose Shoin and other important structures at Nishihonganji had been transferred from Fushimi.[113]

In recent decades, most scholarly opinion holds that the entire Shoin, including the Taimensho, most likely was built 1630–1632.[114] The

paintings in the Taimensho and attached rooms of the Shiroshoin are attributed to Watanabe Ryōkei (d. 1645), a pupil of Kano Mitsunobu, who may have been aided by Kano Naonobu (1607–1650) and other members of the Kano school then working in Kyoto. The massive size of the project and the intricacy of the painting indicate that several artists were involved over many years. In addition to the Taimensho, attached rooms painted around the same time include the Chamber of Wild Geese (Gan no ma) and the Chrysanthemum Chamber (Kiku no ma), named after the themes painted there, as well as the three rooms of the Shiroshoin, featuring bird-and-flower subjects and exemplary emperors from the *Teikan*.

The Taimensho is remarkable for its imposing 203-*tatami*-mat size (the largest extant *shoin*-style room), the ornate floral designs painted on the ceiling panels, and the crane motifs—painted on the side walls and carved into the transoms—from which the Taimensho derives its nickname, Room of Great Birds (Kō no ma).[115] While bird-and-flower motifs are employed for the large *gedan no ma* area, the raised *jōdan no ma* at the north end of the Taimensho is painted with Chinese figures subjects, featuring the *Four Graybeards Returning to Court* in the *tokonoma* alcove at the center. The *jōdan no ma* is designed in the large *shoin* style, with *chōdaigamae* tasseled doors on the west, a massive *tokonoma* in the center, and the raised *jojōdan no ma*—with *chigaidana* shelves and *tsukeshoin* desk—on the east.

The scale and opulence of the room contributed to its legendary origins at Fushimi Castle. However, based on the large size of similar *shoin*-style audience halls at temples such as Chion'in, headquarters of the Jōdo sect, as well as the tremendous wealth of Nishihonganji, the magnificence of the Taimensho is not out of place.[116] Moreover, given the competition of Nishihonganji with its nearby rival Higashihonganji, the impressive scale and pictorial subjects serve a clear purpose: to proclaim the power and legitimacy of the main branch of Jōdo Shinshū. The Taimensho was used during formal audiences in which priests would gather on the large lower *gedan no ma*, while the abbot, his heir apparent, and members of his family would sit on the higher *jōdan no ma* at the front of the hall. The appended *jojōdan no ma*, glimpsed from in front through a window shaped like a ceremonial fan, may have been used as a waiting alcove. Or, because of its *tsukeshoin* desk and *chigaidana* shelves as well as the direct light and view of the garden, it may have been used at other times as a study or relaxation area.[117]

The *jojōdan no ma* (fig. 29) begins the pictorial cycle of figure themes at the north end of the Taimensho. Painted on four small panels, at the base of the latticed sliding doors above the *tsukeshoin* on the east wall, are two young boys who walk toward a group of three youths playing *go*

beneath red and white peonies. In that these boys play *go*, one of the themes associated with the *kinkishoga*, and because the picture is above the *tsukeshoin* desk, the theme of scholarly accomplishment is subtly integrated into this study area.[118] The theme of Chinese children at play *(karako asobi)* is developed in the space below the *chigaidana* on the north wall. Here, under a flowering cherry, three boys frolic with peonies, apparently taken from the peony bush painted on the closest panel of the east wall. The ground where these boys play continues into the two *fusuma* panels at the easternmost portion of the *jōdan no ma*. The cherry bough under which they sport is part of the tree in the adjacent *fusuma*, beneath which three official retainers and two servants stand in discussion. The next panel, showing a palace gate, marks the transition to the central *tokonoma* and leads us to the key image in the entire room.

In this massive picture plane, Ryōkei paints the *Four Graybeards Returning to Court* (fig. 28). Entering the scene from the east, as if they had just passed through the gate in the previous scene, are the Four Graybeards. A blossoming plum emerging from a weathered crag echoes their movement and suggests the rejuvenation of these aged worthies. The Graybeards are led by an official, likely Zhang Liang who fetched them from solitude on Mt. Shang. At the west side of the *tokonoma* is the palace where the crown prince Hui perches on a throne. Three servants attest to his preeminence. To the right of the future monarch is the emperor Gaozu, who sits gazing at his son with paternal admiration. The splendid palace features towering rocks, peonies, pines, and peacocks.

In the next scene, painted on the four *chōdaigamae* doors at the west side of the *jōdan no ma*, we encounter *Xiwangmu Presenting the Peaches of Immortality to Han Wudi* (fig. 27). A verdant pine surrounded by red and white peonies pulls the viewer into this scene from the *tokonoma*. Beneath a pine bough and in a garden enclosed by a balustrade, Wudi assumes a pose like that of his ancestor Gaozu in the previous scene. He is flanked by two attendants and looks toward the next panel, where Xiwangmu sits in a mirrored pose. An attendant walking toward Wudi bears a tray laden with the magical peaches that are the focus of this subject. Three of the Queen Mother's ladies-in-waiting bring the composition to a close. The retinue of Xiwangmu continues in the four *fusuma* that constitute the west wall of the *jōdan no ma*. In one panel, a single lady stands on a bridge, while five others loiter in the two panels that conclude the painting cycle.

At the most general level, the pictures in the *jōjōdan no ma* and *jōdan no ma* express a sense of regal elegance and power. The gold foil and clear brushwork, the auspicious plants, and the imperial themes combine to create a royal space that clearly distinguishes the elevated status

of its inhabitants from that of the priests seated below. More specifically, Ryōkei's paintings are a tribute to the prestige of the abbot, his family, and the heir apparent. Moving geographically and chronologically from east to west, we encounter children playing in the *jōjōdan no ma*, a teenage heir in the central *tokonoma*, and an emperor and "empress" on the front of the *chōdaigamae*. We can well imagine the abbot and his family seated in their appropriate places along the *jōjōdan no ma* and *jōdan no ma* while an assembly of priests looked on.[119] Han Wudi and Xiwangmu are even presented as a familial pair: seated, flanked by attendants, dressed in similarly regal robes, and with Xiwangmu virtually unrecognizable as a Daoist goddess.[120]

This combination of didactic Confucian and auspicious Daoist themes conjoined in a "family portrait," encompassing the two pillars of Chinese culture (and both contained in stories about early Han emperors), may well express the abbot's wish for the continuation of lineage. The picture of the *Four Graybeards Returning to Court,* with its theme of sage advisors paying tribute to a legitimate heir, has a clear message of obedience to the successor apparent. The picture of *Xiwangmu Presenting the Peaches of Immortality to Han Wudi* presents the theme of a monarch receiving a gift from a divine leader. Here, the message could be one of divine intervention in the choice of a successor or, perhaps, the receiving of patronage from imperial or shogunal authorities. Moreover, because the picture also indicates the immortality of Han Wudi, another implication might be that the proper succession indicated by the presence of the Four Graybeards will continue for myriad generations.[121]

More research is needed to determine if there was a succession battle at Nishihonganji when the Taimensho was painted. Even without this knowledge, the schism within the Jōdo Shinshū leadership just a generation earlier, as well as the internecine battles over succession between rival sons of abbots or other monks, gives credence to this interpretation of the painting.[122] If the events painted on the walls of the Taimensho are meant to comment on temple politics, Ryōkei has added several important details. Above the *fusuma* panel showing retainers waiting outside a gate (fig. 27), Ryōkei paints a pavilion that recalls the top floors of the Hiunkaku as seen from the Shoin. In the *fusuma* on the west wall, the loitering female attendants stand next to a small cycad, a type of tropical palmlike plant featured in the Kokei (Tiger's Glen) garden adjacent to the Taimensho.

In conclusion, the foregoing analysis of the potential meaning of the *Four Graybeards Returning to Court* in the Nishihonganji Taimensho is dependent on our knowledge of the context of the painting within its architectural and political environment. It is interesting to speculate that if the Taimensho were indeed from Hideyoshi's Fushimi Castle, that con-

text would suggest a different reading of the same pictures. For instance, because Hideyoshi produced his heir Hideyori (1593–1615) very late in life and, upon his death, left leadership of the Toyotomi family in the hands of this boy, paintings of the Four Graybeards Returning to Court made for the Toyotomi family or their allies between 1593 and 1615 may well have been intended as expressions of political support for the embattled young heir.

Shauna Goodwin has suggested that paintings of the Four Graybeards Returning to Court done after 1615 for former Toyotomi vassals, including those who benefited from Hideyori's funding of temple reconstruction, would have had an added poignancy given the young heir's death at the terrible siege of Osaka Castle.[123] Thus, at one level, Ryōkei's paintings at the Nishihonganji Taimensho may represent a belated tribute to the vanquished boy regent and patron, even as they comment on the legitimacy of succession within the temple. In another hypothesis, Ryōkei's paintings may have replaced undocumented works painted when the temple was built in the 1590s that were lost in the conflagration of 1617. In this case, support for Hideyori would be primary, and any relevance to temple lineage would be secondary. If the Taimensho cycle is interpreted as a statement about the Toyotomi family, the *chōdai-gamae* pictures depicting *Xiwangmu Presenting the Peaches of Immortality to Han Wudi* may be a statement about Hideyori's mother, the beautiful Chacha (1567–1615), Hideyoshi's principle concubine better known as Yododono or Yodogimi. The story of Xiwangmu bestowing Han Wudi with the peaches of immortality had sexual connotations in China.[124] Peaches, symbols of fruition and female sexuality, would indicate the role of Yodogimi in providing the geriatric Hideyoshi with two sons, the second of whom was to become his ill-fated heir. In this reading, the beguiling Xiwangmu (representing Yodogimi) gives the peaches (the fruit of her womb, her son Hideyori) to Han Wudi (Hideyoshi) in order to ensure his immortality (the continuation of the Toyotomi family).

This is, of course, speculation. But the density of these themes, made all the more potent when conflated with other legends from Chinese antiquity, invite such a reading when placed within the possible contexts of their creation. Given the various political implications of Ryōkei's Nishihonganji painting of the *Four Graybeards Returning to Court* and the equally powerful meaning of Eitoku's lost *Seven Sages* and *Four Graybeards* from Azuchi Castle, we can only speculate on the nexus of potential meanings attached to other paintings of these same themes if we could recover their original locations and functions.

Yet, all paintings of scholar-recluses need not have had such potent, political connotations. It is not too difficult to imagine the retired Sakai merchant sitting as abbot in his newly acquired Zen subtemple, the jaun-

diced aristocrat slipping away to his country retreat, or the world-weary *daimyō* ducking into his *chashitsu,* and then, each man—alone or with a coterie of friends—looking up at the pictures of the Seven Sages or the Four Graybeards on his walls and quietly comparing his own condition with those of the Chinese exemplars who, centuries earlier, had also turned their backs—at least temporarily—on existence in the mundane world in exchange for the camaraderie, the poetry, the beauty, and the communitas of a life devoted to aesthetic reclusion. If the thoughts of this priest, this nobleman, and this warrior were no more than a moment's fantasy, it mattered little that the scenes in the paintings were equally fantastic. What did matter was that the experience allowed each man to go on with his life a little more easily—whether that meant a feeling of rich communion with the past, an easing of resignation at residing on the margins of power, or even the granting of greater control over the very society that one pretended to reject. The fantasy was powerful. The sheer number of paintings tells us so.

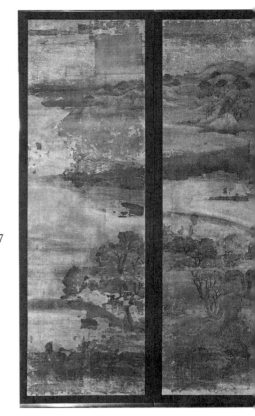

Figure 1. Anonymous, *Senzui Byōbu*, ca. eleventh century. Six-panel screen; ink and color on silk; each panel, 146.4 × 42.7 cm. Kyoto National Museum (formerly Tōji, Kyoto).

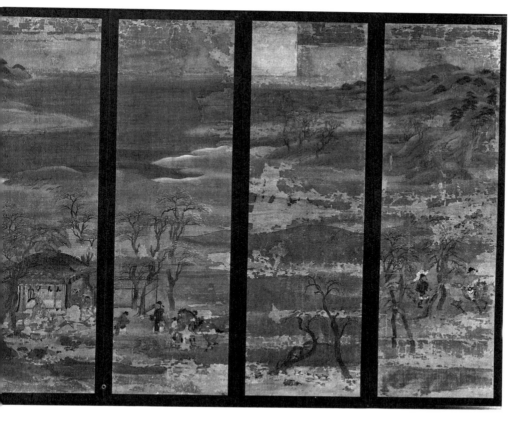

Figure 2. Ike Taiga, "Reciting a Poem" from *Jūben-Jūgi*, 1771.
Album; ink and color on paper; each leaf, 17.9 × 17.9 cm.
Kawabata Yasunari Memorial Hall, Kamakura.

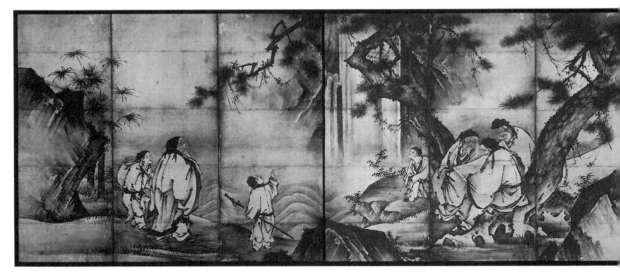

Figure 3. Kano Motonobu, *Four Graybeards* and *Seven Sages*, 1552. Pair of six-panel screens; ink on paper; each screen, 153.3 × 351.5 cm. Tokyo National Museum.

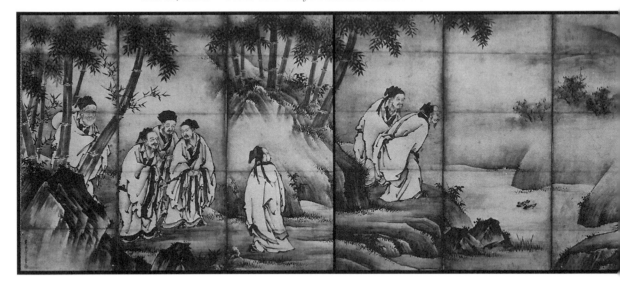

Figure 4. Kano School, *Seven Sages of the Bamboo Grove,* ca. 1650. Five (of eight) *fusuma;* ink on paper. Second Room of Middle Shoin, Katsura Villa, Kyoto.

Figure 5. Shōkadō Shōjō, *Four Graybeards Playing Go* and *Seven Sages Reading a Scroll,* ca. early 1630s. Two *kobusuma;* ink on paper. Ryōkōin, Daitokuji, Kyoto.

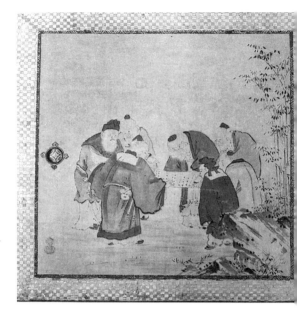

Figure 6. Anonymous, *Four Graybeards Returning to Court,* ca. fifteenth century. Six-panel screen; ink and color on silk. Hōryūji Treasure House, Tokyo National Museum.

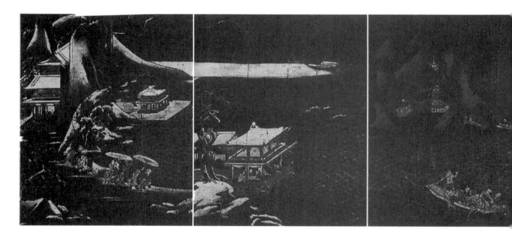

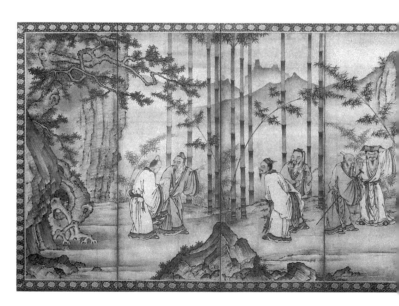

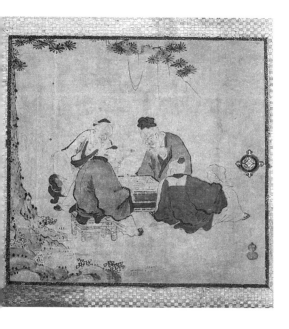

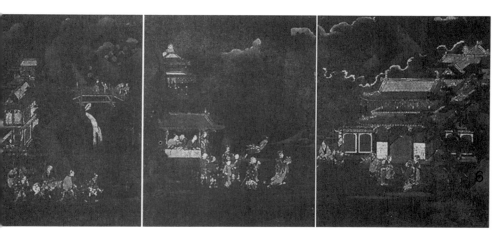

Figure 7. Keison, *Seven Sages,* ca. early sixteenth century. Six-panel screen; ink on paper; 154.5 × 363 cm. Tokyo National Museum.

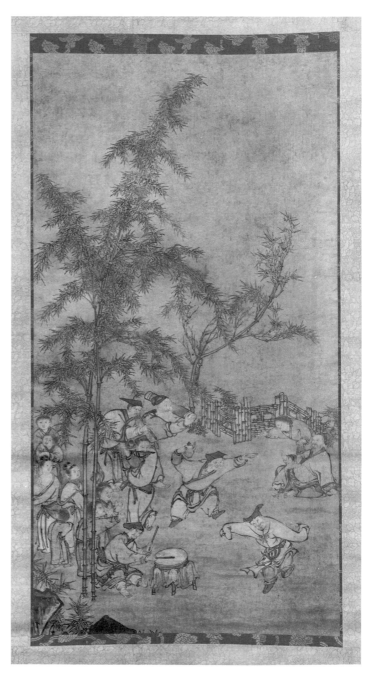

Figure 8. Sesson, *Seven Sages Dancing,* ca. mid-sixteenth century. Hanging scroll; ink and light color on paper; 102.7 × 51.8 cm. Property of Mary Griggs Burke, New York.

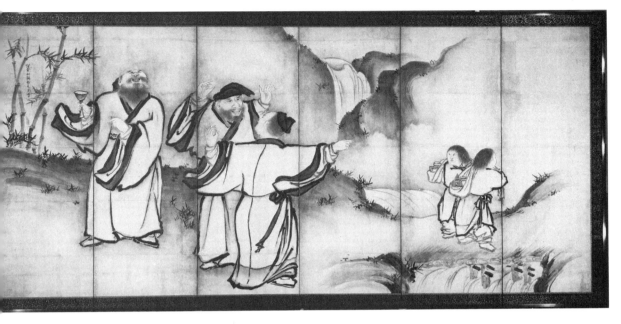

Figure 9. Sesson, *Seven Sages,* ca. mid-sixteenth century. Pair of six-panel screens; ink on paper; each screen, 160 × 325 cm. Hatakeyama Memorial Hall, Tokyo.

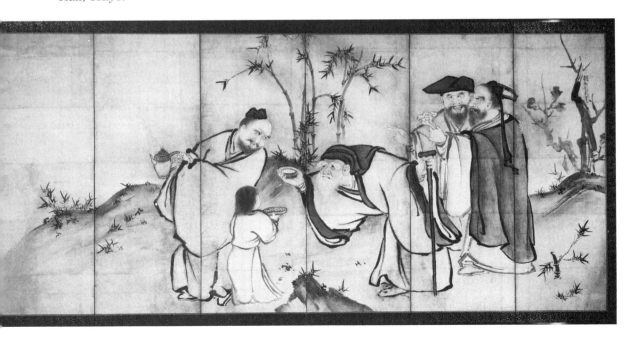

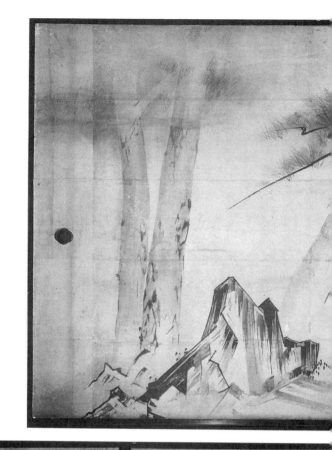

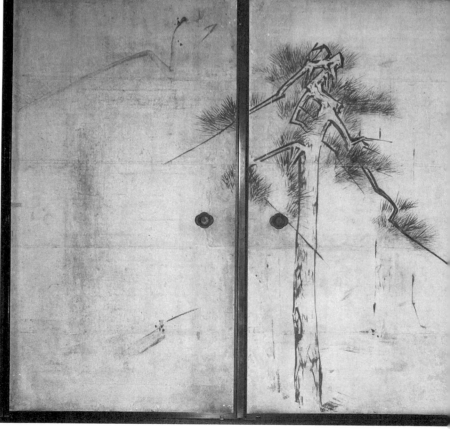

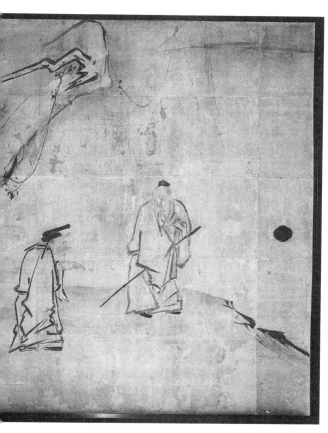

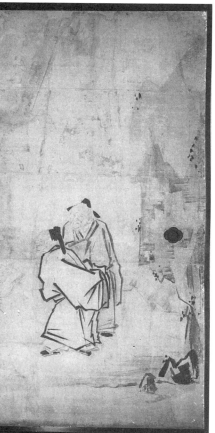

Figure 10. Hasegawa Tōhaku, *Four Graybeards,* 1601. Five (of eight) *fusuma;* ink on paper; each panel, 178 × 93 cm. Shinjuan, Daitokuji, Kyoto.

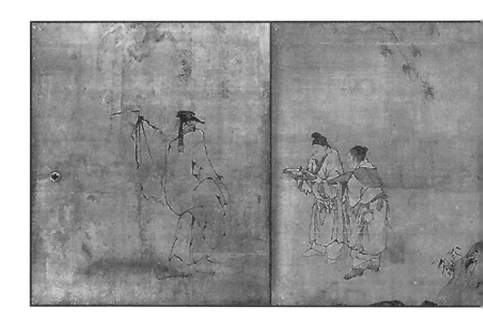

Figure 11. Unkoku Tōgan, *Seven Sages,* ca. late sixteenth century. Eight (of twelve) *fusuma;* ink on paper; each panel, 189 × 141.5 cm. Ōbaiin, Daitokuji, Kyoto.

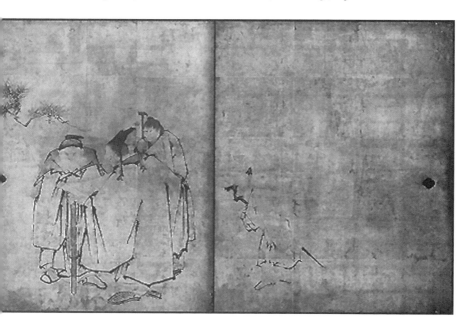

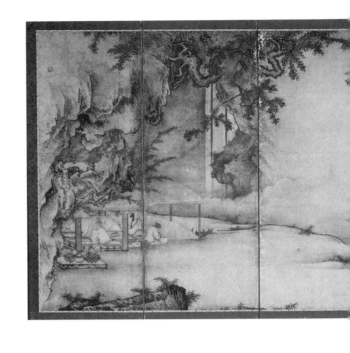

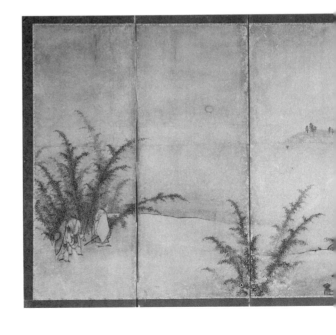

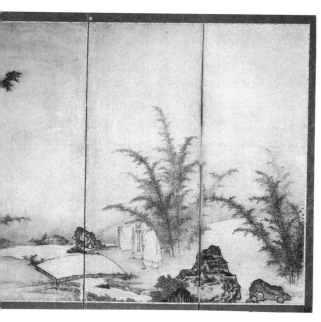

Figure 12. Unkoku Tōgan, *Seven Sages,* ca. late sixteenth or early seventeenth century. Pair of six-panel screens; ink and light color on paper; each screen, 156.3 × 359.6 cm. Eisei bunko, Tokyo.

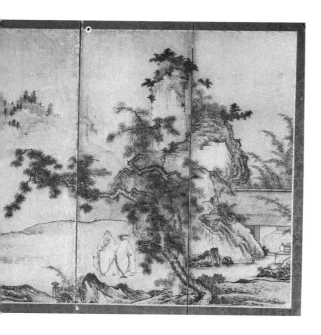

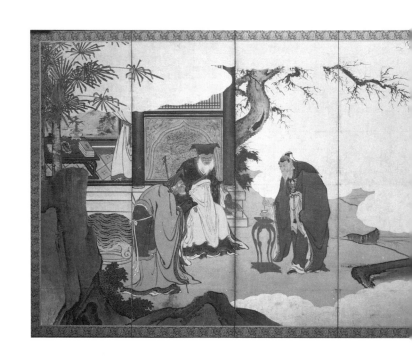

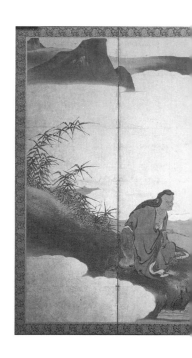

Figure 13. Kano Sanraku, *Wenwang Summoning Taigong Wang* and *Four Graybeards on Mt. Shang,* ca. early seventeenth century. Pair of six-panel screens; ink, color, and gold on paper; each screen, 167.4 × 364.3 cm. Myōshinji, Kyoto.

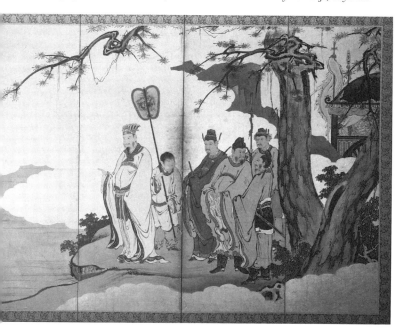

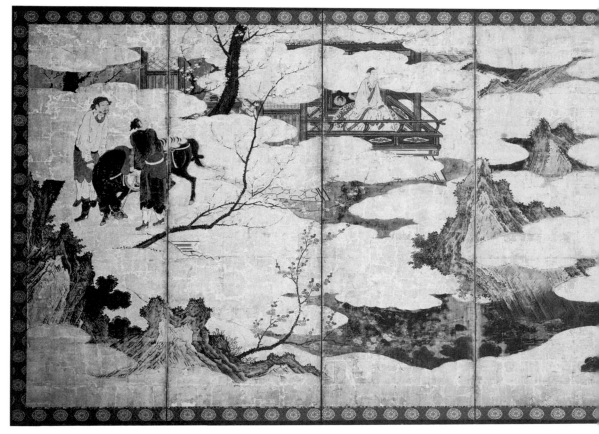

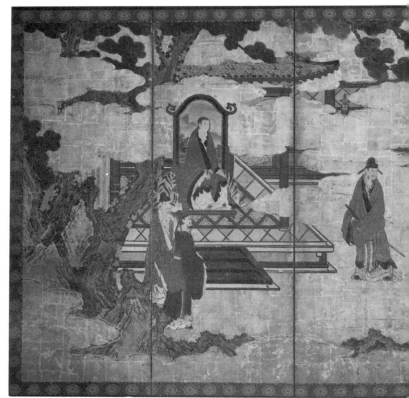

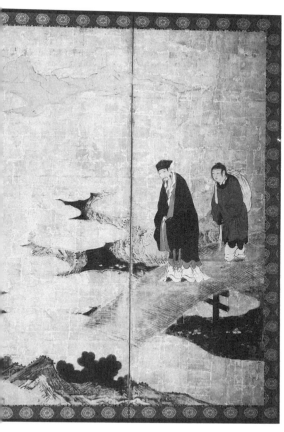

Figure 14. Attr. Kano Mitsunobu, *Four Graybeards Returning to Court* and *Wind and Water Cave*, ca. early seventeenth century. Pair of six-panel screens; ink, color, and gold on paper; each screen, 174.6 × 378.5 cm. The Metropolitan Museum of Art, New York. The Harry C. G. Packard Collection of Asian Art, gift of Harry C. G. Packard. Purchased by Fletcher, Rogers; Harris Brisbane Dick and Louis V. Bell Funds; Joseph Pulitzer Bequest; and the Annenberg Fund, Inc. Gift 1975. (1975. 268. 46, 47)

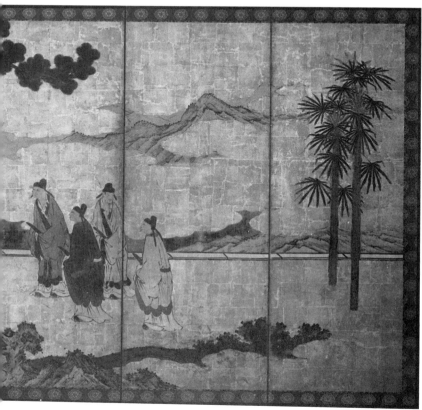

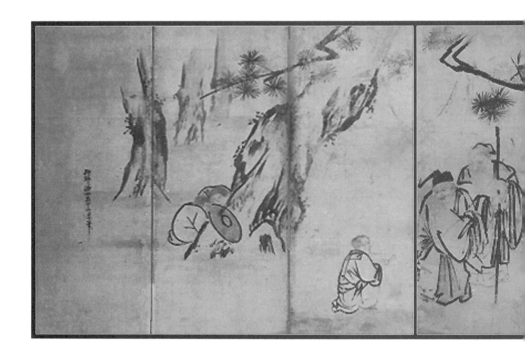

Figure 15. Kano Yasunobu, *Seven Sages* and *Four Graybeards*, 1624. Pair of six-panel screens; ink on paper; each screen, 172.3 × 365.2 cm. Shōjuraigōji, Shiga.

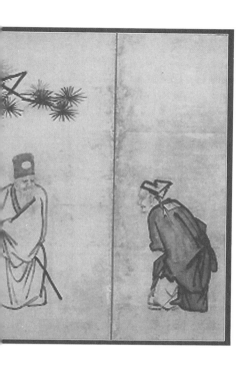

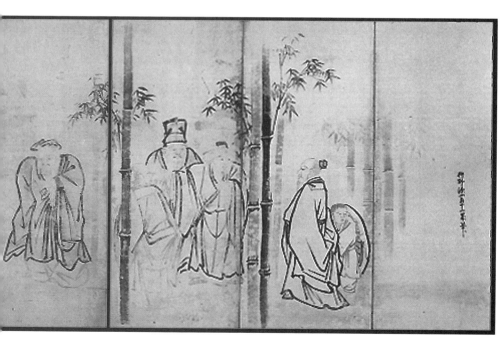

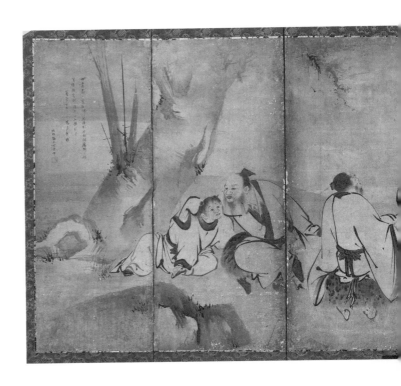

Figure 16. Kaihō Yūshō, *Eight Immortals of the Winecup*, 1602. Six-panel screen; ink on paper; 148 × 358 cm. Kyoto National Museum.

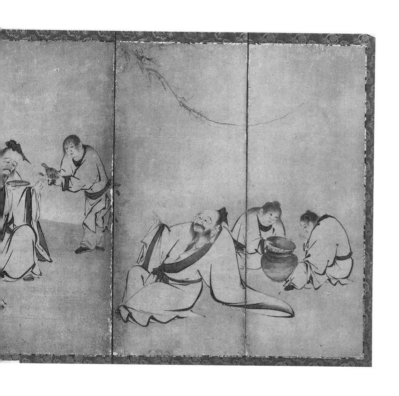

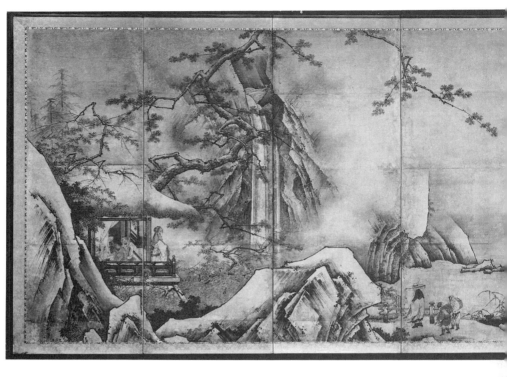

Figure 17. Attr. Kano Motonobu, *Four Gentlemanly Accomplishments,* ca. mid-sixteenth century. Pair of six-panel screens; ink and light color on paper; each screen, 110.2 × 381 cm. The Metropolitan Museum of Art, New York, gift of Peggy and Roger Gerry, 1991. (1991. 480.1)

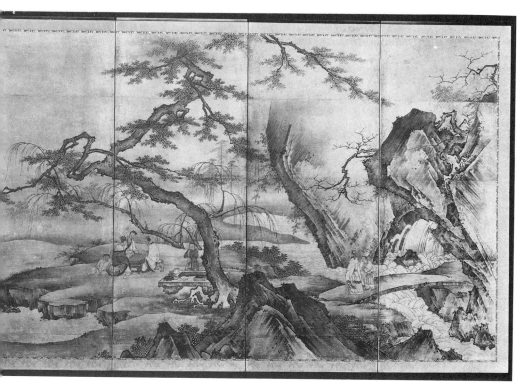

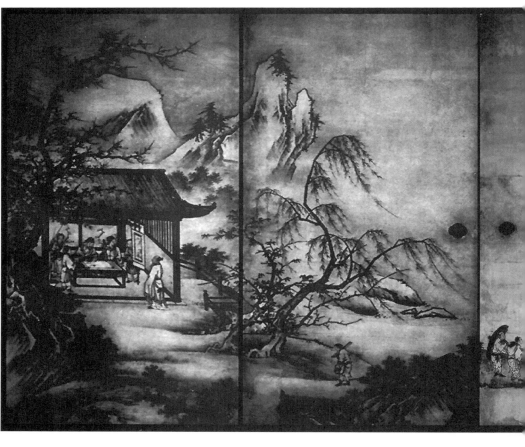

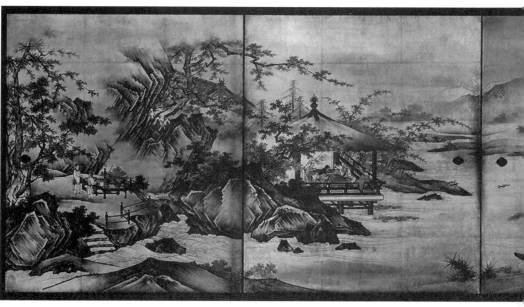

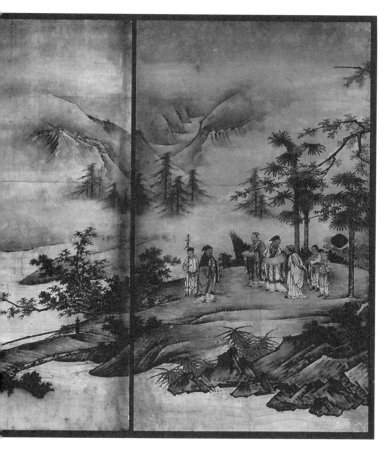

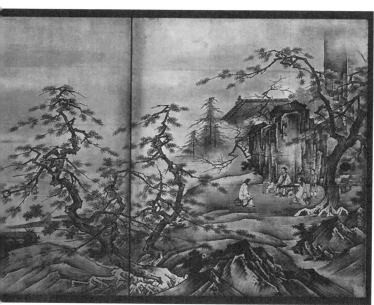

Figure 18. Kano Eitoku, *Four Accomplishments,* 1566. Eight *fusuma;* ink, light color, and gold on paper; each panel, 175 × 142.5 cm. Jukōin, Daitokuji, Kyoto.

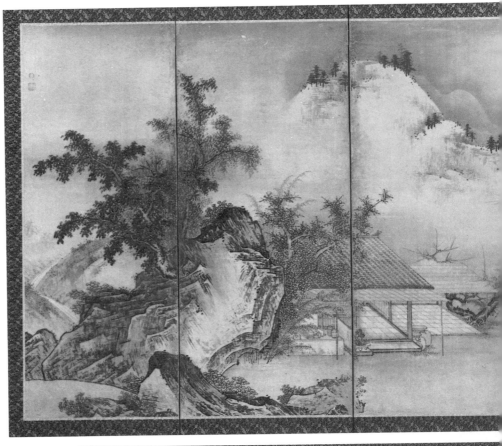

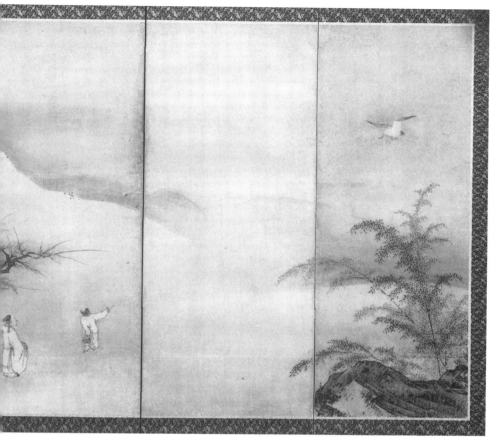

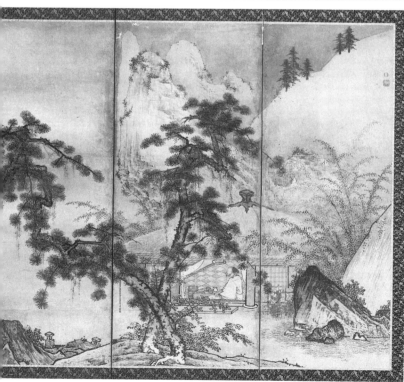

Figure 19. Unkoku Tōgan, *Tao Yuanming* and *Lin Hejing,* ca. early seventeenth century. Pair of six-panel screens; ink and gold wash on paper; each screen, 147 × 358 cm. The Asian Art Museum of San Francisco. The Avery Byundage Collection.

Figure 20. Karakasatei, ca. 1590. Kōdaiji, Kyoto.

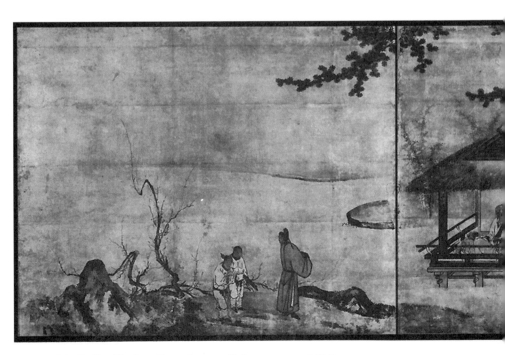

Figure 21. Kaihō Yūshō, *Four Accomplishments*, ca. 1600.
Fusuma, currently mounted as five hanging scrolls; ink on
paper. Kenninji, Kyoto.

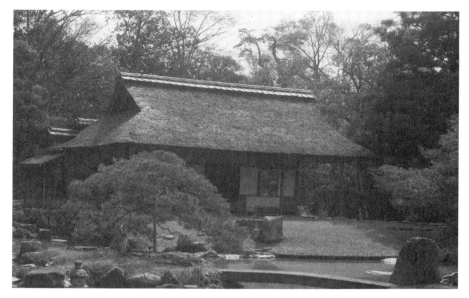

Figure 22. Shōkintei, ca. 1590. Katsura Villa, Kyoto.

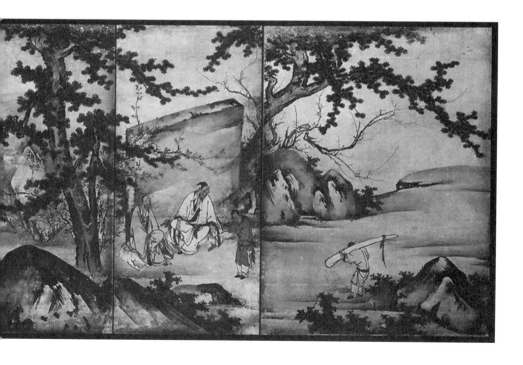

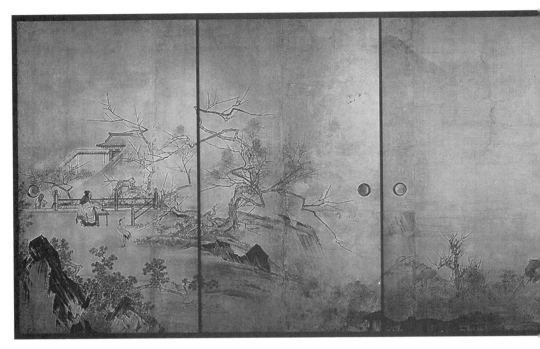

Figure 23. Hasegawa Tōhaku, *Four Admirers,* ca. early seventeenth century. Six (of seven) *fusuma;* ink on paper; each panel, 94.8 × 86.7 cm. Nagoya Railroad Corporation, Aichi.

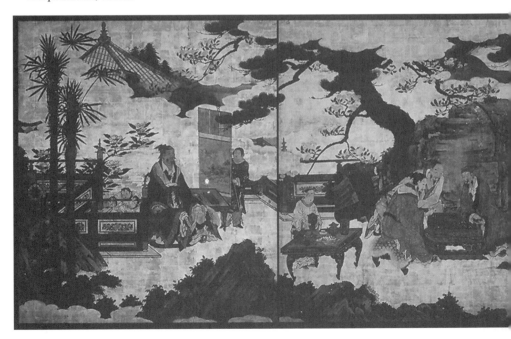

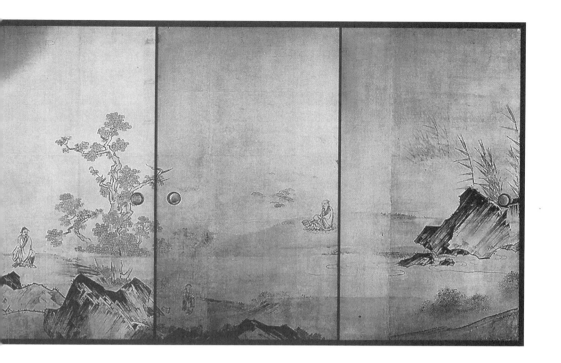

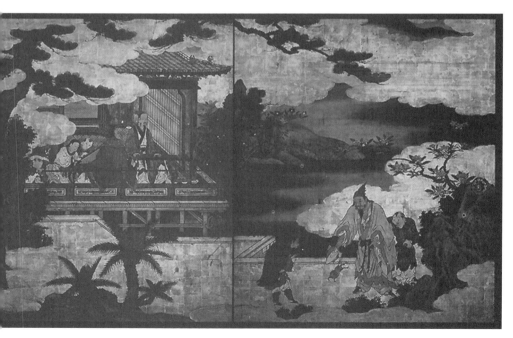

Figure 24. Kano Takanobu, *Four Accomplishments*, ca. 1630. Four
fusuma; ink, color, and gold on paper; each panel, 174 × 139.7 cm.
Eugene Fuller Memorial Collection, 51.37. Seattle Art Museum.
Photograph by Paul Macapin.

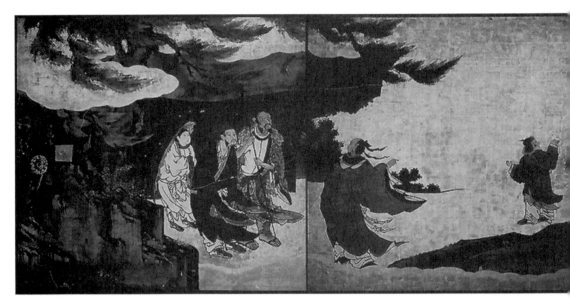

Figure 25. Attr. Kano Kotonobu, *Flying Immortal,* ca. 1606. Four *fusuma;* ink, color, and gold on paper; each panel, 198.2 × 182.9 cm. Originally Ryōanji, Kyoto. The Metropolitan Museum of Art, New York. Purchase, anonymous gift, in honor of Ambassador and Mrs. Michael Mansfield, 1989. (1989. 139.1)

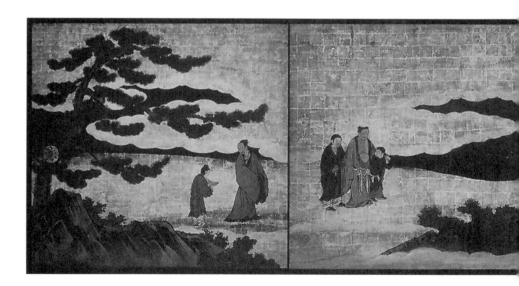

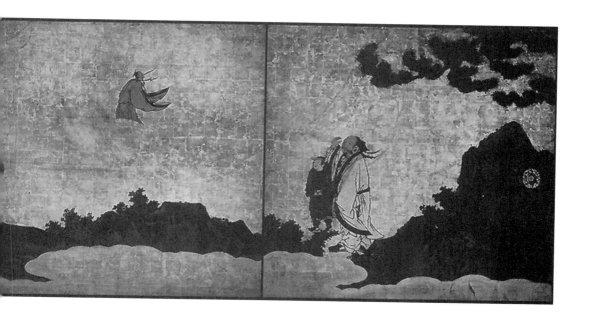

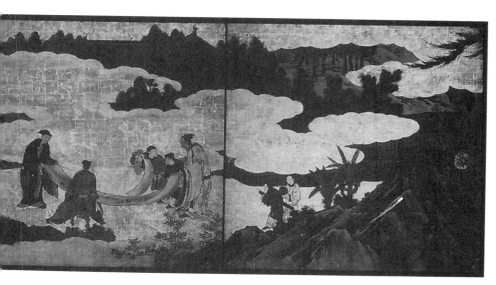

Figure 26. Attr. Kano Kotonobu, *Scholars Reading a Scroll,* ca. 1606. Four *fusuma;* ink, color, and gold on paper; each panel, 198.2 × 182.9 cm. Originally Ryōanji, Kyoto. The Metropolitan Museum of Art, New York. Purchase, anonymous gift, in honor of Ambassador and Mrs. Michael Mansfield, 1989. (1989. 139.2)

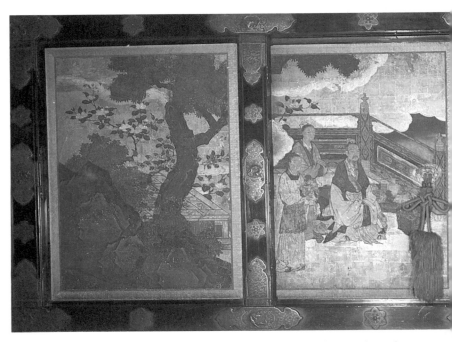

Figure 27. Attr. Watanabe Ryōkei, *Xiwangmu Presenting the Peaches of Immortality to Han Wudi,* ca. 1630. Four *chōdaigamae;* ink and color on gold. Taimensho, Nishihonganji, Kyoto.

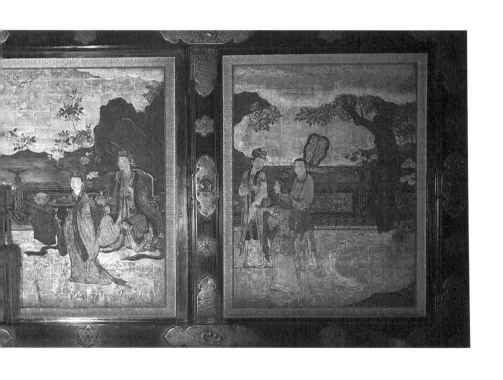

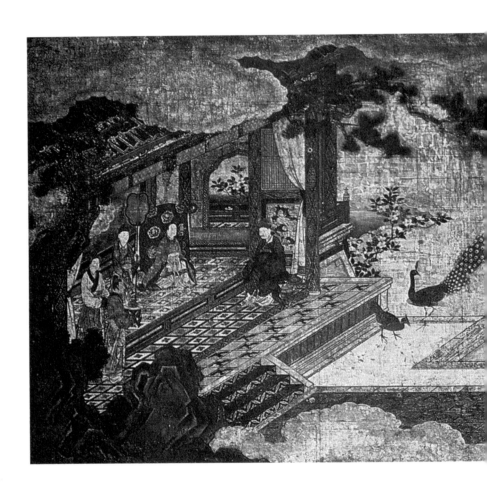

Figure 28. Attr. Watanabe Ryōkei, *Four Graybeards Returning to Court,* ca. 1630. Wall of *tokonoma;* ink and color on gold. Taimensho, Nishihonganji, Kyoto.

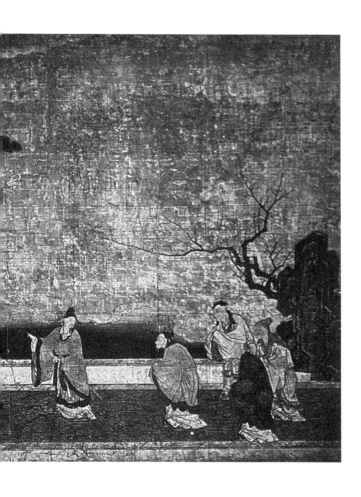

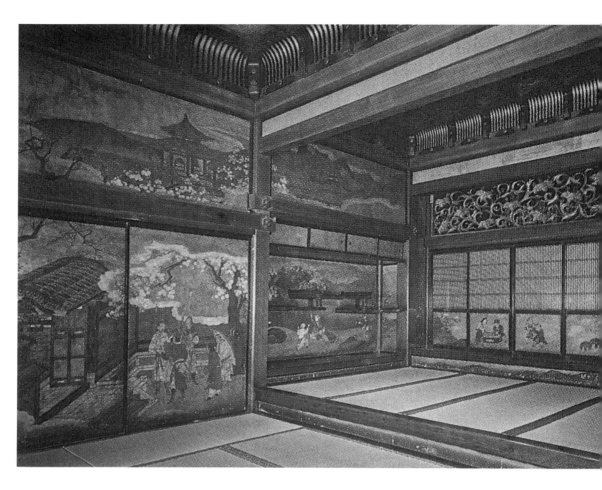

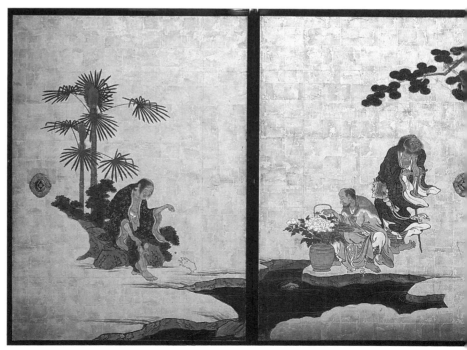

Figure 29. Attr. Watanabe Ryōkei, *Chinese Boys at Play*, ca. 1630. Four *kobusuma,* wall, and two *fusuma;* ink and color on gold. Taimensho, Nishihonganji, Kyoto.

Figure 30. Attr. Kano Sansetsu, *Eight Daoist Immortals*, 1642. Four (of sixteen) *fusuma;* ink and color on gold; each panel, 165.7 × 115.6 cm. Originally Tenshōin, Myōshinji, Kyoto. Minneapolis Institute of Arts. Putnam Dana McMillan Fund. (63–371–4)

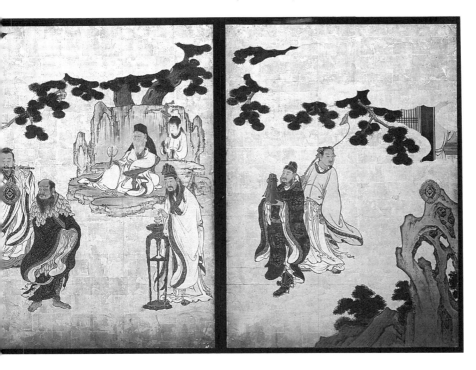

Figure 31. Anonymous, *Shōkadō* from *Miyako rinsen meishō zue*, 1799.

布裹隱几緼褐烏巾
黙匕霄貌昭匕精神
交游造物涵蓋道真
八秩頹走三陽逸民
逸民謂誰六二山心

百書

Figure 32. Kano Tan'yū, *Ishikawa Jōzan*, ca. 1670. Hanging scroll; ink and color on silk; 100.6 × 38.8 cm. Shisendō, Kyoto.

Figure 33. Kano Sansetsu, *Fujiwara Seika Living in Reclusion,* 1639. Hanging scroll (detail); ink and light color on paper; 119.7 × 31.3 cm. Nezu Art Museum, Tokyo.

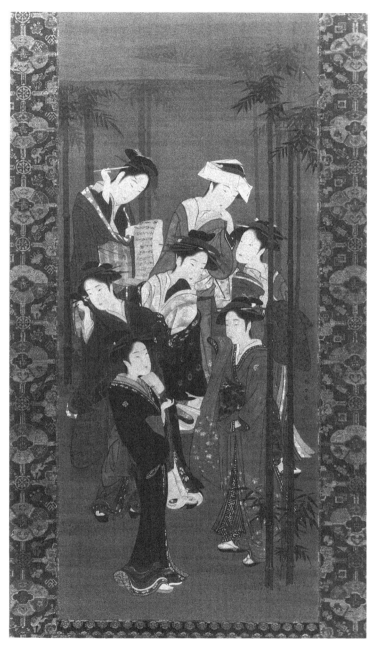

Figure 34. Katsukawa Shunshō, *Seven Beauties of the Bamboo Grove,* ca. 1760s. Hanging scroll; ink and color on silk; 94.2 × 34.7 cm. Tokyo University of Fine Arts.

5.
Self-Cultivation and Sagehood
Aesthetic Reclusion as Lived and Leveraged in the Early Seventeenth Century

THE POWER OF THE FANTASY of aesthetic reclusion, with its dual function as a means of imaginary personal escape and as a method of subtle political commentary on the righteousness of the ruling elite, placed pictures of Chinese scholar-recluses at the very heart of Momoyama and early Edo period culture. In the third chapter of this study, we observed how images of the Seven Sages of the Bamboo Grove and the Four Graybeards of Mt. Shang mirrored the ritual antistructure of tea by allowing for criticism of the social order, but did so in a ritualized and hence symbolic form that actually helped preserve that order. The connection of tea aesthetics with the legitimation strategies, first seen in the Momoyama period regimes of Nobunaga and Hideyoshi, continued to evolve as the Tokugawa government took power in the early decades of the seventeenth century.

That the military rule and national unification begun under Nobunaga and Hideyoshi grew into 250 years of Tokugawa hegemony is an obvious fact of Japanese history. Less obvious is that, throughout this era of military domination, tea remained a key means of social intercourse between warriors, aristocrats, priests, and even merchants.[1] During the early decades of the seventeenth century, when Tokugawa authority was still in its infancy, the dominant patronage, practice, and aesthetic leadership in tea passed from the hands of wealthy Sakai merchants to military men. The "conservative" *wabi* tradition of Rikyū was preserved by leading disciples who were all *daimyō*, the so-called group of seven.[2] Moreover, even the new *kirei sabi* (refined rusticity) style of tea practiced by Kobori Enshū was developed primarily by and for *daimyō*. Not only was Enshū a regional governor under the Tokugawa, his "concessions" to military taste in collecting, display, and interior design led some rivals to deride Enshū's tea, hypocritically, as *daimyō-cha*.[3]

There is no doubt that the mantle of the aesthete-recluse, so central

162

to many tea adepts of the military class, was leveraged as a means of gaining political or social status. However, the guise of the aesthete-recluse could also be employed as a means of escaping from very real political pressures. Aesthetic reclusion played an important role in shaping both the lives of those Momoyama and early Edo period men who chose to become actual aesthete-recluses and the philosophy of those men who developed a particular Japanese brand of neo-Confucianism. For both groups, images of the Seven Sages and the Four Graybeards may well have served as the partial motivation, the practical template, and the cultural justification for their own actions. This chapter offers a partial explanation for the continuing popularity of these pictorial themes in the early seventeenth century by examining first the phenomenon of aesthetic reclusion as a *modus vivendi* and then as one aspect of early Tokugawa period neo-Confucianism. In both cases, aesthetic reclusion posited a theoretical rejection of the political order but, in practice, led to the relatively smooth working of a dictatorial military regime. The chapter concludes by examining those features of reclusion in ancient China that made it so appealing to the men who practiced tea, neo-Confucianism, and painting in late medieval Japan.

Aesthetic Reclusion and Aesthete-Recluses

While tea offered a chance for the temporary and symbolic experience of aesthetic reclusion, for some members of society the ersatz eremitism of tea was not sufficient. For men caught in the shifting tides of early-seventeenth-century politics, the guise of the aesthete-recluse could provide a refuge from political persecution even as it allowed them to remain in the intellectual and artistic world. Indeed, status as a genuine aesthete-recluse must have lent considerable weight to one's credentials as a man of taste. In this section, we examine briefly three men—Kinoshita Chōshōshi, Shōkadō Shōjō, and Ishikawa Jōzan—whose lives as recluses and careers as aesthetes are linked to the Toyotomi-Tokugawa conflicts of 1600 to 1615. Even a glimpse at the biographies of these three men suffices to demonstrate how deeply the ideals of aesthetic reclusion shaped not only the painting and ritual practice of early-seventeenth-century Japan but even the lives of some of its most interesting members.

Kinoshita Chōshōshi (1569–1649), a *waka* poet and *samurai* with connections to both Hideyoshi and Ieyasu, was one of the first men to take political shelter in the dwelling of the aesthete-recluse. Awarded Obama Castle in Wakasa by Hideyoshi, after Hideyoshi's death Chōshōshi was caught in the ensuing power struggle and trapped by conflicting loyalties. At the battle of Sekigahara, his in-law Ieyasu ordered Chōshō-

shi to defend Fushimi Castle, and his Toyotomi patrons expected him to fight against Ieyasu. Unable to choose sides, and always far more comfortable with the poet's brush than the *samurai*'s sword, Chōshōshi went into hiding in Kyoto. After the Tokugawa victory, Chōshōshi was stripped of his fief but, through family connections, was allowed to keep his fortune and, more important, his life. Chōshōshi quietly established himself in a hermitage in the Higashiyama district of Kyoto and spent his days writing poetry and teaching *waka* composition.

Chōshōshi describes his eremitic life in *Sanka no ki* (An Account of My Hut in the Mountains). Although he writes of genteel poverty in two four-and-one-half-mat rooms, Chōshōshi did not want for money. Much to the irritation of Matsunaga Teitoku (1571–1653), his rival in *waka* composition and teaching, Chōshōshi refused to accept money for his services and, even more to Teitoku's chagrin, Chōshōshi assembled one of the finest private libraries of the time—with more than 260 volumes in Japanese and fifteen hundred volumes in Chinese. In *Sanka no ki,* Chōshōshi tells of his joy at receiving friends such as Enshū and Fujiwara Seika, and of decorating his hermitage with the poems of Du Fu. He concludes the description of his life by saying that he lived like a Chinese gentleman as described by Yoshida Kenkō in *Tsurezuregusa.* In his poetry, Chōshōshi frequently adopts the persona of the hermit living in a desolate, weed-choked house or beneath lofty pines, and longing for old friends. In sum, Chōshōshi seems to have lived as a literatus devoted to close friends, poetry, and the spirit of reclusion.[4] A later follower, glossing over Chōshōshi's ignominy in war, wrote, "His decision to abandon the world . . . must surely exist in China, and the Lesser General acted as he did because he had learned the teaching of the sages."[5]

Slightly younger than Chōshōshi was the painter, calligrapher, and tea adept Shōkadō Shōjō (1584–1639).[6] The son of a cleric and himself a Shingon priest at Iwashimizu Hachimangū on Otokoyama south of Kyoto, Shōkadō was only affected indirectly by the power shift from the Toyotomi to the Tokugawa. According to his biographical entry in the 1691 *Honchō gashi* (History of Painting in Japan), Shōkadō learned ink painting from Kano Sanraku in 1615 when the latter took refuge on Otokoyama after fleeing Osaka Castle. Thus, Shōkadō's residence on the periphery of Kyoto led to his training in painting. In the year 1626, Shōkadō was invited to host a tea gathering between the courtier Konoe Nobuhiro (1599–1649) and the warrior Tokugawa Yoshinao (1600–1650); the *chakai* would later facilitate a meeting between leaders of the feuding military and noble factions. Besides sharing an interest in tea with these two men, Shōkadō had personal connections to both Nobuhiro and Yoshinao. Shōkadō's status as a respected *chajin* helped gain him this important role as a go-between. It is also tempting to speculate that Shōkadō's

de facto status as an aesthete-recluse—he was, after all, a man devoted to scholarly arts, and one who lived on a mountain outside of Kyoto—may also have accounted for his role as an intermediary between the Tokugawa *bakufu* and the recalcitrant Kyoto aristocracy.

Although for most of his career Shōkadō lived in the monastery at Iwashimizu hachimangū, then primarily a Shingon temple, he spent his last years dwelling in a tiny hermitage deep in a forested glen on the east side of Otokoyama. The stylish hut, designed by Kobori Enshū, was just slightly more than four-and-one-half *tatami* mats and thatched to resemble a *sōan*.[7] The picture of Shōkadō Shōjō in his hut, from the 1799 *Miyako rinsen meishō zue* (fig. 31), recalls many of the convivial scholar-recluses who populate similarly fashionable hermitages in Momoyama painting.

In many ways, Shōkadō is the quintessential aesthete-recluse, combining residence in a mountain hermitage with communitas, collecting, and devotion to scholarly pastimes. A tea adept closely connected to both Enshū and the circle of *chajin*-priests at Daitokuji, Shōkadō frequently entertained, or was entertained by, the leading artists and intellectuals of his age. In the manner of aesthete-recluses such as the Seven Sages and the Four Graybeards, Shōkadō led an active social life. His stature as a tea man was due in part to his collection of ceramics, calligraphy, and painting. The *Yawata Takimotobō kurachō* (Shōkadō's list of *meibutsu*) includes calligraphy scrolls by famous Japanese calligraphers such as Fujiwara Teika (1162–1241) and paintings attributed to Chinese painters including Mu Xi (fl. mid-13th c.) and Li Di (fl. 1187).[8] Finally, as a painter, calligrapher, poet, and even potter, Shōkadō spent his life in pursuit of scholarly pastimes.

Shōkadō's paintings of the *Four Graybeards Playing Go* and the *Seven Sages Reading a Scroll* (fig. 5) in the Mittan tearoom at Ryōkōin perfectly capture the nexus between aesthetic reclusion as lived, ritualized in tea, and represented pictorially by Chinese models. Looking at these two small panels in the full context of subject, function, and authorship, we witness a three-way convergence of aesthetic reclusion. We see simultaneously: paintings of groups of recluses engaging in scholarly arts; paintings for a room where a group of men would temporarily "leave" society to gather together and engage in elegant pastimes; and paintings by a man who seemingly lived only to meet with friends and to create works of art.

Based on inscriptions on some of his paintings, Shōkadō was acquainted with the "*samurai* turned recluse" Ishikawa Jōzan (1583–1672).[9] Jōzan, last in a long line of family members to serve the Tokugawa clan, established his name as a warrior at the battle of Sekigahara. His ascendance in the Tokugawa hierarchy stalled when he refused an invitation

to tutor one of Ieyasu's sons. Then, in the summer campaign at Osaka Castle in 1615, Jōzan briefly deserted his position, and Ieyasu subsequently released him from shogunal service. At age thirty-three, Jōzan began his career as a scholar, spending the next several decades in residence at Nanzenji, in service to the Asano clan in Hiroshima, and then back in Kyoto at Shōkokuji. Jōzan first immersed himself in the study of Chinese poetry; then, after meeting neo-Confucian scholars Hayashi Razan (1583–1657) and Fujiwara Seika, Jōzan began to read widely in Chinese philosophy. Basing his actions on the examples of Seika (who is treated in the following section), as well as Chinese poet-recluses such as Tao Yuanming and Lin Hejing, in 1641 Jōzan built the Shisendō (Hall of Poetry Immortals) in the hills northeast of Kyoto.

In this elegant but rustic hermitage, nestled against a densely forested hillside, Jōzan hung portraits of thirty-six Chinese poets, most of whom were famous for their reclusive spirit as well as their literary gifts.[10] In the edifying presence of these scholar-recluses from the Chinese past, Jōzan wrote many Chinese poems *(kanshi)* describing his own remote seclusion, freedom from worldly defilement, and spiritual contact with these Chinese exemplars. Despite these poetic proclamations of solitariness, Jōzan was often in close contact with a coterie of like-minded friends. Jōzan represents another example of a man who styled himself an aesthete-recluse, a persona evident in Kano Tan'yū's famous "birthday portrait" of Jōzan (fig. 32). Here, Jōzan has Tan'yū paint him as a Chinese literatus, wearing not only the cap and robe of a Chinese scholar but resting against an elegantly carved desk and carrying the *nyoi* scepter associated with Confucian gentlemen.

For Chōshōshi and Jōzan, as for other *samurai* who found themselves on the wrong side of political events of the early seventeenth century, aesthetic reclusion was a means of declaring oneself politically inactive or void even as it increased one's social prestige. While retirement from political life was not entirely of their own choosing, we can imagine that once Chōshōshi and Jōzan established themselves as aesthete-recluses, their departure from the world of military affairs may well have been recast as a positive act of world rejection and creative liberation. For a voluntary recluse such as Shōkadō, this self-marginalization from the institutional centers of power was largely a means of finding and retaining his creative muse.

In an earlier era, men who sought refuge from social pressures and an opportunity to explore their creative potential would have entered a Zen monastery.[11] By the early seventeenth century, however, the link between Zen and the highest spheres of social prestige and cultural accomplishment was severely compromised. The association of Zen with the most compelling means of self-cultivation (and, hence, creative liber-

ation) was rapidly being replaced as both a philosophy and cultural force by competition from neo-Confucianism. Indeed, the de facto aesthetic reclusion set forth in word and example by Japanese champions of neo-Confucianism adds an important dimension to the creation and reception of pictures of Chinese scholar-recluses in the Momoyama and early Edo periods. In the following section, we observe that the neo-Confucian synthesis of Confucian ideals of social order with Daoist notions of opposition to that order provides a philosophical system in harmony with the social utility and ideology of tea. As such, it is useful to analyze how neo-Confucian ideals of self-cultivation and sagehood relate to reclusion and political legitimation as expressed in tea, as well as in paintings of the Seven Sages and the Four Graybeards.

Fujiwara Seika and Neo-Confucianism

Self-cultivation (or spiritual cultivation) is a basic component of neo-Confucianism, elucidated as one of the principles *(li)* of human virtue by Zhu Xi (1130–1200). Self-cultivation subsumes several other principles, namely, love *(ren)*, righteousness *(yi)*, propriety *(li)*, and wisdom *(ji)*. Recent scholarship has argued that neo-Confucian ideas of self-cultivation were not systematically employed as a legitimation strategy by the Tokugawa government until the late seventeenth century, when Tokugawa *shōgun* such as Ietsuna (1641–1680) viewed themselves as "exemplary rulers" *(meikun)* at the helm of "benevolent government" *(jinsei)*, on the basis of their "selfless intentions, pure dedication, and moral fiber."[12] This is not to say, however, that ideas of self-cultivation and righteous government were unknown or ignored by earlier generations of rulers. We have already seen Nobunaga and Hideyoshi's claims to self-cultivation and virtue in the name of good government. If the adoption of neo-Confucian ideals by later Tokugawa rulers was part of a process of obfuscating certain aspects of their warrior past by manufacturing the qualifications for *kōgi* such as benevolence and wisdom, then this self-mythologizing was also part and parcel of the legitimation strategy of Momoyama period rulers—notwithstanding the subtle or desultory manner of its deployment. Key to this process was self-cultivation and its end, sagehood, by which the ruler could ostensibly demonstrate his virtue, justify his right to rule, and draw upon a long tradition of Chinese theory and related symbolism.

Neo-Confucianism first entered Japan with the influx of Song culture in the thirteenth century. Originally nurtured together with Zen, interest in neo-Confucianism began to gain credence as an independent philosophical system after 1400 as the elites' fascination with Zen slowly withered. This symbiotic relationship with Zen continued through the

sixteenth century, with Japanese neo-Confucian scholars coming primarily from the ranks of Zen priests who utilized neo-Confucian terms to write about the mind. Despite many similarities, such as the practice of quiet sitting and belief in self-enlightenment, neo-Confucianism was far more than a secularized version of Zen. Neo-Confucianism not only offered a system of spiritual discipline, but whereas Zen implied competition with authority in its negation of the phenomenal order, neo-Confucianism affirmed this order and thus bolstered the role of authority. Moreover, where broad learning was antithetical to the basic tenets of Zen and had long been a source of friction within many monasteries, humanistic endeavors were encouraged in neo-Confucianism. In the same vein, the neo-Confucian interest in the individual enabled it to subsume comfortably aspects of Buddhism, Daoism, and secular literature. Finally, despite its relatively long history in Japan, by the late sixteenth century neo-Confucianism was still far enough outside the cultural orthodoxy to be considered a new wave of "Chinese-ness," and thus it carried the prestige and familiar exoticism associated with Chinese culture.

The best view of late-sixteenth- and early-seventeenth-century neo-Confucianism can be obtained by briefly examining the biography and teaching of Fujiwara Seika (1561–1619),[13] the first great Japanese neo-Confucian scholar and, as we have already seen, a friend of aesthete-recluses such as Kinoshita Chōshōshi and Ishikawa Jōzan. Traditional Tokugawa period "mis-accounts" of Seika see him as an advisor to Tokugawa Ieyasu and the cofounder—along with Hayashi Razan—of institutional neo-Confucianism. In fact, Seika had little effect, if any, on the Tokugawa *bakufu*, but was important for establishing the emphasis on self-cultivation and sagehood in Momoyama and early Edo period neo-Confucianism. Seika demonstrates the currency of ideals of aesthetic reclusion in the same period when paintings of scholar-recluses—the Seven Sages and the Four Graybeards—were painted with such frequency.

Seika, a twelfth-generation descendant of the great poet Fujiwara Teika and a passable *waka* poet himself, initially studied Zen as a monk at the Rinzai temple Shōkokuji. Disenchanted, Seika left the monastery and renounced Buddhism to devote himself to Chinese learning and, particularly, neo-Confucianism. At first, Seika seems to have tried to gain influence with various military leaders. In 1593, Seika met Ieyasu at Hideyoshi's Hizen Nagoya Castle in northwest Kyūshū, and several years later, Seika was invited to Ieyasu's castle in Edo to lecture the *daimyō* on a Chinese treatise on government.

Despite this early interest in political aspects of neo-Confucianism, Seika seems to have become increasingly interested in the image and sig-

nificance of the sage in Chinese culture. In 1600, for instance, Seika appeared at Fushimi Castle dressed in the garb of a Chinese literatus—an expression of his "identity as a man of learning."[14] In the last decades of his life, Seika cast off his ties to the military and courted aristocrats and literary men, enjoying friendships with the cultural luminaries Matsunaga Teitoku and Suminokura Soan (1571–1632), as well as Chōshōshi and Jōzan, to name just a few members of Seika's circle. In 1615, Seika "retired" from society, moving to a modest country residence at Ichihara in the hills north of Kyoto, where he spent his time in literary pursuits together with friends and disciples. At this time, he took the name Kitauchi Sanjin or "mountain person in the north."[15] Both in his biography and philosophy, Seika seems to have been something of a romantic, who sought a more perfect existence in the imaginary world of the Chinese sage. According to Razan, in 1604 Seika said that he regretted "not having been born in China or some past age in Japan rather than in this age that did not suit him." However, Seika concluded, if one "strives after the way, the era in which one lives does not matter."[16] Seika's comment captures the translucency of culture—also as pictorialized in Momoyama paintings of scholar-recluses—in which the Chinese past is aligned with the Japanese present.

Seika's philosophy, following the teaching of the Cheng-Zhu school of neo-Confucianism, is marked by an emphasis on the attainment of sagehood. To this end, Seika synthesizes many teachings, utilizing any method or example that seems effective. In this ecumenical doctrine, Seika stresses the sameness underlying different thinkers and philosophical systems. Famous philosophers or sages of the past are viewed as less important in their differences than in their commonality as models of sagehood. Thus, Momoyama painters' strategies of paralleling, combining, and transforming Chinese figures into new hybrid constructions are theoretically sanctioned, or adapted, by Seika. For him, these models from the past are crucial in that they demonstrate how sagehood can be achieved through the self-cultivation of the individual. Sagehood is "no hazy abstraction, but an attainable goal in a post-Buddhist age that required a secular model for immediate emulation."[17]

Seika warns against emulating men who possess false virtue *(kyogen)*, using their wits or talents only for sophistry.[18] In contrast, he espouses self-cultivation—the personal realization of truth based on one's inner experience. One way to this spiritual enlightenment *(sharaku)* is through "quiet sitting" *(seiza)*, a means of stilling the mind, achieving equipoise through the elimination of egotism, and returning to the original state of human goodness. Though this quiet sitting was developed from the seated meditation practiced in Zen, neo-Confucians considered the Buddhist practice essentially amoral.[19] Seika's quiet sitting was not to be prac-

ticed in the institutional environment of a meditation hall but could best
be conducted within the solitude of nature.

In addition to quiet sitting, the neo-Confucianism practiced by Seika
stressed an active contemplation of the world through broad learning.
This learning included mastery of the classics and other literature,
humane concern for one's fellow men, and dedication to public service.
These activities were to be carried out "in a spirit of reverence for life,
a . . . respectful manner . . . balanced by a natural and spontaneous en-
joyment of life, and an elevation of mind which transcended the petty
problems of the world."[20]

These practices were best conducted in a natural setting because,
according to Seika, nature creates an opportunity for discovering the
way. Nature offered the purity conducive to quiet sitting and the pursuit
of learning, yet this interest in the purity of nature was dangerous in that
it could lead one away from the "reality of human affairs" also central to
neo-Confucianism. One answer to this paradox was the social reclusion
practiced by Seika, in which the aspirant to sagehood lives in semiretire-
ment in nature but surrounds himself with books and friends.

Herman Ooms' description of Seika as a "cultural recluse" is well
illustrated in Kano Sansetsu's picture of *Fujiwara Seika Living in Retire-
ment* (fig. 33).[21] The hanging scroll presents Seika as a sinophile recluse,
wearing the garments of a Chinese scholar as he sits quietly with his
books in a stylish retreat. Painted in 1639, long after Seika's death, the
painting stands as a tribute to Seika's neo-Confucian ideal. While the
solitary Japanese subject is quite different from the obvious communitas
demonstrated by the groups of Chinese figures presented in paintings of
the Seven Sages or the Four Graybeards, the underlying sensibility is
exceedingly close. The mood of quiet, scholarly eremitism and elegant
union with nature recalls Tōhaku's *fusuma* of the *Four Admirers* (fig. 23).

Seika's brand of neo-Confucian self-cultivation is obviously very
close to the kind of aesthetic reclusion ritualized in tea and pictorialized
in hermit-theme pictures. In *wabi*-style tea, paintings of scholar-recluses,
and neo-Confucianism as espoused by Seika, intimate contact with
nature, devotion to elegant arts, and communitas with like-minded
friends combine to provide the "recluse" with a kind of secular enlight-
enment. For aesthete-recluses, this personal enlightenment is creative
liberation, while for neo-Confucians it is spiritual self-realization.

The neo-Confucianism espoused by Seika, with its dominant empha-
sis on the self-cultivation and sagehood, has little direct bearing on gov-
ernment but an important oblique connection with the symbolic legiti-
mation of power. In similar fashion to the values previously observed in
hermit-theme painting and tea, the largely personal nature of Seika's
neo-Confucianism may imply a rejection of the normative social order

but poses no real threat to it. In fact, when men in power adapted the ideology of neo-Confucianism and the appelation of sage, the result was a further claim to *kōgi*. In short, military authority can now make claims not only to political preeminence, but also to leadership in the realms of moral and cultural affairs.

However, if neo-Confucian ideology, the ritual of tea, and pictures of Chinese scholar-recluses convey a sense of ethical and cultural superiority, when aristocrats or priests espoused these same ideas, engaged in the same ceremonies, and commissioned the same paintings, then these activities may be seen as an attempt to wrest back the cultural and moral high ground from their rivals in the military class. The remarkable feature about the sponsorship of tea and paintings of scholar-recluses is its very breadth. The culture of aesthetic reclusion provided a set of shared symbols and ideals. Despite the different ramifications of aesthetic reclusion, we see a common core of shared values in Momoyama and early Edo society. Whatever their political conflicts, warriors, aristocrats, and priests were fashioning a common cultural language that included the values of aesthetic reclusion as part of its syntax and social acts such as tea and hermit-theme paintings as a critical component of its lexicon.

The Structure of Antistructure

We conclude this chapter by raising two related questions: how can we more fully account for the linking of Daoist and Confucian subjects in Momoyama and early Edo painting; and how can we explain the appeal of aesthetic reclusion for ideologies as distinct as tea and neo-Confucianism? Although these questions seem direct enough, they have extremely broad implications. In essence, we have argued that, at one level or another, the rich mix of concepts defining aesthetic reclusion lie at the very heart of Momoyama and early Edo culture, informing the major philosophies, rituals, and visual expressions of the age. What was it about the fusion of cultivated men with life in nature that made this combination so deeply compelling? To answer this question, we return to Chinese antiquity to explore some fundamental relationships between Daoism and Confucianism, those neatly balanced models of human experience.

As we have observed, the combination of Daoist and Confucian subjects could take place within a single painting, as in Takanobu's *Four Accomplishments fusuma* (fig. 24) or in adjacent rooms with paintings of Confucian scholars and Daoist immortals—literally placed back-to-back —as in the Metropolitan *fusuma* panels (figs. 25 and 26). Fujiwara Seika's insistence on the similarity underlying all Chinese sages may begin to explain this phenomenon. In addition, we tend to think of Dao-

ism in terms of magic, but as Daoism developed in the early Six Dynasties period, its leading philosophers emphasized the very Confucian qualities of virtue, sincerity, stillness, learning, veneration of teachers, and humanity of the Daoist sage.[22]

Moreover, tea and Daoism, so incompatible at first blush, may share some basic values. In his *Book of Tea* of 1906, Okakura Tenshin (1862–1913) suggests that tea is really a form of Daoism, both "philosophies" concerned with the "art of being in the world."[23] Seven hundred years earlier, in the first Japanese book of tea, *Kissa yōjōki* (Drink Tea and Prolong Life), the priest Eisai (1141–1215) writes at length about the magical properties of the beverage. Eisai even speculates that drinking tea, straight or mixed with mulberry, may result in longevity, sprouting wings, and other attributes associated with Daoist immortals.[24] But the real point of commonality between the later *wabi* form of tea and Daoism is that both posit an ideal world as an escape from the quotidian realm of daily affairs into the purifying sphere of nature. Moreover, this escape is not merely a rejection of the political realm but a way of finding a new order that balances public and private life, society and nature.

Wolfgang Bauer, in *China and the Search for Happiness*, presents an enlightening analysis of Daoism as an antistructure that functions as a key to personal liberation in that it creates a fictive alternative to normative society. Bauer holds that by the fourth century, Daoism had evolved significantly from the wild, anarchic form of earlier periods. For instance, the dominant Daoist idea of paradise was no longer some sparse, ethereal abstraction or disturbing supernatural wonderland but a combination of the temporal happiness of this world with the eternal happiness of heaven. Consequently, the new Daoist hermit was not hostile to society but a beneficial part of it. Daoist attachment to the world, signaled by the struggle to preserve it forever, really functioned as a reification of the world and the idea of social order. The Daoist recluse thus became "a kind of unofficial official, whose sphere of competence is the wilderness."[25] At times of national renewal, such as the beginning of a new dynasty, the "unofficial official" would return to the political center to advise the monarch.

Bauer cites two examples of historical figures who were Daoists and officials. One is Zhang Liang, the same man who appears in the return of the Four Graybeards, and the other is Taigong Wang. Zhang Liang not only recorded Daoist practices of life extension but supposedly possessed a book attributed to Taigong Wang that contained magic secrets of military strategy.[26] We can add to this list Dongfang Shuo, the minister to Han Wudi who reputedly stole the peaches of immortality after they were presented to the emperor by Xiwangmu. The significance of Taigong Wang and Zhang Liang, and Dongfang Shuo to a lesser extent, is

that they appeared to assist warrior-emperors at the founding of new dynasties.

By conflating the Confucian ideal of virtuous rule with the Daoist idea that each new dynasty is the beginning of a "mystical order where the new ruler established harmony between nature and society, he [the emperor] would establish a 'heavenly government,' and be supported by a staff of sages."[27] While earlier forms of Daoism taught anarchy and rejection of any normative order, by the third century a new type of Daoist (or neo-Daoist) philosopher such as Ruan Ji, one of the Seven Sages, proposed a well-run society based on egalitarian relations between men. In *Daren xiansheng zhuan* (Biography of Master Great Man), Ruan Ji suggests that in the ideal society, individuation serves as the norm in opposition to the real world, where the individual is dominated by the demands of the state.[28]

The fusion of Daoism with Confucian values reached its apogee in the writing of Ge Hong (284–363). Expanding on the ideas of Ruan Ji, Ge Hong details the ways in which the realm of the Daoist recluse is beneficial to society. Taking the story of Xu You and Chaofu, Ge Hong explains that their rejection of society was not really a threat to the "hierarchically structured world" but "rather, they warn against the excessive valuation of it, and attempt to make clear that an unshackled life in nature has to be preserved as a correlative to the life molded by society."[29] For Ge Hong, the ideal society was one that preserved the balance between public life, defined by official duty, and the private life, expressed by life in nature.

Not only does nature become a correlative of civilization, but Ge Hong divides the world into three spheres that correspond to the human spirit: the shadow realm of the supernatural; the "original" realm of nature; and the bureaucratic order of society. Each world is necessary to balance the others; and, for the normative political realm to function harmoniously, the other worlds and their residents must be propitiated. In essence, the ideal society must balance and reconcile Daoist anti-authoritarianism with Confucian authority. In this world of balance and moderation, the Daoist sage functions as the "nonappointed official" who rules the mountains and the rivers, just as appointed Confucian officials have jurisdiction over human society.[30]

It is nature, and the life of the recluse there, that function as the middle ground between the otherworld of immortals and the mundane world of political office. But nature not only provides a necessary balance to civilization, it allows for the spiritual freedom at the basis of self-cultivation. Nature can be thought of as the liberating realm of mountains and rivers, which serves to unlock human nature. The notion of *ziran* ("thusness-in-itself" or "naturalness"), a key concept in neo-Daoist

philosophy of the Seven Sages, grows out of the Daoist emphasis on nature. By the fourth century, this conflation of interest in nature and self-nature produced the fad for enjoyment of rustic "paradises" where the elite could temporarily escape the evils of civilization and authority and find self-fulfillment while at the same time maintaining all the pleasures of civilization without the interference of normative society.[31]

In the late-sixteenth- and early-seventeenth-century Japanese culture of reclusion—whether manifest in paintings of scholar-recluses such as the Seven Sages or the Four Graybeards, in tea, or in Seika's brand of neo-Confucianism—nature plays a similar role. On one hand, nature is the setting for the activities espoused in all three forms of eremitic expression.[32] On the other, these forms of Japanese culture all seek to discover the inner nature of the individual. Yet, this discovery neither threatens nor dissolves social structures. To the contrary, in newly founded, authoritarian social orders such as those of the Momoyama and the early Tokugawa periods, the circumscribed and largely ritualized expression of individuality provided a type of indirect political criticism for those marginalized by military rule even as it functioned as a psychological release for men serving in the government.

6.
Epilogue

IN THIS STUDY, we have witnessed how the values of aesthetic reclusion occupy the heart of a range of Momoyama and early Edo period cultural phenomena, including the ideology of tea, neo-Confucianism as taught by Fujiwara Seika, pictures of the Seven Sages of the Bamboo Grove and the Four Graybeards of Mt. Shang, and even the lives of actual hermit-scholars such as Shōkadō Shōjō and Ishikawa Jōzan. In each of these distinct but interrelated manifestations, aesthetic reclusion posits a complex and contradictory relationship to the center of power that it ostensibly rejects. In many ways, the relationship of aesthetic reclusion to political power is best expressed in its early Chinese paradigms—the stories of the Four Graybeards and the Seven Sages. The Four Graybeards, representing the positive valuation of reclusion during their sojourn on Mt. Shang and conversely the sanctioning of political order in their return to the Han court, symbolize both the rejection and validation of power. In related fashion, the Seven Sages represent a refusal to serve the government and devotion to self-cultivation. Yet, because their rejection of politics in favor of devotion to self-exploration through the arts does not directly threaten the political order, it actually serves to support that order by providing a safe outlet for potentially subversive men marginalized by political struggles or by their philosophical views.

The Politics of Aesthetic Reclusion

In essence, aesthetic reclusion is politically ambivalent. While it assumes an inversion of the values of the normative sociopolitical order, by relegating criticism of that order to a personal choice and then channeling that choice into artistic or ritual expression, the political rejection implied by reclusion is safely distanced from revolution. Furthermore, the antistructure provided by the pictorial or ritual world of the recluse

creates a new social order, with distinct parameters and rules of acceptable behavior. The symbolic inversion of social norms produces its own canons or orthodoxy. Again, despite its outward rejection of social and political order, aesthetic reclusion is neither anarchic nor revolutionary.

While ancient Chinese recluses often carried out direct or indirect protests against the political order, these exemplars were recreated and reconfigured in later literature and art so that the original implications are weakened but not destroyed. In similar fashion, Japanese pictures of scholar-recluses usually divest these men of their potentially disruptive individuality so that they may be pressed into recognizable, and easily manipulated, forms. For instance, the combination or pairing of the Confucian Four Graybeards and the neo-Daoist Seven Sages disregards standard Chinese iconography and contravenes Chinese history. Yet, because Japanese artists reconstruct these subjects as part of the broad structure of aesthetic reclusion, which is neither alien to nor incompatible with either of the original themes, the new forms may still resonate with old political implications. As these implications are subsumed, however, under the larger and more politically palatable rubric of aesthetic reclusion, their political punch becomes little more than a gentle nudge.

Because political dislocation reaches its peak in periods of social upheaval, expressions of aesthetic reclusion are of most political utility during these troubled times. The Momoyama epoch, when Oda Nobunaga and Toyotomi Hideyoshi battled to bring about national unification, was a time of almost unparalleled political upheaval. The establishment of Tokugawa hegemony in the early Edo period marked another turbulent age of "dynastic" change. During these unsettled eras, when the political and social order was being restructured, it is no coincidence that ideologies and images of aesthetic reclusion figure so critically in Japanese culture and art. Military leaders had an obvious stake in expressions of cultural reclusion, which demonstrated their ostensible virtue even as they allowed for defeated rivals to channel their loss of power into harmless activities and symbols. For the aristocrats, priests, and defeated warriors marginalized in the power struggles of the late sixteenth and early seventeenth centuries, these same rituals and pictures of aesthetic reclusion likely provided a means of subtle and acceptable political protest. Even more important, aesthetic reclusion offered a way of interpreting social dislocation in positive terms: political marginalization was not the loss of power or prestige but reconfigured as the gain of a venerable tradition predicated on the positive enjoyment of communitas, scholarly pastimes, appreciation of nature, and objects of elegant rusticity.

The extent to which the themes of aesthetic reclusion implicit in pic-

tures of Chinese-hermits resonated with all groups of patrons is seen in the plethora of later *fusuma* and screens that are similar to those Momoyama period pictures discussed in chapter 4. A brief survey of only seventeenth-century *fusuma* and wall paintings by Kano school artists in Kyoto and Shiga area temples reveals both the popularity of these themes for priestly patrons and the manner in which pictures of sages and immortals often were placed in adjacent rooms. At Rinsenji, in Saga, the anonymous paintings of circa 1600 in the Tōhoku no ma show the *kinkishoga* theme.[1] At Myōshinji, Kyoto, the Gedan ichi no ma in the Hōjō of the Tenkyū'in features paintings of the Three Laughers of the Tiger Ravine, Chinese children practicing the *kinkishoga*, and various poet-recluses—all presumably painted about 1631 by Kano Sansetsu.[2] The Shiga'in, Sakamoto, includes *fusuma* of Daoist immortals, the Three Laughers, and the *kinkishoga* attributed to Watanabe Ryōkei. In the Tai-mensho of the massive Ōhōjō at Chion'in, Kyoto, in 1641, Kano Nobu-masa (1607–1658) painted the immortals in the *gedan no ma*, seven scholars in the *chūdan no ma*, and various scholars in the *jōdan no ma*.[3] At the Kyakuden at Shōjuraigōji, in 1641, Kano Naonobu painted the Seven Sages on the north wall and the Four Graybeards on the west wall of the Kenjin no ma, while his brother Kano Tan'yū brushed the *kin-kishoga* on the *kobusuma* of the east wall.[4] Nine years later, Tan'yū painted Lin Hejing and Tao Yuanming, half of the Four Admirers, in the Danna no ma of Shūon'an, Kyoto.[5] In 1657, Tan'yū undertook the sub-stantial task of painting the walls of the Kuroshoin at Nishihonganji, the abbot's elegant living quarters. On the *tokonoma* wall of the *jōdan no ma* is a painting of a scholar reading in a snow-covered hermitage; in the *ni no ma* are pictures of a scholar playing *go* on the east *fusuma*, Tao Yuan-ming on the west *fusuma*, a scholar in a pavilion looking at a waterfall on the *tokonoma* wall, and Chinese boys and a scholar riding a donkey on the lower panels of the *shōji* doors.[6]

The next generation of Kyoto Kano painters was just as active in painting Chinese-hermit themes. At Jissō'in in Iwakura, one room fea-tures Daoist immortals by Kano Eikei (1662–1702),[7] another shows the Nine Old Men by Kano Eishin Yasunobu (1613–1685), and a third in-cludes paintings of the *teikan* reportedly brought from the villa of Jōshū-mon'in, the empress of the Higashiyama emperor. The Shinden at the Bishamondō, Yamashina, painted in 1693 by Kano Dōun Masanobu (1625–1694) for the sixth son of emperor Gosei'in, features rooms with pictures of the Four Admirers, Nine Old Men, the Lanting Gathering, and the *teikan*.[8] At Donge'in, Kyoto, the Hondō includes several rooms of paintings of various scholarly gentleman, including Lin Hejing and Zhou Maoshu, by the Kano pupil Yamaguchi Sekkei (1644–1732).[9] Kano Yasunobu's student Morikawa Kyoroku (1656–1715) painted the Seven

Sages and various Daoist immortals in adjacent rooms at Ryōtanji, Hikone. Adjacent to Kano Mitsunobu's famous *fusuma* in the Ichi no ma and Ni no ma at the Kangaku'in, Onjōji, are three rooms with anonymous and undated paintings of the Nine Old Men, the *kinkishoga*, and the Four Admirers at the West Lake. Finally, in the Kyakuden at Saikyōji, Sakamoto, the so-called Kenjin no ma features the Four Graybeards and Zhang Liang along one wall and the Seven Sages in another, while the *tokonoma* has pictures of scholars at court—perhaps the Four Graybeards after their return or some theme from the *teikan*. Temple legend holds that the paintings, along with the entire structure, were brought from Hideyoshi's Fushimi castle, although the quality and style of the paintings suggests a later and less impressive pedigree.

In almost all of these works, the scholars and immortals are placed in landscape settings, where they stroll along paths and gaze out across lakes or at distant waterfalls from stylish pavilions. Moreover, the paintings invariably show the scholars, and sometimes even the immortals, engaging in scholarly activities. Even those pictures that are not of the *kinkishoga* theme often include at least one figure plucking the *qin* or two men concentrating on a game of *go*. Implicit in all of these figure groups is the theme of communitas, as scholars and immortals gather in groups to converse or read scrolls. Finally, the bevies of fresh-faced servant boys who attend to these elderly recluses are often placed in poses that suggest rather intimate relations with their masters. Thus, as with the hermit-theme paintings of the Momoyama period, these large-scale, ambient *fusuma* sets continue to express the same theme of aesthetic reclusion and to provide archetypes for a genteel life in retirement.[10]

The above survey is limited to ambient paintings at Buddhist temples, but similar subjects were painted on the walls at aristocratic villas and at structures built for *samurai*. We have already referred to the Kano school *fusuma* of the *Four Graybeards and Seven Sages* (fig. 4) in the Ni no ma at the Nakashoin of Katsura villa. We should also note that the Shingoten at Katsura features two *kobusuma* of scholar-recluses in its Ichi no ma, and four *kobusuma* of the *kinkishoga* and two more of unidentified scholars or immortals in its Keshō no ma. The casual elegance of these ink monochrome pictures matches the *kirei sabi* (refined rusticity) tea taste of the entire complex. At the Tsunegoten, the emperor's residence at the Imperial Palace, a pair of undated and anonymous wooden panels, painted with heavy color, show Tao Yuanming Returning Home and Su Dongpo's Red Cliff. *Samurai* patrons also surrounded themselves with themes of scholarly escape. For example, at Nagoya Castle, painted by Tan'yū and his studio in 1633, the Ni no ma—the central chamber—of the Jōrakuden features *fusuma* paintings of the *kinkishoga* theme.[11]

The idea that aesthetic reclusion was deployed, or co-opted, by the elite classes, whether those in or out of power, is demonstrated not only by the fact that the vast majority of images of scholar-recluses were painted for these patrons but also by the existence of numerous parody versions created by the generally merchant-class artists working in the *ukiyoe* genre. Parody or *mitate* images, in which seven fashionably attired courtesans stand chatting or reading a calligraphy scroll in a bamboo grove, were produced both in color prints and painted scrolls. Among the several well-known versions of the theme—including prints by Ishikawa Toyonobu (1711–1785) and Suzuki Harunobu (1724–1770)[12]—the most famous is the hanging scroll in color on silk (fig. 34) by Katsukawa Shunshō (1726–1792), now owned by the Tokyo University of Fine Arts.

This image, and the others like it, present an inversion of orthodox pictures of the Seven Sages. Instead of aged Chinese worthies from the venerable past, Shunshō depicts young Japanese courtesans from the current age. In essence, the culture of the merchant class, represented by seven *geisha*, usurps that of the social and cultural elites, who are represented by symbols such as the Seven Sages. Whether we tend to interpret *mitate* pictures as examples of merchant-class humor that plays harmlessly with history and sociocultural boundaries, or as shots fired in a culture war waged between the merchant and military classes, in *ukiyoe* the Seven Sages are clearly linked with the dominant culture. Rather than serving as antiestablishment icons who contravene normative social and political values, the *ukiyoe* parody of the Seven Sages posits them as orthodox emblems of the political establishment. While Edo period *mitate* of the Seven Sages made by and for the merchant class have a social significance quite different from that found in Momoyama pictures of the Seven Sages produced for military and other elites, both types of pictures imaginatively and purposefully "play" with culture and history. Artists and patrons of both groups manipulate images from a venerable, older tradition in order to bolster their own political and cultural positions.

History, Culture, and Imagination

This study has presupposed, and perhaps even demonstrated, that the relation of art to culture is not reflective so much as it is reflexive. To better understand this connection, we do well to consider that culture, in the conception of Clifford Geertz, is not a force to which social activities, institutions, or forms can be attributed but rather a context in which they can be described more fully. In this conception, works of art are not mere reflections or products of culture, but are themselves "refined and intensified forms of experience."[13]

If culture is a context or a web of experience spun by man, then the relation of art and experience is dialogic rather than dialectical: experience (such as the ritual of tea) structures expression (such as hermit-theme painting), and in turn, expression structures experience.[14] Thus, expressions such as artworks do not merely pictorialize experience, they give it shape and meaning, providing form and suggesting interpretations. Artworks are not only a means by which people constitute, reflect on, and reconstitute the objective facts of their culture but also a means by which people construct and clarify what they perceive, imagine, or merely wish themselves to be. Barbara Myerhoff has written:

> One of the most persistent but elusive ways that people make sense of themselves is to show themselves to themselves through multiple forms, by telling themselves stories, by dramatizing in rituals and other collective enactments; by rendering visible actual and desired truths about themselves and the significance of their existence.[15]

In reconstituting a hermeneutics of Japanese culture, we need emphasize not only what was but what was thought or desired to be. In an investigation of interpretation, objective facts (history as it often is construed) matter less than subjective perceptions. In this study, we have been untroubled with the actual lives or motivations of the Seven Sages and the Four Graybeards, but quite concerned with the Japanese perception and deployment of them. For our purposes, historical reality is history as experienced and as expressed.

In this view, history and culture are constantly constructed or reinvented from an assortment of symbols, customs, memories, needs, and desires. History and culture are, to some degree, a collective fantasy calling on the imagination of all those who wish to belong. This view of culture, which accepts equally both material artifacts and the immaterial realm of the imagination, coincides with André Gide's statement, "Fiction is history which might have taken place, and history fiction which has taken place."[16] In other words, culture is not merely a determined historical reality nor even a continuous flow of related acts or ideas; it is also a particular way of viewing the past. This interpretation of culture echoes Michael Baxandall's definition of tradition as "a specifically discriminating view of the past in an active and reciprocal relation with a developing set of dispositions and skills."[17]

Art, like literature, ritual, or even advertising, is an integral cultural agent: a physical artifact that reveals as well as constructs both actual and desired truths. When we read a novel or look at a painting, we assume that the events depicted are neither "real" events nor a transcription of real events. Rather, the created images are "representations of imagined actions." Although clearly artificial, these two-dimensional fic-

tions brushed on paper build a credible three-dimensional world and create a sense of possible reality. By the believable fiction of, for example, late-sixteenth-century paintings of the Seven Sages and the Four Graybeards, the world of Chinese scholar-recluses is brought into and made part of the real world of Momoyama period priests, aristocrats, and military leaders. Conversely, these men, through these pictorial fictions, are freed to play with the "translucency of culture." Entities distinct in time and place—a room in Kyoto in the 1590s and a bamboo grove outside third-century Loyang or Mt. Shang in the late Qin dynasty —are brought into direct contact. In this sense, late-sixteenth- and early-seventeenth-century Japanese paintings of Chinese hermits are invocations of the "real" invisible worlds of Chinese hermits and aesthetic reclusion as they existed within Momoyama and early Edo period culture. Paintings, although material phenomena, are not abstract or self-contained objects; they are transformative entities brought alive through active reading within the context of culture.

Notes

1. Seen and Unseen Worlds

1. There is no direct proof that the figure in the *Senzui byōbu* is Bo Juyi, but ample circumstantial evidence supports this common attribution. Although Bo was not associated with reclusion in China, his two years in exile below Incense-Burner Peak on Mt. Lu in Jiangxi led to his apotheosis as the recluse-poet par excellence in Heian period Japan. For a summary of the Heian conception of Bo Juyi as a hermit, and a discussion of Bo Juyi as the model behind Genji's exile in the *Suma* chapter of *Genji monogatari*, see Haruo Shirane, *The Bridge of Dreams* (Stanford: Stanford University Press, 1987), 22. In *Genji monogatari hyōshaku*, 3: 129–131, Tamagami Takuya goes so far as to argue that Murasaki Shikibu based her description of Genji's *Suma* dwelling on the *Senzui byōbu* or an earlier prototype. According to temple legend, the screen, long owned by Kyōōgokokuji (Tōji) in Kyoto, was brought from China in 804 by Kōbō daishi (774–835), who had received it as a gift from the emperor. The current screen is likely a copy of the Chinese original.

2. Taiga's *Ten Conveniences* leaves are published and discussed in Suzuki Susumu and Sasaki Jōhei, *Ike Taiga*, vol. 18 of *Nihon bijutsu kaiga zenshū* (Tokyo: Shūeisha, 1980), pls. 37–40 and figs. 26–30.

3. "Hermit" is from the Greek *eremos* meaning "lonely," while the Chinese compounds *tonsei* and *inton* literally read "escaping the world" and "hiding and escaping," respectively.

4. See the fifteenth-century *Senzui byōbu* at Daigoji and the similar screen panels at the Idemitsu and Egawa museums, reproduced in Tokyo kokuritsu hakubutsukan, *Muromachi jidai no byōbue* (Tokyo: Tokyo kokuritsu hakubutsukan, 1989), pls. 3, 4, and 5, respectively.

5. Kasai Masaaki, ed., *Yakuchū Honchō gashi* (Kyoto: Dōhōsha, 1985), 380. *Jōdan*, *chūdan*, and *gedan*, literally "upper step," "middle step," and "lower step," refer to the parts of a large, formal room *(zashiki)* divided physically and symbolically by higher and lower floors.

6. Modern art historical terminology reflects this difference between Muromachi and Momoyama figure subjects. For Muromachi period paintings of Chinese figures, the old Chinese compound *dōshaku jinbutsuga* or "Daoist-Buddhist figure painting" is used frequently, while the more diverse Chinese figure pic-

tures of the Momoyama and early Edo periods are referred to by the more general modern term *kangakei jinbutsuga.*

7. The first known mention of the Four Admirers (or Hall of the Four Admirers) is in Yu Ji's *Siai tiyong xu;* thus Yu is assumed to have been the first to conceive of them as a group. Chinese paintings of the Four Admirers are not known, neither in extant copies nor in catalogs of paintings.

8. Good examples at Zen temples include the *fusuma* paintings of the Seven Sages at the Ōbaiin of Daitokuji (fig. 11) and the Four Graybeards at the Shinjuan of the same temple (fig. 10); for aristocratic residences, the Seven Sages are found in the Middle Shoin (Nakashoin) at Katsura Villa (fig. 4); records reveal that both themes were painted at Azuchi Castle.

9. These arguments are made by Toda Teisuke, "Kangakei jinbutsuzu byōbu no rinkan" in Takeda Tsuneo, ed., *Jinbutsuga: Kangakei jinbutsu,* vol. 4 of *Nihon byōbue shūsei* (Tokyo: Kōdansha, 1980), 131–135, and Kanazawa Hiroshi, "Chūsei kangakei jinbutsuzu byōbu no tenbō," in the same volume, pp. 136–142. Kanazawa does not use the term "decorative" *(sōshokuteki)* but writes that the essential character of *fusuma* and screens is to provide "peacefulness" *(ochitsuki)* and "pleasantness" *(kaitekisa)* to the inhabitants of the spaces defined by these painted architectural dividers.

10. Toda, "Kangakei jinbutsuzu byōbu no rinkan," 134.

11. Kanazawa, "Chūsei kangakei jinbutsuzu byōbu no tenbō," especially pp. 137 and 142. Kanazawa seems to assume for these sixteenth-century screens and *fusuma* an exclusive audience of Zen priests with exactly the same concerns as their counterparts one hundred years earlier. Kanazawa's argument rests in part on the notion that a viewer is neither able nor meant to imagine himself in a painting that contains multiple figures.

12. Hiroshi Ōnishi, "Chinese Lore for Japanese Spaces," *The Metropolitan Museum of Art Bulletin* 51 (Summer 1993): 3–47.

13. Carolyn Wheelwright, "Kano Shoei" (Ph.D. dissertation, Princeton University, 1980), 127–128.

14. Wheelwright, "Kano Shoei," 128.

15. James Cahill, *Sakaki Hyakusen and Early Nanga Painting* (Berkeley: Institute of East Asian Studies, 1983), 74–76.

16. William McNeill, "The Historical Significance of Tea," in Paul Varley and Kumakura Isao, eds., *Tea in Japan: Essays on the History of* Chanoyu (Honolulu: University of Hawai'i Press, 1984), 256.

17. For a further discussion of the dual nature of Confucian eremitism, see Frederick Mote, "Confucian Eremitism in the Yuan period," in Arthur Wright, ed., *The Confucian Persuasion* (Stanford: Stanford University Press, 1960), especially pp. 253–255.

18. A more thorough account of the Seven Sages and Four Graybeards is provided at the outset of chapter 2.

19. It is critical to note that the Four Graybeards of Mt. Shang are pictorialized in two distinct ways: living in reclusion on Mt. Shang, and returning to serve the court. Even in the pictures where the Four Graybeards are presenting themselves at court, the educated viewer is aware that the importance of their return is based, in part, on the pleasant life of reclusion that they have abandoned.

20. The term, especially as applied to early medieval Japanese literature, is discussed in detail in Mezaki Tokue, *Saigyō no shisōshiteki kenkyū* (Tokyo: Yoshikawa kōbunkan, 1978), 100–132.

21. The figures in the paintings and the audience of the paintings are both largely male.

22. For instance, the *fusuma* in the Ōhōjō at Nanzenji were painted originally for the Seiryōden at the Imperial Palace and moved to the Zen temple in 1611 or later.

23. For a discussion of the phenomenon in regard to Japanese literature of the Heian through Muromachi periods, see Michele Marra, *The Aesthetics of Discontent: Politics and Reclusion in Medieval Japanese Literature* (Honolulu: University of Hawai'i Press, 1991).

24. If these documents exist, they have not been published by Japanese art historians who work on Momoyama painting. Even Ōta Gyūichi's account of the paintings at Azuchi Castle is limited to description, never venturing an opinion on signification.

25. In "Chinese Lore for Japanese Spaces," Ōnishi writes of wall paintings: "They act as a medium of visual communication in a more or less intensive social domain, whether for a didactic purpose, for use in ritual, or for the expression of a communal utopian vision" (p. 3). He argues that the development of *fusuma* painting in the Momoyama period is directly related to the desire of patrons to express ambient "messages" (p. 44).

26. Good examples include the Ōhiroma at the Ninomaru palace of Nijō Castle and the Taimensho at Nishihonganji.

27. Historians often cite 1568, the year Oda Nobunaga entered Kyoto, as the beginning of the Momoyama period and 1603, the year Tokugawa Ieyasu (1542–1616) established the Tokugawa bakufu, or 1615, the year of the fall of Osaka Castle and final demise of the Toyotomi family, as its terminus. Cultural historians often extend Momoyama to begin around the mid-sixteenth century and end in the 1620s.

28. Miek Bal and Norman Bryson, "Semiotics and Art History," *The Art Bulletin* 73 (June 1991): 175. Examples relevant to this work include those studies of Momoyama screens concluding that the paintings are decorative because the art historian has determined that the physical context of the screen format is inherently decorative, and those studies holding that Momoyama figure paintings must convey political power because the Momoyama cultural context is primarily one of the positive expression of power.

29. Bal and Bryson, "Semiotics and Art History," 179.

30. William LaFleur, *The Karma of Words: Buddhism and the Literary Arts in Medieval Japan* (Berkeley: University of California Press, 1983), 9.

2. A Tradition of Transformation

1. In *Gujin yishi zhuan, juan* 1:11.

2. The second part of the story is found in Song Lien, *Song xueshi quanji, juan* 13:458–459; *Hanshu, juan* 40:2033–2036 and *juan* 72:3056; and *Shiji, juan* 55: 2044–2047. For a translation, see Burton Watson, trans., *Records of the Grand Historian of China*, vol. 1 (New York: Columbia University Press, 1961), I:148.

3. See Audrey Spiro, *Contemplating the Ancients* (Berkeley and Los Angeles: University of California Press, 1991), 33–36, for an illustration and discussion of the Four Graybeards on the Lelang basket.

4. For a more complete discussion of Chinese paintings of the Four Graybeards, see Ju-yu Jang, "The Hermit-Theme Painting in the Painting Academy of the Ming Dynasty" (M.A. thesis, University of California, Berkeley, 1983), 73–79.

5. This theory is advanced in Donald Holzman, "Les Sept Sages de la Forêt des Bambous et la Societé de leur Temps," *T'oung pao* 44 (1956): 317–346, and Richard Mather, trans., *Shih-Shuo Hsin-Yu: A New Account of Tales of the World* (Minneapolis: University of Minnesota Press, 1976), 371. Indeed, all early accounts of the Seven Sages as a group—*Weishi chunqiu, Jinyangqiu* by Sun Sheng (ca. 302–373), *Zhulin qixian lun* by Dai Kui (d. 396), and *Mingshi zhuan*—are works of the Eastern Jin. The biographies of the Seven Sages, their place in Eastern Jin culture, and their pictorialization (along with Rong Qiqi) in the Nanjing tomb tiles are summarized in Spiro, *Contemplating the Ancients*, 75–121.

6. Wolfgang Bauer, *China and the Search for Happiness*, trans. Michael Shaw (New York: Seabury, 1976), 148.

7. *Shishuo xinyu* includes nearly sixty references to individual members of the Seven Sages and five to the Sages as a group. For an English translation of the text, see Richard Mather, *Shih-shuo Hsin-yu: A New Account of Tales of the World;* for the Chinese text with Japanese notes, see Nekada Makoto, ed., *Sesetsu shingo*, vols. 76–78 of *Shinshaku kanbun taikei* (Tokyo: Meiji shoin, 1975).

8. Etienne Balazs, "Nihilistic Revolt or Mystical Escapism: Currents of Thought in China during the Third Century A.D.," in Etienne Balazs, trans. H. M. Wright and ed. A. Wright, *Chinese Civilization and Bureaucracy: Variations on a Theme* (New Haven: Yale University Press, 1964), 233–235.

9. Translation in Bauer, *China and the Search for Happiness*, 146. The essay, included in the *Ji Kang ji* (*juan* 3:4a), is fully translated by Donald Holzman, *La Vie et la Pensée de Hsi Kang* (Leiden: Brill, 1957), 86–91, and abridged in Mather, *A New Account of Tales of the World*, 103.

10. As Ji Kang was executed for anarchy at age thirty-six; it seems that the combination of unfettered self-cultivation with politics often was better left to theory than practice.

11. Translated by Spiro, *Contemplating the Ancients*, 78; see also James Hightower, "Hsi K'ang's Letter to Shan T'ao" in Cyril Birch, ed., *Anthology of Chinese Literature* (New York: Grove Press, 1955), I:162–166.

12. See Spiro, *Contemplating the Ancients*, 78–79, for an overview of Ji Kang's feeling on the *qin;* see R. H. van Gulik, *The Lore of the Chinese Lute: An Essay on the Ideology of the Chin* (Tokyo: Sophia University, 1969) and *Hsi K'ang and his poetical Essay on the Lute* (Tokyo: Sophia University Press, 1941), 88–89, for translations of Ji's essay on the instrument.

13. Liu's poem *Jiudesong* (In Praise of the Virtues of Wine) appears in *Shishuo xinyu* (*juan* 4:69) and *Wenxuan* (*juan* 4:5b–6a), from which it was known to Ōtomo Tabito. Section 374 of *Mengqiu* includes two stories of Liu Ling's love of drink: the first relates how when Liu rode in a cart, he was always followed by a servant holding a shovel, who was prepared to bury Liu should he suddenly die; the second tells the anecdote in which Liu swears to his wife that he will give up wine, but when begging the gods for the power to fulfill his vow, he drinks the offering wine. Both themes are listed in *Kōsoshū*, Kano Ikkei's 1623 Japanese catalog of Chinese painting themes. These and other stories of Liu Ling's inebriation are included in *Shishuo xinyu* (*juan* 23:3, 6) (Mather, *Shih-Shuo Hsin-Yu*, 372–374), *Jinshu, Jinyangqiu*, and *Zhulin qixian zhuan*.

14. Bauer, *China and the Search for Happiness*, 150.

15. For a translation, see Mather, *Shih-shuo Hsin-yu*, 346–347; for the Chinese text, see Nekada, *Sesetsu shingo*, vol. 78 *of Shinshaku kanbun taikei*, 852–853. The anecdote is discussed in R. H. van Gulik, *Sexual Life in Ancient China*

(Leiden: Brill, 1961), 92, and Brett Hinsch, *Passions of the Cut Sleeve: The Male Homosexual Tradition in China* (Berkeley: University of California Press, 1990), 68–69.

16. The poem, from Ruan's *Yonghuai shi* (Poems Singing the Heart), is translated in Hinsch, *Passions of the Cut Sleeve*, 70–71, and Donald Holzman, *Poetry and Politics: The Life and Works of Juan Ch'i*, A.D. *210–263* (Cambridge: Cambridge University Press, 1976), 123–125.

17. van Gulik, *Sexual Life in Ancient China*, 91.

18. For discussions of Chinese paintings of the Seven Sages, see Ellen Laing, "Neo-Taoism and the 'Seven Sages of the Bamboo Grove' in Chinese Painting," *Artibus Asiae* 36 (1974): 5–54, and Jang, "The Hermit-Theme Painting in the Painting Academy of the Ming Dynasty," especially pp. 64–69.

19. *Kaifūsō* (Fond Recollections of Poetry), the first Japanese *kanshi* anthology, contains several such poems on eremitism. Poem no. 108, by "the recluse" Tami no Kurohito, is translated by Helen McCullough in *Brocade by Night: Kokin Wakashū and the Court Style in Japanese Classical Poetry* (Stanford: Stanford University Press, 1985), 89; for the original text, see Kojima Noriyuki, ed., *Kaifūsō*, vol. 69 of *Nihon koten bungaku taikei* (Tokyo: Iwanami shoten, 1957). Kurohito's "Sitting Alone in the Mountains" is translated in Burton Watson, *Japanese Literature in Chinese* (New York: Columbia University Press, 1975), I:26. The word *tonsei* is used for the first time in Japan in *Kaifūsō*.

20. For a study and partial translation of *Wenxuan*, see David Knechtges, *Wen Xuan, or Selections of Refined Literature*, vol. I, *Rhapsodies on Metropolises and Capitals by Xiao Tong* (Princeton: Princeton University Press, 1972); for the Chinese text with Japanese notes, see Uchida Sennosuke and Ami Yūji, eds., *Monzen*, vols. 14 and 15 of *Shinshaku kanbun taikei* (Tokyo: Meiji shoin, 1974).

21. Uchida and Ami, *Monzen*, 200–216.

22. Ibid. 221–226, 278–282, and 598–600.

23. It was often used to teach Heian aristocrats Chinese language and history, as evidenced by the proverb "Even the sparrows of the Kangakuin sing *Mengqiu*." References to the work are found in *Genji monogatari* and *Makura no sōshi*. A Southern Song edition was known in Japan by the early fourteenth century. The long popularity of the text in the Momoyama period is attested to by an edition printed in Kyoto in 1596. The Chinese text, with notes in Japanese, is found in Hayakawa Mitsusaburō, *Mōgyū* (Tokyo: Meiji shoin, 1973); for a partial translation of the first half of the text, see Burton Watson, trans., *Meng Ch'iu: Famous Episodes from Chinese History and Legend* (Tokyo: Kōdansha International, 1979).

24. Hayakawa, *Mōgyū*. No. 1, pp. 145–148 (Watson, *Meng Ch'iu*, 19–20); no. 25, pp. 187–188; nos. 55 and 56, pp. 236–240 (Watson, *Meng Ch'iu*, 51–52); no. 81, pp. 279–284; no. 117, pp. 339–342 (Watson, *Meng Ch'iu*, 87–88); no. 175, pp. 431–434 (Watson, *Meng Ch'iu*, 114); no. 344, pp. 696–703; no. 373, pp. 740–744; and no. 570, pp. 1040–1042.

25. Translated in McCullough, *Brocade by Night*, 90.

26. Translated by Watson, *Japanese Literature in Chinese*, I:49; for the original text, see Uchida, Senrosuke and Ami Yūji, eds., *Nihon koten bungaku taikei*, (Tokyo: Iwanami shoten, 1959), 24:331.

27. Translated by Ian Levy, *The Ten Thousand Leaves: A Translation of the Man'yōshū, Japan's Premier Anthology of Classical Poetry* (Princeton: Princeton University Press, 1981), 187. The entire sequence is also translated, and dis-

cussed, in Paula Doe, *A Warbler's Song in the Dusk: The Life and Work of Ōtomo Yakamochi (718–785)* (Berkeley: University of California Press, 1982), 34–39.

28. Doe, *A Warbler's Song in the Dusk,* 136.

29. In Earl Miner, ed., *Principles of Classical Japanese Literature* (Princeton: Princeton University Press, 1984), 151–180.

30. Tokue Mezaki, "Aesthetic-Recluses During the Transition from Ancient to Medieval Japan," in Earl Miner, ed., *Principles of Classical Japanese Literature* (Princeton: Princeton University Press, 1985), 153.

31. For a broad discussion of these Japanese immortals, see Hori, "On the Concept of Hijiri (Holy-man)." *Numen* 5, no. 2 (April 1958): 128–160; 5, no. 3 (September 1958): 192–232. For specific examples of these Daoistic *hijiri,* see Makada Morio, ed., *Nihon ryōiki,* vol. 8 of *Kan'yaku Nihon no koten* (Tokyo: Shōgakkan, 1986), 92 and 119, translated in Kyōko Nakamura, *Miraculous Stories from the Japanese Buddhist Tradition: The Nihon Ryoiki of the Monk Kyokai* (Cambridge: Harvard University Press, 1973), 124 and 140–141; Yoshiko Dykstra, *Miraculous Tales of the Lotus Sutra from Ancient Japan: The "Dainihon Hokekyō-kenki" of Priest Chingen* (Honolulu: University of Hawai'i Press, 1983), 70–71; and Kobayashi Chisho, ed., *Uji shūi monogatari,* vol. 28 of *Nihon koten bungaku zenshū* (Tokyo: Shōgakkan, 1972), 293–294, translated in D. E. Mills, *A Collection of Tales from Uji: A Study and Translation of Uji Shūi Monogatari* (Cambridge: Cambridge University Press, 1970), 364–365.

32. See James Legge, trans., *Confucian Analects: The Great Learning and the Doctrine of the Mean* (New York: Dover, 1971), 315.

33. For a translation, see Watson, *Records of the Grand Historian of China,* I:286. For their death poem and an analysis of their significance, see Chi Li, "The Changing Concept of the Recluse in Chinese Literature," *Harvard Journal of Asiatic Studies* 24 (1962): 234–235.

34. For an English translation, see Mills, *A Collection of Tales from Uji,* 436; for the Japanese text, see Watanabe Tsunaya and Nishio Kōichi, eds., *Uji shūi monogatari,* vol. 27 of *Nihon koten bungaku zenshū* (Tokyo: Iwanami shoten, 1960), 434.

35. The story is found in *Shiji* (61:6a, b); for an English translation, see Watson, *Records of the Grand Historian of China,* I:520. The story also is recounted in Huangfu Mi's (215–282) *Gaoshi zhuan* (collected in Tao Zongyi's *Shuofu* juan 57:3a–4a) and his *Yinshi zhuan.* Ruan Ji refers to Xu You and Chaofu in one poem, no. 74 in Holzman, *Poetry and Politics,* 66–67.

36. For an English translation, see Robert Morrell, *Sand and Pebbles (Shasekishū): The Tales of Mujū Ichien, a Voice for Pluralism in Kamakura Buddhism* (Albany: State University of New York Press, 1985), 247; for the Japanese text, see Watanabe Tsunaya, ed., *Shasekishū,* vol. 85 of *Nihon koten bungaku taikei* (Tokyo: Iwanami shoten, 1966), 409–410.

37. This is not the only example of Mujū's bending Chinese history in support of his belief in the efficacy of Buddhist practice. For instance, Mujū explains Zen through the *Zhuangzi* (1:9) and interprets Confucian parables in light of Buddhism (3:6, 3:7, and 9:1).

38. David Pollack, *The Fracture of Meaning: Japan's Synthesis of China from the Eighth through the Eighteenth Centuries* (Princeton: Princeton University Press, 1986).

39. While *Kudai waka* (Waka Written from Lines of Chinese Poetry), compiled in 894 by Ōe no Chisato, translates Chinese poems into Japanese *waka,*

Wakan rōeishū (Collection of Japanese and Chinese Poems for Recitation), compiled circa 1018 by Fujiwara Kintō (966–1041), juxtaposes Japanese *waka* with Chinese poems on the same topics pared down into couplets. Topics relevant to eremitism in *Wakan rōeishuū* include "Hermit's Dwellings" *(senka)*, "Mountain Dwellings" *(sanka)*, and "Leisurely Retreat" *(kankyo)*. See Kawaguchi Hisao and Shido Nobuyoshi, eds., *Wakan rōeishū*, vol. 73 of *Nihon koten bungaku taikei* (Tokyo: Iwanami shoten, 1965), 188–193.

40. Translated by Rosette Willig, *The Changelings (Torikaebaya monogatari)* (Stanford: Stanford University Press, 1988), 20; for the original text, see Suzuki Hiromichi, *Torikaebaya monogatari no kenkyū* (Tokyo: Kasama shoin, 1973), 11.

41. The metaphor is used in similar fashion in poem no. 1339, by Michitsuna's mother (ca. 995), from the *Shūishū* (Collection of Gleanings); see Katagiri Yōichi, *Shūiwakashū no kenkyū* (Kyoto: Daigakudō, 1980), 427. By contrast, the *nō* play *Shakkyō* (Stone Bridge) includes a reference to Wang Zhi's ax handle as part of a much fuller discussion of Wang Zhi's experience in the mountains.

42. Pollack, *The Fracture of Meaning,* 77. Pollack's phrase may sound hyperbolic, but it is amply supported by the evidence surrounding Bo's reception in Heian Japan. Bo's poetry was known in Japan by the middle of the ninth century—the poet's 845 preface to his collected works warns readers against the spurious editions of his poems circulating in Silla and Japan—and by the end of the century he likely was considered the premier Chinese poet. More than half the Chinese poems in the *Kudai waka* are his, 135 of the 588 Chinese selections in the *Wakan rōeishū* are Bo's, and dozens of his verses appear in the *Senzai kaku* (Superb Lines from a Thousand Years). The mid-eleventh-century *waka* anthology *Honchō monzui* also includes several poems by Bo Juyi, while he has 65 of the 542 Chinese verses in *Shinsen rōeishū* (Newly Selected Collection for Recitation), compiled by Fujiwara Mototoshi (d. ca. 1142). In addition, the *Boshi wenji* (*Hakushi monjū* in Japanese) was known to educated Japanese by the middle of the Heian period. Literary indebtedness to Bo Juyi reached its zenith in Fujiwara Teika's (1162–1241) *Monjudai hyakushu* (One Hundred *Waka* on Topics from Bo Juyi's Collected Works). For a discussion of Bo Juyi and Heian poetry, see Kaneko Hikojirō, *Heian jidai bungaku to Hakushi monjū* (Tokyo: Baifukan, 1955).

43. See Shirane, *Bridge of Dreams*, 123, for an analysis of the relationship between the *Kiritsubo* chapter and Bo's famous verse.

44. A short passage in *Makura no sōshi* (Pillowbook), the miscellany by Murasaki's rival, Sei Shōnagon, indicates how deeply Bo Juyi was associated with the grass hut, the symbol of aesthetic reclusion. With a typical mixture of self-congratulation and peevish vexation, Sei reveals that because she completed the last lines of a *waka* that alluded to a verse by Bo Juyi, she was given the nickname *kusa no iori* or "grass hut." For a translation, see Ivan Morris, *The Pillow Book of Sei Shōnagon* (New York: Columbia University Press, 1965), 89; for the original text, see Matsuo Satoshi and Nagai Kazuko, eds., *Makura no sōshi*, vol. 11 of *Nihon koten bungaku zenshū* (Tokyo: Shōgakkan, 1972), 971.

45. For the description of Genji's house, see Edward Seidensticker, trans., *The Tale of Genji* (New York: Knopf, 1976), 21, and Abe Akio, ed., *Genji monogatari* II, vol. 13 of *Nihon koten bungaku zenshū* (Tokyo: Shōgakkan, 1972), 13:179. For the first poem by Bo Juyi (*Collected Works* 14), see Seidensticker, *Tale of Genji*, 238, and Abe, *Genji monogatari*, 194. For the second poem (*Collected Works* 17), see Seidensticker, *Tale of Genji*, 244, and Abe, *Genji monogatari*, 296.

46. See Seidensticker, *Tale of Genji*, 236–238, and Abe, *Genji monogatari*, 190–194.

47. See Seidensticker, *Tale of Genji*, 225, and Abe, *Genji monogatari*, 168.

48. The poem praises the "middle reclusion" *(zhongyin)* of the secretary over the "great reclusion" *(dayin)* of turbulent life at court or in the city, and the "small reclusion" *(xiaoyin)* of solitary life in the country. The poem is translated and discussed in Li, "The Changing Concept of the Recluse in Chinese Literature," 243.

49. For further discussion of Murasaki's appropriation of Bo Juyi in the *Suma* chapter, see Haruo Shirane, *The Bridge of Dreams: A Poetics of "The Tale of Genji"* (Stanford: Stanford University Press, 1987), 21–23, and Pollack, *The Fracture of Meaning*, 68–71.

50. Translated by Seidensticker, *Tale of Genji*, 272; for the Japanese text, see Abe, *Genji monogatari*, 273.

51. Seidensticker, *Tale of Genji*, 272, and Abe, *Genji monogatari*, 273.

52. For an English translation, see Yoshito Hakeda, trans., *Kūkai: Major Works* (New York: Columbia University Press, 1972), 122; for the original text, see Katō Seishin, ed., *Sangō shiiki*, vol. 3 of *Iwanami bunko* (Tokyo: Iwanami shoten, 1939), 37.

53. See Kawaguchi and Shido, eds., *Wakan rōeishū*, 141.

54. See Kōno Tama, ed., *Utsuho monogatari*, vols. 10–12 of *Nihon koten bungaku taikei* (Tokyo: Iwanami shoten, 1959), 270.

55. See Shirane, *Bridge of Dreams*, 15–16.

56. For a brief analysis and translation, see Ward Geddes, trans., *Kara Monogatari: Tales of China* (Tempe: Center for Asian Studies, University of Arizona, 1984), 97–103; for the original text, see Ikenabe Toshinori et al., eds., *Kara monogatari*, vol. 18 of *Kōchū kokubun sōsho* (Tokyo: Hakubinkan, 1915), 14–18.

57. Geddes, *Kara Monogatari*, 49.

58. Translated by Geddes, *Kara monogatari*, 73.

59. For a lengthy discussion of the "eremitization" of Bo Juyi, see Ikeda Toshio, ed., "Kara monogatari to Hakushi monjū," *Tsurumi joshi daigaku kiyō* 4 (1967): 46–47.

60. For the Daoist criticism of Boyi and Shuqi, see *Zhuangzi* (8) (James Legge, trans., *The Texts of Taoism* [New York: Dover, 1962], 273–275). Neo-Daoist attacks of the two men are found in *Hanshu* (65) and in Ruan Ji's poem "Shouyang Mountain" (translated by Holzman, *Poetry and Politics*, 22–24). For neo-Daoist attacks on Xu You and Chaofu, see *Shishuo Xinyu* (2:18) (Mather, *Shih-Shuo Hsin-Yu: A New Account of Tales of the World*, 40), *Jinshu* (49:16.b), *and Wenxuan* (16:7b).

61. For a translation, see Thomas Cogan, trans., *The Tale of the Soga Brothers* (Tokyo: Tokyo University Press, 1987), 132; for the original text, see Ichiko Teiji et al., eds., *Soga monogatari*, vol. 88 of *Nihon koten bungaku taikei* (Tokyo: Iwanami shoten, 1966), 220–221.

62. Translated by Helen McCullough, *The Tale of the Heike* (Stanford: Stanford University Press, 1988), 128; for the original text, see Takagi Ichinosuke et al., eds., *Heike monogatari* vol. 32 of *Nihon koten bungaku taikei* (Tokyo: Iwanami shoten, 1959), 266.

63. Translated by McCullough, *Tale of the Heike*, 343; for the original text, see Takagi et al., eds., *Heike monogatari*, 270.

64. Translated by Cogan, *Tale of the Soga Brothers*, 288; for the original text,

see Ichiko Teiji et al., eds., *Soga monogatari*, vol. 48 of *Nihon koten bungaku taikei* (Tokyo: Iwanami shoten, 1966), 416.

65. William LaFleur, *The Karma of Words: Buddhism and the Literary Arts in Medieval Japan* (Berkeley: University of California Press, 1983), 62.

66. For a translation, see Marian Ury, "Recluses and Eccentric Monks: Tales from the *Hosshinshū* by Kamo no Chōmei," *Monumenta Nipponica* 27 (1972): 169–173; for the original text, see Takao and Nagashima, eds., *Hosshinshū*, 164–165.

67. For a translation, see Dennis Hirota, *Plain Words on the Pure Land Way: Sayings of the Wandering Monks of Medieval Japan* (Kyoto: Ryūkoku University, 1988), 19, 27, and 28; for the original text, see Usui Yoshimi, ed., *Hōjōki, Tsurezuregusa, Ichigon hōdan shū* (Tokyo: Chikuma shōbō, 1970), 310, 316, and 317.

68. Translated by Morrell, *Sand and Pebbles*, 134–135; for the original text, see Watanabe Tsunaya, ed., *Shasekishū*, vol. 85 of *Nihon koten bungaka taikei* (Tokyo: Iwanami shoten, 1966), 162–163.

69. Major studies of *Inton no bungaku* include Sakurai Yoshio, *Inja no fūbō: Inton seikatsu to sono seishin* (Tokyo: Hanawa shobō, 1967) and *Nihon no inja* (Tokyo: Hanawa shobō, 1969); Itō Hiroyuki, *Inton no bungaku* (Tokyo: Kasama shobō, 1975); Hirohata Yazuru, *Chūsei inja bungei no keifu* (Tokyo: Ōfūsha, 1978); and Satō Masahide, *Inja no shisō: Saigyō o megutte* (Tokyo: Tokyo daigaku shuppankai, 1977).

70. Important studies of this material include LaFleur, *The Karma of Words* (especially chapter 3, "Inns and Hermitages: The Structure of Impermanence," and chapter 5, "Chōmei As Hermit: Vimalakirti in the 'Hōjōki' "); Thomas Blenman Hare, "Reading Kamo no Chōmei," *Harvard Journal of Asiatic Studies* 49 (1989); and Michele Marra, *The Aesthetics of Discontent: Politics and Reclusion in Medieval Japanese Literature* (Honolulu: University of Hawai'i Press, 1991) (especially chapter 4, "The Aesthetics of Reclusion: Kamo no Chōmei and the Last Age," and chapter 6, "The Ideal Court: Kenkō's Search for Meaning").

71. For a translation, see Watson, *Japanese Literature in Chinese*, I:61–64 for the original text, see Kakimura Shigematsu, ed., *Honchō monzui chūshaku*, vol. 2 (Tokyo: Toyamabō, 1971).

72. The scholarly ideal of reading by moonlight recalls the fourth-century Chinese scholar Sun Kang, who, too poor to buy candles, read in the winter by moonlight reflected off piled snow. Sun Kang is included in *Mengqiu* no. 193. For a translation, see Watson, *Meng Ch'iu*, 120; for the original text, see Hayakawa, *Mōgyū*, 460–461.

73. See Watson, *Japanese Literature in Chinese*, 63, and Kakimura, *Honchō monzui chūshaku*, 700–701.

74. As translated by Legge (*Confucian Analects*, 311–312), the line reads: "There are three things men find enjoyment in which are advantageous . . . : to find enjoyment in discriminating study of ceremonies and music; to find enjoyment in speaking of the goodness of others; to find enjoyment in having many worthy friends; these are advantageous."

75. For translations of *Hōjōki*, see Donald Keene, "An Account of My Hut" in *An Anthology of Japanese Literature* (New York: Grove Press, 1955), 197–212, and Helen McCullough, "An Account of My Hermitage" in *Classical Japanese Prose: An Anthology* (Stanford, Stanford University Press, 1990), 379–392; for the original text, see Nishio Minoru, ed., *Hōjōki, Tsurezuregusa*, vol. 30 of *Nihon koten*

bungaku taikei (Tokyo: Iwanami shoten, 1957), 23–45. For critical discussions of the work, see notes 69 and 70.

76. However, Chōmei does mention the famous early Heian poet-hermits Semimaru and Sarumaru.

77. Translated by Donald Keene, *Essays in Idleness: The Tsurezuregusa of Kenkō* (New York: Columbia University Press, 1967), 10; for the Japanese text, see Nishio, ed., *Hōjōki, Tsurezuregusa*, 97.

78. For a translation, see Keene, *Essays in Idleness*, 4; for the original text, see Nishio, ed., *Hōjōki, Tsurezuregusa*, 91.

79. Translated by Keene, *Essays in Idleness*, 12; for the original text, see Nishio, ed., *Hōjōki, Tsurezuregusa*, 100.

80. See Keene, *Essays in Idleness*, 18, and Nishio, ed., *Hōjōki, Tsurezuregusa*, 104. The *Mengqiu* account was included in *Mōgyū waka*, a partial translation of *Mengqiu* with appended *waka*, produced by Minamoto Mitsuyuki (1163–1244) in 1204.

81. The line is adapted from a poem by Ji Kang found in *Wenxuan*.

82. Translated by Keene, *Essays in Idleness*, 22; for the original text, see Nishio, ed., *Hōjōki, Tsurezuregusa*, 108.

83. See Keene, *Essays in Idleness*, 146, and Nishio, ed., *Hōjōki, Tsurezure-gusa*, 170. According to accounts in *Jinshu* and *Shishuo xinyu* (24:4) (Mather, *A New Account of Tales of the World*, 394), Ruan Ji was able to make his eyes appear all white to worldly men (whom he disliked) and brown to men he was fond of. The anecdote is recounted in *Mengqiu* (no. 570) and *Mōgyū waka*, from which Kenkō likely adapted it.

84. See Philip B. Yampolsky, ed., *Selected Writings of Nichiren*, trans. Burton Watson (New York: Columbia University Press, 1990), 28.

85. See note 48.

86. Translated by Keene, *Anthology of Japanese Literature*, 211; for the Japanese text, see Nishio, ed., *Hōjōki, Tsurezuregusa*, 43.

87. See Marra, *The Aesthetics of Discontent*, chapter 6.

88. In the very act of their creation, *shigajiku* suggest the spirit of communitas described on the scrolls' surfaces. Typically, a group of priests would gather to compose the poems and the paintings. Thus, the physical genesis of the *shigajiku* is a highly social act, a creative ritual in which like-minded men meet to produce a collective fantasy of escape from the entanglements of the mundane world.

89. For translations of Gozan poetry, see David Pollack, *Zen Poems of the Five Mountains* (New York: Crossroad Publishing and Scholars Press, 1985), and Marian Ury, *Poems of the Five Mountains: An Introduction to the Literature of the Zen Monastaries* (Ann Arbor: Center for Japanese Studies, University of Michigan, 1992). Several good examples of *shosaizu shigajiku* are analyzed, and their poems translated, in Yoshiaki Shimizu, ed., *Japan: The Shaping of Daimyo Culture, 1185–1868* (Washington, D.C., National Gallery of Art, 1988), 143–148.

90. Muromachi period paintings of Tao Yuanming include portraits by Bunsei (fl. mid-15th c.) in the Powers and Asano collections (published in Yoshiaki Shimizu and Carolyn Wheelwright, eds., *Japanese Ink Paintings from American Collections: The Muromachi Period* [Princeton: Princeton University Art Museum, 1976], 79–80), and Tao as one of the Three Laughers (see John M. Rosenfield, "The Unity of the Three Creeds: A Theme in Japanese Ink Painting of the Fifteenth Century" in John W. Hall and Toyoda Takeshi, eds., *Japan in the Muroma-*

chi Age [Berkeley: University of California Press, 1977], 208–217 for a discussion of the theme and pictorial examples). Li Bo is depicted viewing a waterfall in paintings attributed to Sōami (1485–1525) (published in Yoshiko Kakudo, *The Art of Japan: Masterworks in the Asian Art Museum of San Francisco* [San Francisco: Asian Art Museum of San Francisco, 1991], *Sōami/Shōkei*, pl. 52), by Shōkei (fl. ca. 1478–1506) (published in *Egawa bijutsukan kanzō hyakusen* [Nishinomiya: Egawa bijutsukan, 1983], pl. 16), an anonymous scroll (published in Matsushita Takaaki and Kawai Masatomo, *Josetsu/Shūbun* [Tokyo: Shūeisha, 1979], pl. 9,) and by Tōshun (fl. 1506–1542) (published in Tanaka Ichimatsu et al., *Sesshū/Sesson*, vol. 7 of *Suiboku bijutsu taikei* [Tokyo: Kōdansha, 1973], pl. 90). Paintings of Du Fu include one with an inscription by Ashikaga Yoshiaki (1537–1597) in the Seattle Art Museum (published in *A Thousand Cranes: Treasures of Japanese Art* [Seattle: Seattle Art Museum, 1987]), three by Sesshū (1420–1506) (published in Nakamura Tanio, *Sesshū*, vol. 4 of *Nihon bijutsu kaiga zenshū* [Tokyo: Shūeisha, 1980], pl. 65; Hayashiya Seizō, *Chanoyu, Japanese Tea Ceremony*, trans. Emily J. Sano [New York: Japan Society, 1979]; and Matsushita Takaaki, *Josetsu/Shūbun/San'ami*, vol. 6 of *Suiboku bijutsu taikei* [Tokyo: Kōdansha, 1973]), and a single scroll by Tōshun (published in Tanaka et al., *Sesshū/Sesson*, pl. 91). Su Dongpo is illustrated in an anonymous group portrait with his father, Su Xun (1009–1066), and brother Su Zhe (1039–1112) (published in Matsushita Takaaki, *Josetsu/Shūbun/San'ami*, pl. 37) and, during his exile in Hainan, in a painting attributed to Jasoku (d. 1483) in the Metropolitan Museum of Art (published in Barbara Brennan Ford, "The Arts of Japan," *The Metropolitan Museum of Art Bulletin* 45 [Summer 1987], pl. 46). Lin Hejing is the subject of a fan painting by Soga Sōyo (fl. mid-15th c.) (published in Suntory bijutsukan, *Daitokuji Shinju'an meihōten* [Tokyo: Suntory bijutsukan, 1980], pl. 34), hanging scrolls attributed to Ri Shūbun in the Kyoto National Museum (published in Matsushita Takaaki, *Josetsu/Shūbun/San'ami*, pl. 61) and Sōen (fl. 1489–1500) (Tanaka et al., *Sesshū/Sesson*, pl. 15), and a small picture pasted on a screen by Tōshun (published in Tanaka Ichimatsu et al., *Sesshū/Sesson*, pl. 84).

91. Ikkyū's *Kyōunshū* (Crazy Cloud Anthology) includes several poems on Tao Yuanming drinking wine and Du Fu, and twenty-six poems on Lin Hejing. For an English study and partial translation, see Sonja Arntzen, *Ikkyū and the Crazy Cloud Anthology: A Zen Poet of Medieval Japan* (Tokyo: University of Tokyo Press, 1986).

92. The political dimensions of the biographies of Li, Su, and Zhou may have added another level of appeal for these priests whose own desire for escape was partially motivated by the political upheaval of the age or, at least, the political and administrative responsibilities attached to their sacerdotal positions.

93. The text is included in *Dainihon bukkyō zenshū*, vol. 3. Chinese figures are found on pp. 1104–1192.

94. Translated by Hiroshi Ōnishi and Barbara Brennan Ford; see "Gentlemanly Accomplishments: The Adaptation of Chinese Literati Culture," in Barbara Brennan Ford and Oliver Impey, *Japanese Art from the Gerry Collection in the Metropolitan Museum of Art* (New York: The Metropolitan Museum of Art, 1990), 32; for the original text, see Tamamura Takeji, ed., *Gozan bungaku shinshū* (Tokyo: Tokyo daigaku shuppankai, 1967), 1:57.

95. A rare exception appears in *Azuma mondō* (Eastern Dialogues), where the master Sōgi (1421–1502) links two stanzas through a reference to Taigong Wang. For Sōgi's verse, see Kaneko Kinjirō et al., eds., *Renga haikaishū*, vol. 32 of

Nihon koten bungaku zenshū (Tokyo: Shōgakkan, 1974): 229–230. For a broad discussion of medieval *waka*, see Steven Carter, "Waka in the Age of Renga," *Monumenta Nipponica* 36 (Winter 1981).

96. In his 1376 *Kyūshū mondō* (Kyūshū Dialogues), Nijō Yoshimoto (1320–1388) finds the basis for *renga* aesthetics in Chinese poetry, citing the *Shijing* (Books of Odes), as well as the verse of Li Bo, Du Fu, Su Dongpo, and Huang Shangu. Yoshimoto located in these poets not so much models of reclusive purity but creators of a new aesthetic that found beauty in what was desolate, cold, and forlorn. In *Sasamegoto* (Murmurings), the poet Shinkei (1406–1475) champions Du Fu for similar reasons but also finds in Chinese figures archetypes for the recluse's enhanced creative powers. In section fifty-five of the question-and-answer-style treatise, Shinkei answers in the affirmative to the query, "Is it true that if you seek for the true sources of poetry among people devoted to the art, you are more likely to find them manifested by those who desire only a life of tranquillity and seclusion?" (Translated by Dennis Hirota, "In Practice of the Way: *Sasamegoto*, an Instruction Book in Linked Verse," *Chanoyu Quarterly* 19 [1979]: 34.)

97. It is not mere coincidence that *wabi* tea pioneers Murata Jukō and Takeno Jōō were contemporaries of the *renga* masters Shinkei and Sōgi. As Dennis Hirota writes, "In a sense, the early founders of wabi tea—Jukō and Jōō—were the real inheritors of . . . the legacy of *renga*" ("In Practice of the Way," 24).

98. Yoshimoto's instructions are translated in Hirota, "In Practice of the Way," 25. For an extended study of the importance of place in *renga* composition, see H. Mack Horton, "Renga Unbound: Performative Aspects of Japanese Linked Verse," *Harvard Journal of Asiatic Studies* 53 (December 1993): 443–512.

99. See, for example, the fourth stanza of Sōgi's *Wasuregusa* (Grasses of Forgetfulness) translated in Earl Miner, *Japanese Linked Verse* (Princeton: Princeton University Press, 1979), 33. The massive disturbance caused by the Ōnin war caused Shinkei to pass his last years in a hermitage in Sagami province, Sōgi to spend several years traveling around the country, and Shōhaku to build his Yumean hermitage.

100. Miner, *Japanese Linked Verse*, 33. The importance of the hut in *renga* recalls not only the *waka* poetry of Saigyō and the recluse literature of Yasutane, Chōmei, and Kenkō but also the status accorded the ideal studio *(shosai)* in Gozan culture.

101. The work is translated and analyzed by Steven Carter, *Three Poets at Yuyama* (Berkeley: Institute of East Asian Studies, 1983). The Japanese text can be found in Kaneko et al., eds., *Renga haikaishū*, 150–184.

3. Symbolic Virtue and Political Legitimation

1. The words *tonseisha* and *inja* also referred to men who took vows independently *(jiyū shukke)* and retired from lay life but did not affiliate with temples. For a thorough discussion of the medieval use of *tonseisha* and the function of high culture in Kitayama politics, see H. Paul Varley, "Ashikaga Yoshimitsu and the World of Kitayama: Social Change and Shogunal Patronage in Early Muromachi Japan," in John W. Hall and Toyoda Takeshi, eds., *Japan in the Muromachi Age* (Berkeley: University of California Press, 1977).

2. Translated by Varley, "Ashikaga Yoshimitsu and the World of Kitayama," 190; for the Japanese text, see Gotō Tanji and Kamada Kisaburō, eds., *Taiheiki*, vol. 36 of *Nihon koten bungaku taikei* (Tokyo: Iwanami shoten, 1960), 373–374.

3. The most famous cultural advisors to several *shōgun*, Nōami (1397–1471), Geiami (1431–1485), and Sōami (1485–1525) were called *dōbōshū*. *Nihon kokugo daijiten*, vol. 15, lists *dōbōshū*, or aesthetic advisor, as the second meaning for *tonseisha* (p. 111). The role of the Amis, and their status as members of the Jishū or "Time Sect" of Pure Land Buddhism is discussed in Murai Yasuhiko, "Buke bunka to dōbōshū," *Bungaku* 31, no. 1 (1963).

4. David Pollack has suggested that, based on the content of their creative work, even literary monks such as the *renga* poet Shōtetsu (1381–1459), the priest Ikkyū, and the painters Josetsu (1386–1428) and Oguri Sōtan (1413–1481) "considered themselves part of that very broadly defined category known as *tonseisha* (hermits) that included everything from men of religion to men of taste (in other contexts called *suki*)" (*The Fracture of Meaning: Japan's Synthesis of China from the Eighth through the Eighteenth Centuries* [Princeton: Princeton University Press, 1986], 183).

5. Varley, "Ashikaga Yoshimitsu and the World of Kitayama," 213.

6. John W. Hall, "Hideyoshi's Domestic Policies," in John W. Hall et al., eds., *Japan Before Tokugawa: Political Consolidation and Economic Growth, 1500–1650* (Princeton: Princeton University Press, 1981), 196.

7. Weber, "Type of Authority and Imperative Coordination," quoted in George Elison, "Hideyoshi, the Bountiful Minister," in George Elison and Bardwell L. Smith, eds., *Warlords, Artists, and Commoners: Japan in the Sixteenth Century* (Honolulu: University of Hawai'i Press, 1981), 227.

8. For a good introduction to the subject, see Martin Collcutt, "Daimyo and Daimyo Culture," in Yoshiaki Shimizu, ed., *Japan: Shaping of Daimyo Culture, 1185–1868* (Washington, D.C.: National Gallery of Art, 1988), especially pp. 7–14.

9. See Marius Jansen, "Tosa in the Sixteenth Century: The 100 Article Code of Chosokabe Motochika," *Oriens Extremus* 10 (1963): 83–108.

10. For a discussion of *kōgi* as "public good" or "public authority," see Mary Elizabeth Berry, "Public Peace and Private Attachment: The Goals and Conduct of Power in Early Modern Japan," *Journal of Japanese Studies* 12 (1986): 269.

11. See Katsumata Shizuo, "The Development of Sengoku Law," trans. Martin Collcutt, in John W. Hall et al., eds, *Japan Before Tokugawa*, 101–124 for a fuller exploration of *kōgi* and *kiryō*. Much of the following discussion is derived from this important essay.

12. See Fujiki Hisashi, "Tōitsu seiken no seiritsu," in *Iwanamikōza*, vol. 9 of *Nihon rekishi* (Tokyo: Iwanami shoten, 1975), 65–79.

13. In 1565, Nobunaga began using a personal seal with the character *rin* to refer to the mythical Chinese animal the *kirin*, which was supposed to appear in times of good government. Two years later, Nobunaga employed a Ming-style four-character seal reading *tenka fubu* (the realm subjected to the military). In the same year, after winning a battle at Inabayama, he renamed the town Gifu, the Japanese pronunciation of the Chinese town Qifu, where the Zhou ruler Wu-wang began his campaign of conquest in the twelfth century B.C.

14. Visual references to *kōgi* embodied in some Daoist, Buddhist, Confucian, and hermit themes are discussed in chapter 4.

15. Translated by Mary Elizabeth Berry, *Hideyoshi* (Cambridge: Harvard University Press, 1982), 204; for the Japanese text, see Kuwata Tadachika, *Toyotomi Hideyoshi kenkyū* (Tokyo: Kadokawa shoten, 1975), 253–254.

16. See Berry, *Hideyoshi*, 64–65; for the Japanese text, see Ōmura Yūko, "Ten-

shōki," in Tadachika Kuwata, ed., *Taikōshiryōshū* (Tokyo: Shinjinbutsu Ōraisha, 1971), 22.

17. Translated by Berry, *Hideyoshi*, 103; for the Japanese text, see Kusaka Hiroshi, ed., *Hōkō ibun* (Tokyo: Hakubunkan, 1914), 201–202.

18. Keene, "Jōha, a Sixteenth-Century Poet of Linked Verse," in Elison and Smith, eds., *Warlords, Artists, and Commoners*, 125.

19. See Berry, *Hideyoshi*, especially pp. 229–232, for Hideyoshi's patronage and practice of *renga* and *nō* as part of a legitimation strategy and as a sincere avocation.

20. Unlike the modern age, in which tea largely is practiced by women, in the Momoyama period the world of tea was essentially a world of men.

21. See Haga Kōshirō, *Sen no Rikyū* (Tokyo: Yoshikawa kōbunkan, 1978), and Kumakura Isao, *Sen no Rikyū: Inquiries into His Life and Tea,"* trans. Paul Varley, in Paul Varley and Kumakura Isao, eds., *Tea in Japan: Essays on the History of* Chanoyu (Honolulu: University of Hawai'i Press, 1984).

22. Sanetaka's four-mat teahouse, Sumiya, was remodeled from his country residence. According to contemporary descriptions, the courtier planted trees and arranged rocks around the structure to recreate the effect of being in nature. It is described in the entry for the sixth month of Bunka 2 (1502) in Sanjōnishi Sanetaka, *Sanetaka kōki* (Tokyo: *Zoku gunsho ruijū kanseikai*, 1935, 23–24. It is discussed in Moriya Takeshi, "The Mountain Dwelling within the City," *Chanoyu Quarterly* 56 (1989): 11, and Murai Yasuhiko, "The Development of *Chanoyu:* Before Rikyū," trans. Paul Varley, in Varley and Kumakura, eds., *Tea in Japan*, 24.

23. Among the many studies of Katsura, Akira Naitō's *Katsura: A Princely Retreat* offers a good discussion of the retreat as an expression of tea ideals (trans. Charles Terry [Tokyo: Kodansha International, 1977]).

24. Berry, *Hideyoshi*, 224.

25. A good example of this practice is recounted in Ōta Gyūichi's *Shinchō kōki* (The Annals of Nobunaga) (1:4) and repeated in V. Dixon Morris, "The City of Sakai and Urban Autonomy," in Elison and Smith, eds., *Warlords, Artists, and Commoners*, 53.

26. Many of these specific gatherings are discussed in Theodore Ludwig, "*Chanoyu* and Momoyama: Conflict and Transformation in Rikyū's Art," in Varley and Kumakura, eds., *Tea in Japan*, 85–89.

27. Louise A. Cort, quoted in Elison, "Hideyoshi, The Bountiful Minister," in Elison and Smith, eds., *Warlords, Artists, and Commoners*, 239. For a study of the event, see Cort, "The Grand Kitano Tea Gathering," *Chanoyu Quarterly* 31 (1982): 13–43. For a discussion of the Kitano tea gathering within Hideyoshi's strategy of cultural legitimation, see Berry, *Hideyoshi*, 189–192.

28. See Beatrice Bodert-Bailey, "Tea and Counsel: The Political Role of Sen Rikyu," *Chanoyu Quarterly* 41 (1987): 25–34.

29. See Kumakura, "Sen no Rikyū: Inquiries into His Life and Tea," in Varley and Kumakura, eds., *Tea in Japan*, 35–36.

30. Ludwig, "*Chanoyu* and Momoyama," 85. The information on the tea gathering in Kyūshū is drawn from the entries in *Sōtan nikki* for Tenshō 15 (Ludwig, "*Chanoyu* and Momoyama," 88–89).

31. Several members of the Mōri clan were hosted at the rustic Yamazato room in 1585, as were a small group of Jesuits several years later. The priest Luis Frois described the room as filled with paintings showing natural scenes and figures from the ancient history of China and Japan. (See Michael Cooper, *They*

Came to Japan [Berkeley: University of California Press, 1965], 136.) In *Sōtan nikki*, Kamiya Sōtan (1553–1635) describes the room in his diary for 1587, but does not mention any paintings. (See Kuwata Tadachika, ed., *Shinshū chadō zenshū* [Tokyo: Shinjūsha, 1956], 8:202–203; and Sen Sōshitsu, ed., *Chadō koten zenshū,* [Kyoto: Tankōsha, 1958], 6:228).

32. Although no good descriptions of the teahouses survive, the two teahouses rebuilt at Kōdaiji when Hideyoshi's widow Kitamandokoro took up residence there in 1606 are said to have been moved from Fushimi. See Horiguchi Sutemi, *Sōan chashitsu*, vol. 83 of *Nihon no bijutsu* (Tokyo: Shibundō, 1973), for a discussion of the Karakasatei (Chinese-Umbrella Pavilion) and the Shiguretei (Rain Pavilion).

33. Berry, *Hideyoshi*, 230.

34. For introductory essays on *basara* tea, see H. Paul Varley and George Elison, "The Culture of Tea: From Its Origins to Sen no Rikyū," in Elison and Smith, eds., *Warlords, Artists, and Commoners*, and Murai, "The Development of Chanoyu," in Varley and Kumakura, eds., *Tea in Japan*. For an overview of Enshū's *daimyō* tea, see Kumakura Isao, "Kan'ei Culture and *Chanoyu*," trans. Paul Varley, in Varley and Kumakura, eds., *Tea in Japan*.

35. For an introduction to Rikyū's disciples—the so-called Group of Seven—including Oribe, see Murai Yasuhiko, "Rikyu's Disciples," *Chanoyu Quarterly* 66 (1992): 7–35.

36. Arguments attributing the Taian to Rikyū's design and Hideyoshi's patronage are given in Nakamura Masao, "Myōkian Taian oboegaki," and Itoh Teiji, "Sen Rikyū and Taian," *Chanoyu Quarterly* 15 (1982): 7–20. Good photos and a plan are found in Kawakami Mitsugu and Nakamura Masao, *Katsura rikyū to chashitsu*, vol. 15 of *Genshoku nihon no bijutsu* (Tokyo: Shōgakkan, 1967), 96–101. The golden tearoom, as reconstructed at the MOA Museum of Art, Atami, is reproduced in Murai Yasuhiko, "A Biography of Sen Rikyū," *Chanoyu Quarterly* 61 (1990): 39.

37. In the previous pages, we have already mentioned the several small *sōan* where Hideyoshi relaxed after his Kyūshū campaigns, as well as the *sōan* teahouses built in the Yamazatomaru at Osaka and Fushimi Castles.

38. Published in Sen Sōshitsu, ed., *Chadō koten zenshū*, vol. 6 (Kyoto: Tankōsha, 1956), 101–103.

39. Published with annotation in Sen Sōshitsu, ed., *Chadō koten zenshū*, vol. 4. The oldest copy of the manuscript was owned by tea man Tachibana Jitsuzan (1655–1708), who claimed to have received it from a descendant of Sōkei. The rather murky history of the text has led some scholars to surmise that Jitsuzan may have written the text himself, basing it on the teachings attributed to Rikyū by later followers of the Sen schools. Despite the much-debated origin of *Nanpōroku*, few scholars have gone so far as to question the long-held opinion that it generally reflects the philosophy of Rikyū or, at least, that of his closest and most avid disciples.

40. Both are translated in full in Michael Cooper, *This Island Japan* (Tokyo: Kōdansha International, 1973). The writings on tea by Rodrigues and other Jesuits are discussed in Michael Cooper, "The Early Europeans and Tea," in Varley and Kumakura, eds., *Tea in Japan*.

41. Translated by Cooper, "The Early Europeans and Tea," 128–129.

42. Ibid., 129–130.

43. Ludwig, "*Chanoyu* and Momoyama," 95.

44. Victor Turner's ideas on ritual antistructure are developed in *Dramas, Fields and Metaphors: Symbolic Action in Human Society* (Ithaca: Cornell University Press, 1974).

45. Probably for this reason the styles of tea developed by Oribe and Enshū evolved many ways of preserving status distinctions even while maintaining the fiction of world rejection. Not only did these seventeenth-century tea styles—often called *daimyō-cha* to indicate their congeniality to military patrons—allow for the greater display of the host's treasures, but the hierarchical arrangement of seating reinforced status distinctions. For instance, while Oribe extended the *roji*, dividing it into outer *(sotoroji)* and inner *(uchiroji)* sections to symbolize better movement from the mundane outer world to the sacred inner realm of the *chashitsu*, the waiting arbor in the outer *roji* was provided with footrest stones *(fumiishi)*, with different sizes demarking the place and status of each guest.

46. Turner, *Dramas, Fields and Metaphors*, 232.

47. Ibid., 208.

48. Before this, *roji* was written with characters that merely indicate a "path," without any special significance. Because the characters' "dewy ground" are used in the *Lotus Sutra* to indicate an "open ground" of emancipation, Rikyū's choice of the same characters has the implication of spiritual liberation. For further discussion, see Dennis Hirota, "Memoranda on the Words of Rikyū, *Nanpōroku* Book I," *Chanoyu Quarterly* 25 (1980): 33.

49. Hirota, "Memoranda of the Words of Rikyū, *Nanpōroku* Book I," 34. In section 33 of the *Oboegaki*, Rikyū is quoted as saying, "A chanoyu gathering is impossible unless people can escape from this mundane world to place free of defilement" (translated by Varley, "Purity and Purification in the *Nampō Roku*," *Chanoyu Quarterly* 48 [1989], 16).

50. Kumakura, "Sen no Rikyū," 52–53.

51. João Rodrigues reports this custom in *Arte de Cha* (see Cooper, "The Early Europeans and Tea," 127).

52. A *roji tsue* designed by Rikyū is illustrated in Kyoto kokuritsu hakubutsukan, *Sen no Rikyūten* (Kyoto: Kyoto kokuritsu hakubutsukan, 1990), 28.

53. Translated by Hirota, "Memoranda of the Words of Rikyū, *Nampōroku* Book I," 33.

54. The function of the *tsukubai* recalls the hand-washing basin at Shintō shrines and is symbolically reminiscent of the river that pilgrims forded before entering the Naiku at Ise Jingū. The seventeenth-century *roji* at Omote senke, Kyoto, includes an actual stream. In *The Garden Art of Japan*, Masao Hayakawa writes that by making the guest bend low to wash his hands and mouth, the *tsukubai* makes him "aware of his own psychological tensions, and through this act, to rid himself of them" (trans. Richard L. Gage [New York: Weatherhill, 1973], 172).

55. Varley, "Purity and Purification in the *Nampō Roku*," 9–10.

56. Turner, *Dramas, Fields and Metaphors*, 208.

57. For a similar summary of the symbolic roles of the *roji* and *sōan*, see Teiji Itoh, *Space and Illusion in the Japanese Garden*, trans. Ralph Friedman and Masajirō Shimamura (New York: Weatherhill, 1973), 84.

58. Turner, *Dramas, Fields and Metaphors*, 232.

59. Ibid., 243.

60. In some mid-seventeenth-century tea gatherings, participants changed into special dress in a changing room located in the outer *roji*.

61. In *The World of the Japanese Garden* (New York: Weatherhill, 1968), 192, Lorraine Kuck suggests that the *sōan* is "an echo down the centuries" of Bo Juyi's Grass Cottage on Mt. Lu.

62. Translated by Cooper, "The Early Europeans and Tea," 124.

63. Among the many good sources on the ceramics and utensils associated with *wabicha* is Kyoto kokuritsu hakubutsukan, *Sen no Rikyū ten*.

64. Turner, *Dramas, Fields and Metaphors*, 248.

65. Cooper, "The Early Europeans and Tea," 124.

66. Turner, *Dramas, Fields and Metaphors*, 203.

67. It is interesting to note again that the original grouping of the Seven Sages is likely the work of Eastern Jin literati who sought to create models for their own behavior.

68. Turner, *Dramas, Fields and Metaphors*, 148.

69. Ibid., 238.

70. Ibid., 248.

71. Ibid., 268.

4. The Visual Structure of Aesthetic Reclusion

1. Many temples in Kyoto and Shiga, seeking to bolster the pedigree of their *fusuma*, claim them to be not only the works of "name" painters such as Kano Eitoku or Kano Sanraku but to have come from Hideyoshi's Fushimi Castle after it was dismantled by the Tokugawa *bakufu* or from the imperial palace. In many cases, the paintings may well have come from other places, but probably from castles less grand than Fushimi or from aristocratic dwellings less august than the imperial palace.

2. *Konendai ryakki* is found in Hanawa Hokinoichi, ed., [*Shinkō*] *Gunsho ruijū* (Tokyo: Nagai shoseki, 1929), 184. The placement of the screens may be seen in a detail showing the Shishinden from the first scroll of the late-twelfth-century *Ban Dainagon ekotoba emaki* (see Tanaka Ichimatsu, ed., vol. 4 of *Nihon emakimono zenshū* [Tokyo: Kadokawa shoten, 1961], or Komatsu Shigemi, ed., vol. 2 of *Nihon emaki taisei* [Tokyo: Chūōkōronsha, 1977]).

3. The history of the *kenjō no sōji* and the famous copies made by Kano Takanobu (1571–1618) in 1614 are presented in Kawamoto Shigeo et al., "Kenjō sōji no kenkyū," *Kokka* 1028 (1979): 9–26 and 1029 (1979): 7–31.

4. Likely emulating the deployment of the *kenjō no sōji* by the imperial household, the Tokugawa *bakufu* commissioned Kano artists to create a set of hanging scrolls of Confucius and his followers for the *sekiten* ceremony celebrating Confucius. A portrait of Confucius was placed in the center of the hall, while portraits of important disciples and sages were arranged along the sides. The *sekiten* ceremony, first held in Japan in 701 and revived by the Tokugawa in the seventeenth century, is still held at Yushima Seidō in Tokyo. One scroll from a set of Confucian sages painted by Kano Seisen'in (1796–1846) is owned by the Freer Gallery, Washington, D.C.

5. For an excellent discussion of this and other expressions of good government in Chinese painting, see the chapter "Political Themes in Chinese Painting," in James Cahill, *Three Alternative Histories of Chinese Painting* (Lawrence: Spencer Museum of Art, 1988).

6. An illustrated book of the theme was copied and published by Toyotomi Hideyori (1593–1615) in 1606. Screens by Kano Sanraku (1559–1633) and an anonymous Kano screen in the Tokyo National Museum are the earliest Japanese

examples. These works are well studied in Nakamura Tanio, "Concerning the Tei-kanzu Cooperatively Done by the Kano School," *Museum* 79 (October 1957): 23–25. Another early pair of screens by Kano Jinnojō (Kyoto National Museum) is studied in Takeda Tsuneo, "Shinsetsu'in Teikanzu byōbu to Kano Jinnojō ni tsuite," *Kokka* 956 (1973): 9–16. The *fusuma* by Kano Tan'yū in the *Jōrakuden* of Nagoya Castle are most fully reproduced in Ishikawa kenritsu bijutsukan, *Nago-yajō shōhekiga meisakuten* (Kanazawa: Ishikawa kenritsu bijutsukan, 1990), pls. 18–20.

7. See chapter 1, n. 10.

8. See chapter 2, pp. 37–38.

9. To the best of our knowledge, the paintings are unpublished and un-studied. They may have been made for Hōryūji or, as with many other objects there, given to the temple by a private patron for whom they originally were made.

10. See Ward Geddes, trans., *Kara monogatari: Tales of China* (Tempe: Center for Asian Studies, University of Arizona, 1984), 102.

11. An echo of the Taigong Wang panels is seen in the small polychrome-and-gold screen in the Denver Art Museum that depicts Wenwang riding in a carriage to meet Taigong Wang, who sits fishing by a river. The style of this unpublished screen indicates a Kano artist and a seventeenth-century date. The same theme is painted by Hasegawa Tōin (fl. ca. 1620) in polychrome on gold on several *fusuma* in the Kyakuden of the Zuiganji, Matsushima. They are published in Tsu-neo Takeda, *Shōbyōga*, vol. 13 of *Genshoku nihon no bijutsu* (Tokyo: Shōgakkan, 1967), fig. 70.

12. This anonymous painting, in a private collection, is published in Takeda Tsuneo, ed., *Bekkan: byōbue taikan*, vol. 28 of *Nihon byōbue shūsei* (Tokyo: Kōdansha, 1980), 79.

13. This pair of screens, recently attributed to Kano Mitsunobu (d. 1608), is published in Shimada Shūjirō et al., *Shōbyōga*, vol. 4 of *Zaigai* Nihon no *shihō* (Tokyo: Mainichi shinbun, 1979), pls. 15–16; and in Hiroshi Ōnishi, "Chinese Lore for Japanese Spaces," *The Metropolitan Museum of Art Bulletin* (Summer 1993), pls. 40–41.

14. Illustrated in Doi Tsugiyoshi, ed., *Kano Sanraku/Sansetsu*, vol. 12 of *Nihon bijutsu kaiga zenshū* (Tokyo: Shūeisha, 1976), pl. 23, and Takeda Tsuneo, ed., *Jinbutsuga: kangakei jinbutsuga*, vol. 4 of *Nihon byōbue shūsei* (Tokyo: Kōdansha, 1980), pls. 65–66. Although the pair of six-panel screens in poly-chrome and gold bear neither signature nor seals of Sanraku, and historically were attributed to Yūshō, contemporary opinion is unanimous in crediting these paintings to Sanraku. These screens are one of three pair by Sanraku at Myōshinji, all listed as Important Cultural Properties. Based on style, they date from the beginning of the seventeenth century.

15. It is published in Nakajima Junji, "The Influence of Hanging Scrolls on the Formation of Screens," *Bijutsushi* 61 (June 1966), pl. 12. The composition of this scroll suggests that it may have been part of a diptych or triptych and origi-nally was painted with another Chinese figure subject, perhaps the Four Gray-beards.

16. It is published in Tokyo kokuritsu hakubutsukan, *Nihon no suibokuga* (Tokyo: Tokyo kokuritsu hakubutsukan, 1987), pl. 105, and Osaka shiritsu biju-tsukan, *Shoki byōbue* (Osaka: Osaka shiritsu bijutsukan, 1966), pl. 20. For a biog-raphy of Keison and examples of his paintings, see Tokyo Metropolitan Teien Art

Museum, *Muromachi bijutsu to sengoku gadan* (Tokyo: Tokyo-to bunka shinkō-kai, 1986), pls. 21–25. Because single screens are quite rare, there is a good chance that this picture of the Seven Sages originally was paired with another figure subject, perhaps the Four Graybeards.

17. For examples, see the *Three Laughers of the Tiger Ravine* and *Landscapes* triptych (Tochigi Prefectural Museum) and *Chōkarō, Tekkai* and *Rodōhin* triptych (Tokiwayama bunko, Kamakura), illustrated in Tokyo Metropolitan Teien Art Museum, *Muromachi bijutsu to sengoku gadan* (Tokyo: Tokyo-to bunka shinkō-kai, 1986), pls. 26 and 25, respectively.

18. It is published in Kameda Tsutomu, *Sesson*, vol. 8 of *Nihon bijutsu kaiga zenshū* (Tokyo: Shūeisha, 1980), pl. 23, and in Miyeko Murase, *Japanese Art: Selections from the Mary and Jackson Burke Collection* (New York: The Metropolitan Museum of Art, 1975). A triptych attributed to Sesson in the Fujita bijutsu-kan, Osaka, shows three of the sages reading a scroll in front of bamboo, and four standing beneath a pine. It is published in *Yamato bunka* 74 (1975), pl. 11. For an excellent English overview of Sesson's career, see Barbara Ford, "The Self-Portrait of Sesson Shūkei," *Archives of Asian Art* 35 (1982): 6–26.

19. See chapter 2, p. 23.

20. These screens, executed in ink and light colors on paper, located in a private collection, are published in Kameda, *Sesson*, pl. 29. The seven equestrians are likely the Seven Sages of the Bamboo Grove because Sesson includes several clumps of bamboo. These equestrian sages are not found elsewhere in extant Japanese paintings. In China, however, *Lidai zhulu huamu (Rekidai choroku gamoku)* lists the theme of the Seven Sages Passing the Barrier. The Freer Gallery, Washington, D.C., owns an anonymous fifteenth-century scroll of *The Seven Scholars Going Through the Pass*, which shows seven men riding donkeys. For an illustration of this scroll and an extended discussion of the theme, see Ju-yu Jang, "The Hermit-Theme Painting in the Painting Academy of the Ming Dynasty," 65–69.

21. These screens, ranked as Important Cultural Properties, are published in Kameda, *Sesson*, pl. 28, and Michael Cunningham, *The Triumph of Japanese Style: Sixteenth-Century Art in Japan* (Cleveland: Cleveland Museum of Art, 1991), pl. 15.

22. A picture taking its inspiration from those of Sesson is the scroll *Sages in a Bamboo Grove* by the sixteenth-century painter Rikō. Although only four sages are shown, because the painting has been cut down from a larger composition it is likely that it was originally part of a scene showing the Seven Sages. The wildly mirthful expression of the figures, together with gourds, links this scroll to typical early sixteenth-century versions. The scroll is published in Hisao Sugahara, *Japanese Ink Painting and Calligraphy from the Collection of the Tokiwayama Bunko* (Brooklyn: Brooklyn Museum of Art, 1967), pl. 32.

23. For instance, they are excluded from Yamaoka Taizō, *Kano Masanobu/Motonobu*, vol. 7 of *Nihon bijutsu kaiga zenshū* (Tokyo: Shūeisha, 1981), and from recent exhibitions of Muromachi screen paintings.

24. For a good discussion of the structure of the Kano school under Motonobu, see Yoshiaki Shimizu, "Workshop Management of the Early Kano Painters, ca. A.D. 1530–1600," *Archives of Asian Art* 34 (1981): 32–47.

25. Published in Nakajima Junji, *Hasegawa Tōhaku*, vol. 10 of *Nihon bijutsu kaiga zenshū* (Tokyo: Shūeisha, 1979), pl. 20.

26. Published in Nakajima, *Hasegawa Tōhaku*, pls. 17 and 42, and in Suntory bijutsukan, *Daitokuji Shinjuan meihōten* (Tokyo: Suntory bijutsukan, 1980), pl. 39.

27. Published in Kawai, *Yūshō/Tōgan*, vol. 11 of *Nihon bijutsu kaiga zenshū* (Tokyo: Shūeisha, 1978), pl. 13. The *fusuma*, painted around 1599, are now mounted as hanging scrolls and are stored at the Kyoto National Museum.

28. The two works are published in Kawai, *Yūshō/Tōgan*, pls. 38 and 44, respectively. For a discussion in English, the Ōbaiin *fusuma* are published in Metropolitan Museum of Art, *Momoyama: Japanese Art in the Age of Grandeur*, no. 19 (New York: Metropolitan Museum of Art, 1975), and the Eisei bunko screens are published in Shimizu, *Japan: The Shaping of Daimyo Culture, 1185–1868* (Washington, D.C., National Gallery of Art, 1988), pl. 119. The Ōbaiin screens may have been painted around 1588, when the Ōbaiin was built for the *daimyō* Kobayakawa Takakage (1532–1596), although on the basis of style, Kawai speculates that they might well have been brushed about 1595. Various arguments on dating the *fusuma* and screen are given by Yamamoto Hideo in his essay and catalog entries in Yamaguchi kenritsu bijutsukan, *Unkoku Tōgan to Momoyama jidai* (Yamaguchi: Yamaguchi kenritsu bijutsukan, 1984), especially pp. 36–43, and in "Unkoku Tōgan to sono ippa," *Nihon no bijutsu* 320 (March 1993).

29. Shōkadō's *kobusuma* at the Ryōkō'in, and painted in the early 1630s, are published in Takeda Tsuneo, *Kano Tan'yū*, vol. 15 of *Nihon bijutsu kaiga zenshū* (Tokyo: Shūeisha, 1978), fig. 17, and are discussed in Kendall Brown, "Shokado Shojo as 'Tea Painter,' " *Chanoyu Quarterly* 49 (Spring 1987), especially pp. 25–27. Yasunobu's screens, done when he was but a lad of twelve, are published in Takeda Tsuneo, *Jinbutsuga: kangakei jinbutsuga*, pl. 113, and in Kendall Brown, "Tan'yū ni miru Kanoha no kangakei jinbutsuga no tenkai," in *Bijutsushi no danmen* (Osaka: Seibundō, 1994), especially pp. 262–263 (fig. 6).

30. See chapter 3, p. 48.

31. See, for instance, the Kano fan paintings illustrated in Takeda Tsuneo, "Nanzenjizō senmen byōbu ni tsuite," *Kokka* 872 (1964).

32. The close relation of Yasunobu's screens to others attributed to Tan'yū is discussed in Brown, "Tan'yū ni miru Kanoha no kangakei jinbutsuga no tenkai," 249–265.

33. That the Seven Sages should be depicted in conversation is thematically appropriate because "pure conversation" is one of their salient characteristics in the Chinese tradition.

34. It is precisely the lack of these standard references to communitas that make rather atypical Tōhaku's Tenjuan and Shinjuan *Four Graybeards fusuma* and Yūshō's *Seven Sages fusuma* at Kenninji.

35. The emphasis on texts, both in the forms of books and calligraphy scrolls, may also relate to the fact that the Seven Sages were associated with Chinese learning, which typically took the form of written texts. Moreover, several of the Seven Sages were famous for their poems and essays. Thus, sagehood and written texts go hand in hand.

36. The painting is in a room where Shōkadō and his friends, including the abbot Kōgetsu Sōgan (1574–1643), would gather not only to meet for the shared experience of drinking tea but to look at the famous calligraphy scroll by the Song master Mian Xiangjie (1107–1186), after whom the room was named. Shōkadō's painting of the *Seven Sages Reading a Scroll* thus parallels the activity for which the room was used.

37. The sole extant exception are Yūshō's *Palace Ladies* and *Four Accomplishments* screens in the Tokyo National Museum. A detail is published in Kawai,

Yūshō/Tōgan, pt. 10, and the entire pair in Shiga kenritsu Biwako bunkakan, *Kaihō Yūshō*, pl. 17 (Shiga: Shiga kenritsu Biwako bunkakan, 1986).

38. Because the members of these groups are listed in Kano Ikkei's *Kōso-shū* of 1623, seventeenth-century Kano painters, at least, likely knew the names and various legends associated with these and other Chinese figure subjects. See Sakazaki Tan, ed., *Nihon garon taikan*, vol. I (Tokyo: Arusu, 1922), 685–687.

39. The screen, in the Kyoto National Museum and designated an Important Cultural Property, is published in Kawai, *Yūshō/Tōgan*, pl. 21. The Eight Immortals of the Winecup subject is inferred from the presence of four inebriated men (with four more presumed to exist in the missing companion screen). However, because this screen differs from later pictures, which typically illustrate the actions of the eight men as described in Du Fu's verse, it is possible that Yūshō's painting is of a different theme.

40. For a discussion of the so-called *chigo monogatari* genre and a translation, see Margaret Childs, "Chigo monogatari: Love Stories or Buddhist Sermons?" *Monumenta Nipponica* 35 (Summer 1980): 127–151.

41. In the Eisei bunko, Tokyo, it is published in Mitsui bunko, *Muromachi kinpekiga kara kinsei e* (Tokyo: Benridō, 1990), pl. 11.

42. For studies of homosexuality in Japanese history, see Iwata Jun'ichi, *Honchō nanshokukō* (Tokyo: Chimaki sangyō yūgen kaisha, 1973), and Hiratsuka Ryosen, *Nihon ni okeru nanshoku no kenkyū* (Tokyo: Nihon no rigakusha, 1983). For a study in English, see Tsuneo Watanabe and Junichi Iwata, *The Love of the Samurai: A Thousand Years of Japanese Homosexuality*, trans. D. R. Roberts (London: Gay Man's Press, 1989).

43. See Sakazaki, *Nihon garon taikan*, 725.

44. For more information on the incident, see Ogawa Tamaki and Yamamoto Kazuyoshi, *Sotōba shishū*, vol. 2 (Tokyo: Tsukuma shobō, 1984), 490.

45. This interpretation is offered by Shauna Goodwin in the unpublished paper, "Beautiful Youths: A Pair of Kano Screens in the Metropolitan Museum."

46. Takeda Tsuneo, *Nanzenji senmen byōbu*, vol. 6 of *Bijutsu senshū* (Tokyo: Fuji art shuppan, 1973).

47. See p. 49.

48. Translated by Goulden, *Current Anthropology* 28 (1987): 41–48. For another important study, see Nakano Chizuru, "Dōkei to seisei," *Gekkan hyakka* 271:19–22.

49. Iijima Yoshiharu, "Folk Culture and the Liminality of Children," trans. Charles Goulden, *Current Anthropology* 28 (1987): 42.

50. The screens are published in Matsushita Takaaki and Masatomo Kawai, *Josetsu/Shūbun*, vol. 2 of *Nihon bijutsu kaiga zenshū* (Tokyo: Shūeisha, 1979), pls. 12 and 13, and in Takeda, ed., *Jinbutsuga: Kangakei jinbutsuga*, pls. 1 and 2. The Yōtokuin *fusuma* are reproduced in Takeda, ed., *Jinbutsuga: Kangakei jinbutsuga*, figs. 1 and 2, and a detail is reproduced in Tanaka Ichimatsu, *Japanese Ink Painting: Shūbun to Sesshū*, trans. Bruce Darling (New York: Weatherhill, 1972), pl. 84.

51. Shabaku's screens and the scrolls by Ren Renfa (Tokyo National Museum) are published in Yamashita Yūji, "Shabaku hitsu, kinkishogazu byōbu," *Kokka* 1122 (1989): 20–27. Yamashita also provides a brief history of early *kinki-shoga* paintings in Japan.

52. The Reiun'in *fusuma* and the Tokyo National Museum screens are

published in Yamaoka, *Kano Masanobu/Motonobu,* pls. 60 and 61, and fig. 35, respectively.

53. Published in Barbara Ford and Oliver Impey, *Japanese Art from the Gerry Collection in the Metropolitan Museum of Art* (New York: Metropolitan Museum of Art, 1990), pl. 4, and Shizuoka kenritsu bijutsukan, *Kanoha no kyoshōtachi,* (Shizuoka: Kanoha no kyoshōtachiten jikkō iinkai, 1989), pl. 7.

54. For a similar image of Su Dongpo, see the anonymous late-fifteenth-century hanging scroll showing Su Dongpo in Straw Hat and Wooden Shoes in the Metropolitan Museum of Art, published in Barbara Ford, "The Arts of Japan," *The Metropolitan Museum of Art Bulletin* 45 (Summer 1987), pl. 46.

55. In Sōkei's Yōtokuin *fusuma* of the *Four Accomplishments,* only one scholar listens.

56. The hanging scroll of this subject by Kano Masanobu (1434–1530), in the Nakamura collection, Tokyo, is published in Yamaoka, *Kano Masanobu/Motonobu,* pls. 6 and 7.

57. Takeda, *Kano Tan'yū,* 106.

58. See chapter 2, p. 23.

59. Yūshō, in particular, often obscures one, two, or, in some cases, all four of these elegant pastimes. His *Four Accomplishments* screens in the Reidōin of Kenninji, published in Kawai, *Yūshō/Tōgan,* pl. 20, provide a good example.

60. The late Muromachi versions—by Josetsu/Minchō. Sōkei and Shabaku—are somewhat ambiguous but seem to show scholars painting or, at least, inscribing paintings. Thus, these early *kinkishoga* paintings depict the scholars actively performing the Four Accomplishments.

61. A good example of this theme in Chinese painting is Du Jin's *Enjoying Antiquities* in the National Palace Museum, Taipei, published in Richard Barnhart, *Painters of the Great Ming: The Imperial Court and the Zhe School* (Dallas: Dallas Museum of Art, 1993), fig. 42.

62. To expand on the comparison of the bridge and *roji* gates, when the bridge is placed at the right of a painting (from where the viewer enters visually), as in Motonobu's Metropolitan *Four Accomplishments* screens (fig. 17), the analogy is to the entry gate of the *roji;* but when the bridge is placed in the center of the composition, as in Tōgan's Seven Sages screens (fig. 14), the analogy is to the *nakakuguri* (middle wicket), which separates the relatively impure outer *roji* from the purer inner *roji.* In many paintings, the *sōan*-like pavilion is located at the far left and thus is entered visually only after crossing bridges and passing through a purifying expanse of nature.

63. The anomalous placement of a garden fence in a natural setting is a feature of Chinese landscapes beginning with Southern Song Academy painting. It is often found in such Zhe school paintings as Zhong Li's (active ca. 1480–1500) *Gazing at a Waterfall,* now in the Metropolitan Museum of Art and published in Barnhart, *Painters of the Great Ming: The Imperial Court and the Zhe School.*

64. We already observed that this subject is synthesized in Motonobu's Metropolitan screens (fig. 17) and that Motonobu's Tokyo National Museum screen pairs the two subjects. Yūshō paired *fusuma* paintings of the same subjects at the Reidōin of Kenninji, published in Kawai, *Yūshō/Tōgan,* pls. 11 and 19. Kano Yasunobu pairs the Seven Sages and Li Bo in screens at Sanjichionji, published in Takeda, *Jinbutsuga Kangakei jinbutsuga,* pls. 128 and 129.

65. A Kano fan mounted on a screen at Nanzenji shows Hanshan writing on a rock while his companion Shide watches. It is published as fan no. 123 in Takeda, "Nanzenjizō senmen harimaze byōbu ni tsuite."

66. The short hand scroll attributed to Ma Yuan in the Cincinnati Art Museum provides the earliest extant example.

67. In China, the bamboo and pine, along with the plum, make up the so-called Three Friends of Winter *(suihan sanyou)*, plants that retain their leaves even under harsh conditions. These three plants, together with snowy mountains, appear in Tōgan's *Tao Yuanming, Lin Hejing* screens (fig. 19).

68. Even the few close-up compositions that minimize setting—such as Sanraku's *Four Graybeards on Mt. Shang* (fig. 13)—include a view inside a lodging.

69. See chapter 2, pp. 46–48. Although the poems written on these paintings often imply scholarly communitas, it is rarely pictured.

70. All eight panels are published in Yamaguchi kenritsu bijutsukan, *Unkoku Tōgan to Momoyama jidai*, pl. 7, and the reference plate. A related composition is found in the *Landscape with Pavilions* screens in the Kumaya bijutsukan, Hagi, published in Kawai, *Yūshō/Tōgan*, pl. 46.

71. See chapter 3, p. 67.

72. Good examples by Tōgan include landscape screens in the Bunkachō (Kawai, *Yūshō/Tōgan*, pl. 56) and the Important Cultural Properties screens in a private collection (Kawai, *Yūshō/Tōgan*, pl. 55), as well as the *fusuma* at the Hōjō of the Ōbaiin (Kawai, *Yūshō/Tōgan*, pl. 51).

73. See chapter 3, note 132.

74. For a survey of these paintings, see Barnhart, *Painters of the Great Ming*.

75. See, for example, the imperial palace in Ryōkei's *Four Graybeards Returning to Court* (fig. 28).

76. See chapter 2, pp. 31–33.

77. These paintings were installed in the attached *shoin* of the Joan at the Shōden'in of Kenninji by Oda Urakusai (1547–1621) in 1618, but since this was after Tōhaku's death, the original location of the painting is unknown. Now in the Urakuen at Inuyama, Aichi, the six *fusuma* are published in Nakajima, *Hasegawa Tōhaku*, pl. 45. While this version is missing the panels showing Tao Yuanming, Tōhaku's picture of the same subject at the Ryōkōin of Daitokuji (Nakajima, *Hasegawa Tōhaku*, fig. 9) contains all four men.

78. The screens are published in Yoshiko Kakudo, *The Art of Japan: Masterworks in the Asian Art Museum of San Francisco* (San Francisco: The Asian Art Museum of San Francisco, 1991), 102–103, and discussed in Suzukake Shizuya, "Unkoku Tōgan hitsu 'Tōemnei Rinnasei zu,'" *Kokka* 750 (September 1954): 265–267. The biography and poetry of Lin Hejing, whose name Hejing (harmonious tranquillity) was bestowed on him by Song emperor Renzong (r. 1023–1063), is discussed in Kōjirō Yoshikawa, *An Introduction to Sung Poetry*, trans. Burton Watson (Cambridge: Harvard University Press, 1967), 53; Jonathan Chaves, *Mei Yao-Ch'en and the Development of Early Sung Poetry* (New York: Columbia University Press, 1976), 58–59; and Maggie Bickford and Mary Gardner Neill, *Bones of Jade, Soul of Ice: The Flowering Plum in Chinese Art* (New Haven: Yale University Art Gallery, 1985), 23–32. Tao Yuanming, whose self-given sobriquet Qian means "to hide," is studied in Burton Watson, *Chinese Lyricism* (New York: Columbia University Press, 1971), 76–79, and James Robert Hightower, trans., *The Poetry of T'ao Ch'ien* (Oxford: Clarendon, 1970).

79. A famous example is the pair of *Sages* and *Immortals* screens, in a private collection, that show Taigong Wang and another sage sitting along a river in the right screen, and the Daoist Li Tieguai and other immortals in its mate. Long attributed to Eitoku, the schematic figures combined with elegantly curving trees probably indicate the hand of a Kano painter working in the 1590s. It is pub-

lished in Doi, ed., *Kano Eitoku/Mitsunobu*, pl. 51, and Metropolitan Museum of Art, *Momoyama, Japanese Art in the Age of Grandeur*, pl. 6.

80. Traditionally attributed to Eitoku, over the past decades the attribution to his second son, Takanobu, has been widely accepted. Painted in ink and heavy color on gold, the *fusuma* are published in Doi, *Kano Eitoku/Mitsunobu*, pl. 43, and Seattle Art Museum, *A Thousand Cranes* (Seattle: Seattle Art Museum, 1987), pl. 49.

81. See chapter 2, p. 31.

82. In this vein, William Rathbun describes the painting as one that "emphasizes the popularization of once-noble themes and the growing dominance of the decorative aspect in Momoyama period screen painting," which "resulted directly from the taste of the parvenu class of warrior rulers" (Seattle Art Museum, *A Thousand Cranes*, 154).

83. See Takeda Tsuneo, *Kinsei shoki shōhekiga no kenkyū* (Tokyo: Yoshikawa kōbunkan, 1983), 195–200.

84. Ōnishi, "Chinese Lore for Japanese Spaces," pls. 27 and 28. Based on style, Ōnishi postulates these paintings as the work of Eitoku's obscure third son, Kotonobu (active early 17th c.)—a painter who served the Hosokawa family, patrons of the Ryōanji Hōjō.

85. Ōnishi, "Chinese Lore for Japanese Spaces," 24.

86. Other good examples of Daoist immortals mixed with *kinkishoga* elements and generic scholar-recluses are found in the *fusuma* now at the Hōjō at Nanzenji and those attributed to Mitsunobu in the southeast room of the Daishoin at Myōhōin, Kyoto. Both *fusuma* sets are badly damaged, and because of their inconsistent arrangement, they were likely moved from other locations. Details of the Myōhōin paintings are reproduced in Tsuneo Takeda, *Kano Eitoku*, trans. H. Mack Horton and Catherine Kaputa (Tokyo: Kodansha International, 1977), pls. 93–96. All of the Nanzenji paintings are published in Yamane Yūzō, ed., *Nanzenji honbō*, vol. 10 of *Shōhekiga zenshū* (Tokyo: Bijutsushuppansha, 1968), and details are published in Takeda, *Kano Eitoku*, pls. 97–100, and in Ōnishi, "Chinese Lore for Japanese Spaces," pl. 57.

87. The volumes *Kano Eitoku/Mitsunobu*, *Hasegawa Tōhaku*, *Yūshō/Tōgan*, and *Kano Tan'yū* in the *Nihon bijutsu kaiga zenshū* series all contain lengthy discussions of the styles employed by those artists. Among books written by Japanese authors and translated into English, Takeda Tsuneo's *Kano Eitoku* and Doi Tsugiyoshi's *Momoyama Decorative Painting*, from the Kōdansha Japanese Arts Library and the Heibonsha survey of Japanese Art, respectively, provide informative analyses of the styles of individual artists and the general characteristics of Momoyama *shōhekiga*.

88. For a compilation of his many articles on the implications of style, see Takeda, *Kinsei shoki shōhekiga no kenkyū*. Several articles in English also discuss the ramifications of style. Carolyn Wheelwright's "Kano Painters of the Sixteenth Century A.D.: The Development of Motonobu's Daisen'in Style," *Archives of Asian Art* 34 (1981): 6–31, and her adaptation of Bettina Klein's "Japanese Kinbyōbu: The Gold-Leafed Folding Screens of the Muromachi Period," *Artibus Asiae* 45, no. 1 (1984), p. 34, and 45, no. 2/3 (1984), pp. 101–174, show the antecedents and repercussions, respectively, of Motonobu's polychrome and monochrome bird-and-flower styles. In Wheelwright's "A Visualization of Eitoku's Lost Paintings at Azuchi Castle," in George Elison and Bardwell L. Smith, eds., *Warlords, Artists, and Commoners: Japan in the Sixteenth Century* (Honolulu: University of Hawai'i

Press, 1981), 87–112, and "Tōhaku's Black and Gold," *Ars Orientalis* 16 (1986): 1–32, Wheelwright analyzes the history of ink monochrome and color-on-gold painting as they evolved in the Momoyama period.

89. One Momoyama painter who employs a style that falls between these poles is Soga Chokuan (fl. 1596–1610). His pairs of screens *Four Graybeards of Mt. Shang, Three Laughers of the Tiger Ravine* (Henjōkōin, Mt. Kōya), and *Four Graybeards of Mt. Shang, Seven Sages of the Bamboo Grove* (Kanagawa kenritsu bijutsukan) mix ink, color, and areas of light gold wash. Among Edo period *shōhekiga* of the Seven Sages, we have encountered only one work, a two-panel screen of the *Seven Sages with Pine, Bamboo and Plum* by Kano Sosen (1820–1900), in a private collection, in which they are rendered in color on gold.

90. Kano Sansetsu's 1632 set of fifteen hanging scrolls showing Confucious and exemplary followers provides an excellent example. Now in the Tokyo National Museum, it is published in Doi, *Kano Sanraku/Sansetsu*, pls. 56 and 57, and fig. 32.

91. A good example of this style by Eitoku is the pair of Tokyo National Museum hanging scrolls of *Xu You and Chaofu*, published in Doi, *Kano Eitoku/Mitsunobu*, pl. 11; Takeda, *Kano Eitoku*, pls. 26 and 27; and Metropolitan Museum of Art, *Momoyama, Japanese Art in the Age of Grandeur*, pl. 5.

92. Cahill, *Three Alternative Histories of Chinese Painting*, 22.

93. Ibid., 23.

94. See Takeda, *Bekkan: byōbue taikan*, vol. 18 of *Nihon byōbue shūsei*, 79 and 162.

95. Ōnishi, "Chinese Lore for Japanese Spaces," 46.

96. The *fusuma* are part of a set painted in 1647 for the Tenshōin at Myōshinji. They are published in Doi, *Kano Sanraku/Sansetsu*, pl. 52, Ōnishi, "Chinese Lore for Japanese Spaces," pl. 59, and Robert Jacobsen, *The Art of Japanese Screen Painting* (Minneapolis: Minneapolis Institute of Art, 1985), pl. 5. In his catalog essay on them, Jacobsen identifies the various immortals.

97. Although activities such as scholarly pastimes, appreciating nature, collecting antiquities, and communing with associates are only hinted at in Sansetsu's *Eight Daoist Immortals* screens, the Kano paintings in color on gold at Nanzenji and Myōhōin more clearly show Daoist immortals engaged in these characteristic expressions of aesthetic reclusion. See note 86.

98. The difficulty of determining the function of paintings in the *hōjō* is related to the rather broad function of the rooms. Most *hōjō* contain a central Buddhist chamber *(butusma)*, where a Buddhist alter is located. In typical *hōjō*, the *butusma* is flanked by two rooms in back (the abbot's sleeping chamber and study) and three in front. The three front rooms are usually called the *reinoma*, *shitchū*, and *dannanoma*, names that indicate an entry drawing room, central room, and patron's room, respectively, but the different functions of these rooms—if any—are uncertain. They may have been used for informal religious ceremonies, for formal or casual meetings between the abbot and resident monks or guests, and even for "cultural activities" ranging from gazing into the attached gardens to tea gatherings. Because the uses of these rooms are so varied, the probability of one-to-one correspondence between pictorial theme and function is very remote. For a general discussion of paintings in *hōjō*, see Takeda, *Kinsei shoki shōhekiga no kenkyū*, 117–121 and 195–200. The various *hōjō* at Daitokuji are examined, in English, in Jon Carter Covell and Sobin Yamada, *Zen at Daitokuji* (Tokyo: Weatherhill, 1981). For a detailed analysis of the *fusuma*

paintings at the Daisen'in *hōjō*, together with the evolution and meaning of painting in late-medieval Zen hōjō, see Ogawa Hiromitsu, "Daisen'in hōjō fusumae kō," *Kokka* 1120, 1121, and 1122 (1989).

99. The Jesuit Luis Frois wrote that Gifu Castle was "adorned with rich tapestries depicting the ancient legends of China and Japan." Translated in Michael Cooper, *They Came to Japan* (Berkeley: University of California Press, 1965), 133.

100. Naitō Akira, "Azuchijō no kenkyū," *Kokka* 987 (1986): 7–117 and 988 (1976): 7–63. A summary is offered in Takayanagi Shun'ichi, "The Glory That Was Azuchi," *Monumenta Nipponica* 32 (1977): 515–524.

101. *Shinchō kōki* is published in Ōkuni Takahiro and Iwasawa Yoshiko, eds., *Shinchō kōki*, vol. 254 of *Kadokawa bunko* (Tokyo: Kadokawa, 1969). The description of the interior (part 9, section 5) is partially translated in George Elison, "The Cross and the Sword: Patterns of Momoyama History," in Elison and Smith, eds., *Warlords, Artists, and Commoners*, 64–65. The account by Luis Frois is translated in Cooper, *They Came to Japan*, 134–137.

102. In Elison and Smith, eds., *Warlords, Artists, and Commoners*, 87–111. The recreation of the top floors of Azuchi Castle was based on research by Tsuji Nobuo and carried out by students from the Tokyo University of Fine Arts and Kyoto University of Fine Arts for display in the Japanese Pavilion at the 1992 Seville World's Fair. In discussing the plan of Azuchi Castle, older articles typically refer to seven floors, while more recent works refer to six floors but seven levels (including the basement). This study will follow the more current use of six floors.

103. The modern term *tenshu*, meaning castle tower, may stem from Azuchi Castle, where it may have been employed literally to refer to Nobunaga as "Heaven's keeper." See Naitō, "Azuchijō no kenkyū," 14–16.

104. Stated in Herman Ooms, "Neo-Confucianism and the Formation of Early Tokugawa Ideology: Contours of the Problem," in Peter Nosco, ed., *Confucianism and Tokugawa Culture* (Princeton: Princeton University Press, 1984), 35–36. We are unable to find any references to this Shinto deity. In "A Visualization of Eitoku's Lost Paintings at Azuchi Castle," (p. 91), Wheelwright mentions a "tray landscape" *(bonsan)* placed in a *shoin*-style room attached to the Taimensho.

105. Wheelwright, "A Visualization of Eitoku's Lost Paintings at Azuchi Castle," 91.

106. Wheelwright, "A Visualization of Eitoku's Lost Paintings at Azuchi Castle," 103. Yūshō's screens are published in Shiga kenritsu Biwako bunkakan, *Kaihō Yūshō* (Shiga: Shiga kenritsu Biwako bunkakan, 1986), pl. 13.

107. Now in the Tokyo National Museum, Motonobu's panels are published in Yamaoka, *Kano Masanobu/Motonobu*, pl. 51.

108. In "Azuchijō no kenkyū" (*Kokka* 988:30), Naitō suggests that Xu You and Chaofu were a theme of military comradeship. Wheelwright ("A Visualization of Eitoku's Lost Paintings at Azuchi Castle," 107) speculates that the theme might have been "proselytizing," perhaps suggesting good government in tandem with the paintings of phoenix and paulownia in the next room.

109. See Sakazaki, *Nihon garon taikan*, 673–676.

110. Naitō, "Azuchijō no kenkyū," 34. The cycle would make most sense chronologically if the Four Graybeards were painted above the west door, thus placing them between Laozi and Wenwang. The placement of the Seven Sages on the east wall would position them between Confucius and his disciples, a strange place in light of the Seven Sages neo-Daoist associations in China, but one making rough chronological sense.

111. In this building, where physical height equates to symbolic importance, if Naitō's supposition about their placement above the doors is correct, then the significance of these themes is underscored physically.

112. In "A Visualization of Eitoku's Lost Paintings at Azuchi Castle," (p. 111), Wheelwright writes powerfully about "this room of denaturalized veneers" and the "abstracted physical forces" of Eitoku's brushwork.

113. The attribution of the building to Hideyoshi's Fushimi Castle is still repeated in the Japanese-language booklet issued by the temple. According to an interview (May 1990) with Dennis Hirota of the Hongwanji International Center, and translator of *Honganji: Transmitting the Path of Shin Buddhism*, the translators of the English version decided to follow recent scholarship and consign this explanation to the status of "legend."

114. Writing in 1968 in *Nishihonganji*, vol. 6 of *Shōhekiga zenshū* (Tokyo: Bijutsu shuppansha, 1968), the only complete study of the paintings at the temple, Doi Tsugiyoshi does not take a definitive stand on the issue. In an interview (May 1990), Takeda Tsuneo stated that he is confident the paintings were not made for Fushimi Castle. In *Shoin-zukuri* (translated as *Architecture in the Shoin Style*, trans. H. Mack Horton [Tokyo: Kōdansha International and Seibundō, 1985]), architectural historian Hashimoto Fumio postulates construction around 1632.

115. The auspicious theme of cranes was also found in the Taimensho at Azuchi Castle.

116. The worldly values espoused in Jōdo shinshū, a sect that encourages its clergy to have families and makes no restrictions on diet, may also be expressed in this lavish design.

117. Hashimoto, *Architecture in the Shoin Style*, 126.

118. The theme of Chinese boys engaged in the *kinkishoga* was painted in 1631 by Kano Sansetsu at the base of door panels in the *shoin* at the Tenkyūin of Myōshinji. See Tsuji Nobuo, *Myōshinji Tenkyū'in*, vol. 2 of *Shōhekiga zenshū* (Tokyo: Bijutsu shuppansha, 1968), 65.

119. The subtle and meaningful combination of figure themes in the Taimensho is echoed by the arrangement of pictorial subjects in the adjacent rooms. The Gan no ma and Kiku no ma to the west feature bird-and-flower themes, while the main room of the Shiroshoin, directly to the north, features "good emperors" from the *Teikan*. The outer two rooms in the northwest corner thus serve as transitional spaces between the bird-and-flower antechambers and the main Shoin depicting Chinese emperors. Ryōkei and his assistants effect this transition by painting the corner room with a design of peacocks, birds associated with the Chinese imperial family. The middle room of the Shiroshoin features birds and flowers on the west side (the portion next to the peacock room), but then these motifs give way to a landscape scene of the emperor Tangwang freeing birds trapped in hunters' nets. This subject, one motif from the *Teikan*, introduces the other *Teikan* themes painted in the adjacent room.

120. In spite of her appearance here, Xiwangmu, or the "Queen Mother of the West," is a Daoist goddess rather than a secular monarch. She is, however, the most notable female monarch in ancient Chinese culture.

121. In the thirteenth-century *Kara monogatari*, the story of Xiwangmu presenting the peaches to Han Wudi is recounted immediately before the tale of the Four Graybeards' return to support Huidi against Gaozu. As in almost all other Momoyama examples, Ryōkei's painting of the *Four Graybeards Returning to Court* ignores the criticism of Gaozu in stressing reverence for the crown prince.

In similar fashion, the dramatic portion of Xiwangmu's tale, in which the peaches are pilfered by Wudi's advisor Dongfang Shuo (Tōbōsaku)—an event retold in the nō plays *Seiōbo* and *Tōbōsaku*—is entirely absent in Ryōkei's version.

122. If there were in fact a succession battle between sons, legitimate and illegitimate, of the emperor, the Four Graybeards Returning to Court theme may have had literal more than symbolic importance here.

123. Goodwin, "Beautiful Youths," 10.

124. In *Sexual Life in Ancient China* (Leiden: Brill, 1961), R. H. van Gulik mentions that Chinese sexual treatises through the Ming dynasty attributed the first teaching of sexual secrets to Xiwangmu and her meeting with Han Wudi (p. 136).

5. Self-Cultivation and Sagehood

1. For a discussion of tea in the Edo period, see Kumakura Isao, "Kan'ei Culture and *Chanoyu*," trans. Paul Varley, in Varley and Kumakura, eds., *Tea in Japan*; Paul Varley, "*Chanoyu*: From the Genroku Epoch to Modern Times," in Varley and Kumakura, eds., *Tea in Japan*. For an example of the role of tea in facilitating meeting between aristocrats and warriors, see the following discussion of Shōkadō Shōjō.

2. One of this group was Nobunaga's brother Urakusai, mentioned in chapter 4 (p. 98) as the patron who installed Tōhaku's *Four Admirers* panels into his *shoin*-style pavilion at Kenninji. For a discussion of the biographies and grouping of these *daimyō chajin*, see Murai Yasuhiko, "Rikyū's Disciples," *Chanoyu Quarterly* 66 (1991), 7–35.

3. In the opening lines of *Kakisute-bumi* (Private Jottings), Enshū writes, "The way of tea . . . contains nothing very new, consisting simply of loyalty and filial piety, the diligent execution of the business of each household, and, above all, the need to ensure that old friendships do not die." (Translated in Seizō Hayashiya et al., eds., *Japanese Arts and the Tea Ceremony*, trans. Joseph Macadam (New York: Weatherhill, 1974), 91. For an English biography of Enshū, see Teiji Itoh, "Kobori Enshū: Architectural Genius and Chanoyu Master," *Chanoyu Quarterly* 44 (1985): 7–37.

4. Much of his poetry is collected in Takagi Ichinosuke and Hisamatsu Sen'ichi, *Kinsei waka shū;* a few examples are translated in Keene, *World Within Walls: Japanese Literature of the Premodern Era 1600–1867* (New York: Grove Press, 1976), 306.

5. Translated in Donald Keene, *Some Japanese Portraits* (Tokyo: Kōdansha International, 1978), 82.

6. For his biography and a brief analysis of his painting as an expression of Enshū's *kirei sabi* aesthetic, see Kendall Brown, "Shōkadō Shōjō As Tea Painter," *Chanoyu Quarterly* 49 (Spring 1987): 7–40. Many of his paintings are reproduced in Yamato bunkakan, *Shōkadō Shōjō: Chanoyu no kokoro to hitsuboku* (Nara: Yamato bunkakan, 1993).

7. The original location on Otokoyama is currently marked with an explanatory plaque; the Shōkadō hermitage is reconstructed on the grounds of the Tsukamoto Shōkadō shiryōkan in neighboring Yawatachō.

8. Li Di's famous *Ox and Herdboy* scrolls in the Yamato bunkakan, Nara, are likely from Shōkadō's collection, as they are listed among his treasures.

9. Much of the following biography is culled from Thomas Rimer, "Ishikawa Jōzan," in Rimer, et al., *Shisendō: Hall of the Poetry Immortals* (New York: Weath-

erhill, 1991), 3–26. For a fuller treatment in Japanese, see Narabayashi Tadao, *Bunjin e no shosha* (Kyoto: Tankōsha, 1975).

10. See Rimer, "Ishikawa Jōzan," in Rimer et al., *Shisendō*, 14–15. One of these "portraits," painted by Kano Tan'yū, is published in Rimer et al., *Shisendō*, 184.

11. Jōzan, who entered two Zen monasteries before building the Shisendō, provides a good example of eventual rejection of monastic life.

12. See Herman Ooms, *Tokugawa Ideology: Early Constructs, 1570–1686* (Princeton: Princeton University Press, 1985), 56.

13. For Seika's writings and a brief introduction to his life and work, see *Fujiwara Seika, Hayashi Razan*, vol. 28 in the *Nihon shisō taikei* (Tokyo: Iwanami shoten, 1975).

14. Ooms, *Tokugawa Ideology*, 112.

15. See Imanaka Kanshi, *Seikagaku to Razangaku* (Tokyo: Sōbunsha, 1972), 93–95.

16. Ooms, *Tokugawa Ideology*, 114.

17. William Theodore deBary, "Sagehood As a Secular and Spiritual Ideal in Tokugawa Neo-Confucianism," in William Theodore deBary and Irene Bloom, eds., *Principle and Practicality: Essays on Neo-Confucianism and Practical Learning* (New York: Columbia University Press, 1975), 127.

18. For a fuller discussion of this idea developed in the 1606 *Suntetsu roku* (Record of Pithy Sayings), see Ooms, *Tokugawa Ideology*, 114.

19. See deBary, "Neo-Confucian Cultivation and the Seventeenth-Century 'Enlightenment,'" in William Theodore deBary, ed., *The Unfolding of Neo-Confucianism* (New York: Columbia University Press, 1975), 170–172.

20. deBary, "Sagehood As a Secular and Spiritual Ideal in Tokugawa Neo-Confucianism," 128.

21. The picture bears poetic inscriptions in Chinese by Hayashi Razan and Hori Kyōan (1585–1642). Owned by the Nezu bijutsukan, Tokyo, it is published in Doi Tsugiyoshi, ed., *Kano Sanraku/Sansetsu* vol. 12 of *Nihon bijutsu kaiga zenshū* (Tokyo: Shūeisha, 1976), pl. 67. This scroll, together with a similar one by Sansetsu showing an unnamed scholar and bearing a poem by Chōshōshi, are published in Yamato bunkakan, *Kano Sansetsu* (Tokyo: Kyōikusha, 1981), pls. 2 and 3, respectively.

22. See John Blofield, *Taoism: The Road to Immortality* (Boulder: Shambala, 1978), 23.

23. Kakuzo Okakura, *The Book of Tea* (Rutland, Vt.: Tuttle, 1956), 52.

24. See Theodore Ludwig, "Before Rikyu: Religious and Aesthetic Influences in the Early History of the Tea Ceremony," *Monumenta Nipponica* 36 (1981): 367–390.

25. Wolfgang Bauer, *China and the Search for Happiness*, trans. Michael Shaw (New York: Seabury, 1976), 105.

26. Bauer, *China and the Search for Happiness*, 113 and 124. This book was supposedly brought to Japan, where Yoshitsune came into possession of it. Taigong Wang and Zhang Liang also appear in the *Shenxian zhuan* (Biographies of Gods and Immortals) in a list of thirteen Daoist councilors to the founders of dynasties.

27. Bauer, *China and the Search for Happiness*, 125.

28. See Bauer, *China and the Search for Happiness*, 135–137, for an extended discussion of Ruan Ji's text.

29. Bauer, *China and the Search for Happiness*, 137.

30. Ibid., 137–138.

31. Ibid., 142–143.

32. When we consider the painting cycles inside Buddhist temples, aristocratic villas, or even warrior castles, where rooms of Daoist and Confucian recluses were mixed with scenes of auspicious birds and flowers, then this setting in nature becomes even more dramatic.

6. Epilogue

1. They are published in Kawakami Mitsugu and Takeda Tsuneo, *Shaji no kenzōbutsu to shōhekiga* (Tokyo: Kyōtoshi bunka kankōkyoku bunkazai hogoka, 1978), 17–22.

2. The *Gedan ichi no ma*, along with the entire Hōjō complex, is published in Doi Tsugiyoshi, ed., *Tenkyū'in*, vol. 2 of *Shōhekiga zenshū* (Tokyo: Bijutsu shuppansha, 1968).

3. The paintings at the Taimensho of the Ōhōjō are published in Doi Tsugiyoshi, ed., *Chion'in*, vol. 9 of *Shōhekiga zenshū* (Tokyo: Bijutsu shuppansha, 1968).

4. The image is published in Takeda Tsuneo, *Kano Tan'yū*, vol. 15 of *Nihon bijutsu kaiga zenshū* (Tokyo: Shūeisha, 1978), 63.

5. The panel of Lin Hejing is published in Takeda, *Kano Tan'yū*, pl. 57.

6. The Kuroshoin, along with the images from the Shiroshoin and Taimensho, are published in Doi Tsugiyoshi, ed., *Nishihonganji*, vol. 6 of *Shōhekiga zenshū* (Tokyo: Bijutsu shuppansha, 1968).

7. See Doi Tsugiyoshi, "Jissō'in no Kano Eikei," *Bi to kōgei* 159.

8. Published in Kawakami and Takeda, *Shaji no kenzōbutsu to shōhekiga*, 32–40.

9. Published in Kawakami and Takeda, *Shaji no kenzōbutsu to shōhekiga*, 24–31.

10. There is a second, minor stylistic tradition of painting the Seven Sages and the Four Graybeards in ink monochrome, which seems to have been confined to screens. This tradition likely takes Tōhaku's 1607 pair of screens of the *Seven Sages* at the Ryōsokuin, Kyoto (published in Nakajima Shunji, *Hasegawa Tōhaku*, vol. 10 of *Nihon bijutsu kaiga zenshū* [Tokyo: Shūeisha, 1979], pl. 49). The enlargement of these figures, elimination of all landscape except for a few rocks and bamboo stalks, and reliance on bolder, more expressive brushwork is adapted in two nearly identical pairs of screens showing the Seven Sages and the Four Graybeards (one in the Cleveland Museum of Art and the other in a private collection in New York), borrowed in Kano Yasunobu's screens at Shōjuraigōji (fig. 15), and even echoed in a screen of the Seven Sages by Kano Hōgai (1828–1888) (Kyoto kokuritsu hakubutsukan, *Kano Hōgai* [Kyoto: Kyoto shibunsha, 1989], pl. 15). In contrast to most other images, which stress the associations of aesthetic reclusion, these paintings seem to present the Seven Sages or the Four Graybeards as generic symbols for the prestige of Chinese learning and the authority of venerable patriarchs. These screens are published, and discussed in more detail, in Kendall Brown, "Tan'yū ni miru Kanoha no kangakei jinbutsuga no tenkai" in *Bijutsushi no danmen* (Osaka: Seibundō, 1994), 249–265.

11. The *Four Accomplishments* panels, and the other paintings at Nagoya Castle, are published in Takeda Tsuneo, *Nagoyajō*, vol. 4 of *Shōhekiga zenshū* (Tokyo: Bijutsu shuppansha, 1968), and in Ishikawa kenritsu bijutsukan, *Nagoyajō shōhekiga meisakuten* (Kanazawa: Ishikawa kenritsu bijutsukan, 1990).

12. They are reproduced in Yoshida Teruji et al., *Ukiyoe taisei* vol. 1, (Tokyo: Tōhō shoin, 1930), figs. 207 and 20, respectively.

13. John Dewey, *Art as Experience* (New York: Capricorn Books, 1934), 3.

14. For further discussion of the dialogic relation of cultural experience and art, see Edward Bruner, "Experience and Its Expressions," in Victor Turner and Edward Bruner, eds., *The Anthropology of Experience* (Urbana: University of Illinois Press, 1986), 7–30.

15. Barbara Myerhoff, "Life Not Death in Venice: Its Second Life," in Turner and Bruner, eds., *The Anthropology of Experience*, 261.

16. André Gide, *The Vatican Cellars* (Harmondsworth: Penguin, 1969), 88.

17. Michael Baxandall, *Patterns of Intention* (New Haven: Yale University Press, 1985), 62.

Glossary

Akechi Mitsuhide	明智光秀	bun	文
Aki no yo no nagamonogatari		Bunsei	文清
	秋夜長物語	*butusma*	仏間
Akizato Ritō	秋里籬島	*byōbu*	屏風
Amida	阿弥陀	Chacha	茶々
Anling	安陵	*chajin*	茶人
Anxi	安釐	*chakai*	茶会
Arima	有馬	*Changhenge*	長恨歌
Ariwara Yukihira	在原行平	*chanoyu*	茶の湯
Asano	浅野	Chaofu	巢父
Ashikaga	足利	*chashitsu*	茶室
Ashikaga Yoshiaki	足利義昭	Chen Ping	陳平
Ashikaga Yoshimasa	足利義政	Cheng-Zhu	程朱
Ashikaga Yoshimitsu	足利義満	*chigaidana*	違棚
Azuchi	安土	*chigo*	稚児
Azuma mondō	吾妻問答	*Chigo monogatari*	稚児物語
bakufu	幕府	chikurin no shichiken	竹林の七賢
basara	婆娑羅	Chingen	鎮源
Bishamondō	毘沙門堂	Chion'in	知恩院
bishōnen	美少年	*Chiteiki*	池亭記
biwa	琵琶	Chizō	智蔵
Bo Juyi	白居易	*chōdaigamae*	帳台構
Bonsan	盆山	Chōsokabe Motochika	長宗我部元親
Boshi changqing ji	白氏長慶集	*chōzubachi*	手水鉢
Boshi wenji	白氏文集	Chu	楚
Boya	伯牙	*chūdan*	中段
Boyi	伯夷	*chūdan no ma*	中段の間
bu	武	*Chuxueji*	初學記
Budai	布袋	Dai Kui	戴逵

Daigoji	醍醐寺	*gedan ichi no ma*	下段一の間
daimyō	大名	*gedan no ma*	下段の間
daimyō chajin	大名茶人	Geiami	芸阿弥
daimyō-cha	大名茶	*Genji monogatari*	源氏物語
Daisen'in	大仙院	Gepparō	月波楼
daisu	台子	*geta*	下駄
Daitokuji	大徳寺	Gifu	岐阜
danna no ma	旦那の間	*go*	碁
Daren xiansheng zhuan	大人先生傳	*gong*	公
dayin	大隱	Gosei'in	後西院
Dazaifu	太宰府	Gozan	五山
dōbōshū	同朋衆	Guangwu	光武
dokugin	独吟	*Guiqulai*	帰去来
Donge'in	曇華院	*Gujin yishi zhuan*	古今逸士傳
Dongfang Shuo	東方朔	*gunki monogatari*	軍記物語
Dongwanggong	東王公	*gunsen*	群仙
Dongyuan gong	東園公	Gushan	孤山
dōshaku jinbutsuga	道釈人物画	Guzhu	孤竹
Du Fu	杜甫	*Gyokutai shin'eishū*	玉臺新詠集
Eisai	栄西	*Hakushi monjū*	白氏文集
En no Gyōja	役行者	Hanshan	寒山
fengliu	風流	*Hanshu*	漢書
Fengshuidong	風水洞	*hao*	皓
fuchū	不忠	Hasegawa	長谷川
Fujiwara Kintō	藤原公任	Hasegawa Tōhaku	長谷川等伯
Fujiwara Mototoshi	藤原基俊	Hasegawa Tōin	長谷川等胤
Fujiwara Seika	藤原惺窩	*hassen*	八仙
Fujiwara Teika	藤原定家	Hayashi Razan	林羅山
fumiishi	踏石	*Heike monogatari*	平家物語
Fumon'in	普門院	Henjōkōin	遍昭光院
Furuta Oribe	古田織部	Hiei	比叡
fūryū	風流	Higashihonganji	東本願寺
Fushimi	伏見	Higashiyama	東山
fusuma	襖	*hijiri*	聖
Fuxi	伏犠	Hikone	彦根
ga	画	Hiunkaku	飛雲閣
Gakuō	岳翁	Hizen Nagoya	肥前名護屋
Gan no ma	雁の間	*hōjō*	方丈
gaoshi	高士	*Hōjōki*	方丈記
Gaoshi zhuan	高士傳	*Honchō gashi*	本朝画史
Gaozu	高祖	*Honchō monzui*	本朝文粋
Ge Hong	葛洪	*hondō*	本堂
gedan	下段	Honganji	本願寺

Hongmen	鴻門	*jinsei*	仁政
Hori Kyōan	堀杏庵	*Jinshu*	晋書
Hōryūji	法隆寺	*Jinyangqiu*	晋陽秋
Hosokawa	細川	Jishū	時宗
Hosshinshū	發心集	Jissō'in	実相院
Hsi K'ang	嵆康	*Jiudesong*	酒徳頌
Huang Shangu	黄山谷	*jiyū shukke*	自由出家
Huangdi	黄帝	Joan	如庵
Huangfu Mi	皇甫謐	*jōdan*	上段
Huidi	惠帝	*jōdan no ma*	上段の間
Ichi no ma	一の間	Jōdo	浄土
Ichigon hōdan	一言芳談	Jōdo shinshū	浄土真宗
Ichihara	市原	*jojōdan no ma*	上々段の間
ichiza	一座	Jōrakuden	上洛殿
Ii Nagashiro	伊永氏	Josetsu	如拙
Ike Taiga	池大雅	Jōshinji	浄信寺
Ikkyū	一休	Jōshūmon'in	承秋門院
Inaba	因幡	*juan*	巻
Inabayama	稲葉山	*Jūben jūgi*	十便十宜
inchū hassen	飲中八仙	Jukōin	聚光院
inja	隠者	Jurakudai	聚楽第
inja no bungaku	隠者の文学	*Kaifūsō*	懐風藻
inton	隠遁	Kaihō	海北
inton no bungaku	隠遁の文学	Kaihō Yūshō	海北友松
intonsha	隠遁者	*kaisho*	会所
Inuyama	犬山	*kaitekisa*	快適さ
io	庵	*Kakisute-bumi*	書捨文
iori	庵	Kamei Korenori	亀井茲矩
Ise Jingū	伊勢神宮	*Kamei kotsujiron*	仮名乞児論
Ishikawa Jōzan	石川丈山	Kamiya Sōtan	神谷宗湛
Ishikawa Toyonobu	石川豊信	Kamo no Chōmei	鴨長明
Ishin Sūden	以心崇伝	*kangakei jinbutsuga*	漢画系人物画
Ishiyama honganji	石山本願寺	Kangaku'in	勧学院
Iwakura	岩倉	Kangakue	勧学會
Iwashimizu hachimangū		*kankyo*	閑居
	石清水八幡宮	Kano	狩野
Jasoku	蛇足	Kano Dōun Masanobu	狩野洞雲益信
Ji	智	Kano Eikei	狩野永敬
Ji Kang	嵆康	Kano Einō	狩野永納
Ji Kang ji	嵆康集	Kano Eisen'in	狩野栄川院
Jiangxi	江西	Kano Eishin Yasunobu	狩野永真安信
Jiaoli xiansheng	角里先生	Kano Eitoku	狩野永徳
jikishin	直心	Kano Hōgai	狩野芳崖

Kano Ikkei	狩野一渓	Kisen	喜撰
Kano Jinnojō	狩野甚之丞	*Kissa yōjōki*	喫茶養生記
Kano Kotonobu	狩野言信	Kitamandokoro	北政所
Kano Masanobu	狩野正信	Kitano	北野
Kano Mitsunobu	狩野光信	Kitauchi Sanjin	北内山人
Kano Motonobu	狩野元信	Kitayama	北山
Kano Naonobu	狩野尚信	Kō no ma	鴻の間
Kano Nobumasa	狩野信政	Kobayakawa Takakage	小早川隆景
Kano Sanraku	狩野山楽	Kōbō daishi	弘法大師
Kano Sansetsu	狩野山雪	Kobori Enshū	小堀遠州
Kano Seisen'in	狩野晴川院	*kobusuma*	小襖
Kano Shōei	狩野松栄	Kōdaiji	高台寺
Kano Sosen	狩野素川	Kōgetsu Sōgan	江月宗玩
Kano Takanobu	狩野孝信	*kōgi*	公儀
Kano Tan'yū	狩野探幽	*koke no tamoto*	苔の袂
Kano Yasunobu	狩野安信	Kokei	虎渓
kanpaku	関白	*Kokinshū*	古今集
Kanrin gohōshū	翰林五鳳集	*kokka*	国家
kanshi	漢詩	*Konendai ryakki*	小年代略記
kao-shih	高士	Konoe Nobuhiro	近衛信尋
Kara monogatari	唐物語	*kōshi*	高士
Karakasatei	傘亭	Koshoin	古書院
karako asobi	唐子遊	*Kōsoshū*	後素集
karameita	唐めいた	Kōya	高野
katanakake	刀掛	Kōzei Ryūha	江西竜派
Katsukawa Shunshō	勝川春章	*Kudai waka*	句題和歌
Katsura	桂	Kūkai	空海
Keikokushū	経国集	*Kundaikan sōchōki*	君台勧左右帳記
Keison	啓孫		
kenjin no ma	賢人の間	Kuroshoin	黒書院
kenjō no sōji	賢聖の障子	*kusa no io*	草の庵
Kenkō Shōkei	賢江祥啓	*kusa no iori*	草の庵
Kenninji	建仁寺	*kyakuden*	客殿
Keshō no ma	化粧の間	Kyakuden no ma	客殿の間
ki	棋	*kyogen*	虚言
Kiku no ma	菊の間	Kyōkai	景戒
kin	琴	Kyōōgokokuji	教王護国寺
kinkishoga	琴棋書画	*Kyōunshū*	狂雲集
Kinoshita Chōshōshi	木下長嘯子	*kyūrō*	九老
kirei sabi	奇麗寂	*Kyūshū mondō*	九州問答
kirin	麒麟	Laozi	老子
Kiritsubo	桐壺	*li*	理
kiryō	器量	*li*	礼

Li Bi	李泌	Mōri	毛利
Li Bo	李白	Morikawa Kyoroku	森川許六
Li Di	李迪	Mu Xi	牧谿
Li Han	李瀚	Mujū	無住
Li Jietui	李節推	Murasaki Shikibu	紫式部
Li Liweng	李笠翁	Murata Jukō	村田珠光
Li Tieguai	李鐵拐	Mushanokōji	武者小路
Liang Kai	梁楷	Myōhōin	妙法院
Lidai zhulu huamu	歴代著録画目	Myōkian	妙喜庵
Lin Bu	林逋	Myōshinji	妙心寺
Lin Hejing	林和靖	*naiki*	内記
Liu Ling	劉伶	Naiku	内宮
Liu Yiqing	劉義慶	*nakakuguri*	中潜
Longyang	龍陽	Nakashoin	中書院
Lu (Empress)	呂	*nakatsukasa-shō*	中務省
Lu (Mt.)	盧	Nanga	南画
Lu Dongbin	呂洞賓	Nanpō Sōkei	南坊宗啓
Lunyu	論語	*Nanpōroku*	南坊録
Ma Xia	馬夏	*nanshoku*	男色
Ma Yuan	馬遠	Nanzenji	南禅寺
Makura no sōshi	枕草子	*narihisago*	生瓢
Man'yōshū	万葉集	Ni no ma	二の間
Matsunaga Teitoku	松永貞徳	Nichiren	日蓮
Matsushima	松島	*Nihon ryōiki*	日本霊異記
meibutsu	名物	*nijiriguchi*	躙口
meikun	名君	Nijō	二条
Mengqiu	蒙求	Nijō Yoshimoto	二条良基
Michitsuna	道綱	*nijūshikō*	二十四孝
Minamoto Mitsuyuki	源光行	Ninomaru	二の丸
Minchō	明兆	Nishihonganji	西本願寺
Ming-Ch'ing	明清	*nō*	能
Minghuan	明皇	*nō-yōsangyō*	農養蚕業
Mingshi zhuan	名士傳	Nōami	能阿弥
Miotsukushi	澪標	Nobufusa	宣房
mitate	見立	*nyoi*	如意
Mittan	密庵	Ōbaiin	黄梅院
Miyako rinsen meishō zue		Obama	小浜
	都林泉名勝図	*Oboegaki*	覚書
	會	*ochitsuki*	落着き
Mōgyū waka	蒙求和歌	Oda Nobunaga	織田信長
Monjudai hyakushu	文集題百首	Oda Urakusai	織田有楽斎
monogatari	物語	Ōe no Chisato	大江千里
Monzen	文選	Ōgimachi	正親町

Oguri Sōkei	小栗宗継	*roji*	露地，露次，
Oguri Sōtan	小栗宗湛		路次，路地
Ōhara	大原	*roji tsue*	露地杖
ōhiroma	木広間	Rokujō	六条
ōhōjō	大方丈	Rong Qiqi	荣启期
Okakura Tenshin	岡倉天心	Ruan Ji	阮籍
Ōmine	大峰	Ruan Xian	阮咸
Omote senke	表千家	Ryōanji	竜安寺
Ōnin	応仁	Ryōkōin	竜光院
Onjōji	園城寺	Ryōsokuin	両足院
Ōsen Keisan	横川景三	Ryōtanji	龍潭寺
Ōta Gyūichi	太田牛一	Ryōzen	良遷
Ōtani	大谷	Saga	嵯峨
Otokoyama	男山	Sagami	相模
Ōtomo Ikenushi	大伴池主	Saigyō	西行
Ōtomo Tabito	大伴旅人	Saikyōji	西教寺
Ōtomo Yakamochi	大伴家持	Sakai	堺
Otomo Sōrin	大友宗麟	*Sakaki*	賢木
Pipa jing	琵琶経	Sakaki Hyakusen	彭城百川
Qi	戚	Sakamoto	坂本
Qili Ji	綺里季	*samurai*	侍
qin	琴	Sanbōin	三宝院
qingtan	清談	*Sanetaka kōki*	実隆公記
Raku	楽	*Sangō shiiki*	三教指帰
rakuchū rakugaizu	洛中洛外図	Sanjichionji	三時知恩寺
Rei no ma	礼の間	Sanjōnishi Sanetaka	三条西実隆
Reidōin	霊洞院	*sanka*	山家
Reiun'in	霊雲院	*Sanka no ki*	山家の記
Reizei	冷泉	Sarumaru	猿丸
Rekidai choroku gamoku		Sasaki Dōyo	佐々木道誉
	歴代著録畫目	*Sasamegoto*	ささめごと
ren	仁	Satomura Jōha	里村紹巴
Ren Renfa	任仁発	Sei Shōnagon	清少納言
renga	連歌	*seiken*	聖賢
Renga haikaishū	連歌俳諧集	Seiryōden	清涼殿
Renri hishō	連理秘抄	Seiwa	清和
Renzong	仁宗	*seiza*	静座
Ri Shūbun	李秀文	*seji no kegare*	世事の穢
Rikō	利光	Sekigahara	関ケ原
rin	麟	*sekiten*	釈奠
Rinsenji	臨川寺	Semimaru	蝉丸
Rinzai	臨済	Sen Rikyū	千利休
Risshō ankokuron	立正安国論	*sengoku*	戦国

senka	仙家	Shiroshoin	白書院
sennin	仙人	Shisendō	詩仙堂
Sennin no ma	仙人の間	Shishinden	紫宸殿
Senzai kaku	千載佳句	*Shishuo xinyu*	世説新語
Senzui byōbu	山水屏風	*shisui*	四睡
Sesetsu shingo	世説新語	*shitchū*	室中
Sesshū Tōyō	雪舟等揚	*sho*	書
Sesson Shūkei	雪村周継	*shōchikubai*	松竹梅
setsuwa	説話	Shōden'in	正伝院
Shabaku	遮莫	*shōgun*	将軍
Shakkyō	石橋	Shōhaku	肖柏
Shakyamuni	釈迦年尼	*shōhekiga*	障壁画
Shan Tao	山濤	*shoin*	書院
Shang	商	*shōji*	障子
Shangshan sihao	商山四皓	Shōjuraigōji	聖衆来迎寺
Shanxi	陝西	Shōkadō Shōjō	松花堂昭乗
sharaku	洒落	Shōkei	祥啓
Shariden	舎利殿	Shōkintei	松琴亭
Shariden byōbu	舎利殿屏風	Shōkokuji	相国寺
Shasekishū	沙石集	Shōkyōden	承香殿
Shennong	神農	*shosai*	書斎
Shenxian zhuan	神仙伝	*shosaizu*	書斎図
shiai	四愛	Shōtetsu	正徹
shiba no io	柴の庵	Shouyang	首陽
Shichijō	七条	Shōzan shikō	商山四皓
Shide	拾得	*Shūishū*	拾遺集
Shiga'in	滋賀院	*Shuofu*	説郭
shigajiku	詩画軸	Shūon'an	酬恩庵
Shiguretei	時雨亭	Shuqi	叔齊
Shiji	史記	*Shuyiji*	述異記
Shijing	詩経	*Siai tiyong xu*	四愛題詠序
Shikano	鹿野	Sima Qian	司馬遷
shikō raichō	四皓来朝	Sōami	相阿弥
Shina jinmeibu	支那人名部	*sōan*	草庵
Shinchō kōki	信長公記	*sōan chashitsu*	草庵茶室
shinden	寝殿	Sōchō	宗長
Shingon	真言	*sodezuri matsu*	袖摺松
Shingoten	新御殿	Sōen	宗淵
Shinjuan	真珠庵	Soga Chokuan	曽我直庵
Shinkei	心敬	*Soga monogatari*	曽我物語
Shinsen rōeishū	新撰朗詠集	Soga Sōyo	曽我宗誉
shintai	神体	Sōgi	宗祇
Shintō	神道	Sōkei	宋啓

Song	宋	Tenshōin	天祥院
Song Lien	宋濂	*Tenshōki*	天正記
Song xueshi quanji	宋学士全集	*Tenshu sashizu*	天守指図
sōshokuteki	装飾的	Tō no Chūjō	頭中将
Sōtan nikki	宗湛日記	*tobiishi*	飛石
sotoroji	外露地	*tōcha*	闘茶
Su Dongpo	蘇東坡	Tōfukuji	東福寺
Su Xun	蘇洵	Tohoku no ma	東北の間
Su Zhe	蘇轍	Tōji	東寺
Sugawara Michizane	菅原道真	*tokonoma*	床の間
suihan sanyou	歳寒三友	Tokugawa	徳川
Sukeakira	資明	Tokugawa Ietsuna	徳川家綱
suki	数奇(数寄)	Tokugawa Ieyasu	徳川家康
suki no tonsei	数奇の遁世	Tokugawa Yoshinao	徳川義直
suki no tonseisha	数奇の遁世者	*ton*	遁
Suma	須磨	*tonsei*	遁世，貪世
Suminokura Soan	角倉素庵	*tonsei no hito*	遁世の人
Sumiya	角屋	*tonseisha*	遁世者
Sumiyoshi Hiroyuki	住吉広行	*Torikaebaya monogatari*	とりかえばや
Sun Kang	孫康		物言
Sun Sheng	孫盛	Toshihito	智仁
Suntetsu roku	寸鉄録	Tōshun	等春
Suzuki Harunobu	鈴木春信	Toyotomi Hideyori	豊臣秀頼
T'ien-t'ai	天台	Toyotomi Hideyoshi	豊臣秀吉
Tachibana Jitsuzan	立花実山	Tsuda Sōkyū	津田宗及
Taian	待庵	*tsukeshoin*	付書院
Taigong Wang	太公望	*tsukubai*	蹲踞
Taiheiki	太平記	*tsukubau*	蹲う
taimensho	対面所	Tsunegoten	常御殿
Taira	平	*Tsurezuregusa*	徒然草
Takeno Jōō	武野紹鴎	*uchiroji*	内露地
Tami no Kurohito	民黒人	*Uji shūi monogatari*	宇治拾遺物語
Tangwang	湯王	*ukiyoe*	浮世繪
Tao Qian	陶潜	Unkoku	雲谷
Tao Yuanming	陶淵明	Unkoku Tōgan	雲谷等顔
Tao Zongyi	陶宗儀	Urakuen	有楽苑
tatami	畳	*uta monogatari*	歌物語
teikan	帝鑑	*Utsuho monogatari*	宇津保物語
Teikanzu	帝鑑図	*wabi*	侘
Tenjuan	天授庵	*wabicha*	侘茶
tenka	天下	*waka*	和歌
tenka fubu	天下布武	*wakan*	和漢
Tenkyū'in	天球院	*Wakan rōeishū*	和漢朗詠集

Wakasa	若狭	Yamazatomaru	山里丸
wakashudō	若衆道	Yan Ziling	嚴子陵
Wang Anshi	王安石	Yang guifei	楊貴妃
Wang Rong	王戎	*Yangshenglun*	養生論
Wang Wei	王維	Yao	尭
Wang Xizhi	王羲之	*Yawata Takimotobō kurachō*	
Wang Zhi	王質		八幡滝本房
Wangchuan	輞川		蔵帳
washi	和紙	Yawatachō	八幡町
Wasuregusa	萱草	*yi*	義
Watanabe Ryōkei	渡辺了慶	Yin	殷
Wei	魏	Yin (prince)	隱
Wei (River)	渭	Ying	穎
Wei-Jin	魏晋	*Yinshi zhuan*	隱士傳
weiqi	圍棋	*Yiwen leiju*	藝文類聚
Weishi chunqiu	魏氏春秋	Yododono	淀殿
Wen (Emperor)	文	Yodogimi	淀君
wen-jen	文人	*Yonghuai shi*	詠懐詩
Wenwang	文王	*Yongshi shi*	詠史詩
Wenxuan	文選	Yosa Buson	与謝蕪村
Wu Wei	呉偉	Yoshida Kenkō	吉田兼好
Wudi	武帝	Yoshimine Yasuyo	良岑安世
Wuwang	武王	Yoshishige Yasutane	慶滋保胤
Xiwangmu	西王母	Yōshō	陽性
Xia Gui	夏珪	*yosutebito*	世捨人
Xia Huanggong	夏黄公	Yōtokuin	養徳院
Xiang Xiu	向秀	Yōzei	陽成
Xianzi	蜆子	Yu Ji	虞集
Xiao He	蕭何	Yuan	元
Xiao Tong	蕭統	Yuan Zhen	元積
Xiaojing	孝經	Yumean	夢庵
xiaoyin	小隱	Yushima Seidō	湯島聖堂
Xu Jian	徐堅	*Yutai xinyong*	玉臺新詠
Xu You	許由	Yuyama	湯山
Xuanzong	玄宗	*Yuyama sangin hyakuin*	湯山三吟百韻
yado	宿	*za*	座
yadori	宿	*zashiki*	座敷
yamagatsu	山がつ	Zen	禅
Yamaguchi Sekkei	山口雪渓	Zhang Guolao	張果老
Yamanoue Sōji	山上宗二	Zhang Liang	張良
Yamanoue Sōjiki	山上宗二記	Zhao Mengfu	趙孟頫
Yamashina	山科	*zhaoyin*	招隱
yamazato	山里	Zhe	浙

Zhong Changtong	仲長統	Zhuangzi	莊子
Zhong Li	鍾禮	zhulin qixian	竹林七賢
Zhong Ziqi	鍾子期	*Zhulin qixian lun*	竹林七賢論
Zhongli Quan	鍾離權	*Zhulin qixian zhuan*	竹林七賢傳
zhongyin	中隱	Zhu Xi	朱熹
Zhou	周	*ziran*	自然
Zhou (emperor)	紂	*Zokusui shishū*	統翠詩集
Zhou Dunyi	周敦頤	Zuiganji	瑞巖寺
Zhou Maoshu	周茂叔	Zuihōin	瑞峰院

Bibliography

Abe, Akio, ed. *Genji monogatari* II. Vol. 13 of *Nihon koten bungaku zenshū*. Tokyo: Shōgakkan, 1972.

Ackerman, James. "Toward a New Social Theory of Art." *New Literary History* 4 (Winter 1973): 315–330.

Akazawa, Eiji. "Jūgoseiki zenhan ni okeru sanzuiga no tenkai." In *Tōyō ni okeru sanzui hyōgen* II. Osaka: Kokusai kōryū bijutsushi kenkyūkai, 1984.

Akiyama, Terukazu. *Japanese Painting*. Lucerne: Skira, 1961.

Araki, James. *The Ballad Drama of Medieval Japan*. Rutland, Vt.: Tuttle, 1978.

Arntzen, Sonja. *Ikkyū and the Crazy Cloud Anthology*. Tokyo: University of Tokyo Press, 1986.

Bal, Miek, and Norman Bryson. "Semiotics and Art History." *The Art Bulletin* 73 (June 1991): 174–208.

Balazs, Etienne. "Nihilistic Revolt or Mystical Escapism: Currents of Thought in China during the Third Century A.D." in Etienne Balazs, *Chinese Civilization and Bureaucracy: Variations on a Theme,* translated by H. M. Wright, edited by Arthur Wright. New Haven: Yale University Press, 1964.

Barnhart, Richard. *Painters of the Great Ming: The Imperial Court and the Zhe School*. Dallas: Dallas Museum of Art, 1993.

Bauer, Wolfgang. *China and the Search for Happiness*. Translated by Michael Shaw. New York: The Seabury Press, 1976.

Baxandall, Michael. *Patterns of Intention*. New Haven: Yale University Press, 1985.

Berry, Mary Elizabeth. *Hideyoshi*. Cambridge: Harvard University Press, 1982.

———. "Public Peace and Private Attachment: The Goals of Power and Conduct in Early Modern Japan." *Journal of Japanese Studies* 12 (1986).

Bickford, Maggie, and Mary Gardner Neill. *Bones of Jade, Soul of Ice: The Flowering Plum in Chinese Art*. New Haven: Yale University Art Gallery, 1985.

Blacker, Carmen. *The Catalpa Bow*. London: Allen and Unwin, 1975.

Blofield, John. *Taoism: The Road to Immortality*. Boulder: Shambala, 1978.

Bodert-Bailey, Beatrice. "Tea and Counsel: The Political Role of Sen Rikyu." *Chanoyu Quarterly* 41 (1987): 25–34.

Brown, Kendall. "The Paintings of Shokado Shojo: Crosscurrents in Early Seventeenth-Century Painting." Master's thesis, University of California, Berkeley, 1985.

———. "Shokado Shojo as 'Tea Painter.'" *Chanoyu Quarterly* 49 (Spring 1987): 7–40.

———. "Tan'yū ni miru Kanoha no kangakei jinbutsuga no tenkai." In *Bijutsushi no danmen.* Osaka: Seibundō, 1994, 249–265.

Bruner, Edward. "Experience and Its Expressions." In Victor Turner and Edward Bruner, eds., *The Anthropology of Experience.* Urbana: University of Illinois Press, 1986.

Cahill, James. *Sakaki Hyakusen and Early Nanga Painting.* Berkeley: Institute of East Asian Studies, 1983.

———. *Three Alternative Histories of Chinese Painting.* Lawrence: Spencer Museum of Art, 1988.

Carter, Steven. *Three Poets at Yuyama.* Berkeley: Institute of East Asian Studies, 1983.

———. "*Waka* in the Age of *Renga.*" *Monumenta Nipponica* 36 (Winter 1981): 425–444.

Chang, Kang-i Sun. *Six Dynasties Poetry.* Princeton, Princeton University Press, 1986.

Chaves, Jonathan. *Mei Yao-Ch'en and the Development of Early Sung Poetry.* New York: Columbia University Press, 1976.

Childs, Margaret. "Chigo monogatari: Love Stories or Buddhist Sermons?" *Monumenta Nipponica* 35 (Summer 1980): 127–151.

———. *Rethinking Sorrow.* Ann Arbor: Center for Japanese Studies, University of Michigan, 1991.

Cogan, Thomas, trans. *The Tale of the Soga Brothers.* Tokyo: Tokyo University Press, 1987.

Collcutt, Martin. "Daimyo and Daimyo Culture." In Shimizu, ed., *Japan: Shaping of Daimyo Culture, 1185–1868.* Washington, D.C.: National Gallery of Art, 1988.

———. *Five Mountains: The Rinzai Zen Monastic Institution in Medieval Japan.* Cambridge: Harvard University Press, 1981.

Cole, Wendall. *Kyoto in the Momoyama Period.* Norman: Oklahoma University Press, 1967.

Cooper, Michael. "The Early Europeans and Tea." In Paul Varley and Isao Kumakura, eds., *Tea in Japan: Essays on the History of Chanoyu.* Honolulu: University of Hawai'i Press, 1984.

———. *They Came to Japan.* Berkeley: University of California Press, 1965.

———. *This Island Japan.* Tokyo: Kōdansha International, 1973.

Cort, Louise Allison. "The Grand Kitano Tea Gathering." *Chanoyu Quarterly* 31 (1982): 15–44.

Covell, Jon Carter. *Unravelling Zen's Red Thread: Ikkyu's Controversial Way.* Seoul: Hollym, 1980.

Covell, Jon Carter, and Sobin Yamada. *Zen at Daitokuji.* New York: Weatherhill, 1974.

Cunningham, Michael. *The Triumph of Japanese Style: Sixteenth-Century Art in Japan.* Cleveland: Cleveland Museum of Art, 1991.

Dainihon bukkyō zenshū vol. 3.

deBary, William Theodore. "Neo-Confucian Cultivation and the Seventeenth-Century 'Enlightenment.'" In William Theodore deBary, ed., *The Unfolding of Neo-Confucianism.* New York: Columbia University Press, 1975.

———. "Sagehood as a Secular and Spiritual Ideal in Tokugawa Neo-Confucianism." In William Theodore deBary and Irene Bloom, eds., *Principle and Prac-*

ticality: Essays on Neo-Confucianism and Practical Learning. New York: Columbia University Press, 1975.

Dewey, John. *Art As Experience.* New York: Capricorn Books, 1934.

Dilthey, Whilhelm. *Pattern and Meaning in History.* Edited by H. P. Dickman, New York: Harper Torchbooks, 1961.

Doe, Paula. *A Warbler's Song in the Dusk: The Life and Work of Ōtomo Yakamochi (718–785).* Berkeley: University of California Press, 1982.

Doi, Tsugiyoshi, ed. *Chion'in.* Vol. 9 of *Shōhekiga zenshū.* Tokyo: Bijutsu shuppansha, 1968.

———. *Eitoku to Sanraku: Momoyama kaiga no sekai.* Tokyo: Shimizu shoin, 1972.

———. *Hasegawa Tōhaku.* Tokyo: Kōdansha, 1977.

———. "Jissō'in" no Kano Eikei," *Bi to Kōgei* 159.

———. *Kano Eitoku/Mitsunobu.* Vol. 9 of *Nihon bijutsu kaiga zenshū.* Tokyo: Shūeisha, 1978.

———. *Kano Sanraku/Sansetsu.* Vol. 12 of *Nihon bijutsu kaiga zenshū.* Tokyo: Shūeisha, 1976.

———. *Momoyama Decorative Painting.* Translated by Edna B. Crawford. Tokyo: Heibonsha International, 1977.

———. *Motonobu/Eitoku.* Vol. 8 of *Suiboku bijutsu taikei.* Tokyo: Kōdansha, 1974.

———. *Nishihonganji.* Vol. 6 of *Shōhekiga zenshū.* Tokyo: Bijutsu shuppansha, 1968.

———. *Tenkyū'in.* Vol. 2 of *Shōhekiga zenshū.* Tokyo: Bijutsu shuppansha, 1968.

Dykstra, Yoshiko. *Miraculous Tales of the Lotus Sutra from Ancient Japan: The "Dainihon Hokekyokenki" of Priest Chingen.* Honolulu: University of Hawai'i Press, 1983.

Egawa bijutsukan. *Egawa bijutsukan kanzō hyakusen.* Nishinomiya: Egawa bijutsukan, 1983.

Elison, George. "The Cross and the Sword: Patterns of Momoyama History." In George Elison and Bardwell L. Smith, eds., *Warlords, Artists, and Commoners: Japan in the Sixteenth Century.* Honolulu: University of Hawai'i Press, 1981.

———. "Hideyoshi, the Bountiful Minister." In George Elison and Bardwell L. Smith, eds., *Warlords, Artists, and Commoners: Japan in the Sixteenth Century* Honolulu: University of Hawai'i Press, 1981.

Feifel, George. "The Biography of Po Chu-i." *Monumenta Serica* 17 (1958).

Fong, Mary. "The Iconography of the Popular Gods of Happiness, Emoluments, and Longevity (Fu Lu Shou)." *Artibus Asiae* 44 (1983).

Ford, Barbara Brennan. "The Arts of Japan." *The Metropolitan Museum of Art Bulletin* 45 (Summer 1987).

———. "Gentlemanly Accomplishments: The Adaptation of Chinese Literati Culture." In Barbara Ford and Oliver Impey, *Japanese Art from the Gerry Collection in the Metropolitan Museum of Art.* New York: The Metropolitan Museum of Art, 1990.

———. "The Self-Portrait of Sesson Shūkei." *Archives of Asian Art* 35 (1982): 6–26.

Fuji, Masahara. *Chūgoku no inja.* Tokyo: Iwanami shoten, 1973.

Fujiki, Hisashi. "The Political Posture of Oda Nobunaga." Translated by George Elison. In John W. Hall, et al., eds., *Japan Before Tokugawa: Political Consolidation and Economic Growth, 1500–1650.* Princeton: Princeton University Press, 1981.

———. "Tōitsu seiken no seiritsu." In *Iwanamikōza,* vol. 9 of *Nihon rekishi.* Tokyo: Iwanami shoten, 1975.

Fujiwara, Seika. Hayashi Razan. Vol. 28 of *Nihon shisō taikei.* Tokyo: Iwanami shoten, 1975.

Geddes, Ward, trans. *Kara monogatari: Tales of China.* Tempe: Center for Asian Studies, University of Arizona, 1984.

Geertz, Clifford. "Art As a Culture System." *Modern Language Notes* 91 (1976).

———. *The Interpretation of Cultures.* New York: Basic Books, 1973.

———. "Making Experience, Authoring Selves." In Victor Turner and Edward Bruner, eds., *The Anthropology of Experience.* Urbana: University of Illinois Press, 1986.

Gide, André. *The Vatican Cellars.* Harmondsworth: Penguin, 1969.

Giradot, N. J. *Myth and Meaning in Early Taoism.* Berkeley: University of California Press, 1983.

Goodwin, Shauna. "Beautiful Youths: A Pair of Kano Screens in the Metropolitan Museum." Unpublished paper, Yale University, 1986.

Gotō, Tanji, and Kamada Kisaburō, eds. *Taiheiki.* Vol. 36 of *Nihon koten bungaku taikei.* Tokyo: Iwanami shoten, 1960.

Haga, Kōshirō. *Sen no Rikyū.* Tokyo: Yoshikawa kōbunkan, 1978.

———. "The Wabi Aesthetic Through the Ages." Translated by Martin Colcutt. In Paul Varley and Isao Kumakura, eds., *Tea in Japan: Essays on the History of Chanoyu.* Honolulu: University of Hawai'i Press, 1984.

Hakeda, Yoshito, trans. *Kūkai: Major Works.* New York: Columbia University Press, 1972.

Hall, John W. "The Confucian Teacher in Tokugawa Japan." In Arthur Wright, ed., *Confucianism in Action.* Stanford: Stanford University Press, 1959.

———. "Hideyoshi's Domestic Policies." In John W. Hall, et al., eds., *Japan Before Tokugawa: Political Consolidation and Economic Growth, 1500–1650.* Princeton: Princeton University Press, 1981.

Hanawa, Hokinoichi, ed. *Shinkō Gunsho ruijū.* Tokyo: Nagai shoseki, 1929.

Hare, Thomas Blenman. "Reading Kamo no Chōmei." *Harvard Journal of Asiatic Studies* 49 (1989): 173–228.

Harootunian, H. D. *Things Seen and Unseen: Discourse and Ideology in Tokugawa Nativism.* Chicago: University of Chicago Press, 1988.

Hashimoto, Fumio. *Architecture in the Shoin Style.* Translated by H. Mack Horton. Tokyo: Kōdansha International and Seibundō, 1985.

Hauser, William. "Osaka Castle and Tokugawa Authority in Western Japan." In Jeffrey Mass and William Hauser, eds., *The Bakufu in Japanese History.* Stanford, Stanford University Press, 1985.

Hayakawa, Masao. *The Garden Art of Japan.* Translated by Richard L. Gage. New York: Weatherhill, 1973.

Hayakawa, Mitsusaburō. *Mōgyū.* Tokyo: Meiji shoin, 1973.

Hayashi, Susumu. "Sesson hitsu 'Chikurin shichiken byōbu' (Toyama kinenkan) ni tsuite." In Takeda Tsuneo, ed., *Jinbutsuga: kangakei jinbutsuga,* vol. 4 of *Nihon byōbue shūsei.* Tokyo: Kōdansha, 1980.

Hayashiya, Seizō. *Chanoyu, Japanese Tea Ceremony.* Translated by Emily J. Sano. New York: Japan Society, 1979.

———. "Kyoto in the Muromachi Age." Translated by George Elison. In John Whitney Hall and Toyoda Takeshi, eds., *Japan in the Muromachi Age.* Berkeley: University of California Press, 1977.

Hayashiya, Seizō, et al., eds. *Japanese Arts and the Tea Ceremony.* Translated by Joseph Macadam. New York: Weatherhill, 1974.

Hawkes, David. *Ch'u Tz'u: The Songs of the South.* London: Oxford University Press, 1959.

Hightower, James Robert. "Hsi K'ang's Letter to Shan T'ao" in Cyril Birch, ed., *Anthology of Chinese Literature*, vol. I. New York: Grove Press, 1955.

————, trans. *The Poetry of T'ao Ch'ien*. Oxford: Clarendon, 1970.

Hinsch, Brett. *Passions of the Cut Sleeve: The Male Homosexual Tradition in China*. Berkeley: University of California Press, 1990.

Hiratsuka, Ryosen. *Nihon ni okeru nanshoku no kenkyū*. Tokyo: Nihon no riga-kusha, 1983.

Hirohata, Yuzuru. *Chūsei inja bungei no keifu*. Tokyo: Ōfūsha, 1978.

Hirota, Dennis. "Heart's Mastery: The *Kokoro no Fumi*, The Tea Letter of Murata Shuko to his Disciple Choin." *Chanoyu Quarterly* 22 (1979): 7–24.

————. "In Practice of the Way: *Sasamegoto*, an Instruction Book in Linked Verse." *Chanoyu Quarterly* 19 (1979): 23–46.

————. "Memoranda of the Words of Rikyu, *Nampōroku* Book I." *Chanoyu Quarterly* 25 (1980): 31–47.

————. "The One-Page Testament Attributed to Rikyu *(Rikyu Ichimai Kisho-mon)*." *Chanoyu Quarterly* 33 (1983): 41–52.

————. *Plain Words on the Pure Land Way: Sayings of the Wandering Monks of Medieval Japan*. Translation of *Ichigon Hōdan*. Kyoto: Ryūkoku University, 1988.

————. "*The Zen Tea Record*. A Statement of Chanoyu as Buddhist Practice." *Chanoyu Quarterly* 54 (1988): 32–59.

Holzman, Donald. *Poetry and Politics: The Life and Works of Juan Ch'i*, A.D. 210–263. Cambridge: Cambridge University Press, 1976.

————. "Les Sept Sages de la Forêt des Bambous et la Societé de leur Temps." *T'oung Pao* 44 (1956): 317–346.

————. *La Vie et la Pensée de Hsi Kang*. Leiden: Brill, 1957.

Hori, Ichirō. "On the Concept of *Hijiri* (Holy-man)." *Numen* 5, no. 2 (April 1958): 128–160; 5, no. 3 (September 1958): 199–232.

Horiguchi, Sutemi. *Sōan chashitsu*. Vol. 83 of *Nihon no bijutsu*. Tokyo: Shibundō, 1973.

————. *Rikyū no chashitsu*. Tokyo: Kajima kenkyūsho shuppankai, 1968.

Horton, H. Mack. "Renga Unbound: Performative Aspects of Japanese Linked Verse." *Harvard Journal of Asiatic Studies* 53 (December 1993): 443–512.

Ichiko, Teiji, et al., eds. *Soga monogatari*. Vol. 88 of *Nihon koten bungaku taikei*. Tokyo: Iwanami shoten, 1966.

Iijima, Yoshihara. "Folk Culture and the Liminility of Children." Translated by Charles Goulden. *Current Anthropology* 28 (1987): 41–48.

Ikeda, Toshio, ed. *Kara monogatari*. Tokyo: Koten bunko, 1942.

————. "Kara monogatari to Hakushi monjū." *Tsurumi joshi daigaku kiyō* 4 (1967): 35–69.

Ikenabe, Toshinori, et al., eds. *Yamato monogatari, Kara monogatari, Izumi shi-kibu nikki*. Vol. 18 of *Kōchū kokubun sōsho*. Tokyo: Hakubinakan, 1915.

Imanaka, Kanshi. *Seikagaku to Razangaku*. Tokyo: Sōbunsha, 1972.

Ishida, Yoshida. *Inja no bungaku kumon suru bi*. Tokyo: Hanawa shobō, 1969.

Ishikawa kenritsu bijutsuken. *Nagoyajō shōhekiga meisakuten*. Kanazawa: Ishi-kawa kenritsu bijutsukan, 1990.

Itō, Hiroyuki, ed. *Chūsei no inja bungaku*. Tokyo: Gakuseisha, 1977.

————. *Inton no bungaku: Mōnen to kakusei*. Tokyo: Kasama shobō, 1975.

Itō, Yoshi, ed. *Sankashū*. Vol. 51 of *Nihon koten zenshū*. Tokyo: Asahi shibundō, 1957.

Itoh, Teiji. "Kobori Enshū: Architectural Genius and Chanoyu Master." *Chanoyu Quarterly* 44 (1985): 7–37.

———. "Sen Rikyū and Taian." *Chanoyu Quarterly* 15 (1982): 7–20.

———. *Space and Illusion in the Japanese Garden.* Translated by Ralph Friedman and Masajirō Shimamura. New York: Weatherhill, 1973.

Iwata, Jun'ichi. *Honchō nanshokukō.* Tokyo: Chimaki sangyō yūgen kaisha, 1973.

Jacobsen, Robert. *The Art of Japanese Screen Painting.* Minneapolis: Minneapolis Institute of Art, 1985.

Jameson, Fredric. *The Political Unconscious: Narrative as a Symbolic Act.* Ithaca: Cornell University Press, 1981.

Jang, Ju-yu. "The Hermit-Theme Painting in the Painting Academy of the Ming Dynasty." Master's thesis, University of California, Berkeley, 1983.

Jansen, Marius. "Tosa in the Sixteenth Century: The 100 Article Code of Chosokabe Motochika." *Oriens Extremus* 10 (1963): 83–108.

Kakimura, Shigematsu, ed. *Honchō monzui chūshaku.* 2 vols. Tokyo: Toyamabō, 1971.

Kakudo, Yoshiko. *The Art of Japan: Masterworks in the Asian Art Museum of San Francisco.* San Francisco: Asian Art Museum of San Francisco, 1991.

Kameda, Tsutomu. *Sesson.* Vol. 8 of *Nihon bijutsu kaiga zenshū.* Tokyo: Shūeisha, 1980.

Kanazawa, Hiroshi. "Chūsei kangakei jinbutsuzu byōbu no tenbō." In Takeda Tsuneo, ed., *Jinbutsuga: kangakei jinbutsu,* vol. 4 of *Nihon byōbue shūsei.* Tokyo: Kōdansha, 1980.

Kaneko, Hikojirō. *Heian jidai bungaku to Hakushi monjū.* Tokyo: Baifukan, 1955.

Kaneko, Kinjirō, et al., eds. *Renga haikaishū.* Vol. 32 of *Nihon koten bungaku zenshū.* Tokyo: Shōgakkan, 1974.

Karaki, Junzō. *Chūsei no bungaku.* Tokyo: Chikuma shobō, 1965.

Kasai, Masaaki, ed. *Yakuchū Honchō gashi.* Kyoto: Dōhōsha, 1985.

Katagiri, Yōichi. *Shūiwakashū no kenkyū.* Kyoto: Daigakudō, 1980.

Katō, Seishin, ed. *Sangō shiiki.* Vol. 3 of *Iwanami bunko.* Tokyo: Iwanami shoten, 1939.

Katsumata, Shizuo. "The Development of Sengoku Law." Translated by Martin Colcutt. In John W. Hall and Toyoda Takeshi eds., *Japan in the Muromachi Age.* Berkeley: University of California Press, 1977.

Kawaguchi, Hisao. *Heianchō no kanbungaku.* Tokyo: Yoshikawa kobundō, 1981.

Kawaguchi, Hisao, and Shido Nobuyoshi, eds. *Wakan rōeishū.* Vol. 73 of *Nihon koten bungaku taikei.* Tokyo: Iwanami shoten, 1965.

Kawai, Masatomo. *Yūshō/Tōgan.* Vol. 11 of *Nihon bijutsu kaiga zenshū.* Tokyo: Shūeisha, 1978.

Kawai, Masatomo, et al. *Dorakka korekushon: suibokuga meisakuten.* Tokyo: Nihon keizai shinbun, 1986.

Kawakami, Mitsugu, and Nakamura Masao. *Katsura rikyū to chashitsu.* Vol. 15 of *Genshoku nihon no bijutsu.* Tokyo: Shōgakkan, 1967.

Kawakami, Mitsugu, and Takeda Tsuneo. *Shaji no kenzōbutsu to shōhekiga.* Kyoto: Kyōtoshi bunka kankōkyoku bunkazai hogoka, 1978.

Kawamoto, Hideo, et al. "Kenjō no sōji no kenkyū." *Kokka* 1028 (1979): 9–26; 1029 (1979): 7–31.

Kawamoto, Shigeo, and Hilda Katō. "The *Mumyoshu* of Kamo no Chomei and Its Significance." *Monumenta Nipponica* 23: 3–4 (October 1968): 321–430.

Keene, Donald. *Some Japanese Portraits.* Tokyo: Kōdansha International, 1978.

Keene, Donald, trans. "An Account of My Hut." In Donald Keene, ed., *An Anthology of Japanese Literature.* New York: Grove Press, 1955.

———. *Essays in Idleness: The Tsurezuregusa of Kenkō.* New York: Columbia University Press, 1967.

————. "Jōha, a Sixteenth-Century Poet of Linked Verse." In George Elison and Bardwell L. Smith, eds., *Warlords, Artists, and Commoners*. Honolulu: University of Hawai'i Press, 1981.

————. *World Within Walls: Japanese Literature of the Pre-Modern Era 1600–1867*. New York: Grove Press, 1976.

Klein, Bettina. "Japanese Kinbyōbu: The Gold-Leafed Folding Screens of the Muromachi Period." Translated by Carolyn Wheelwright. *Artibus Asiae* 45, no. 1 (1984): 5–34; 45, no. 2/3 (1984): 101–174.

Knechtges, David. *Wen Xuan, or Selections of Refined Literature*. Vol. I: *Rhapsodies on Metropolises and Capitals by Xiao Tong*. Princeton: Princeton University Press, 1972.

Kobayashi, Chisho, ed. *Uji shūi monogatari*. Vol. 28 of *Nihon koten bungaku zenshū*. Tokyo: Shōgakkan, 1972.

Kojima, Noriyuki, ed. *Kaifūsō*. Vol. 69 of *Nihon koten bungaku taikei*. Tokyo: Iwanami shoten, 1957.

Komatsu, Shigemi, ed. *Ban Dainagon ekotoba emaki*. Vol. 2 of *Nihon emaki taisei*. Tokyo: Chūōkōronsha, 1977.

Konishi, Jin'ichi. "Michi and Medieval Writing." In Earl Miner, ed., *Principles of Classical Japanese Literature*. Princeton, Princeton University Press, 1985.

Kōno, Motoaki. "The Kano School: The Japanese 'Academy' and Its Literature." *Bijutsushiron*. Tokyo: Tokyo daigaku bungakubu bijutsushi kenkyūshitsu, 1989.

Kōno, Tama, ed. *Utsuho monogatari*. Vols. 10–12 of *Nihon koten bungaku taikei*. Tokyo: Iwanami shoten, 1959.

Kuck, Lorraine. *The World of the Japanese Garden*. New York: Weatherhill, 1968.

Kumakura, Isao. "Kan'ei Culture and *Chanoyu*." Translated by Paul Varley. In Paul Varley and Kumakura Isao, eds., *Tea in Japan: Essays on the History of Chanoyu*. Honolulu: University of Hawai'i Press, 1984.

————. "Sen no Rikyū: Inquiries into His Life and Tea." Translated by Paul Varley. In Paul Varley and Kumakura Isao, eds., *Tea in Japan: Essays on the History of* Chanoyu. Honolulu: University of Hawai'i Press, 1984.

Kurata, Junnosuke. *Kōsankoku* in *Kanshi taikei*. Tokyo: Shūeisha, 1967.

Kusaka, Hiroshi, ed. *Hōkō ibun*. Tokyo: Hakubunkan, 1914.

Kuwata, Tadachika. *Toyotomi Hideyoshi kenkyū*. Tokyo: Kadokawa shoten, 1975.

Kuwata, Tadashika, ed. *Shinshū chadō zenshū*. Tokyo: Shinjūsha, 1956.

Kyoto kokuritsu hakubutsukan. *Kano Hōgai*. Kyoto: Kyoto shibunsha, 1989.

————. *Sanzui: Shisō to bijutsu*. Kyoto: Kyoto kokuritsu hakubutsukan, 1983.

————. *Sen no Rikyūten*. Kyoto: Kyoto kokuritsu hakubutsukan, 1990.

LaFleur, William. *The Karma of Words: Buddhism and the Literary Arts in Medieval Japan*. Berkeley: University of California Press, 1983.

Laing, Ellen. "Neo-Taoism and the Seven Sages of the Bamboo Grove in Chinese Painting." *Artibus Asiae* 36 (1974): 5–54.

Legge, James, trans. *Confucian Analects: The Great Learning and the Doctrine of the Mean*. New York: Dover, 1971.

Legge, James, trans. *The Texts of Taoism*. New York: Dover, 1962.

Levy, Ian, trans. *The Ten Thousand Leaves: A Translation of the Man'yōshū, Japan's Premier Anthology of Classical Poetry*. Princeton: Princeton University Press, 1981.

Li, Chi. "The Changing Concept of the Recluse in Chinese Literature." *Harvard Journal of Asiatic Studies* 24 (1962): 234–247.

Ludwig, Theodore. "Before Rikyu: Religious and Aesthetic Influences in the Early History of the Tea Ceremony." *Monumenta Nipponica* 36 (1981): 367–390.

———. *"Chanoyu* and Momoyama: Conflict and Transformation in Rikyū's Art."
In Paul Varley and Kumakura Isao, eds., *Tea in Japan: Essays on the History
of* Chanoyu. Honolulu: University of Hawai'i Press, 1984.

McCullough, Helen. *Classical Japanese Prose: An Anthology.* Stanford, Stanford
University Press, 1990.

McCullough, Helen, trans. *Brocade by Night: Kokin Wakashū and the Court Style
in Japanese Classical Poetry.* Stanford: Stanford University Press, 1985.

———. *Kokin Wakashū: The First Imperial Anthology of Japanese Poetry, with Tosa
Nikki and Shinsen Waka.* Stanford, Stanford University Press, 1985.

———. *The Taiheiki: A Chronicle of Medieval Japan.* New York: Columbia Univer-
sity Press, 1959.

———. *The Tale of the Heike.* Stanford: Stanford University Press, 1988.

———. *Yoshitsune: A Fifteenth-Century Japanese Chronicle.* Tokyo: University of
Tokyo Press, 1960.

McMullin, Neil. *Buddhism and the State in Sixteenth-Century Japan.* Princeton:
Princeton University Press, 1985.

McNeill, William H. "The Historical Significance of Tea." In Paul Varley and
Kumakura Isao, eds., *Tea in Japan: Essays on the History of* Chanoyu. Hono-
lulu: University of Hawai'i Press, 1984.

Makada, Morio, ed. *Nihon ryōiki.* Vol. 8 of *Kan'yaku Nihon no koten.* Tokyo: Shō-
gakkan, 1986.

Marra, Michele. *The Aesthetics of Discontent: Politics and Reclusion in Medieval
Japanese Literature.* Honolulu: University of Hawai'i Press, 1991.

Maruyama, Masao. *Studies in the Intellectual History of Tokugawa Japan.* Trans-
lated by Mikiso Hane. Tokyo: University of Tokyo Press, 1974.

Mather, Richard, trans. *Shih-shuo Hsin-yu: A New Account of Tales of the World.*
Minneapolis: University of Minnesota Press, 1976.

Matisoff, Susan. "Images of Exile and Pilgrimage: Zeami's *Kintosho.*" *Monu-
menta Nipponica* 34 (1979): 449–465.

Matsushita, Takaaki. *Josetsu/Shūbun/Saiami.* Vol. 6 of *Suiboku bijutsu taikei.*
Tokyo: Kōdansha, 1973.

Matsushita, Takaaki, and Masatomo Kawai. *Josetsu/Shūbun.* Vol. 2 of *Nihon
bijutsu kaiga zenshū.* Tokyo: Shūeisha, 1979.

Metropolitan Museum of Art. *Momoyama: Japanese Art in the Age of Grandeur.*
New York: Metropolitan Museum of Art, 1975.

Mezaki, Tokue. "Aesthete-Recluses during the Transition from Ancient to Medi-
eval Japan." In Earl Miner, ed., *Principles of Classical Japanese Literature.*
Princeton: Princeton University Press, 1985.

———. *Saigyō no shisōshiteki kenkyū.* Tokyo: Yoshikawa kōbunkan, 1978.

———. *Shukke, Tonsei.* Tokyo: Chūōkōronsha, 1976.

Mills, D. E. *A Collection of Tales from Uji: A Study and Translation of Uji Shūi
Monogatari.* Cambridge: Cambridge University Press, 1970.

Minamoto, Toyomune. "Ōgon no Momoyama jidai." In *Momoyama no hana: Byō-
bue, fusumae.* Tokyo: Suntory bijutsukan, 1989.

———. *Soga Jasoku.* Vol. 3 of *Nihon bijutsu kaiga zenshū.* Tokyo: Shūeisha,
1980.

Miner, Earl. *Japanese Linked Verse.* Princeton: Princeton University Press, 1979.

Mitsui bunko. *Muromachi kinpekiga kara kinsei e.* Tokyo: Benridō, 1990.

Moriya, Takeshi. "The Mountain Dwelling within the City." *Chanoyu Quarterly* 56
(1989): 7–21.

Morrell, Robert, trans. *Sand and Pebbles (Shasekishū): The Tales of Mujū Ichien, a*

Voice for Pluralism in Kamakura Buddhism. Albany: State University of New York Press, 1985.

Morris, Ivan, trans. *The Pillow Book of Sei Shōnagon*. New York: Columbia University Press, 1965.

Morris, V. Dixon. "The City of Sakai and Urban Autonomy." In George Elison and Bardwell L. Smith, eds., *Warlords, Artists, and Commoners: Japan in the Sixteenth Century*. Honolulu: University of Hawai'i Press, 1981.

Mote, Frederick. "Confucian Eremitism in the Yuan Period." In Arthur Wright, ed., *The Confucian Persuasion*. Stanford: Stanford University Press, 1960.

Murai, Yasuhiko. "A Biography of Sen Rikyu," *Chanoyu Quarterly* 61 (1990): 7–56.

———. "Buke bunka to dōbōshū." *Bungaku* 31, no. 1 (1963): 66–79.

———. "The Development of Chanoyu: Before Rikyu." Translated by H. Paul Varley. In Paul Varley and Kumakura Isao, eds., *Tea in Japan: Essays on the History of Chanoyu*. Honolulu: University of Hawai'i Press, 1984.

———. "Rikyu's Disciples." *Chanoyu Quarterly* 66 (1992): 7–35.

Murase, Miyeko. *Japanese Art: Selections from the Mary and Jackson Burke Collection*. New York: The Metropolitan Museum of Art, 1975.

Myerhoff, Barbara. "Life Not Death in Venice: Its Second Life." In Victor Turner and Edward Bruner, eds., *The Anthropology of Experience*. Urbana: University of Illinois Press, 1986.

Naba, Toshisada. "Dōkyō no Nihonkoku e no ryūden ni tsuite." *Tōhō shūkyō* 2 (1953): 1–22; 4–5 (1954): 58–122.

Nagai, Kazuko, and Matsuo Satoshi, eds. *Makura no sōshi*. Vol. 11 of *Nihon koten bungaku zenshū*. Tokyo: Shōgakkan, 1974.

Naitō, Akira. "Azuchijō no kenkyū". *Kokka* 987 (1976): 7–117; 988 (1976): 7–63.

———. *Katsura: A Princely Retreat*. Trans. Charles Terry. Tokyo: Kōdansha International, 1977.

Nakajima, Junji. *Hasegawa Tōhaku*. Vol. 10 of *Nihon bijutsu kaiga zenshū*. Tokyo: Shūeisha, 1979.

———. "The Influence of Hanging Scrolls on the Formation of Screens," *Bijutsushi* 61 (June 1966).

Nakamura, Kyōko. *Miraculous Stories from the Japanese Buddhist Tradition: The Nihon Ryoiki of the Monk Kyokai*. Cambridge: Harvard University Press, 1973.

Nakamura, Tanio. *Sesshū*. Vol. 4 of *Nihon bijutsu kaiga zenshū*. Tokyo: Shūeisha, 1980.

Nakamura, Yukihiko. *Nakamura Yukihiko chojutsushū*. Tokyo: Chūōkōronsha, 1983.

Nakano, Chizuru. "Dōkei to seisei." *Gekkan hyakka* 271 (n.d.): 19–22.

Narabayashi, Tadao. *Bunjin e no shosha*. Kyoto: Tankōsha, 1975.

Nekada, Makoto, ed. *Sesetsu shingo*. Vols. 76–78 of *Shinshaku kanbun taikei*. Tokyo: Meiji shoin, 1975.

Nemoto, Makoto. *Sensei shakai ni okeru teikō seishin*. Tokyo: 1952.

Nishio, Minoru, ed. *Hōjōki, Tsurezuregusa*. Vol. 30 of *Nihon koten bungaku taikei*. Tokyo: Iwanami shoten, 1957.

Nosco, Peter, ed. *Confucianism and Tokugawa Culture*. Princeton: Princeton University Press, 1984.

Obi, Kōichi. *Chūgoku no inton shisō*. Tokyo: Chūkō shinsho, 1988.

Ogawa, Hiromitsu. "Daisen'in hōjō fusumae kō." *Kokka* (1989): 1120–1122.

Ogawa, Tamaki, and Yamamoto Kazuyoshi. *Sotōba shishū*. Vol. 2. Tokyo: Tsukuma shobō, 1984.

Okakura, Kakuzo. *The Book of Tea*. Rutland, Vt: Tuttle, 1956.

Okumura, Kōsaku. *Inton kijin no genryū*. Tokyo: Kasama shoin, 1975.

Ōkuni, Takahiro, and Iwasawa Yoshiko, eds. *Shinchō kōki*. Vol. 254 of *Kadokawa bunko*. Tokyo: Kadokawa, 1969.

Ōmura, Yūko. "Tenshōki." In Kuwata Tadachika, ed., *Taikō shiryōshū*. Tokyo: Shinjinbutsu ōraisha, 1971.

Ōnishi, Hiroshi. "Chinese Lore for Japanese Spaces." *The Metropolitan Museum of Art Bulletin* 51 (Summer 1993): 3–47.

Ooms, Herman. "Neo-Confucianism and the Formation of Early Tokugawa Ideology: Contours of the Problem." In Peter Nosco, ed., *Confucianism and Tokugawa Culture*. Princeton: Princeton University Press, 1984.

———. *Tokugawa Ideology: Early Constructs, 1570–1680*. Princeton: Princeton University Press, 1985.

Osaka shiritsu bijutsukan. *Chūsei shōbyōe*. Osaka: Osaka shiritsu bijutsukan, 1979.

———. *Shoki byōbue*. Osaka: Osaka shiritsu bijutsukan, 1966.

Plutschow, Herbert, and Hideichi Fukuda, trans. *Four Japanese Travel Diaries of the Middle Ages*. Cornell University East Asian Papers 25. Ithaca: Cornell University, 1981.

Pollack, David. *The Fracture of Meaning: Japan's Synthesis of China from the Eighth through the Eighteenth Centuries*. Princeton: Princeton University Press, 1986.

Pollack, David, trans. *Zen Poems of the Five Mountains*. New York: Crossroad Publishing and Scholars Press, 1985.

Pontynen, Arthur. "The Deification of Laozi in Chinese History and Art." *Oriental Art* 26 (Autumn 1980): 308–313.

Rimer, Thomas, et al. *Shisendō: Hall of the Poetry Immortals*. New York: Weatherhill, 1991.

Rohlich, Thomas, trans. *A Tale of Eleventh-Century Japan: Hamamatsu Chūnagon Monogatari*. Princeton: Princeton University Press, 1983.

Rosenfield, John. "The Unity of the Three Creeds: A Theme in Japanese Ink Painting of the Fifteenth Century." In John W. Hall and Toyoda Takeshi, eds., *Japan in the Muromachi Age*. Berkeley: University of California Press, 1977.

Sakaiya, Taichi, ed. *Maboroshi no Azuchijō tenshu fukugen*. Tokyo: Nihon keizai shinbun, 1992.

Sakazaki, Tan, ed. *Nihon garon taikan*. Vol. I. Tokyo: Arusu, 1922.

Sakurai, Yoshio. *Inja no fūbō: Inton seikatsu to sono seishin*. Tokyo: Hanawa shobō, 1967.

———. *Nihon no inja*. Tokyo: Hanawa shobō, 1969.

Sanjōnishi Sanetaka. *Sanetaka-kō ki*. Tokyo: Zoku Gunsho ruijū kanseikai, 1935.

Sasaki, Junnosuke. "The Changing Rationale of Daimyo Control in the Emergence of the Bakuhan State." Translated by Ronald Toby. In John W. Hall, et al., eds., *Japan before Tokugawa: Political Consolidation and Economic Growth, 1500–1650*. Princeton: Princeton University Press, 1981.

Saso, Michael, and David Chappell, eds. *Buddhist and Taoist Studies* I. Asian Studies at Hawaii, no. 18. Honolulu: University of Hawai'i Press, 1977.

Satō, Masahide. *Inja no shisō: Saigyō o megutte*. Tokyo: Tokyo daigaku shuppankai, 1977.

Seattle Art Museum. *A Thousand Cranes*. Seattle: Seattle Art Museum, 1987.

Seidensticker, Edward, trans. *The Tale of Genji*. New York: Knopf, 1976.

Sen Sōshitsu, ed. *Chadō koten zenshū*. Vols. 4 and 6. Kyoto: Tankōsha, 1956.

Shiga kenritsu Biwako bunkakan, ed. *Kaihō Yūshō*. Shiga: Shiga kenritsu Biwako bunkakan, 1986.

Shimada, Shūjirō, et al. *Shōbyōga*. Vol. 4 of *Zaigai Nihon no shihō*. Tokyo: Mainichi shinbun, 1979.

Shimizu, Yoshiaki, "Workshop Management of the Early Kano Painters, ca. A.D. 1530–1600," *Archives of Asian Art* 34 (1981): 32–47.

Shimizu, Yoshiaki, ed. *Japan: The Shaping of Daimyo Culture, 1185–1868*. Washington, D.C.: National Gallery of Art, 1988.

Shimizu, Yoshiaki, and Carolyn Wheelwright, eds. *Japanese Ink Paintings from American Collections: The Muromachi Period*. Princeton: Princeton University Art Museum, 1976.

Shirane, Haruo. *The Bridge of Dreams: A Poetics of "The Tale of Genji."* Stanford: Stanford University Press, 1987.

Shizuoka kenritsu bijutsukan, ed. *Kanoha no kyoshōtachi*. Shizuoka: Kanoha no kyoshōtachiren jikkō iinkai, 1989.

Spiro, Audrey. *Contemplating the Ancients*. Berkeley and Los Angeles: University of California Press, 1991.

Sugahara, Hisao. *Japanese Ink Painting and Calligraphy from the Collection of the Tokiwayama Bunko*. Brooklyn: Brooklyn Museum of Art, 1967.

Sugane, Nobuyuki. *Shiikawakashū zenshaku*. Tokyo: Kasama shoin, 1983.

Suntory bijutsukan. *Daitokuji Shinju'an meihōten*. Tokyo: Suntory bijutsukan, 1980.

Suzukake, Shizuya. "Unkoku Tōgan hitsu 'Toenmei Rinnasei zu,'" *Kokka* 750 (September 1954): 265–267.

Suzuki, Hiromichi. *Torikaebaya monogatari no kenkyū*. Tokyo: Kasama shoin, 1973.

Suzuki, Hiromichi, ed. *Torikaebaya*. Osaka: Izumi shoin, 1988.

Suzuki, Susumu, and Sasaki Jōhei. *Ike Taiga*. Vol. 18 of *Nihon bijutsu kaiga zenshū*. Tokyo: Shūeisha, 1980.

Takagi, Ichinosuke, and Hisamatsu Sen'ichi. *Kinsei waka shū*. Vol. 93 of *Nihon koten bungaku taikei*. Tokyo: Iwanami shoten, 1966.

Takagi, Ichinosuke, et al., eds. *Heike monogatari*. Vol. 32 of *Nihon koten bungaku taikei*. Tokyo: Iwanami shoten, 1959.

———. *Konjaku monogatarishū*. Vol. 24 of *Nihon koten bungaku taikei*. Tokyo: Iwanami shoten, 1959.

Takayanagi, Shun'ichi. "The Glory That Was Azuchi." *Monumenta Nipponica* 32 (1977): 515–524.

Takeda, Tsuneo. *Bekkan: byōbue taikan*. Vol. 18 of *Nihon byōbue shūsei*. Tokyo: Kōdansha, 1980.

———. *Chūsei shōbyōga*. Kyoto: Kyoto kokuritsu hakubutsukan, 1969.

———. "Freer bijutsukanzō 'Kuninobu' in 'kinkishogazu' byōbu." In Shimada Shujirō et al., *Shōbyōga*, vol. 4 of *Zaigai Nihon no shihō*. Tokyo: Mainichi shinbunsha, 1979.

———. "Gensō kōteie." *Kokka* 1049 (1982): 13–25.

———. *Jinbutsuga: kangakei jinbutsuga*. Vol. 4 of *Nihon byōbue shūsei*. Tokyo: Kōdansha, 1980.

———. *Kano Eitoku*. Translated by H. Mack Horton and Catherine Kaputa. Tokyo and New York: Kodansha International, 1977.

———. "Kano-ha to Momoyama gadan." *Museum* 344 (1979): 4–14.

———. *Kano Tan'yū*. Vol. 15 of *Nihon bijutsu kaiga zenshū*. Tokyo: Shūeisha, 1978.

———. *Kenninji.* Vol. 7 of Shōhekiga zenshū. Tokyo: Bijutsu shuppansha, 1968.

———. *Kinsei shoki shōhekiga no kenkyū.* Tokyo: Yoshikawa kōbunkan, 1983.

———. *Motonobu/Eitoku/Tan'yū.* Tokyo: Shōgakkan, 1979.

———. *Nagoyajō.* Vol. 4 of *Shōhekiga zenshū.* Tokyo: Bijutsu shuppansha, 1968.

———. "Nanzenjizō senmen harimaze byōbu ni tsuite." *Kokka* 872 (1964).

———. "Nanzenji senmen byōbu." Vol. 6 of *Bijutsu senshu.* Tokyo: Fuji art shuppan, 1973.

———. "Omote to oku: shōhekiga o megutte." *Kenchikushi gaku* 11 (1988): 60–79.

———. "Shinsetsu'in *Teikanzu* byōbu to Kano Jinnojō ni tsuite." *Kokka* 956 (1973): 9–16.

———. *Shōbyōga.* Vol. 13 of *Genshoku nihon no bijutsu.* Tokyo: Shōgakkan, 1967.

———. *Tōhaku/Yūsho.* Vol. 9 of *Suiboku bijutsu taikei.* Tokyo: Kōdansha, 1973.

Tamagami, Takuya. *Genji monogatari hyōshaku.* Vol. 3. Tokyo: Kadokawa shoten, 1964.

Tamai, Kōsuke, ed. *Kaidōki, Tōkan kikō, Izayoi nikki.* Vol. 66 of *Nihon koten zenshū.* Tokyo: Asahi shinbun, 1957.

Tamamura, Takeji, ed. *Gozan bungaku shinshū.* Tokyo: Tokyo daigaku shuppankai, 1967.

Tanabe, Tsukusa. *Tsurezuregusa shochi.* Vol. 32 of *Nihon koten bungaku zenshū.* Tokyo: Shōgakkan, 1974.

Tanaka, Ichimatsu, ed. *Ban Dainagon ekotoba emaki.* Vol. 4 of *Nihon emakimono zenshū.* Tokyo: Kadokawa shoten, 1961.

Tanaka, Ichimatsu, et al. *Daitokuji Shinjuan.* Vol. 8 of *Shōhekiga zenshū.* Tokyo: Bijutsu shuppansha, 1968.

———. *Japanese Ink Painting: Shūbun to Sesshū.* Translated by Bruce Darling. New York: Weatherhill, 1972.

———. *Kaō/Mokuan/Minchō.* Vol. 5 of *Suiboku bijutsu taikei.* Tokyo: Kōdansha, 1974.

———. *Sesshū.* Tokyo: Heibonsha, 1984.

———. *Sesshū/Sesson.* Vol. 7 of *Suiboku bijutsu taikei.* Tokyo: Kōdansha, 1973.

Tokyo Metropolitan Teien Art Museum. *Muromachi bijutsu to sengoku gadan.* Tokyo: Tokyo-to bunka shinkōkai, 1986.

Tokyo kokuritsu hakubutsukan. *Muromachi jidai no bijutsu.* Tokyo: Tokyo kokuritsu hakubutsukan, 1989.

———. *Muromachi jidai no byōbue.* Tokyo: Tokyo kokuritsu hakubutsukan, 1989.

———. *Nihon no suibokuga.* Tokyo: Tokyo kokuritsu hakubutsukan, 1987.

Totman, Conrad. "English-Language Studies of Medieval Japan: An Assessment." *Journal of Asian Studies* 38 (1979): 541–555.

———. *Politics in the Tokugawa Bakufu,* 1600–1843. Cambridge: Harvard University Press, 1967.

———. "The State of the Art; The Art of the State(?); And Where Do We Go from Here?" *Harvard Journal of Asian Studies* 336 (1976): 240–255.

Tsuchida, Kyoson. "Kano Eitoku fusumae ron." *Tōyō Bijutsu* 13 (1931).

———. "Momoyama jidai makki no fusumae ron." *Tōyō Bijutsu* 13 (1931).

Tsuji, Nobuo. *Myōshinji Tenkyū'in.* Vol. 2 of *Shōhekiga zenshū.* Tokyo: Bijutsu shuppansha, 1968.

———. "Nanzenji honbō daihōjō shōhekiga no yōshiki oyobi hissha ni tsuite." *Kokka* 903 (1967).

Turner, Victor. *Dramas, Fields, and Metaphors: Symbolic Action in Human Society.* Ithaca: Cornell University Press, 1974.

Uchida, Sennosuke. *Gyokudai shin'eishū.* Vols. 60 and 61 of *Shinshaku kanbun taikei.* Tokyo: Meiji shoin, 1974.

Uchida, Sennosuke, and Ami Yūji, eds. *Monzen.* Vols. 14 and 15 of *Shinshaku kanbun taikei.* Tokyo: Meiji shoin, 1974.

Ueno, Osamu. *Goshūishū zengo.* Tokyo: Kasama shoin, 1976.

Ury, Marian. *Poems of the Five Mountains: An Introduction to the Literature of the Zen Monastaries.* Ann Arbor: Center for Japanese Studies, University of Michigan, 1992.

———. "Recluses and Eccentric Monks: Tales from the *Hosshinshū* by Kamo no Chōmei." *Monumenta Nipponica* 27 (1972): 149–173.

———. *Tales of Times Now Past: Sixty-Two Stories from a Medieval Japanese Collection.* Berkeley: University of California Press, 1979.

Usui, Yoshimi, ed. *Hōjōki, Tsurezuregusa, Ichigon hōdan shū.* Tokyo: Chikuma shobō, 1970.

van Gulik, R. H. *The Lore of the Chinese Lute: An Essay on the Ideology of the Chin.* Tokyo: Sophia University, 1969.

———. *Hsi K'ang and His Poetical Essay on the Lute.* Tokyo: Sophia University Press, 1941.

———. *Sexual Life in Ancient China.* Leiden: Brill, 1961.

Varley, H. Paul. "Ashikaga Yoshimitsu and the World of Kitayama: Social Change and Shogunal Patronage in Early Muromachi Japan." In John W. Hall and Toyoda Takeshi, eds., *Japan in the Muromachi Age.* Berkeley: University of California Press, 1977.

———. *Japanese Culture.* 3d ed. Honolulu: University of Hawai'i Press, 1984.

———. "Purity and Purification in the *Nampō Roku.*" *Chanoyu Quarterly* 48 (1987): 7–20.

Varley, H. Paul, and George Elison. "The Culture of Tea: From Its Origins to Sen no Rikyū." In George Elison and Bardwell Smith, eds., *Warlords, Artists, and Commoners.* Honolulu: University of Hawai'i Press, 1981.

Varley, Paul, and Kumakura Isao, eds. *Tea in Japan: Essays on the History of Chanoyu.* Honolulu: University of Hawai'i Press, 1984.

Wang, Shizhen, comp. *Liexian quanzhuan,* reprinted in *Zhongguo gudai banhua congkan.* Shanghai: Wenwu chuganshe, 1961.

Warner, Langdon. *The Enduring Art of Japan.* Cambridge: Harvard University Press, 1952.

Watanabe, Tsunaya, ed. *Shasekishū.* Vol. 85 of *Nihon koten bungaku taikei.* Tokyo: Iwanami shoten, 1966.

Watanabe, Tsunaya, and Kōichi Nishio, eds. *Uji shūi monogatari.* Vol. 27 of *Nihon koten bungaku taikei.* Tokyo: Iwanami shoten, 1960.

Watanabe, Tsuneo, and Iwata Junjichi. *The Love of the Samurai: A Thousand Years of Japanese Homosexuality.* Translated by D. R. Roberts. London: Gay Man's Press, 1989.

Watson, Burton. *Chinese Lyricism.* New York: Columbia University Press, 1971.

———. *Japanese Literature in Chinese.* Vol. I. New York: Columbia University Press, 1975.

———. *Kanshi: The Poetry of Ishikawa Jozan and Other Edo-Period Poets.* San Francisco: North Point Press, 1990.

Watson, Burton, trans. *Chuang Tz'u.* New York: Columbia University Press, 1964.

———. *Meng Ch'iu: Famous Episodes from Chinese History and Legend.* Tokyo: Kodansha International, 1979.

———. *Records of the Grand Historian of China.* Vol. I. New York, Columbia University Press, 1961.

Webb, Glenn. "Japanese Scholarship behind Momoyama Paintings and Trends in Japanese Paintings ca. 1500–1700, as Seen in the Light of a Stylistic Reexam-

ination of the Nature of Chinese Influence on Kano Painters and Some of
 Their Contemporaries." Ph.D. dissertation, University of Chicago, 1970.

Welch, Holmes, and Anna Seidel, eds. *Facets of Taoism: Essays on Chinese Reli-
 gion.* New Haven: Yale University Press, 1979.

Wheelwright, Carolyn. "Kano Painters of the Sixteenth Century A.D.: The Devel-
 opment of Motonobu's Daisen'in Style." *Archives of Asian Art* 34 (1981): 6–31.

———. "Kano Shoei." Ph.D. dissertation, Princeton University, 1980.

———. "Tohaku's Black and Gold," *Ars Orientalis* 16 (1986): 1–32.

———. "A Visualization of Eitoku's Lost Paintings at Azuchi Castle." In George
 Elison and Bardwell L. Smith, eds. *Warlords, Artists, and Commoners: Japan
 in the Sixteenth Century.* Honolulu: University of Hawai'i Press, 1981.

Willig, Rosette, trans. *The Changelings (Torikaebaya monogatari).* Stanford: Stan-
 ford University Press, 1988.

Yamaguchi kenritsu bijutsukan. *Unkoku Tōgan to Momoyama jidai.* Yamaguchi:
 Yamaguchi kenritsu bijutsukan, 1984.

Yamamori, Tetsuo. "Kamo no Chōmei, the Recluse." *Chanoyu Quarterly* 64
 (1991): 30–45.

Yamamoto, Hideo. "Unkoku Tōgan to sono ippa," *Nihon no bijutsu* 320 (March
 1993).

Yamane, Yūzō, et al. *Nanzenji honbō.* Vol. 10 of *Shōhekiga zenshū.* Tokyo: Bijutsu
 shuppansha, 1968.

Yamaoka, Taizō. *Kano Masanobu/Motonobu.* Vol. 7 of *Nihon bijutsu kaiga zen-
 shū.* Tokyo: Shūeisha, 1981.

Yamashita, Yūji. "Shabaku hitsu kinkishogazu byōbu." *Kokka* 1122 (1989): 20–27.

Yamato bunkakan. *Kano Sansetsu.* Nara: Yamato bunkakan, 1986.

———. *Shōkadō Shōjō: Chanoyu no kokoro to hitsuboku.* Nara: Yamato bunka-
 kan, 1993.

Yampolsky, Philip B., ed. *Selected Writings of Nichiren.* Translated by Burton Wat-
 son. New York: Columbia University Press, 1990.

Yoshida, Kiwamu. *Chūsei no shisō.* Tokyo: Kyōikusha, 1981.

Yoshida, Teruji, et al. *Ukiyoe taisei.* Vol. 1. Tokyo: Kyōiku shoin, 1930.

Yoshikawa, Kōjirō. *An Introduction to Sung Poetry.* Translated by Burton Watson.
 Cambridge: Harvard University Press, 1967.

Index

aesthetic reclusion *(suki no tonsei):* as creative liberation, 163–167; and Four Graybeards, 21; and Fujiwara Seika's neo-Confucianism, 170; in *Genji monogatari,* 31–32; in Gozan poetry and painting, 46–47; as lifestyle, 163–166; and liminality, 64; in literature, 19; in painting, 175–176; in painting, as rationale for analysis, 74, 98; in painting, seventeenth century, 178; in painting, significance of, 11, 13–14; patronage of, 171; pictorialization of, 76; political deployment of, 44–46; as political escape, 163–167; popularity of, 176; in recluse literature, 45; in *renga,* 52; and Seven Sages and Four Graybeards, 24; in tea, 63, 68; and *tonseisha,* 55; in *waka,* 28

Agriculture and Sericulture *(nō-yōsangyō),* 76

Aki no yo no nagamonogatari (A Long Tale for an Autumn Night), 87

architecture. *See* hermitages; tea huts; *shoin*-style architecture

aristocrats: as art patrons, 8–11, 13–14, 178; as tea patrons, 59–61

art: as cultural agent, 15, 17–18, 47, 180–181

Ashikaga Yoshimasa (1436–1490), 54–55

Ashikaga Yoshimitsu (1358–1408), 54–55

Azuchi Castle, 57, 106–109, 208 n. 102–103

Bal, Mieke, 17–18

Bauer, Wolfgang, 23, 172–173

Baxandall, Michael, 180

Berry, Mary E., 59

bird-and-flower painting, 15, 102

Bo Juyi (Hakkyoi, 772–846), 4; *Chang-henge,* 31; in *Chiteiki,* 40–41; in *Genji monogatari,* 31–32, 190 n. 49; in Heian *monogatari,* 30–32; as hermit, 28, 190 n. 59; hermitage of, 199 n. 61; in *Hōjōki,* 42; in *Honchō monzui,* 189 n. 42; in *Kara monogatari,* 35; in *Makura no sōshi,* 189 n. 44; and "middle reclusion," 45; in *Tsurezuregusa,* 43. See also *Senzui Byōbu*

boy attendants, 87, 100

Boya (Hakuga), 90, 98

Boyi (Hakui), 29, 190 n. 60; in *Taiheiki,* 37

Bryson, Norman, 17–18

Budai (Hotei), 3

Buddhism: in *Chiteiki,* 40; and *Ichigon hōdan,* 39; and neo-Confucianism, 168. *See also* Jōdo Shinshū

Buddhist literature, 29–30, 34

byōbu. See wall painting

Cahill, James, 8, 104

Chacha (Yododono or Yodogimi, 1567–1615), 116

chanoyu. See tea

Chaofu (Sōho), 4, 38, 190 n. 60; at Azuchi Castle, 108, 208 n. 108; and Daoism, 173; in *Heike monogatari,* 37; in *Kara monogatari,* 35–36; in *Kanrin gohōshū,* 49; in Momoyama painting, 7, 207 n. 91; at Nishihonganji, 112; in *Shasekishū,* 29–30; in *Soga monogatari,* 37; in *Taiheiki,* 37

About the Author

Kendall H. Brown, a specialist in Japanese painting, is assistant professor of Asian art history at the University of Southern California. He received his B.A. and M.A. at the University of California, Berkeley, and his Ph.D in the History of Art from Yale University. He has also studied at Kyoto University on a Japan Foundation Fellowship and at Osaka University on a Japanese Education Ministry Fellowship. Recent publications include two exhibition catalogs on early twentieth century Japanese prints in the *shin-hanga* style. He is currently writing a book on the cultural history of Japanese-style gardens in North America.